DATE DUE

ill : 686 239	
due 5/3/89	
OCT 2 8 1990	

BRODART, INC. Cat. No. 23-221

PRAIRIE SCHOOL ARCHITECTURE

PRAIRIE SCHOOL ARCHITECTURE

Studies from 'THE WESTERN ARCHITECT'

Edited and Introduced by H. ALLEN BROOKS

VNR VAN NOSTRAND REINHOLD COMPANY
NEW YORK CINCINNATI TORONTO LONDON MELBOURNE

First published in paperback in 1983
Copyright © 1975 by University of Toronto Press
Library of Congress Catalog Card Number 82-50455
ISBN 0-442-21309-3

Printed in the United States of America

Van Nostrand Reinhold Company, Inc.
135 West 50th Street
New York, New York 10020

Fleet Publishers
1410 Birchmount Road
Scarborough, Ontario M1P 2E7, Canada

Van Nostrand Reinhold
480 Latrobe Street
Melbourne, Victoria 3000, Australia

Van Nostrand Reinhold Company Limited
Molly Millars Lane
Wokingham, Berkshire, RG11 2PY England

Cloth edition published 1975 by University of Toronto Press

16 15 14 13 12 11 10 9 8 7 6 5 4 3 2 1

Contents

Contents vii

Notes to the Contents

Walter Burley Griffin: August 1913. This volume was mistakenly designated Volume 20 in the original publication.

Purcell & Elmslie: January 1915. The 'letters' at the beginning of this article are the fictitious creation of Purcell and Elmslie.

Purcell & Elmslie: July 1915. These plates were prepared originally for the January 1915 issue, but the publisher erred and requested twice as many illustrations as space in that issue permitted. As in the earlier issues, the ornament was designed by Elmslie, while Purcell took charge of the layout.

George W. Maher: March 1914. The drawing at the bottom of page 165 is from Volume 18, Number 1, January 1912.

Spencer & Powers: April 1914. The name of the firm was Robert C. Spencer, Jr prior to late 1905. The drawing at the bottom of page 195 (page 39 of the issue) has been transposed from page 34 of the issue.

Guenzel & Drummond: February 1915. The name of the firm was William E. Drummond prior to 1912.

Tallmadge & Watson: December 1915. The illustrations on page 271 (page 50 of the issue) have been assembled from pages 50, 52, and 51 of the issue.

Barry Byrne: March 1924: The preamble to the article has been omitted and the layout of pages 304–5 (originally pages 34–5 of the issue) has been altered. The frontispiece of the issue has been added to page 305.

Introduction

The Prairie School created some of the finest and most original architecture that America has ever known, an indigenous architecture that taught us to exalt nature's own materials, to explore new ways of relating buildings to the landscape, and to enhance our experience of living through new concepts of interior space. It was an architecture of the Midwest, yet its significance was never so limited. With roots deep in the nineteenth century, and with strength drawn from the Shingle Style, the commercial architecture of Chicago, and the English Arts and Crafts Movement, the Prairie School, in turn, nourished architecture in Europe and Australia, and provided the seeds from which a new, distinctly American architecture was to grow after the Second World War. Viewed in an international context, the movement was a regional, primarily architectural, manifestation of the turn-of-the-century reform and revolt in the visual arts of which Art Nouveau, the Austrian Secession, and the Glasgow School were also vital parts.

The Prairie School began in the last years of the nineteenth century, perhaps at that moment in 1897 when Dwight Perkins, Robert Spencer, Frank Lloyd Wright, and Myron Hunt formed a coterie at Steinway Hall in Chicago. Membership in this group constantly fluctuated but not its cherished goal – the development of an American architecture especially suited to the Midwest. To Louis Sullivan they turned for inspiration and to them, as well as others, he addressed his 'The Young Man in Architecture' (1900) and his 'Kindergarten Chats' (1901–02). But a form-giver, not a philosopher, was needed, and Sullivan's preoccupation with commercial architecture offered little guidance to men primarily concerned with designing houses.

Sullivan's disciple, Frank Lloyd Wright, was the first among the group to achieve a viable synthesis, and thereafter leadership passed to him: the center of activity moved from Steinway Hall to Wright's Oak Park studio. There several younger men obtained their training, including Walter Burley Griffin, William Drummond, Barry Byrne, and John Van Bergen. Others, such as George Elmslie and William Steele, worked for Sullivan, while William Purcell, George Maher, Robert Spencer, Thomas Tallmadge, and Vernon Watson

apprenticed under various architects before striking out on their own. Work by all these men is represented in this book. In retrospect we recognize this period as the formative, experimental phase of the movement, one marked by diversity rather than the assimilated stylistic expression which typified the later years.

For the Prairie School, the climactic years came between 1910 and 1914–16, when quality and inventiveness reached their zenith and the greatest quantity of work was produced. Not only houses, but banks, churches, libraries, schools, clubs, shops, offices, and civic buildings were built as the school's influence spread in the Midwest and was felt from coast to coast. But the prominence these men enjoyed was subsequently forgotten, in part due to Wright who heaped scorn upon them and tirelessly insisted that the school had collapsed because of his departure in 1909 (first to Europe, then to Wisconsin and Japan). In truth the opposite situation prevailed: Wright's career after 1909 was eclipsed by the movement, and he received comparatively few Midwest commissions, while the lion's share of new work passed to his colleagues.

Many sources contributed to the visual characteristics embraced by the group. For example, there was the Arts and Crafts Movement with its concern for 'honesty' in use of materials and disdain for apparent pretension. (This fostered in England a revival of Medieval cottage architecture, itself not without relevance for the American Midwest.) The Shingle Style supplied the idea of continuity of surface and open interiors; the bungalow low, horizontal silhouettes; and the vernacular suggested arrangements for massing and the grouping of parts. Sullivan's best work served as a lesson in elimination, and the so-called primitive architecture of the Southwest and Central America confirmed the validity of simplified massing, geometric shapes, and an isolated, abstract ornament.

These buildings might be constructed of wood (rough sawn and stained), plaster (tinted off-white), brick, or random-cut limestone, but seldom were more than two materials combined in a single building. And – in sharp contrast to traditional practice – the same materials, treated in a similar way, were used both for the interior and exterior finish. Although structural innovation is seldom associated with residential design, concrete and concrete block were occasionally used, and efforts were made to resolve the problem inherent in their structural expression.

For the layman, however, the hallmark of the Prairie School was the use of natural materials, precise, angular forms, continuous horizontals punctuated by short verticals, and a sense that the building belonged to the landscape. Few observers appreciated how some of these buildings obliterated age-old tradi-

tions regarding size and arrangement of rooms and successfully established new, highly efficient interiors which did much to enhance the experience of living by virtue of their subtle means of defining and enclosing space.

Although Wright's contribution to the Prairie School is familiar, the substantial contribution of others should also be recognized. Walter Burley Griffin, for example, developed a split-level, vertical organization of space in contrast to Wright's horizontal flow. He charted a course in the assimilation of pre-Columbian architecture that Wright later followed up, and he exploited the use of concrete (and its structural expression) in residential architecture at a time when Wright was proposing, but not building, houses of concrete. Indeed, Griffin developed a workable system of concrete blocks (called Knitlock) which he patented in 1917, long before Wright's more publicized concrete block experiments of the 1920s (Millard house, Pasadena, etc). These achievements by Griffin were considerable, yet each of the architects made some contribution, great or small, and within the limits of the school evolved a manner of his own. The work of Barry Byrne emphasized severe, space-enclosing cubic shapes, rather than space-defining intersecting verticals and horizontals; William Drummond accentuated precise geometric forms, the right angle, and the slab roof; Purcell and Elmslie often stressed surface in relation to sharp-edged voids (in their late, white-stucco work this prefigured the International Style); and Louis Sullivan, whose post-1900 designs clearly fall within the context of the Prairie School, brilliantly fused his rich, organic ornament with simple, monumental forms to create some of the most stunning buildings of his career.

In spite of these achievements, the Prairie School was living on borrowed time; change was in the air. The Midwest was increasingly aware that it differed – socially, culturally – from the East, and this led to the displacement of spontaneous values by imported ones. A pertinent example of the early freedom from cultural servitude is found in the choice of place names. These lacked historical association: the Midwesterner picked names like Oak Park, Riverside, Spring Green, and La Crosse. Contrast the more indebted East, where Rome, Syracuse, Troy, and Ithaca were chosen names and the classical orders prevailed, while in Portsmouth, Boston, New London, and Williamsburg the initial architectural allegiance was with England. The Midwest's intuitive or 'unspoiled' (to borrow a word from Wright) instincts helped foster the Prairie School; it was the repression of these values which spelled its doom. By 1916 these architects received ever fewer commissions, and the remaining work was seldom for designing houses, the specialization for which they had been trained.

Not until after the Second World War did American architecture seek regeneration from its native soil. At that time public taste again came to favor natural materials and low, small-scale, anti-monumental architecture – an architecture rooted in the earth. Features from the prairie house, at first ill-understood and debased, became the basis for the ubiquitous split-level, ranch-style houses of the 1950s, but since then more positive developments have occurred, initially in California, and most recently in the Midwest itself, where the work of the Prairie School has inspired a younger generation in the direction of a new, vital course for American architecture.

The *Western Architect*, published in Minneapolis, was the only journal extensively to document the work of the Prairie School. Today it is so rare that only three or four complete sets exist. The first issue appeared in August 1902, but nine years passed before the Prairie School received any significant recognition, and this was of a negative sort. The November 1911 issue lashed out editorially against Wright. The pretext was contrived: the New York based *Architectural Record* (which long had been sympathetic toward Midwest progressivism) had published a thoughtful, well-reasoned article comparing Sullivan's Babson house and Wright's Coonley house. The *Western Architect* chose to 'review' this article and, in an obvious attempt to malign Wright, misrepresented much of what was said. The writer reported that 'between the lines' one could read that 'the house by Mr Wright ... is practically a freak,' and concluded, 'none have ... failed so signally in the production of livable houses as Frank Lloyd Wright.'

Robert Craik McLean probably wrote these lines. He had been with the *Western Architect* since 1905, and previously edited the *Inland Architect and News Record* of Chicago (which ceased publication in 1908). All things considered, it seems likely that McLean nourished a personal, as well as professional, dislike for Wright, one which earlier had shaped the editorial policy of the Chicago monthly, and which was not out of step with the ultra-conservative *Western Architect* as managed by Edward A. Purdy.

But the *Western Architect's* abuse of Wright brought matters to a head. A storm of protest apparently followed; Wright's work, after all, had become familiar to readers through two monographs and the coverage given him by Eastern magazines. Sensitive to its subscribers' interests, the *Western Architect* did an about-face. The December issue devoted its lead article to Wright, a maneuver which presumably necessitated re-setting copy on short notice. The subject was the City National Bank of Mason City, Iowa (see pp. 3–7), which, being a bank,

required no retraction of cutting remarks previously made about Wright's houses. The ice, however, was broken.

William Gray Purcell, a former Sullivan apprentice then practising in Minneapolis, was consulted by Purdy concerning policy, and henceforth the Prairie School received some tentative recognition. In 1912 articles appeared by Purcell on Griffin, and by Griffin on his plan for Canberra (see pp. 38–45; Griffin's sudden international acclaim as designer of Australia's federal capital must have helped to convince Purdy to publish work by the Prairie School); there were also three excellent articles by the Dutch architect H.P. Berlage, for whom Purcell had helped arrange an American lecture tour.

The year 1913 opened with an issue devoted to the work of Purcell and Elmslie, the architects themselves preparing the layout, marginal decorations, text, and captions (see pp. 46–79). The following month 'Taliesin, the Home of Frank Lloyd Wright and a Study of the Owner' appeared; this curious four-page spread commenced with a statement that adequate photographs 'are impossible to procure' (presumably an excuse for giving minimal coverage to Wright's Wisconsin home) and immediately avoided further comment by re-printing a long quotation from the English architect C.R. Ashbee (whose name was misspelled). This was as close, apparently, as the *Western Architect* could come to honoring Wright; the August issue, by contrast, was completely given over to Griffin's work (see pp. 8–37).

In 1914, the March issue was devoted to George W. Maher (see pp. 162–90) and the April issue (with text by Purcell) to Spencer and Powers (see pp. 191–219). By December the editors were at last ready to commit themselves: 'the interesting, vitalized work of the present lies along ... progressive lines. This work we will carefully select and illustrate in ... 1915.' And true to their word 1915 saw two issues given over to Purcell and Elmslie (see pp. 80–129), portions of two issues to John S. Van Bergen (pp. 246–67), and one issue each to the firms of Guenzel and Drummond (pp. 220–45) and Tallmadge and Watson (pp. 268–89). This was a high water mark for contemporary reporting on the Prairie School. Henceforth, when recognition came it was usually for a single building, as in the detailed coverage of Louis Sullivan's Merchants National Bank, Grinnell, Iowa (published 1916; see pp. 290–300), Purcell and Elmslie's Woodbury County Court House (1921; pp. 130–61), and Wright's Imperial Hotel, Tokyo, which was illustrated with poor quality photographs in 1923. To Barry Byrne, whose Midwest practice began in 1914, space was accorded in 1924 and 1925 (pp. 304–29). Prior to terminating publication in 1931, the

Western Architect recognized a younger generation, including John Lloyd Wright (the architect's second son) and Bruce Goff. Only one major Prairie School architect never had a survey devoted to his work – Frank Lloyd Wright.

In selecting material for this volume, virtually all Prairie School work published in the *Western Architect* has been included. Omitted are a few plates that appeared in scattered issues (unless they could be appended to a longer series, as were pp. 261–7, and 288–9), and the occasional photograph illustrating designs by lesser architects. Also omitted or condensed are some articles from the later years, especially after 1920.

Eleven architects or firms appear in the table of contents; for each there follows a short biographical sketch, printed in alphabetical order. Readers wishing further information about these men, their work, and the environmental situation which fostered and then curtailed the growth of the school, are referred to my book, *The Prairie School: Frank Lloyd Wright and His Midwest Contemporaries* (University of Toronto Press, Toronto and Buffalo, 1972).

BARRY BYRNE (1883–1967) entered Wright's studio in 1902 without previous training or experience, and remained there until 1908. He then worked briefly for Griffin before moving to Seattle, Washington, where he established a partnership with another former Wright employee, Andrew Willatzen. This lasted about five years. In 1914 Byrne returned to Illinois, via California, in order to manage Griffin's affairs after the latter left for Australia. From 1920 on, his major client was the Catholic Church; an association with John Ryan during the early 1920s was a business, not a design, arrangement. Although trained with Wright, Byrne responded more to Sullivan's sense of form, this preference being heightened by his contact with Irving Gill, the architecture of the Southwest, and his work with Griffin. Severe, space-enclosing cubic shapes, rather than space-defining verticals and horizontals, typified his designs. Exterior ornament (seldom used on houses) emphasized edges and changes in plane; it framed or emphasized wall surfaces rather than adorning them.

WALTER BURLEY GRIFFIN (1876–1937), after receiving his BS degree in architecture from the University of Illinois in 1899, joined the group at Steinway Hall. In 1901 he was employed by Wright, and eventually became office manager and job superintendent at the Oak Park studio before a quarrel precipitated his departure late in 1905. Thereafter he spent some five years assimilating the influence of Wright, but he ultimately became one of the most original and inventive designers among the Prairie School. In 1911 he married Marion

Mahony (1871–1962). She was a graduate of MIT, had worked intermittently for Wright since 1895, and was responsible for many of the beautiful renderings of Wright's, and later of Griffin's, work. She also designed, under Wright's direction, much of the furniture and interior ornament for his houses. During the period 1909–12, while von Holst was temporarily in charge of Wright's commissions, she did design a few houses. Her ideas influenced Griffin, yet none of his post-marriage work is entirely by her hand. She prepared the splendid drawings of his prize-winning plan (1912) for Canberra, and this event led to their departure for Australia and the termination of Griffin's American career.

GUENZEL & DRUMMOND were in partnership only from 1912 to 1915, and seldom if ever worked as a designing team. Louis Guenzel (1860–1956) was older and had money, connections, and business ability, all of which his partner lacked. William E. Drummond (1876–1946), son of a carpenter-contractor, had studied one year at the Department of Architecture, University of Illinois, then had spent several months in Sullivan's office, and, about 1899, joined Wright's studio staff. There he remained until 1909 except for the period between 1901 and 1903 or 1904, when he worked for both Richard E. Schmidt and D.H. Burham. In 1909 he entered private practice, although his earliest commission, the First Congregational Church in Austin, Illinois, was undertaken while still with Wright. All the work illustrated in the *Western Architect* of February 1915 (see pp. 220–45) is probably of his design, except for the inn (bottom of page 236) and the apartment and office buildings (page 238) which were Guenzel's contribution.

GEORGE W. MAHER (1864–1926) was born in West Virginia, attended school in Indiana, and, apparently at the age of 13, began working for Bauer & Hill in Chicago before joining Joseph Lyman Silsbee's staff (where Elmslie and Wright later were employed). In 1888 he entered private practice, soon settling in Kenilworth where much of his work remains today. Although inventive and intent upon creating an American style, he possessed limited powers of assimilation and lacked an intuitive sense of proportions. A steady evolution, therefore, is not apparent in his work. Rather he jumped from one design type to another, which in later years led him ever closer to his, often European, sources. He was a dedicated architect, and his influence, in its own way, must have been nearly as great as Wright's; but, despondent at not attaining his professional goal, in 1926 he took his own life.

PURCELL & ELMSLIE George Grant Elmslie (1871–1952) was an apprentice in Silsbee's office when, through Wright's recommendation, he found work with Sullivan, with whom he remained until 1909. At that time he joined Purcell and Feick in partnership; he had met Purcell, and obtained temporary work for him, in Sullivan's office in 1903. William Gray Purcell (1880–1965) was raised in Oak Park, studied architecture at Cornell, traveled and worked in California (with John Galen Howard, among others), and made a European tour with classmate George Feick, Jr before these two men founded a firm in Minneapolis (1907) which Elmslie joined two years later. Feick was an engineer, and by 1913 had withdrawn from the partnership in which his participation had been nominal. Purcell and Elmslie were an ideal designing team, Purcell's contribution emphasizing the logic, Elmslie's the graphics, of the final scheme. With his proclivity for public relations, Purcell obtained a wide variety of work before failing health led him, in 1920, to move to Oregon, and two years later to dissolve the firm. Elmslie continued in practice, but his work lacked its former vigor and resolve, and seldom did his occasional client seek residential designs.

SPENCER & POWERS formed their partnership late in 1905. Robert C. Spencer, Jr (1865–1953) was born in Milwaukee, graduated from the University of Wisconsin, attended MIT, and apprenticed with, among others, Sheply, Rutan & Coolidge (in both their Boston and Chicago offices) before entering practice in 1895. He soon became Wright's closest friend and apparently was responsible for Wright's move to Steinway Hall; in 1900 he wrote a major article about Wright's work for the *Architectural Review*. Spencer was prolific as an author (between 1905 and 1909 he wrote more than twenty articles just for the *House Beautiful*), and this publicity did much to enhance the prestige of the Prairie School. His partner, Horace S. Powers (1872–1928), was a native Chicagoan and graduate of Armour Institute of Technology (now IIT); Powers' role was as office manager rather than co-designer.

WILLIAM L. STEELE (1875–1949) was a native of Illinois, and received his BS degree in architecture and engineering from the state university in 1896. Prior to 1904, when he moved to Iowa, he worked in Chicago, three years of that time in Sullivan's office where Elmslie was second in command. The *Western Architect* text (see pp. 130–7) relates the fascinating story of how Elmslie designed, under Steele's jurisdiction, the Woodbury County Court House, the largest civic structure ever constructed by the Prairie School.

LOUIS H. SULLIVAN (1856–1924) and Dankmar Adler were in partnership until 1895, with Adler attending to the technical and business problems of the firm. Thereafter Sullivan received few commissions, although he did design several small-town banks between 1907 and 1919. These, a fusion of rich, organic ornament and simple, monumental forms, are among the greatest works of his career. The earliest was the National Farmers Bank at Owatonna, Minnesota, exuberant in its internal ornament, while the penultimate was the People's Savings and Loan Association Bank at Sidney, Ohio, which internally is severe. The bank at Grinnell, Iowa (see pp. 290–300) stands midway in time (1914) and interpretation between these two extremes.

TALLMADGE & WATSON met while working in D.H. Burham's office, and formed a partnership in 1905. Thomas E. Tallmadge (1876–1940) had graduated from MIT (1898), and Vernon S. Watson (1879?–1950) from the Armour Institute of Technology (1900). The latter, apparently, was the real designer in the firm, although historian Tallmadge is better known because of his numerous publications. Their early prairie houses have little in common with their later church designs.

JOHN S. VAN BERGEN (1885–1969) was born in Oak Park and graduated from the local high school. Thereafter he helped his uncle, a speculative builder, before spending nearly two years with Griffin at Steinway Hall, learning the rudiments of architecture. Thus equipped (and with as well a three-month course at Chicago Technical College), he obtained work with Wright. The latter, before the year was out, left for Europe, leaving Van Bergen and Isabel Roberts, his secretary, to deal with clients and close the studio. Van Bergen then spent a year with Drummond before entering private practice. His subsequent work often followed Wrightian themes, although admittedly he had little time to assimilate his training before commissions were curtailed.

FRANK LLOYD WRIGHT (1867–1959) needs little introduction. He was born in Wisconsin. His formal education was interrupted before he completed high school although he subsequently attended a few courses, mainly in drafting and other pre-engineering subjects, at the University of Wisconsin. In 1887 he moved to Chicago, where for some months he worked for the residential architect Joseph Lyman Silsbee before obtaining employment with Adler & Sullivan, with whom he stayed until 1893. That year he began his private

practice. He had two offices, one at his Oak Park home, the other in Chicago where, during the winter of 1896–7, he joined the group at Steinway Hall. By 1900–02, while in this environment, he had attained full maturity as a designer, and his prairie houses of the following decade (Willits, Martin, Coonley, Robie) remain among his best known works. In September 1909, with the Mason City bank and hotel (pp. 3–7) still under construction, he left for Europe where he completed the drawings for his splendid folio, *Ausgefühute Bauten und Entwürfe von Frank Lloyd Wright* (Berlin, 1910). Late in 1910 he returned home and soon after moved to Taliesin, which he built near Spring Green, Wisconsin. With the exception of Midway Gardens (1914), his work, much reduced in volume, thereafter lay mainly outside the Midwest, at least until after the Second World War.

H. ALLEN BROOKS

PRAIRIE SCHOOL ARCHITECTURE

CITY NATIONAL BANK OF MASON CITY, IOWA
Frank Lloyd Wright, Architect

The building for the City National Bank of Mason City, was designed with the idea that a bank building is itself a strong box on a large scale; a well aired and lighted fireproof vault. The problem was complicated by the commercial consideration of offices overhead, for rent. A bank building of this type is usually either an undignified collapse between a pseudo-classic temple and a one-horse office building, or it is the one with the other piled on top of it. The fenestration of the offices in this case was so combined with the fenestration necessary to amply light the bank, that of the whole window treatment of a richly varied frieze was formed above to crown the massive unbroken wall surface below. The offices were thus absorbed in the nature of the scheme and contributed to the dignity of the whole building, instead of detracting from it.

The bank room itself, was moved aside from the party line to insure light and air on all sides; the ground space thus left was utilized for office quarters. By this means, a continuous border of windows was carried around the high banking room at the ceiling, affording light with perfect distribution, as well as good ventilation. These windows form a frieze of light within the bank room; they combine with the office windows in the frieze which the whole super-structure becomes outside; thus the walls of the bank, 16 feet above the side walk are a solid mass unbroken by openings save the entrance. The entrance and upper windows are guarded by heavy bronze castings, so that the bank, itself, is a strong box splendidly lighted and ventilated. As a banking institution should be an expression of integrity in its nature, the materials of which it was built were honestly used with no veneers or facings, or fake columns or fake architecture that had to be made just for effect.

The building is what it is by virtue of its nature and has the solidity, dignity and completeness which ideals of this character alone can give to a building. The same stone and brick which built the outside, built the inside. The interior fittings were designed in connection with the reinforced burglar proof vault altogether of permanent material and of the same character as the walls, so that bank room and fittings are a unit. There is common sense in the handling of the various features of this building. There is such a thing as common sense in the art of architecture. What distinction the structure has is due, in a measure, to this extraordinary view.

The building is situated on a prominent corner, opposite the central park of the city. A city wherein most of the buildings are rather cheerless in character, so quiet colored ceramic inlays were used to brighten the exterior. Dignity is not necessarily pretentious, stupid or ponderous. A touch of grace and amenity was given to the walls to gladden the eyes. The eyes of a modern American community are starved for color, as a rule—a precious quality in the joy of living—lost. The City National Bank has established a precedent, which if quietly and intelligently followed will make of city environment a pleasanter, happier thing in which to live.

As any good thing artistically must have, the building as a whole has a marked, distinct individuality. This is due in a large measure to the same ideals behind its design, the common sense of its structure and somewhat to the feeling for proportion and the knowledge of architectural grammar possessed by its architect. It is an honest pioneer in a field where wasteful pretense and borrowed finery are used to characterize and give distinction to enterprises which are in themselves simple and dignified, if treated honestly on their merits.

THE SPIRIT OF MERCURY
CITY NATIONAL BANK OF MASON CITY, IOWA

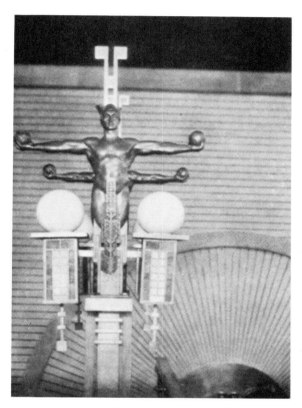

R. W. BOCK, SCULPTOR

Mercury, the god of Greek mythology was a son of Zeus and fostered abundance and prosperity, and consequently was adopted as the patron of commerce and finance. He has always been depicted as a slim youth of nervous disposition and fleet of foot, serving as messenger to the gods. His field of action was varied and manifold and not always creditable to himself. In applying the spirit of Mercury to our modern purposes (symbolically speaking) he serves the purpose of the general development of the money power, and like it springs from the soil to organic shape to become that tremendous factor, the all powerful domineering spirit of the time, to whom kingdoms bow and nations tremble. The figure therefore is depicted as rising straight like a plant out of the ground assuming shape as it develops and crystallizes, this being emphasized by the chrystal forms clinging to the figure much in the nature of a chrysalis. The upper part of the figure shows it to be of unusual strength upon whose powerful straight arms, lever-like, the world is balanced. The head-dress of wings and dolphin head are characteristic of Mercury as represented by the ancients.

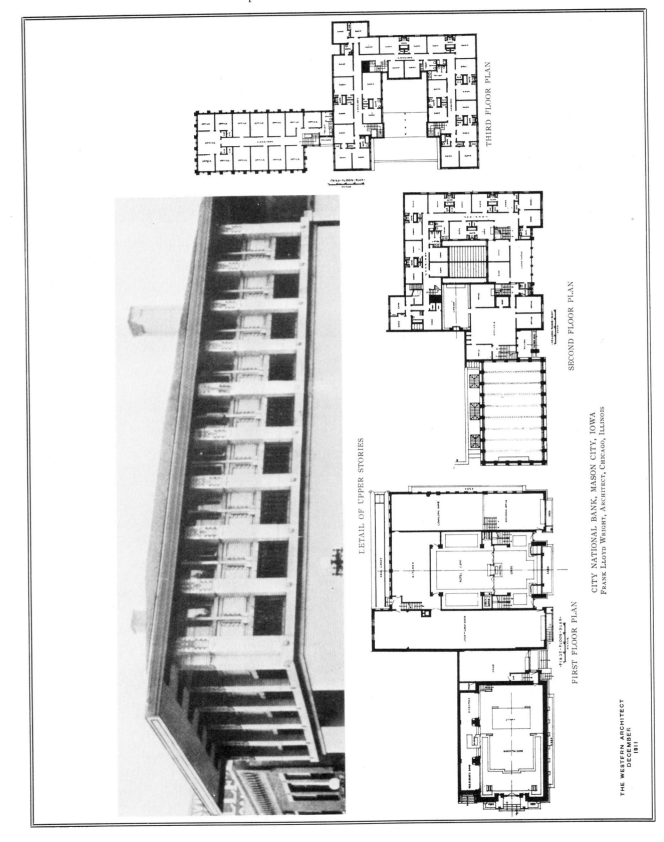

THIRD FLOOR PLAN

SECOND FLOOR PLAN

DETAIL OF UPPER STORIES

FIRST FLOOR PLAN

CITY NATIONAL BANK, MASON CITY, IOWA
FRANK LLOYD WRIGHT, ARCHITECT, CHICAGO, ILLINOIS

THE WESTERN ARCHITECT
DECEMBER
1911

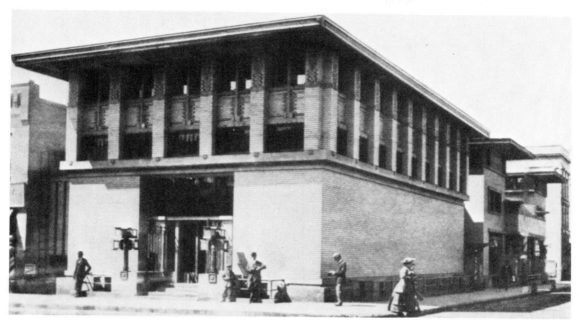

BANK BUILDING

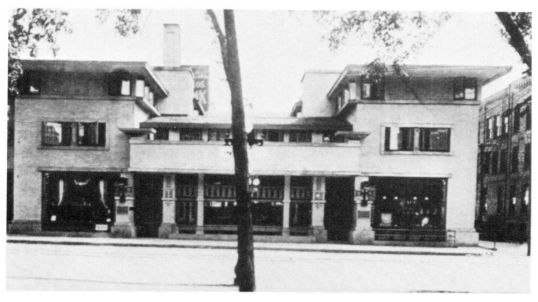

SHOP FRONTS

CITY NATIONAL BANK, MASON CITY, IOWA
Frank Lloyd Wright, Architect, Chicago, Illinois

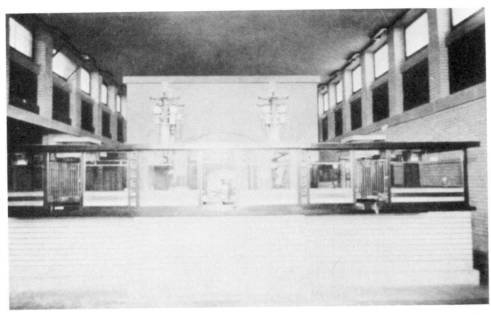

INTERIOR OF BANKING ROOM

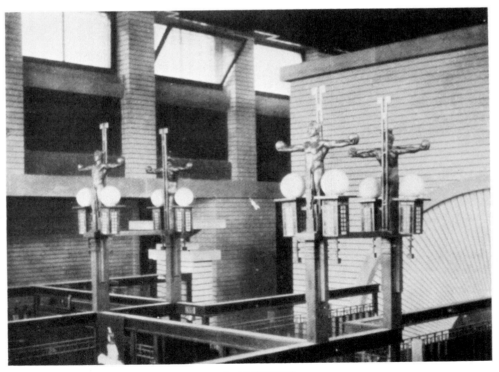

DETAIL OF INTERIOR

CITY NATIONAL BANK, MASON CITY, IOWA
Frank Lloyd Wright, Architect, Chicago, Illinois

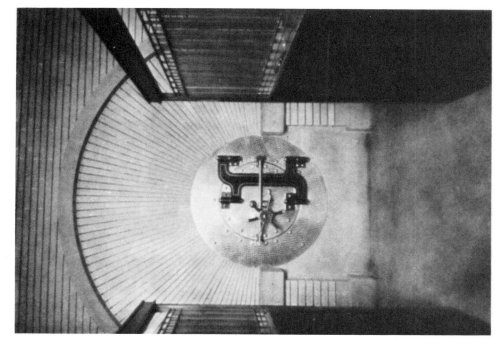

VAULT

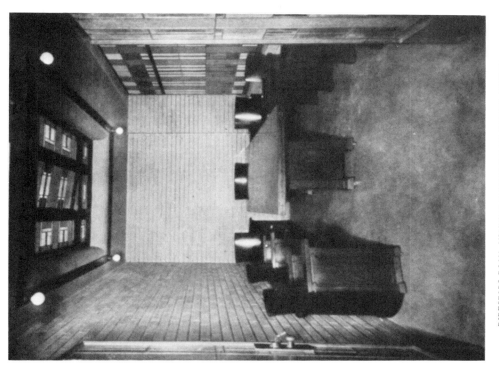

DIRECTORS ROOM, SHOWING FURNITURE OF SPECIAL DESIGN

CITY NATIONAL BANK, MASON CITY, IOWA
FRANK LLOYD WRIGHT, ARCHITECT, CHICAGO, ILLINOIS

THE WESTERN ARCHITECT
DECEMBER
1911

THE WESTERN ARCHITECT

A NATIONAL JOURNAL OF ARCHITECTURE AND
ALLIED ARTS, PUBLISHED MONTHLY

| VOLUME 19 | AUGUST 1913 | NO. 8 |

TRIER CENTER NEIGHBORHOOD, WINNETKA, ILL.

A Domestic Community For Immediate Zone, Chicago
Walter Burley Griffin, Architect

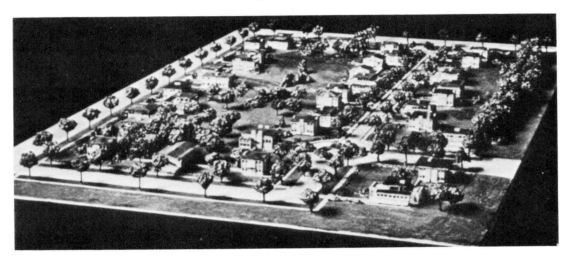

MODEL OF TRIER CENTER

Near the southern boundary of the village of Winnetka this neighborhood of thirty homes on nine acres lies between the suburban stations of Kenilworth and Winnetka on the Chicago and Northweatern Railroad, with a station of the Chicago-Milwaukee Electirc line about a hundred feet from the south west corner of the tract.

The site is flat with only a sprinkling of trees except in the northwest quarter on which there is a dense growth of young oaks and ash with one Indian trail mark swamp white oak. There are, however, acres of wild roses as attractive with their red stems and fruit in the winter as with their flowers and leaves in the summer and there have been planted this spring some ten thousand trees, shrubs and vines of species characteristically interesting in the winter time, to be used in setting off the buildings as rapidly as completed.

The neighborhood takes its name from the elaborate development the past year of the adjacent new Trier High School into a complete domestic social center for the entire township where in quadrangular grouping, with a park and garden setting, besides the play grounds and game fields, are provided restaurant, auditorium, theater, gymnasia and natatorium additional to the full educational equipment, recognizing a new function which our public school buildings have begun to assume to make them count for the older members of the family as well as the children.

Because of a determination to preserve for the neighborhood a maximum of the site's natural beauty and to secure that garden charm which alone justifies living out in the suburbs; the architecture of the houses is reduced to a minimum of scale, height and obtrusiveness, considerations that have dicatated masonry construction with its minimum of trim and accessory features and a maximum suitability to bower and embellishment with luxuriant growth not only over walls but roofs also. Furthermore the

extensiveness of the operation with repetition of structural forms affords opportunity for considerable economy in masonry operations so that these houses can be carried out even in fireproof construction by eliminating much of the expensive interior wood trim and finish necessary to frame construction.

Taking advantage of their fireproof character, the houses are, in general coupled together often with a connection of walled service court yard or low lying garage or other outbuilding structure, tending to obviate the petty spotiness and monotony of isolated single little houses. An informal architectural composition of each pair into a single unit is furthermore invited by the obvious benefit arising from co-ordination in the location of their entrances, service, and most public functions, separating these thoroughfares to almost twice the distance apart that is possible otherwise and placing them where the requirements of privacy are the minimum and where the public intrusion to the entrances and the external service utilities are, in opposition, neutralized as well as screened by the buildings themselves from all the rest of the premises.

The concentration of the business ends of the houses and the reduction of their distances from the street to a modest fore court garden setting, dictates the planning of the other rooms and verandas to be such as will secure the best views and the sunny aspects as well as privacy.

The houses are so arranged in the pairs as to secure freedom and informality, for example that combination with a connection only near the corners leaves the four sides of each structure free and open; and the juxtaposition of a one story with a two story house in diverse ways leads to endless variety and diversity despite the constant repetition of simplest forms and no introduction of unnecessary elements. Again the pairs treated as units are also grouped into the larger unit composition that embraces the block or court frontage as the case may be. By spacing the couples alternating across the street as well as back and forth from the street, prospects

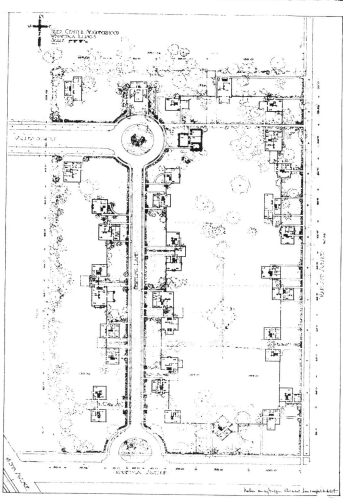

PLAT OF TRIER CENTER

from each are opened up clear through the grounds and past as many as four houses laterally, vistas terminated reciprocally in most cases by architectural or garden elements entirely within the community. The typical private allotment is 64 feet by 149 feet.

THE ARCHITECT'S OWN HOME

This house is one of a series of thirty-five small fireproof cottages that represent an attempt to demonstrate some of the advantages of recently developed practical and esthetic principles for the layout of small home groups.

Among these advantages, besides the generally recognized saving in wholesale building operation, especially for fireproof structures, are: Greater

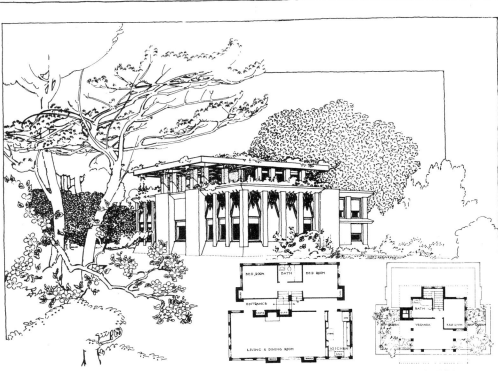

FIRST HOUSE DESIGNED FOR TRIER CENTER. WALTER BURLEY GRIFFIN, ARCHITECT

utilization of the ground and openness of view, first through clustering together and thus concentrating the public thoroughfare and service functions of the houses to leave wider, freer ground space for private use and preservation of the rural character; secondly, by arranging the clusters with respect to each other to give vistas from all principal rooms extending over at least two unobstructed lots in each direction; thirdly, in the combination and composition of units of simplest form, single little houses, into picturesque or formal designs, using connecting walls and hedges with tree and shrub backgrounds to help convert each house that alone would be an unmitigated box into an appropriate link of a rambling, cozy, private community home of separated wings, bays and pavilions, such as might constitute the dream of the useless overgrown Castle in Spain toward which each of us is so often selfishly and aristocratically inclined.

By means of co-terminating restrictions in the title deeds it is possible to maintain the community ideal of this development so long as this particular community wishes starting with permanent buildings and garden settings completed in all cases and with families who desire the open and co-operative treatment of the garden area we may feel assured that these possibilities will be developed to their

utmost. No outbuildings are to be allowed outside restricted court garden limits indicated in the original plan. Hedges and wire fences will be the reliance for separating the private gardens so far as isolation is desired by any families. The low walls indicating the demarcation between private garden and public fore courts are part of the original construction and an important factor in unifying the treatment of the thoroughfare spaces and bringing down in height and connecting with the earth the building features of whole garden scheme.

The street leading into the tract from the west and the lane leading through it are formally set off by the terminal public parks and the approaches from each direction are closed by buildings which will be correspondingly accentuated in their architectural relationship with the remaining houses, as in the case of the first one of the herewith illustrated.

The concrete pavement of Bertling Lane is only of that extent which permits one vehicle to pass another backed against the side and is to be in accord with the general garden character having a grit surface treatment and no curbs. Modest four foot sidewalks are separated from it on either side by three foot parkings of evergreen vines, and summer flowers. Though this community will not

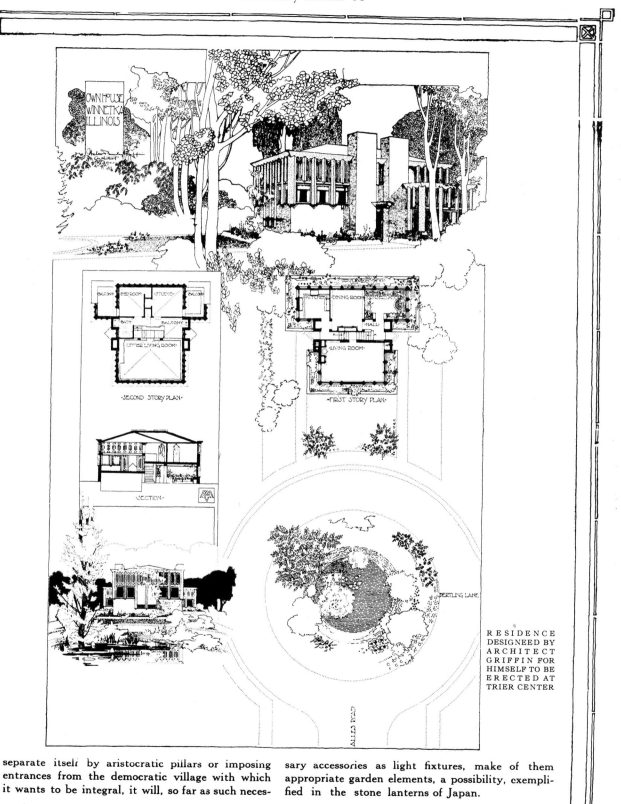

OWN HOUSE
WINNETKA
ILLINOIS

·SECOND STORY PLAN·

·FIRST STORY PLAN·

·SECTION·

RESIDENCE
DESIGNEED BY
ARCHITECT
GRIFFIN FOR
HIMSELF TO BE
ERECTED AT
TRIER CENTER

separate itself by aristocratic pillars or imposing entrances from the democratic village with which it wants to be integral, it will, so far as such necessary accessories as light fixtures, make of them appropriate garden elements, a possibility, exemplified in the stone lanterns of Japan.

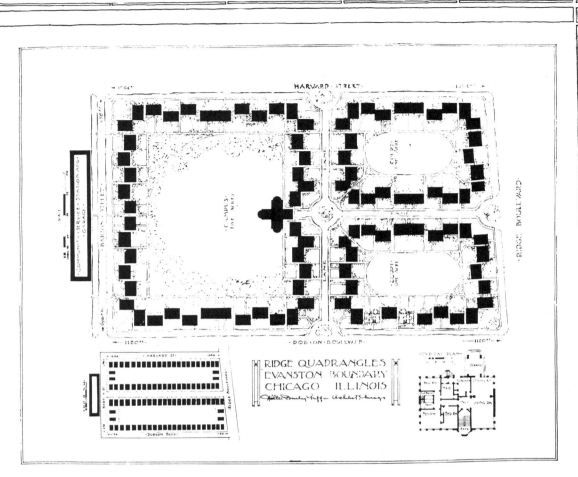

RIDGE QUADRANGLES

DOMESTIC COMMUNITY PROJECT OF CO-OPER-ATIVE HOMES FOR INNER SUBURBAN ZONE, CHICAGO, ILLINOIS

The site of Ridge Quadrangles is a sylvan plain, belted with oak forests extending across one of those sand spit bars that mark the former existence of lake or sea over the Chicago district, in this case some 20 feet above the general level about it. Its east frontage is at the edge of this ridge on the boulevard that forms the principal connection for motor traffic between Chicago and the north shore, some three blocks distant from the Milwaukee line of the Chicago and Northwestern Railroad, whose tracks will comprise its primary commuters' connection with the heart of Chicago.

Ridge Quadrangles is co-operative for 200 families in just the same way and to the same extent as is the ordinary apartment building of ten or a dozen stories sandwiched into the turmoil of the city itself. But in addition to these ordinary co-operative advantages of heat, light, water and care are those of its own recreation grounds and club house and smokeless service plant. The club house in which all householders have joint interest is a country club and family club available the year round and within a few steps of each member of the 1,000 community population.

Among the practical means to the accomplishment of this project it may be necessary to point out only one feature facilitating a single unit of heating and other community services. An equipment duct extending continuously through the basements of the buildings involving no additional excavation, obviating not only street pipes but all stubs and connections, accessible throughout; conservative of heating and preventive of all leakage of other form of energy or deterioration of the pipes.

The typical plan illustrates a two family house for southern frontages only. Those of the other frontages as well as other situations are regulated by the local determinants.

In a previous arrangement of this property is afforded a deadly parallel which we cannot help illustrating not because the scheme which the owners

first adopted is bad in itself but because its defects are those typical of universal practice, while it had advantages which ordinary practice seldom realizes in the absence of alleys and in location of the buildings close to the approach frontages and the consequent increase of the rear space to the maximum available in the 150 foot depth for each owner to be utilized for actual living space. The same purpose of maximum development and maximum frontage, as carried out in the finally adopted scheme for within one of the same number of houses of identical size and shape has, however, given seven acres of really valuable recreation space and greatly enhanced view and air provision for all, with each owner left with the same street frontage and a depth

of 100 feet for exclusive use. The advantage of placing each building in direction parallel to its lot and park frontage is that this arrangement gives maximum benefit of the best views. Staggering the structures themselves opens prospects still further to the extent of at least one and generally the two additional sides for each house. All will benefit not only from the open campus and courts for rest and recreation free from vehicle traffic and danger but also will enjoy lane approaches which, ample for vehicles, are sequestered and domesticated in relation to the through lines of traffic of the city by terminal parks set off with evergreen plantings and reflecting pool.

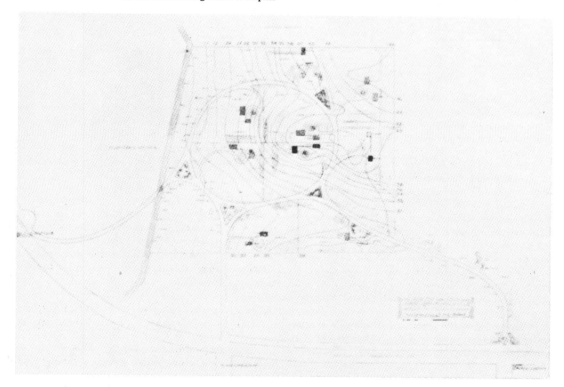

GROUND PLAN FOR EMORY HILLS DEVELOPMENT. WALTER BURLEY GRIFFIN, ARCHITECT

EMORY HILLS

DOMESTIC COMMUNITY DEVELOPMENT IN SMALL FARMS, FOR OUTER SUBURBAN ZONE, CHICAGO, ILLINOIS

In Emory Hills, a development of 20 acres at Wheaton, Illinois, into nine small farms of various areas, the problem was to afford the maximum opportunity to Chicago commuters at a distance of 28 miles from the city to make use of their limited

hours of freedom in a more substantial form of recreation than mere pleasure seeking. Under such conditions farming is properly an intensive craft and not another species of executive distraction to add to those of the organizations with which these commuters are identified in the city itself. The prime objects in the scheme of this group is then the maximum of convenience for the work of each plot for a minimum of expense in equipment and help, utilizing the various modern public service obtain-

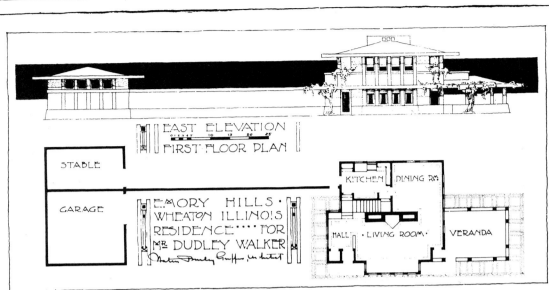

SKETCH OF FIRST HOUSE FOR MR. WALKER AT EMORY HILLS. WALTER BURLEY GRIFFIN, ARCHITECT

able from the town with which it is connected. However, health and enjoyment of mind and body before pecuniary profits are objectives demanding natural rural attractiveness.

Roadways are run in easy sweeps with the sharper curvatures concealing the steeper ascents. Tangential intersections permit narrow traffic ways with easy turns at the same time affording frequent wooded park spaces, preserving the rural character, offering shelter, diversifying the views, increasing the floral variety and adding means for passing or turning vehicles. The private roadways to the individual farms are treated as natural branches of the public road system and are therefore governed by the same considerations and kept within the minimum extent that is compatable with the reaching of a commanding building site for each homestead and its direct connection with Emory Station to the northeast which is more important of two outlets on account of the lesser fare obtaining to Chicago.

Effort has been made to group the domestic buildings so as to oppose and neutralize their most objectionable aspects, to compose each group into a single architectural unit and to distribute these units where they command the finest views on the one hand and, on the other hand, help to screen such less desirable prospects as that to the east, which on the plan is represented at the bottom, and where the railway and other features of the town life tend to be somewhat in evidence.

In the public plantings of this subdivision as carried out, emphasis has been placed particularly on winter attractiveness, making of the public spaces, cases of evergreen foliage and colored stems or fruit throughout the six months of generally dull landscape. Private plantings serve for screening out, closing in and subdividing each property in the ways that will enhance to the most its apparent area and disguise any unnatural lack of continuity with its surrounding areas.

The plot in the southeast corner of the tract, low-lying and flat, is given over to general recreation for children of this community and its planting area utilized for nursery growth to economically supply the demands of the roadside shrubberies.

One house on the north is now occupied and another indicated next south of it, under construction.

CLARK'S RESUBDIVISION OF ADDITION TO GRINNELL, IOWA. TOWN EXTENSION

The resubdivision of Janey's addition to Grinnell, Iowa, was brought about when, after some eight lots had been sold, it became apparent that the sewer problem of the old rectangular arrangement was about to involve an expenditure entirely disproportionate to the whole undertaking.

The original plat consisted in a purely mechanical extension of the typical layout that comprises the whole of the city which, although on a rolling prairie, has not in general quite the same degree of accentuation of the hill and vale that characterizes this twenty acre tract.

For the purpose of comparison of two methods of platting we may disregard the very obvious advantages of following the ravines with roadways

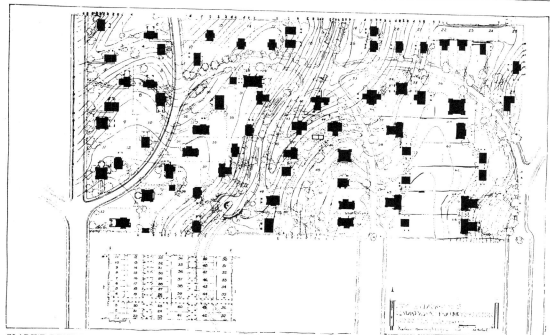

CLARK'E RESUBDIVISION OF ADDITION TO GRINNELL, IOWA, SHOWING THE ORIGINAL
RECTANGULAR SUBDIVISION SCHEME. WALTER BURLEY GRIFFIN, ARCHITECT :: ::

by which the excavation for the underground service equipment is merely a matter of frost line; of lots uniformly high relative to the street and its outlooks; and of that treatment whereby the informality of the rolling disposition is accentuated by the parklike character of the roadways, paths and terminal parkings; all of which are in contrast with the brutal mutilation of the natural advantages by the typical rectangular extension, its expensive lots to be filled or graded down with abrupt and steep grades and barren deserts of pavements, ungainly slopes to descend or treadmill inclined plane to climb with no stimulus to the imagination in prospect, monotonous views and staccato building repetition.

That the differences in economy of equipment are real and very great no one will deny. They were the inducements to the undertaking of this resubdivision; but disregarding not only these very obvious items but also the less tangible values accruing from the aesthetic attractions and the natural adaptation of groups to the beautiful hill and vale which will induce an influx to this property as the most desirable in Grinnell, disregarding both these factors and merely looking at the proposition as a real estate man wanting the greatest quantity of salable plots on paper, a comparison between the two schemes is still startling as to the primitive, inexcusable deficiency in our regulation procedure in property subdivision.

For instance taking the prices given to the original 57 lots at which rate 8 of them had been sold and had to be bought back in order to permit the resubdi-

RESIDENCE OF B. J. RICKER, GRINNELL, IOWA. WALTER BURLEY GRIFFIN, ARCHITECT

vision to proceed, applying these values to the lots in the corresponding location of the 66 parcels of the new resubdivision, we find a total increase in the salable land area of Clark's Resubdivision aggregating $10,500 as compared with the valuation of Janey's subdivision. In other words, the total increase in lots of the same average depth of the Clark Resubdivision as compared with the previous Janey's Subdivision of the same tract amounts to 30.6%. This latter frontage is so distributed as to increase the total number of lots from 57 to 66 while the minimum lot frontage is 75 feet throughout (excepting two 50 foot lots) whereas formerly half the lots approximated only 50 feet frontage each, and only the remaining 29 averaged 75 feet frontage.

The houses indicated on the plat are to illustrate its scale. Though not intended for execution in this site, for construction is beyond the present scope of this project, they are in fact plans of buildings actually erected elsewhere in the practise of the architect, one instance being the house of Mr. B. J. Ricker bordering the subdivision.

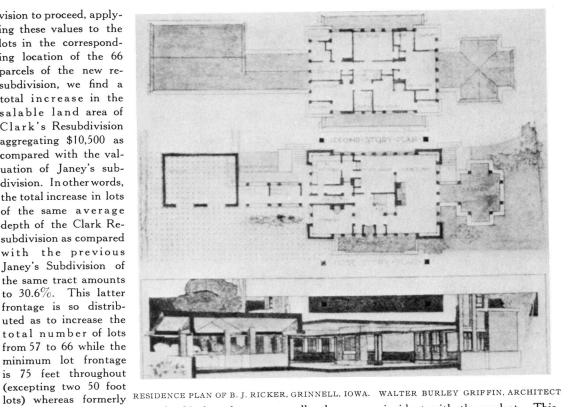

RESIDENCE PLAN OF B. J. RICKER, GRINNELL, IOWA. WALTER BURLEY GRIFFIN, ARCHITECT

ROCK CREST AND ROCK GLEN. DOMESTIC COMMUNITY DEVELOPMENT, MASON CITY, IOWA

Rock Crest and Rock Glen occupy the two sides of the valley which Willow Creek has carved out of the rocks within three blocks of the central square of Mason City, Iowa. In common with many such beautiful pieces of nature it has been neglected during the growth of the community in favor of the commonplace building sites all around it, awaiting the day which seems to be approaching when the imagination of the people is sufficiently stimulated by opportunity for unique development in those instances where long abuse has not been, as is generally the case, coincident with the neglect. This example comprises 18 acres of the creek frontage between two bridges. That at the north is a permanent masonry arch carrying an important thoroughfare route and fixes definitely the boundary in that direction but the western foot bridge is merely a temporary structure and its removal in the near future is promised for the opening up of another five acres up-stream of a territory where rock and dell have still different forms of expression to be preserved and respected.

The vertical bluffs of Willow Creek alternate from side to side of its sinuous course. In the portion illustrated they comprise the south and west banks, opposed by a gentle slope of meadow and open woods extending gradually up to almost equal elevation north and west within the limits of the tract. Wherever this rise has been less than that naturally it has been augmented artificially by grading and filling to form a commanding hill at the north east corner with lesser mounds and ravines masking the south embankment of the State street bridge approach and finally with a considerable artificial rock work precipice covering the bridge abutments, matching in a way the bluffs from which

the concrete arch springs on the east and forming the semblance of a canyon.

Where the boundaries of the tract were not already set off by the natural screen of forest growth, the structures have been disposed to make a frame for this area as complete as possible, in conformity with its standards.

Moreover by the relegation of the houses to the perimeter the area of gentle slope to the river will be preserved indefinitely for open view very much as nature designed it and for those purposes of retreat and recreation to which nature has so well adapted it.

The endless fascinating possibilities for domestic architecture with the unrepeated variations of view, soil, ruggedness, luxuriance, prominence and seclusion, need only the due attitude of appreciation to work themselves out in structures as unique as their sites, cut into rock or perched on the crest or nestled in the cove as the case may be.

The dam has been reconstructed in concrete from that of the old time grist mill that long occupied this site and whose foundation masonry is being transformed into a modest hydroelectric plant pumping water to a reservoir on the heights for fountain and hose purposes and generating electric current for the illumination of the public spaces.

This dam is designed ultimately to be traversed by a concrete bridge superstructure giving the architectural falls dignity and significance, adding security to the boating on the mill pond and offering access by easy ravine route to the crest lookouts.

For such co-ordinate development various property interests had to be brought together on the basis of a common ideal and bounden to it throughout the extent of the tract so that the improvements have been going forward from the various angles with the assurance and co-operation that can come only from uniform control.

IDALIA, LEE COUNTY, FLORIDA. SMALL COMMUNITY CENTER IN A CITRUS ORCHARD DISTRICT

Idalia, Lee county, Florida, lies on sandy palmetto flats and pine hammocks about five feet above the high water level of the Caloosahatchi river and with a maximum average variation in elevation represented by that figure. In its layout the problem was to match in salable lots the showing of the preordained conventional treatment. Such amenities as public parks on the river front and esplanades were permissible only when obtained without encroachment on that assumed maximum of salable space. The site being naturally flat the roads are,

(Continued an Page 79)

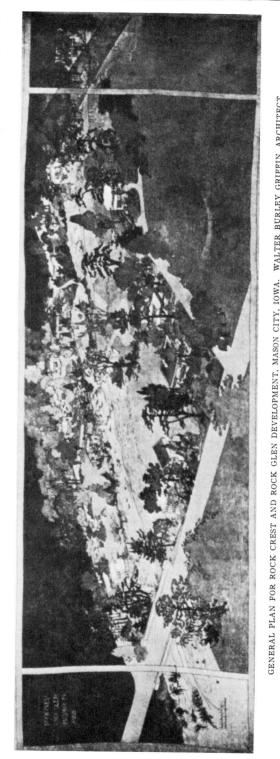

GENERAL PLAN FOR ROCK CREST AND ROCK GLEN DEVELOPMENT, MASON CITY, IOWA. WALTER BURLEY GRIFFIN, ARCHITECT

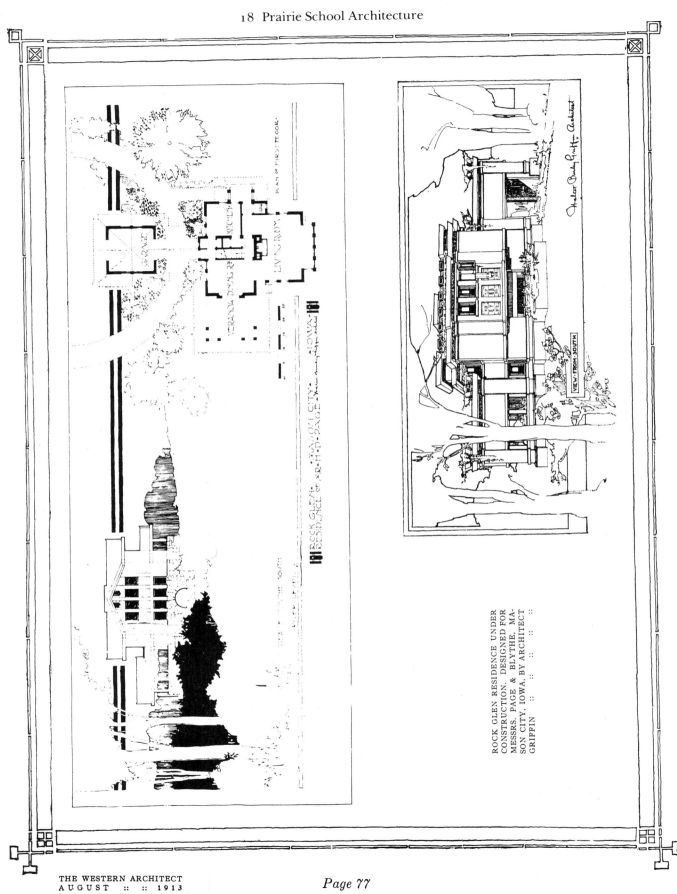

ROCK GLEN RESIDENCE UNDER CONSTRUCTION. DESIGNED FOR MESSRS. PAGE & BLYTHE. MASON CITY, IOWA. BY ARCHITECT GRIFFIN :: :: :: :: ::

OFFICES OF P. F. VOLLAND & CO., MONROE BUILDING, CHICAGO, ILLINOIS. WALTER BURLEY GRIFFIN, ARCHITECT :: :: ::

(Continued from Page 76)

therefore, direct necessarily. The one crossing from east to west is the diverted course of a through roadway. The north and south ways open up the best views of the river's expanse where the water vista is greatest and give access to the water and public park space for the people at the most desirable points. The lagoon terminating the west street is natural. The main esplanade commands the longest sweep of the river.

Since at present transportation is mainly from the gulf port of Fort Meyer, eighteen miles by water, the dock is the main station for both freight and passengers. It is placed, however, where its clutter will not interfere with the prospect or dignity of the water front. The main esplanade as an approach leads where the maximum of passenger traffic will not cross the freight handling space which is directly connected by alley shipping ways to the rears of all the mercantile and industrial sites. The electric railroad station eventually will co-ordinate with the water station in its position at the other end of the esplanade and in common with the water gate offers the advantage of comprehensive and most attractive aspect of this little community to the new arrival. Facing the esplanade also will be public buildings and hotel as well as stores and shops and the generous allowance for a setting of tropical verdure and flower gardens may well permit this village to utilize the advantages of its southern situation.

In the first building to be constructed, aside from the temporary saw mill, is illustrated an informal type of

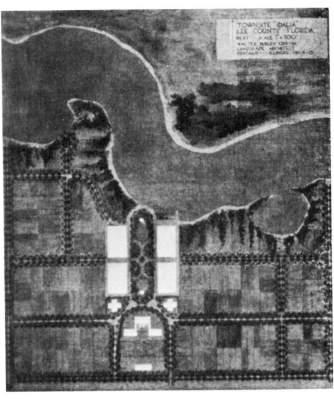

PLAN FOR IDALIA

business structure for general store and keeper's flat, emphasizing the residential cottage expression for a community center of an orchard district which should extend through all its various functions. This building provides sales and store rooms at the initial transportation center facing the water front from the dock to the esplanade.

The trees of streets and parks, as indicated, will be exclusively of broad leaf evergreens, the taller avenue trees being complemented throughout with shrubs of long flowering periods in addition to perpetual verdure.

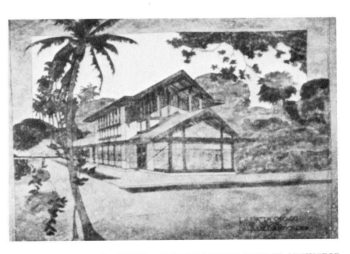

FIRST STORE BUILDING, IDALIA. WALTER BURLEY GRIFFIN, ARCHITECT

CANBERRA, CAPITAL CITY OF AUSTRALIA. COMPETITIVE PLAN CLASS-
IFICATION OF FUNCTIONS. WALTER BURLEY GRIFFIN, ARCHITECT ::

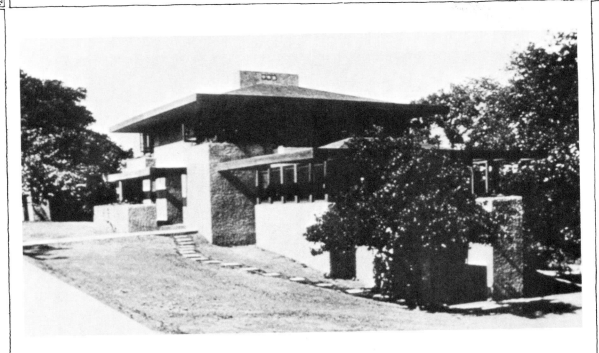

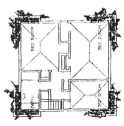

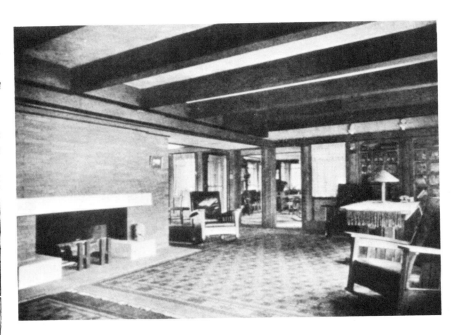

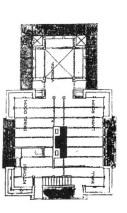

RESIDENCE FOR MR. RULE OF THE ROCK GLEN COMMUNITY, MASON CITY, IOWA
WALTER BURLEY GRIFFIN, ARCHITECT :: :: :: :: :: :: :: :: ::

THE WESTERN ARCHITECT
AUGUST :: :: 1913

HOLAHAN RESIDENCE IN ROCK GLEN COMMUNITY, MASON CITY, IOWA
WALTER BURLEY GRIFFIN, ARCHITECT :: :: :: :: :: ::

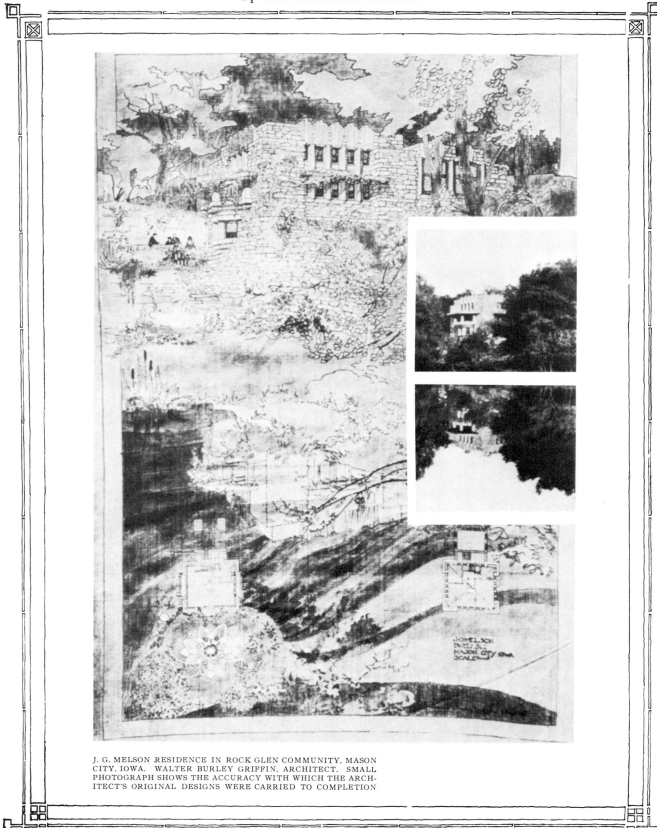

J. G. MELSON RESIDENCE IN ROCK GLEN COMMUNITY, MASON
CITY, IOWA. WALTER BURLEY GRIFFIN, ARCHITECT. SMALL
PHOTOGRAPH SHOWS THE ACCURACY WITH WHICH THE ARCH-
ITECT'S ORIGINAL DESIGNS WERE CARRIED TO COMPLETION

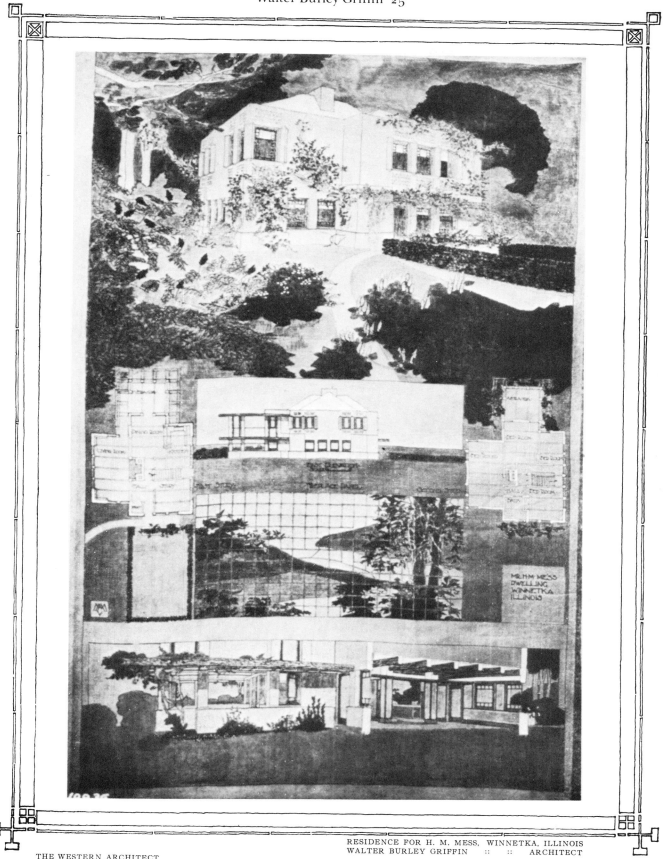

RESIDENCE FOR H. M. MESS, WINNETKA, ILLINOIS
WALTER BURLEY GRIFFIN :: :: ARCHITECT

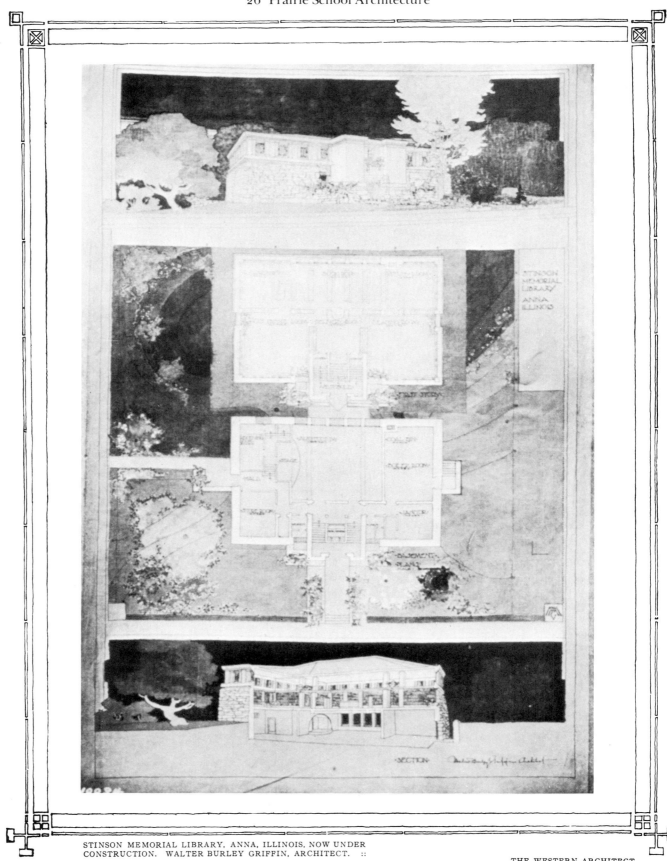

STINSON MEMORIAL LIBRARY, ANNA, ILLINOIS, NOW UNDER
CONSTRUCTION. WALTER BURLEY GRIFFIN, ARCHITECT. ::

FIRST STORY PLAN·

BILLIARD·ROOM

OFFICE ENTRANCE

TOILET COAT·ROOM·

LOUNGING·ROOM·

VERANDA·

SECOND STORY PLAN·

CARD ROOM CARD ROOM

DINING ·ROOM

BUFFET TOILET

BALCONY UPPER PART OF BALCONY
 LOUNGING ROOM·

SIDE ELEVATION·

NILES CLUB
NILES· MICHIGAN
SCALE

FRONT·ELEVATION· SECTION

DESIGN FOR NILES CLUB, NILES, MICHIGAN
WALTER BURLEY GRIFFIN, ARCHITECT :: ::

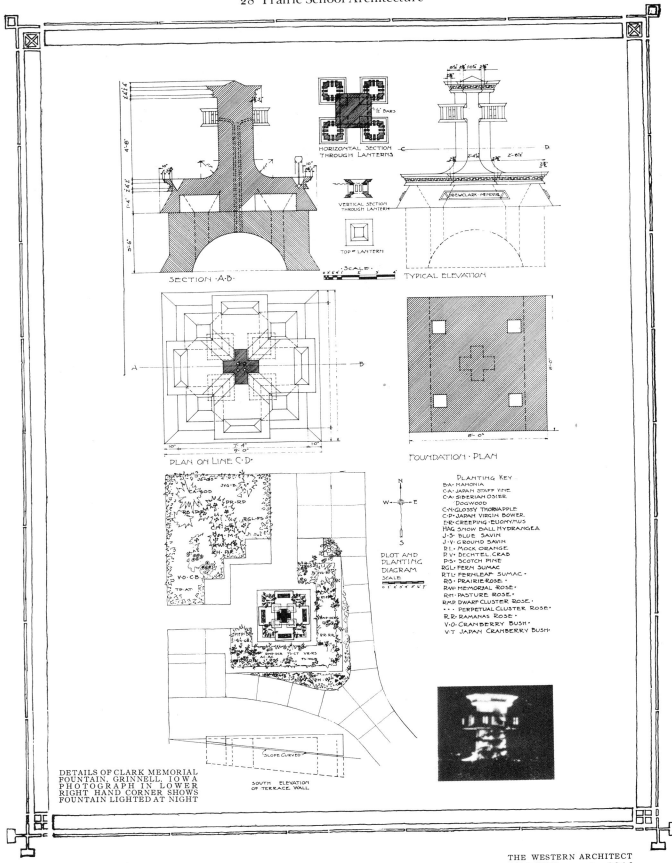

SECTION ·A·B·

HORIZONTAL SECTION
THROUGH LANTERNS

VERTICAL SECTION
THROUGH LANTERN

TOP · LANTERN

SCALE

TYPICAL ELEVATION

DR·EW·CLARK·MEMORIAL·

PLAN ON LINE C·D·

FOUNDATION · PLAN

PLOT AND
PLANTING
DIAGRAM
SCALE

PLANTING KEY
B·A· MAHONIA
C·A· JAPAN STAFF VINE
C·A· SIBERIAN OSIER
 DOGWOOD
C·N· GLOSSY THORNAPPLE
C·P· JAPAN VIRGIN BOWER
E·R· CREEPING EUONYMUS
H·A·G· SNOW BALL HYDRANGEA
J·S· BLUE SAVIN
J·V· GROUND SAVIN
P·I· MOCK ORANGE
P·V· DECHTEL CRAB
P·S· SCOTCH PINE
R·G·L· FERN SUMAC
R·T·L· FERNLEAF SUMAC ·
R·S· PRAIRIE ROSE ·
R·W· MEMORIAL ROSE ·
R·H· PASTURE ROSE ·
R·M·D· DWARF CLUSTER ROSE ·
· · · PERPETUAL CLUSTER ROSE ·
R·R· RAMANAS ROSE ·
V·O· CRANBERRY BUSH ·
V·T· JAPAN CRANBERRY BUSH·

SOUTH ELEVATION
OF TERRACE WALL

SLOPE CURVED

DETAILS OF CLARK MEMORIAL
FOUNTAIN, GRINNELL, IOWA
PHOTOGRAPH IN LOWER
RIGHT HAND CORNER SHOWS
FOUNTAIN LIGHTED AT NIGHT

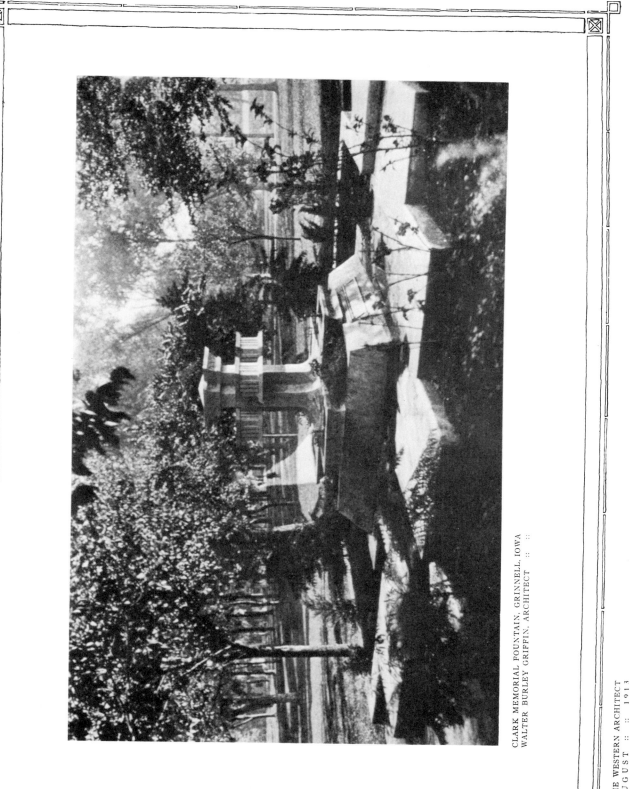

CLARK MEMORIAL FOUNTAIN, GRINNELL, IOWA
WALTER BURLEY GRIFFIN, ARCHITECT :: ::

TYPICAL · STORY

BASEMENT

· ALBERT · COHN ·
· TWO · FLAT · BUILDING · CHICAGO ·

SECTION

TWO FLAT BUILDING
DESIGNED BY WALTER
BURLEY GRIFFIN,
ARCHITECT :: :: ::

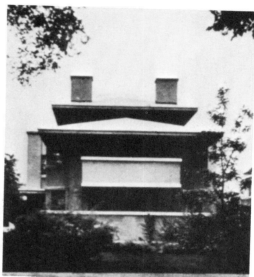

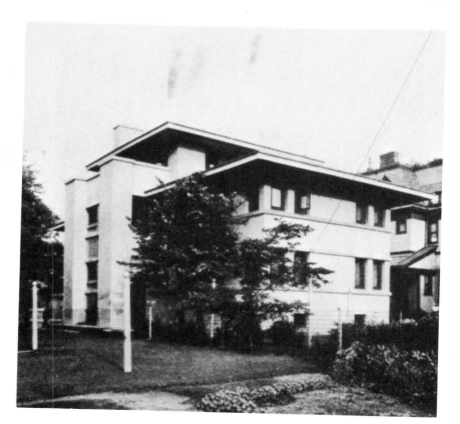

TWO FAMILY APART-
MENT HOUSE, CHICA-
GO, ILL. WALTER
BURLEY GRIFFIN,
ARCHITECT

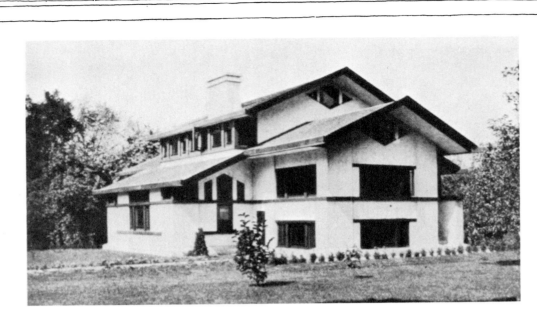

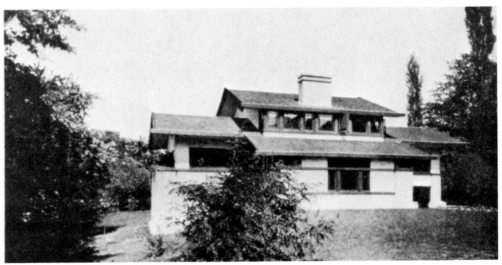

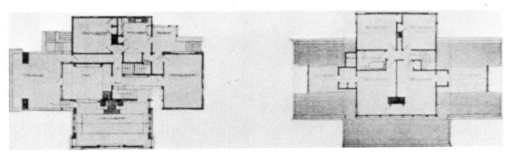

RESIDENCE EDWARDSVILLE, ILLINOIS
WALTER BURLEY GRIFFIN, ARCHITECT

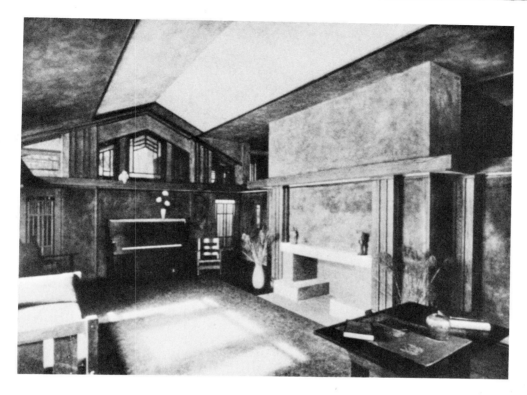

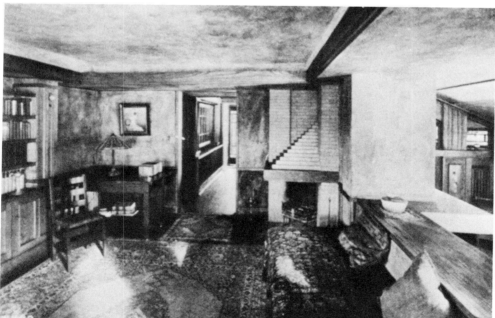

INTERIOR RESIDENCE EDWARDSVILLE, ILLINOIS
WALTER BURLEY GRIFFIN, ARCHITECT :: ::

FIRST·FLOOR·PLAN·

SECOND·FLOOR·PLAN

RESIDENCE ELMHURST, ILLINOIS. WALTER BURLEY GRIFFIN, ARCHITECT

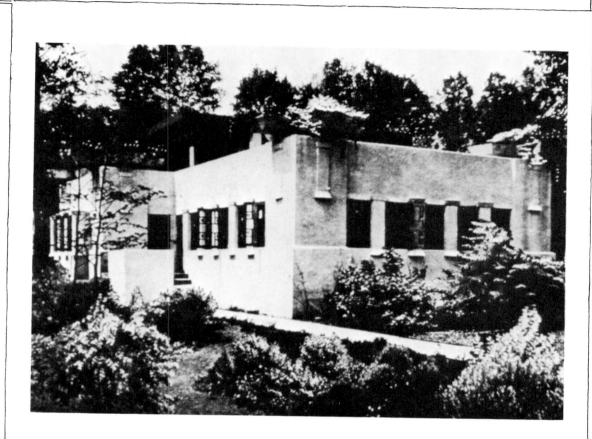

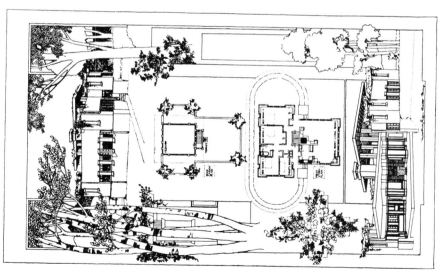

RESIDENCE KENILWORTH, ILLINOIS
WALTER BURLEY GRIFFIN, ARCHITECT

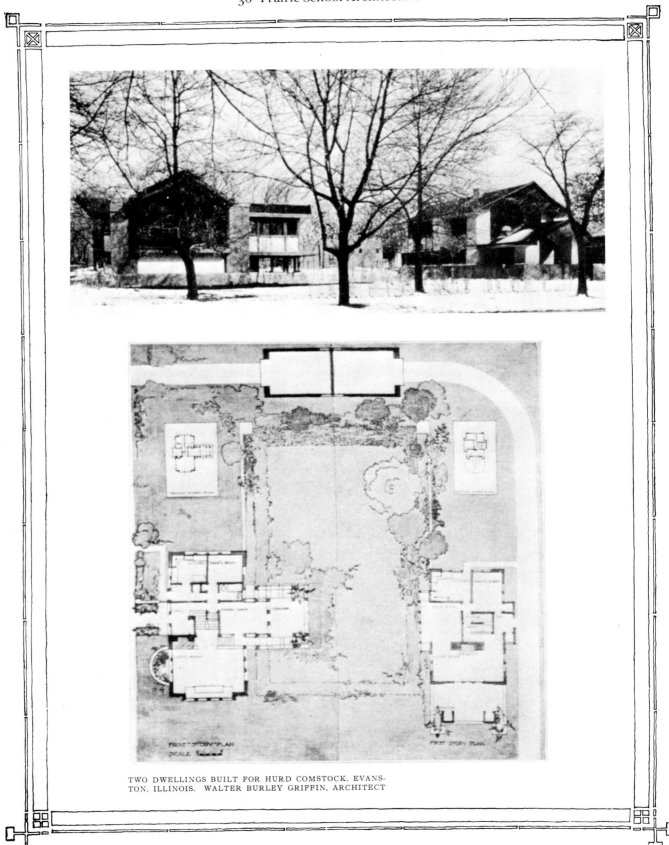

TWO DWELLINGS BUILT FOR HURD COMSTOCK, EVANS-
TON, ILLINOIS. WALTER BURLEY GRIFFIN, ARCHITECT

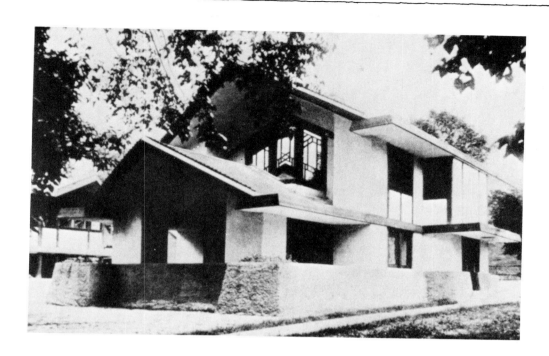

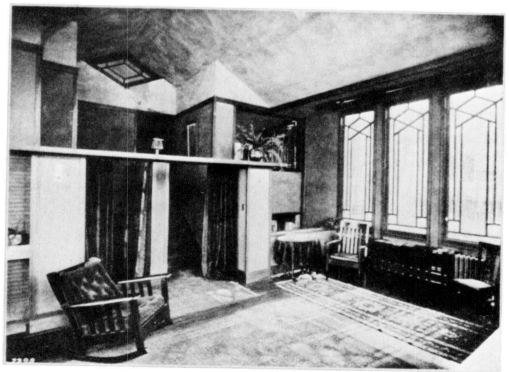

COMSTOCK RESIDENCE, EVANSTON, ILLINOIS
WALTER BURLEY GRIFFIN, ARCHITECT :: ::

COMMONWEALTH OF AUSTRALIA FEDERAL CAPITOL COMPETITION

By Walter Burley Griffin, Architect.

Plan of City and Environs, (A), shows Mount Ainslie, elevation 2,762 feet, at the northeast corner of the city proper; Black Mountain, elevation 2,658 feet, near the northwest corner which is four miles west of the first point; and Mugga Mugga, elevation 2,662 feet, almost six miles south of Ainslie and two miles south of the city proper, being the highest point in the range of mountains protecting the city from southern winds.

The line "C-D" extending south-southwest from Ainslie is the main architectural "land" axis. The line extending from Black Mountain perpendicular to it is the secondary or "water" axis "A-B". These two axes form the basis for the grouping of the Federal Buildings shown in black.

The group at the westward end of this latter axis is the University; the group lying south of it is the Government. The Capitol, the last building on the southern arm of the "land" axis, comprises the executive offices flanked by the residences of Governor General and Premier, occupying a lofty hill; the next building north of this is the Parliament House occupying the brow of a lesser hill; the remainder of the Government Group being departmental and judiciary buildings disposed about a water court on a terrace forty feet lower than that of the Parliament. The group on the northern arm of the same axis is the Recreation Group of the Public Gardens on the slope of the northern water front, comprising Stadium, National Theater and Opera in the center, Museum, Galleries, Zoological Garden, Baths and Gymnasia on the sides, with the Casino as the northern-most isolated structure at the foot of Mount Ainslie. The eastern most group is the Military Post on the summit of a lofty hill.

The public buildings that are not federal are clustered in two municipal centers; that to the north of the Capitol being the Administrative Group, the other to the northeast of the Capitol being the Market Group. The Administrative Center comprises the City Hall surrounded by Court Houses, Post Offices, Banks and private offices. The Market Center is occupied by the station on the slope of the foot of a hill with public markets facing the lower side, while the land rising to the Cathedral and Barracks forms the remaining sides. The avenue connecting these two municipal centers forms a thoroughfare for the central shopping district.

The remaining centers shown on the plan are for ultimate suburban extension, that to the west, of rugged topography, is on the flats, a manufacturing suburb, those to the southeast in the alluvial valley comprise semi-agricultural suburbs for intensive gardening, horticulture, poultry raising, etc.

The railway is treated only secondarily to the streets in its formal alignment with prominent objective points for each turn, withal following a uniform grade, depressed to allow the streets overhead crossing with slight elevation.

Of the five water bodies occupying the center of the city, the lower four are continuous, formed by damming the Molonglo River below town, level 1,825 feet, the upper and larger lake being ten feet higher and impounded by a dam at the railway crossing.

THE WESTERN ARCHITECT
SEPTEMBER
1912

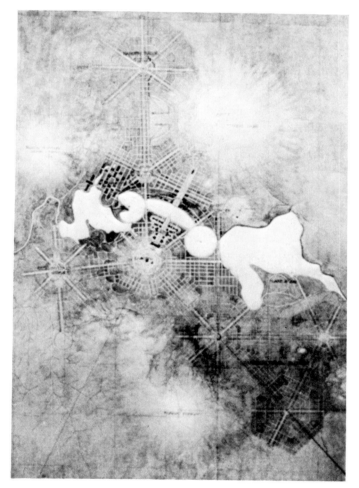

PLAN OF CITY AND ENVIRONS (A)

COMMONWEALTH OF AUSTRALIA FEDERAL CAPITOL COMPETITION
AWARDED FIRST PRIZE
WALTER BURLEY GRIFFIN, ARCHITECT

THE WESTERN ARCHITECT
SEPTEMBER
1912

COMMONWEALTH OF AUSTRALIA FEDERAL CAPITOL COMPETITION—*Continued*

PERSPECTIVE "B"

View from the summit of Mount Ainslie of the entire city, showing parkway extending from the mountain to the departmental terrace court, with Parliament and Capitol Hills and snow-capped Bimberi thirty miles distant, all in one line:—the "land" axis of the Federal Building Group.

SECTION "C"

Illustrating facades of the Government Buildings toward the central water basin, whose extent is indicated by the reflection; the pyramidal structure in the center is the Capitol crowning a hill 230 feet above the water level and a mile back of the water front. In front the long low-lying structure is the Parliament Building, crowning a hill ninety feet lower and about three-eighths of a mile nearer the water. While the central building on the water is the "Water Gate" on the water level, with a colonnaded forum above terminating and facing the terraced court of the departmental buildings, which are the large buildings comprising the rest of the group; those facing the water front forming the front of the terrace with their foundation walls thirty feet high. The residences of the Premier and Governor General are the smaller structures among the trees in the background at either side of the Capitol; the remaining buildings indicated being private residences on the hillside. The terminal accents of the picture are the piers of the bridges.

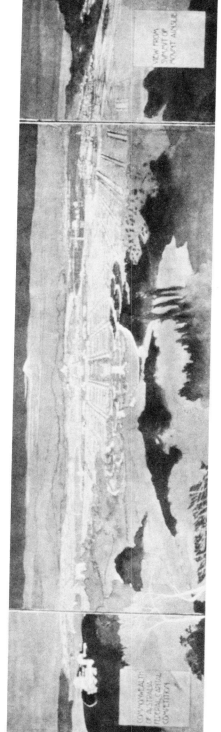

PERSPECTIVE (B)

SECTION (C)

FACADE OF GOVERNMENT GROUP

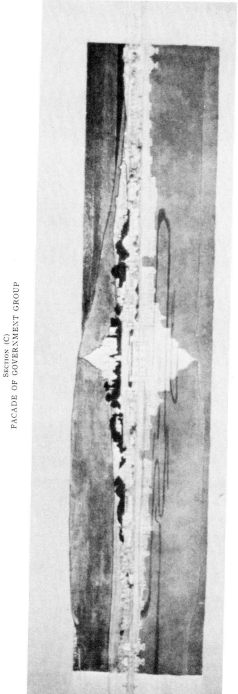

COMMONWEALTH OF AUSTRALIA FEDERAL CAPITOL COMPETITION
AWARDED FIRST PRIZE
WALTER BURLEY GRIFFIN, ARCHITECT

THE WESTERN ARCHITECT
SEPTEMBER
1912

COMMONWEALTH OF AUSTRALIA FEDERAL CAPITOL COMPETITION—*Continued.*

SECTION "D"

Second of a series of four continuous drawings, illustrating section through the city along the "land" axis facing the eastern side. The preceding portion, not here illustrated, showed profile of Mount Ainslie. This portion shows at the left the Casino at the foot of Mount Ainslie, then groups of residences, hotels, etc., on the hills beyond Ainslie Parkway, then the railway cut, viaduct, warehouses over the tracks and subway entrances beyond. The Cathedral on the hill closes the vista of the right-of-way. The next vista, closed by the station and the military post on the hill beyond it, is along the Municipal Avenue flanked by Auditorium and Theater structures on either side facing the parkway. Continuing to the right are the Gallery of Plastic Art, Museum of Archeology and the Stadium in succession, followed by views of the Aviary, Gymnasia, Baths and the piers of the bridges along the curving side of the central basin.

SECTION "E"

Third of the same series, beginning at the left with the continuation of the bridge at the east end of the central basin, and a cut through the "Water Gate" and superimposed forum followed by end of one of the judiciary buildings occupying the front terrace; other departmental buildings facing this water court, at the right end of which is the ramp to the Parliament House; after which come sections through the latter, tram subway, fountain and Capitol at the summit of the hill. The subsequent drawing, not here illustrated, represents profile of the hilly range lying south of the city.

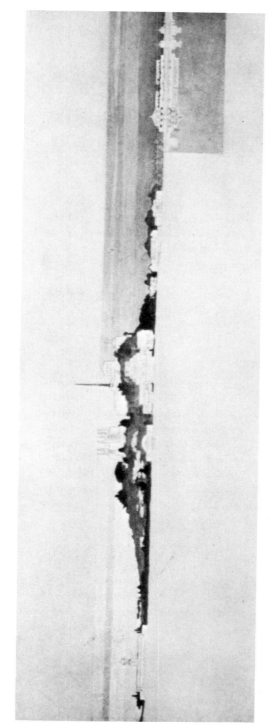

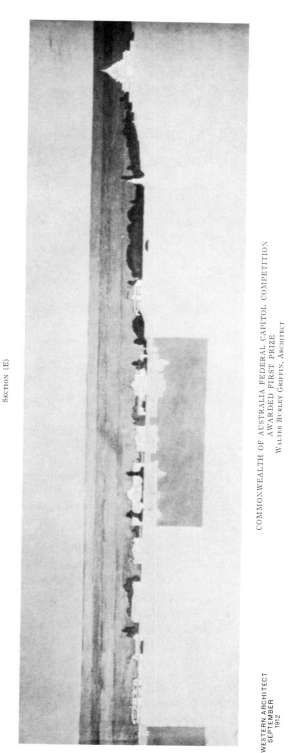

Section (D)

Section (E)

COMMONWEALTH OF AUSTRALIA FEDERAL CAPITOL COMPETITION
AWARDED FIRST PRIZE
Walter Burley Griffin, Architect

THE WESTERN ARCHITECT
SEPTEMBER
1912

COMMONWEALTH OF AUSTRALIA FEDERAL CAPITOL COMPETITION—*Continued*

SECTION "F"

Second of a series of four drawings illustrating section of city through "water" axis facing the northern side. The first of the series, not here illustrated, being profile of Black Mountain, and at its base the beginning of the University which this drawing completes, showing successively a portion of the Technological Schools on the left end of the bridge and the main Technology Building across the stream, followed by the quadrangles of the Natural Sciences arranged symmetrically about the tall structure of the Library and General Assembly, of which this view is sectional. To the right of this are: first, the Law and Group of Law and Pedagogy, and then reflected in the lower circular basin are the Printery and Mint on either side of the City Hall with its tower.

SECTION "G"

Third of the series along the "water" axis facing the northern side. This section comprises the central water front between the bridges as indicated by the reflection and shows conical Mount Ainslie, the northern terminal of the "land" axis with the Casino at its base, at the end of the vista, a long wide parkway extending from the Stadium on the water front. At either side of the parkway are the Federal Theater and Opera, back of the Stadium wings; on either side of this extend the Public Gardens with the Museum and Galleries completing the central group, and the Aviary and Aquarium as the terminal accents. At either side, after these, partly hidden by the bridge structure, are the buildings of the Zoological Gardens on the left and of the Baths and Gymnasia on the right; the buildings in the background are industrial buildings along the Municipal Avenue, the highest being a hotel on a foothill beyond this avenue.

SECTION "H"

Completes the series along the northern side of the "water" axis, showing in the foreground the general group of the station and markets with the Power House at the dam backed by the Church and Barracks on their respective hills. The remainder comprises a portion of the wooded slopes of upper lake park.

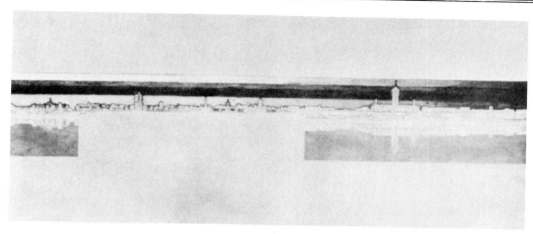

SECTION (F)

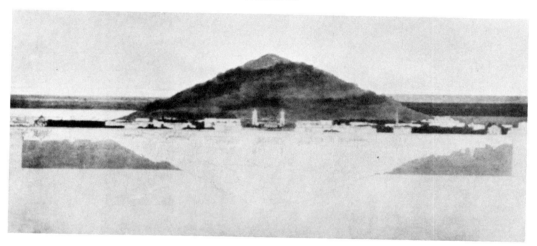

SECTION (G)

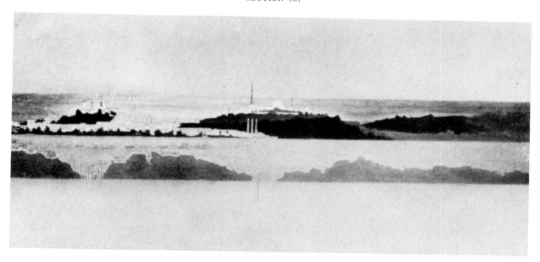

SECTION (H)
COMMONWEALTH OF AUSTRALIA FEDERAL CAPITOL COMPETITION
AWARDED FIRST PRIZE
WALTER BURLEY GRIFFIN, ARCHITECT

THE WESTERN ARCHITECT

A NATIONAL JOURNAL OF ARCHITECTURE AND ALLIED ARTS, PUBLISHED MONTHLY

VOLUME 19 JANUARY, 1913 NO. 1

Illustrating the work of Purcell, Feick and Elmslie, Architects, with descriptions and comments by the authors, together with a brief statement of the background of their belief.

THE STATICS AND DYNAMICS OF ARCHITECTURE

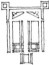THE Unity of Life is divided into two phases—the Static and the Dynamic.

The Static phase is all pervasive, is universal, is eternal, and does not change.

The Dynamic phase is likewise universal and eternal, but conjoined with creative spirit, it changes with every process of nature.

The Statics and Dynamics of Life, in whatever functions and forms they are manifest, definitely and intimately make up the sum total of the experiences of a Life, in all its infinite variety, in all its operation through the field of its activity, be it years, days, hours, or untold aeons of time; they concern its birth, its adolescence, its flowering, its decadence, its death and its immortality. The Statics and Dynamics of an individual Life are the quiescent changeless mind and the ever-flowering, ever-flowing, ever-moving, ever-changing action of the will, the heart, the soul, upon that mind.

Let us keep before us this picture, for the usual formulae do not, as a rule, convey the idea of the stillness of the mind, its sublime quietude, and the ebb and flow of the spirit that is conjoined with it.

The Statics and Dynamics of a Life constitute the actual, the ever present,—whatever is heard, said, done, felt or conveyed to others through the operation of the personality in its complete, living equipment.

While the Statics of Life, considered as the mind, are universal and changeless, the Dynamics of Life,

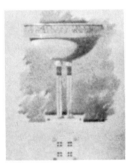

AVIATION CUP IN SILVER AND ENAMEL :: CHICAGO

DETAIL, OWRE DWELLING MINNEAPOLIS, MINNESOTA

FURNITURE, MILLAR DWELLING :: PITTSBURG, PENN.

considered as the will, the heart, the soul, are all pervasive, all inclusive, defining all things, but quite particular, quite local, quite native, quite personal, and with ramifications as greatly separated as is the heart of a wayside flower from the heart of man.

Amongst our human kind we shall consider that the mind is the common denominator of us all; and that the will, the soul, the heart, is the common differentiator of us all which develops the personality of races, nations, tribes, communities, through every conceivable variety of circumstance and environment, into our Chinese, our Hindoo, our Hottentot, our Red man, our Malay, our White man with his burden.

The works of man are delicately related to himself and elaborately a part of himself and conform in their essence to the same cosmical program as do the mind and soul of man.

Where we find the soul of one race differing from another, we find the works of its creation differing in just the particular way that the soul differs; and, conversely, we may observe in its work what manner of race it is.

Consider the Chinaman at his ivories, his enamels, his rugs, his verses—what a story is there; consider the Eskimo at his skins and his hunting spears—what a story. The same Statics is there, the same mind, but what a variation in the texture of the heart and soul and the impelling will. Consider the mediaeval monk at his illuminating and our modern multiple press—what a story, what a

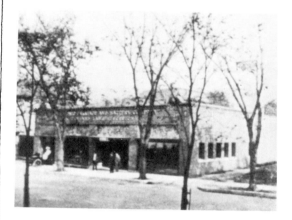

BUILDING FOR THE RAUCH AND LANG COMPANY
MINNEAPOLIS :: :: :: :: :: :: MINNESOTA

romance, what a change of circumstance. Consider the trail of the caravan across the sea of sand, the camel with untold history written on his antique head, and then consider the pathway of the modern ocean liner with the concentrated power of the overwhelming turbine; we dream of a long story between these, a fascinating romance of the play and counterplay, foil and counterfoil, intermeshing and

special interpretation whatever the subject in hand may be; whether it be Painting, Sculpture, Architecture, Weaving, Pottery, Literature, Poetry, Farming, or the infinite variety of the work of the artisan? Surely no art or craft requires special interpretation since we see all about us that the realm of human activity is one whole, that all activity is fundamentally alike and produced by the operation of the same powers.

An art work may be defined in terms that correspond with life itself, as divided into its two phases—the Static and Dynamic. All art work may be so classified. The same human forces are at work and the same material forces are being worked on in weaving a rug as in making a garden for flowers to bloom. The same human forces are at work and the same material forces are being worked on in building a Parthenon or a steel girdle around the globe. The Statics and Dynamics of man, operating in the field of material things, which, in their last analysis, are part of himself, produce, create, replenish the earth, and we may call the resultant fine art, bad art, black or blue art, as we please.

To consider the Art of Architecture in its immediate relation to life is the burden of these memoranda. In so considering, we may go as far in history as material evidence will lead us, into the mists of time. We will find essentially as much then, as now, of the story of building and as much then, as now, of that which is really important. For there is surely no difference in the powers expressed between such works as the Dolmens and Menhirs of antiquity and the most elaborate and sumptuous work of other ages. Surely there is no difference between Stone-

TERRA COTTA IN THE RAUCH AND LANG GARAGE

DETAIL OF BRACKET AT ENTRANCE, OWRE DWELLING

SOFFIT, BABSON BUILDING
CHICAGO :: :: ILLINOIS

FOR ATKINSON DWELLING
BISMARCK, NORTH DAKOTA

blending of the Statics and Dynamics of Life, of man, and of the works of man.

Would it not appear reasonable to assume that the various works of man, with special reference to the field of art and craft, have particular significance when considered from a viewpoint that requires no

henge as an evidence of the power to build and the Doge's Palace, or the Canadian Pacific Railway. We find throughout the ages a marvelous assemblage of the architectural work of man,—boundary stones, memorials, huts, caves for shelter and for home, buildings for pleasure, buildings for sacrifice, build-

ings for adoration and worship, buildings for business, for social and industrial use, buildings for travel, for transportation on land and sea or in the air, all of which illustrate the power and the need, the hopes, and wonderful dreams, the avarice and shame, the glory of mankind. All of these works contain finally the two elements and nothing more, —the Static and Dynamic. They could not otherwise exist. We find the same play of forces there as elsewhere—the powers that dwell in man himself.

The Statics of Architecture concern the quiet powers within the structural forms of the pier, the column, the lintel, the arch and dome, as well as in the minor kindred forms directly descended from these. These in-dwelling powers are universal and do not change. The Dynamics of Architecture concern the play of the human heart, soul and impelling will upon the purely Static forms and *change*, eternally *change* as human beings vary.

The sublime rectitude and constancy of the *unchanging* elements of Architecture are their chief glory, but also the qualities through which they have been betrayed.

The quiet power within the column is universally within the column. The column can only have a column power. The quiet power within the lintel is universally within the lintel. The lintel can only have a lintel power, no more, no less. The quiet power within the dome is universally within the dome. The dome can only have a dome power. The Greek column and the Romanesque column have the same Static nature, it could not be otherwise, but the Greek column changes in Dynamic expression with the heart, soul and impelling will of the Greek, with the Dynamics of the Greek

but no farther than the cry from the personality of the Hindoo to the personality of the Roman.

A nation, tribe, or community can only in their Architectural work express their own Dynamic quality.

When the attempt is made, as it has myriad times in the past and present, to betray and stultify the simple Statics of Architecture, the result is deplorable. The Statics are helpless in the face of the impelling will and desire of man. They have no choice at times but to accept the scorn and contumely of changeling man; to accept whims for real purposes, heartless jests for genuine impulses.

When we see in modern days a Doric column serving as a monument, we wonder if reason, conscience, and intellectual stability have departed our land. It must be borne in mind that the Doric column, in itself, is not vital, any more than a telegraph pole is vital. Strung with wire, the telegraph pole is an organic part of Life, and, therefore, complete. In the same way the Doric column is not vital until directly associated with its lintel. This is fundamental and relates to all the Architectural elements.

The column, with its overwhelming desire for the presence of a lintel, is certainly amusing, yet tragical and pathetic, when set apart as a memorial commemorating great achievement. Well may we praise the great men of the race, well may we revere the works of their hands, but who is there to pity the poor Column and share its abandoned grief? The saddest figure in Architectural history is the column; it has been so derided in its association with its lintel, its arch and its dome. Here we have its

MILLAR CURTAINS AND
GLASS, PITTSBURG, PENN.

HENRY BABSON LAMP
RIVERSIDE :: :: ILLINOIS

MILLAR TERRACE VASE
IN MATTE GREEN "TECO"

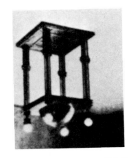

ELECTRIC FIXTURE
J. C. CROSS, M. D.

in other words, it could not be otherwise. The Hindoo dome and the Roman dome have the same Static nature, just as the Hindoo and the Roman have the same Static nature, but the cry is far indeed from the expression given to the Hindoo dome to the expression given to the Roman dome,

Static elements strained beyond reason; there we have its power associated with a weakling lintel, arch or dome, and so on. Similarly, we have the power of the lintel ignored and debased in genderless association with the column.

This lack of co-ordination in architectural

matters springs from the lack of co-ordination between the mind and the heart of man. For when co-ordination is complete, the work of his hands is complete, vital, organic, intensely human.

In the Architectural art, man has a medium of expression of marvelous usefulness and completeness. No art is so intimate as the Architectural art. With no art does he, day by day, come into such close fellowship. With the simple forms at hand, the simple fundamentals, what may not be accom-

nation proud, another humble, another wise. We see a nation once lordly and supreme become supine and decadent, and, contrariwise, we see a nation arise from slavish dependence to be a principality of power. We see all this in the Architecture of the past and the present, telling us of error, of baseness, of betrayal, as well as the splendor of equal achievement.

That there has been an over-supply of baseness and betrayal evidenced in historic Architecture, one

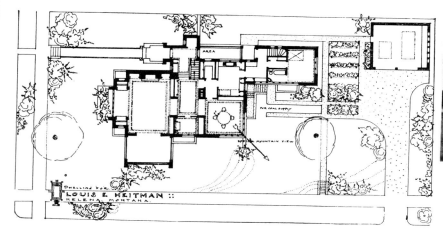

BRADLEY
FURNITURE
MADISON
WISCONSIN

plished in sincerity, truthfulness, gentleness and courage? What may not the modern heart and soul, in harmony with its mind, accomplish? We cannot claim for our own use the Dynamics of the Architecture of the various nations of the past. The Dynamics of Greek Architecture was a purely personal matter with the Greek— it belongs to him, and he—he is long since dead; so is the Roman dead and so is the mediaeval romanticist dead. Why should we have the cerements of by-gone architectures habiting our new problems, our fresh, vital, instinctive Architectural work? We are not playing fair with our minds and so not playing fair with the helpless Static forms of building.

The field of Architecture is the most engaging and romantic in the world—so much does it tell, and in such a fair and splendid way. There is no misgiving, nothing tentative; nothing tantamount, nothing more than should be; nothing less than should be.

We see, in the buildings, one nation given to self glorification; another to immolation. We see a

BOOKCASE GLASS :: OWRE DWELLING

who runs may read. This has been so because there has been less of normal co-ordination between the mind and the heart necessary to produce a rational and organic work. The mind of man has largely in the past, as now, been the victim of the unorganized changing impulses dwelling within his soul and just in this way have the Statics of Architecture been betrayed by the Dynamics of Architecture through the power of changeling man.

For man is the creator and man is the creature.

Man is the optimist, man is the pessimist.

Man is a peace, man is of war.

Man is domestic, man is a reveller.

Man is simple, man is complex.

Man is wise, man is crafty.

Man is direct, man is subtle.

Man is of the sun and stars, man is of the earth.

Man is winsome, man is repulsive.

Man is candid, man is evasive.

Man witnesseth the morning lark aloft the sky and sings its praises, man is a sluggard and desires enslavement.

Man arises in his might and smites the unjust, the cruel, the rapacious.

In Architecture, we may see all this, all the story of mankind. In its dark days, we see a bewildering uncertainty in its buildings; in its clear days, we see clarity, power and certainty in its buildings. In days of romance and chivalry, we see buildings which partake of the high tide of the thought and ways of the men and women who then lived. In days of exploit and strife, what do we see?

conquering armies, we see all this web of life in the Architecture, pickings from here, pluckings from there, all kinds and descriptions of Architectural transplantings that are not part and parcel of the people.

When we see a nation like the Roman at the time of the Christian era, we see an Architectural expression naturally centrifugal, naturally sumptuous, naturally of a conquering and law-giving aspect; in other words, we read a nearly world-wide Roman

MONUMENT AT THE GRAVE OF DR. W. C. GRAY PH. D., LL. D.

In days when fateful Egypt, with her gaiety and gloom emerged into the known world, what do we see? We see Architectural work that partook of her every thought, of her myriad gods, her myriad unseen powers, her eager desire to fathom the unknown and to keep in touch with it.

When we see a nation like the Chinese, naturally flowing toward herself, we see an Architecture of a marvelously racial quality in its every line and form of expression; Chinese of the Chinese, because of the heart, the soul, the will, the power to do, the power to dream, the power to love, the power to believe of the Chinese. But the mind of the Chinese is no whit different from our own. When we see such an exhibit of Architecture, we see Chinese Dynamics crystalized in building form. No misgiving, no thievery, no humbugging, but a clean, clear mirror, flawless from the film of an alien thought.

BURLINGTON WATCH CASE

When we see a nation like the Hindoo, we read a story similar to the Chinese; and in all nations where the flow of life is more centripetal than centrifugal. Where we see a nation that has been swept in times past by moving hordes, settled by nomadic tribes, which come and go, deluged by

Empire from the splendor of the seats of the mighty to the vast aqueductal systems; from the majestic forum to the war gates so seldom closed.

The correlation and adjustment of the above aspects of Life and Architecture may be tenuous and subtly withdrawn, or of commanding presence. The relation of the Hindoo to his Temple is like a drop of crystalline dew, while the relation of the Roman to his Temple is as a full banked stream swelling to the ocean. The one, very much subjective, and the other, very much objective—so is the Hindoo to the Roman.

In the modern world the field of the Statics of Architecture has been widened, deepened and greatly enhanced in value and in usefulness to serve the power of modern man and the new needs of a new time. The Dynamics of modern man and life in general have vitally changed and the broadening of the Static field came in response to this need. In olden days they had stone lintels governing a twenty foot span and such we have yet, but consider in addition a steel lintel governing a two hundred foot span, to say nothing of trusses in steel and cantilevers in steel with spans of two thousand feet. In olden days, they had stone piled on stone into a stone column, and we have them yet, but witness a steel column twenty inches square carrying a

million pounds. The same old Statics in lintel and column, but such an expansion of usefulness, such a gift to man from the smoky Pittsburghs of America, Great Britain and Germany.

WHEN we consider the great expansion made servant to us in the use of steel, let us not forget the majesty and sublimity that dwelt within the forms of old. Let us walk in spirit around them and return refreshed from communion with the mighty of other days. When we look at Karnak, we see Architectural work evincing the power of physical immortality. The Statics of the Egyptian work are so prefigured with Dynamic expression as to give this visual impression. The work had to endure to fulfill its function in Egyptian life. What we see is the Egyptian, no more, no less. This work could not exist anywhere else in the world because such a race as the Egyptian did not exist anywhere else and such a race could only develop in the valley and delta of the Nile.

Every nation within our historic ken has given us at one time or another the highest expression of its civilization in its Architecture, its reason for being, its passionate ecstacy, its exalted spiritual power, its naive simple humanness, its serious commonplaceness, its particular, perihelion in the utterance of its hopes and dreams. This highest expression of a civilization varies in intensity with the quality of the people; so the glory that was Greece and the grandeur that was Rome are palpitating words of descriptive accuracy.

VIEW OF NORTH END, GALLAHER DWELLING FROM DRIVE

The people of to-day are the heirs of the ages. In the domain of Architecture, with all the achievements of the past forming a background of appealing significance and with broadened out field of modern ways and means, a simple, romantic, coherent, sane and eloquent Architecture will surely arise. Have we not more of the simple humanities expressed in the conduct of our ways than the Roman; a more psychic and intuitive sensibility than the Greek (imagine a Greek at a modern symphony concert); have we not less of the bewildering spiritual uncertainty of the people of the middle ages of Europe? Does it not appear that humanity, the vast massic sweep of a world-wide humanity, is, through the slow and ever expanding surge of life, coming into the age, into its final aspect, wherein the completest expression of man in his environment, with the aid of the mighty machine, is to be worked out in the arts and industries of the world?

The freer the citizen, the broader and simpler the spiritual outlook; the broader and simpler our conduct of business; the greater and nobler our art will be. The depth of humanness in the conduct of our affairs will measure and plumb our art, and, contrariwise, we are to be measured and plumbed by our art.

In America, the Art of Architecture has been treasured largely as a matter of inapt and absurd

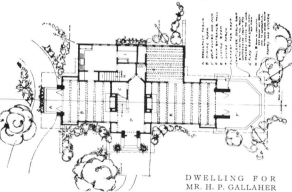

DWELLING FOR MR. H. P. GALLAHER

tradition. We have been as a people obsessed with the idea that we are too young to have an art, too immature, or too busy. But it is universally conceded by our fellowmen that, as a people, we are very much alive, very much poised on the keen point of time and expectancy; and, therefore, not only

not too young to develop an art, but nearly to the point where we may become too old to develop— to pass our high tide, as a people, with our noses at the grindstone of prosperity, and success as the final and permanent attribute of our last judgment declaration.

We have looked across the seas for our mentor in Architectural matters, for things worthy and without reproach, and have not stood on the rectitude of our own natural impulses. In this, we have been aided, abetted and victimized by those who ought to know better—our teachers —who have and do declare, by practice and precept, that the realm of Architecture, the Art of Architecture, is a sacred arcanum wherein only the initiated may enter.

AMERICA has done greatly in the material world through the exercise of her natural powers, has performed great sacrifices in the moral world, has undergone pain of growth in the travail of her spirit. She has climbed many a hilltop, seen many a sunrise and has essentially maintained, with but little reproach, the integrity of her nature in the by and large of it.

Surely it would appear the American people have superb Dynamic power, but the field of Architecture has been allowed to become quite a desert with scarce an oasis to greet the sanguine believer. The great and wonderful animating spirit of the American heart and soul have not been made use of. We have begged, borrowed and stolen, because the lords and masters of the Architectural Art said it

Architecture that could, by the farthest cry, prefigure the Statics of Steel, or of Concrete, or of the the combination of the two? We believe that there is fitness to spare and power to spare, and aptness to express our civilization and our contact with our environment in all our work.

Just let us be simple, surely that is all; in all the history of the world it was never anything else; just let us be honest and candid, true, sweet, and kindly, and then the Great Spirit, the All in All, will feed our nature from the ever-flowing stream of the Romance of living things.

We see many queer things in a day's Architectural journey—look at the Doric column on the front of an American bank; it is not amusing, it is tragic.

Witness an office building, partly Roman, partly Renaissance, partly modern, this and that,— this is tragedy and comedy combined; tragic in the complete adumbration of the real Statics of the work, and comic in the terrific striving and grim gaiety of the designer in getting in useless architectural forms and plenty of them before the building got to its predestined roof, and put an estopper on his charming fancies.

We cannot expect to habilitate ourselves with the Dynamics of the Greek, Roman, Italian, French, or English in our architectural life—the masquerade is too absurd—but we do it, and, seemingly, get away with it. The average modern Architect has about as much idea of the fitness of an architectural form to suit a definite purpose as though he went to a shooting gallery, and aiming his rifle at a swiftly passing order, shoots a column in the

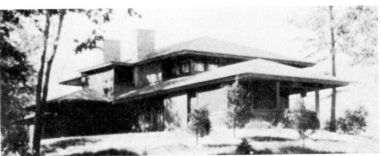

DWELLING FOR H. P. GALLAHER, ZUMBRA HEIGHTS OVERLOOKING LAKE MINNETONKA

GALLAHER AUTOMOBILE ENTRANCE BREAKFAST PORCH

was the thing to do. These men imply that there is no Dynamic quality in the American citizen fit to clothe and animate the Statics of the Art of Architecture, modern, amplified and broadened as these Statics are. What is there in the Dynamics of Greek, Roman, Mediaeval, Sarcaenic, or Hindoo

abacus, or some such weak spot and lugs it all away, discovering the while what particular game he has bagged—Corinthian, Doric, Ionic, etc.

The story of the abuse of the beneficently useful is as old as the hills; it seems as though the more beneficently useful, the more general the abuse.

Everything in the world has its specific use and the use of things determines the shape or form they take in a general and sometimes in quite a particular way. We know what a fork is in use, and we would know what it should look like if we had never seen it. Form and Function, use and shape, may never be separated; they are one, all inclusive, without exception.

The story of the abuse of the useful is nowhere more in evidence than in Architecture. Since the

American Library, although perchance there are a few in the country, nor is it an American Museum, because there aren't any. Nor is it an American Bank, probably not, for there isn't one in New York, Boston or Chicago, and so on to the end of the chapter. It is merely a travesty on the glory that was Greece and a parade of the fact that since the Greek is dead there is no harm in pilfering in his grave.

We believe in the gradual evolution of material

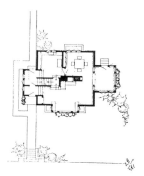 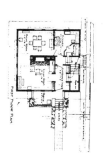 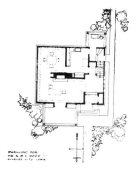 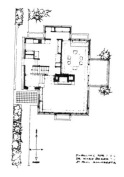

McCOSKER, MINNEAPOLIS　　PROJECT, OWATONNA, MINNESOTA :: :: ::　　DODD, CHARLES CITY, IOWA :: ::　　BEEBE, ST. PAUL MINNESOTA ::

Greek Temple drew its breath of life in Greece, as a direct expression of the Greek and the total reaction of his environment on him, surely it is clear that the use of the Greek form in modern work is a travesty on what was part of Greek life. We abuse the Greek in resorting to copy his architectural forms; when we should be worshipping at the shrine of Greek Art in serious contemplation, we violate the sacredness of the altar.

We know, with a fair degree of accuracy, what the Greek was, mentally and psychologically, and we know and feel that the art work of the Greeks looks as Greek work should look. Postulate Greek art, and we may realize the Greek. Splendid their work, serene, everlastingly and beautifully poised.

When we look at a Greek Temple in America (and we are only using the Greek Temple as representing a condition, there are plenty of others) what do we see, a Library, a Museum, a Bank, or a Music Hall? No, hardly. It isn't likely an

things and of social and industrial organisms, but also we believe in the creatively electric, the complete, the wonderfully personal and all containing Now, for doing our things in our own measured way, in sincerity, in honor, in truth.

We desire the right to do for ourselves, feel for ourselves, love for ourselves, sustain the burden of the heritage of glory from the past for ourselves.

 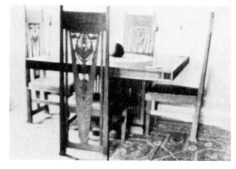

AVIATION CUP, CHICAGO MEET　　FURNITURE FOR BONNIE H. ELMSLIE

We desire reverence for our great Dynamic power, our great Static power, instead of stultification and debasement.

Think of the fact of our prairies, fragrant, beautiful and desirable, our great watersheds, our vast riverways, our great lakes, and the procession

of the seasons moving across the face of them. Think of us as a people, born into such a context of environment, and dream of an Architecture arising from the Dynamics of a race so nurtured, so blessed. There is no limit to the diversity and eloquence of an Architecture so arising.

But after all, it is not so much the grandeur and splendor of an environment that vitally matters but the nature of the reaction of the environment on the human heart, soul and impelling will.

"Lo, the poor Indian, whose untutored mind
 Sees God in clouds and hears Him in the wind."

May it not be possible that it is Lo, the poor Whiteman, who doesn't see the fairy stories of this land any nearer at hand than the clouds, nor in a more manageable place than in he winds?

D O we believe in our own integrity? Then let us express our integrity in our works, let us not dissimulate.

Do we believe in our stability as a people? Then let us express our stability in our works, let us not waver and qualify ourselves.

Do we believe in our spiritual resources? Then let us rely on ourselves, let us not forsake ourselves.

Do we believe in the divine creative impulse

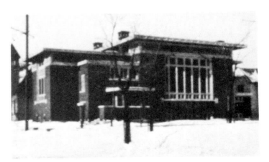

STEWART MEMORIAL CHURCH, MINNEAPOLIS

dwelling within us and working through us? Then let us not deceive ourselves, let us believe that beneficence may be worked through us, that genuine power is common to all, that no living, moving, having its being object in all creation has been omitted. So let us not be led astray in bewildering ways, uncommon to us all.

Do we believe in the reality of Life? Then let us not deny our presence in the supernal scheme of an ordered universe.

Do we believe in the romance of Life? Then let us utter a song.

Do we believe in the glory and splendor of Life? Then let us shape and cohere the drift of our days that the works of our hands may not be found wanting, but be full of that high spirit of great endeavor, full of enthusiasm, full of candor, of mildness, of virtue, of an excellence of sanity, and of a supreme regard for the simpleness, the quietness, and of that hallowed and eloquent gentleness that dwell at the core of every human heart.

All of this is merely a simple extension of the view of the field wherein Architecture among a people arises, and, as we persist in our belief in the reality of this field, will we develop an Architecture that is of us and in no other way?

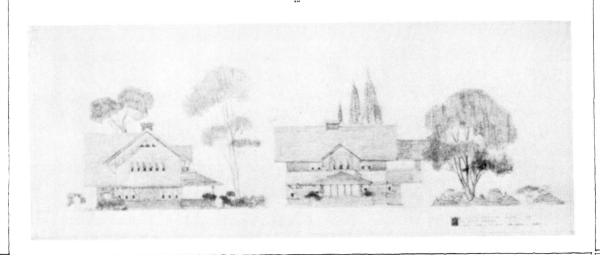

Purcell,
Feick
and
Elmslie

Being of the West, Western, and having been surrounded by an atmosphere of progressivism (radicalism if you please), *The Western Architect* must confess to a deep and a strong liking for the young men, Purcell, Feick & Elmslie, and for what they are contributing to present day architectural thought. In politics, religion and social customs the spirit which has moved us to "Insurge" has spread throughout our Nation and the World and although this same progressive and equally sensible

MR. FEICK

movement in architecture is supposed to be confined to a small territory West of the Mississippi River, we believe that its influence on the thought of the Age is going to be as tremendously effective as has been the ultimate effect of the teachings of the so-called Radical leaders in other spheres of progress. Being impressed with what these young men

MR. PURCELL

have accomplished and believing that our readers might like to be brought into personal touch with

ways. Mr. Elmslie began architectural life in Chicago back in 1892 as a part of the activity that really started the Middle Western movement in Architecture. Mr. Purcell "just grew up" architecturally in the midst of this progressive atmosphere. Mr. Feick came across it, apparently with a sort of a hunger for something which the new work offered. The Scotchman was taken bodily from his native heather and was let down in the midst of the work preliminary to the designing of the Transportation Building for the Chicago Fair. The Irish-American was started in his thinking by a nature loving grandfather, a genial philosopher, who understood the evolutionary idea and loved to watch it working in the woods, among the trees and animals

MR. ELMSLIE

and through his fellowmen. The German-American at the age of eight invented a rat trap out of a hole in the back yard filled in $7.85 worth of his fathers' best spar varnish; and then commenced a systematic study of bugs, stones, plants, wood, earth, sky, air and all that is in and of them. He stored away all that he found out in a most systematic memory. With characteristic modesty these young men have consistently kept out of print, and it is only through long perseverance that *The Western Architect* is now able to give its readers the first work of the firm of Purcell, Feick & Elmslie, that has been published in the architectural press. We trust that this

DWELLING FOR MR. E. C. TILLOTSON :: MINNEAPOLIS

the authors, we take pleasure in presenting portraits of the three, not as good as we might have wished but offered as they are. It is interesting to find that each member of the firm apparently came to his convictions about Architecture in quite different

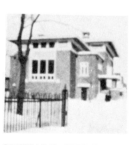

STEWART MEMORIAL CHURCH, MINNEAPOLIS

message which is the latest word in American Architecture will bring to our subscribers the same pleasure in reading that it gives us to publish, and create an interest in the gospel of true Progressiveness which, from time to time *The Western Architect* will preach.

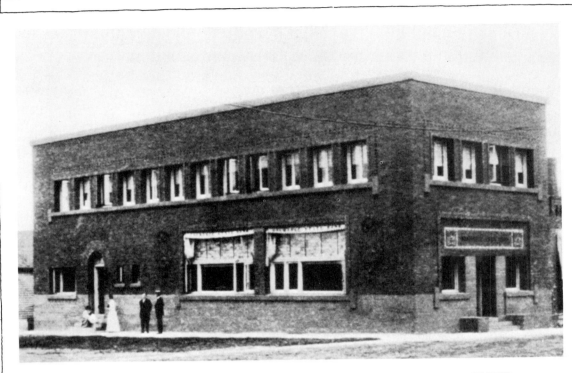

A BANKING OFFICE IN A VILLAGE OF SIX OR SEVEN HUNDRED PERSONS. GRAND MEADOW
RESTS IN THE CENTER OF A RATHER BROADLY DEVELOPED FARM AND DAIRY REGION

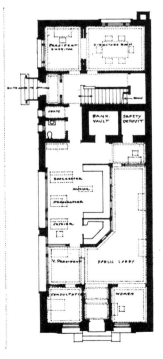

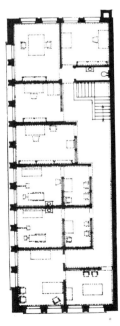

THIS BUILDING IS A GOOD EXAMPLE OF WHAT MAY RE-
SULT WHEN NOT ONLY WHAT ARE CALLED THE "PRACTI-
CAL" REQUIREMENTS FIND FREE OPPORTUNITY FOR TAK-
ING NATURAL ARCHITECTURAL FORMS BUT WHERE NATIVE
HUMAN ELEMENTS AS WELL HAVE EQUAL OPPORTUNITY
TO BRING WHAT THEY MAY TO THE QUALITY OF THE
WORK. THE BASIC CONCEPTION OF THE RELATION BE-
TWEEN FORM AND FUNCTION ALLOWS FREE EXPRESSION
BOTH TO THE WAY THE BUILDING MATERIALS BELONG
TOGETHER AND TO THE WAY THE MEN, THE BANKING
BUSINESS AND THE COMMUNITY BELONG TOGETHER

EXCHANGE STATE BANK
GRAND MEADOW MINN...

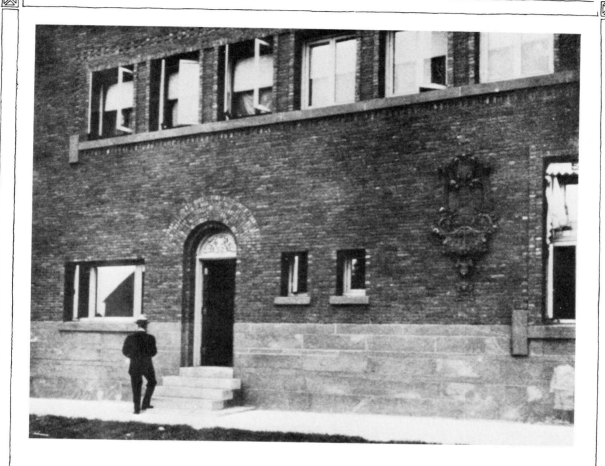

VIEWS OF THE GRAND
MEADOW BANK

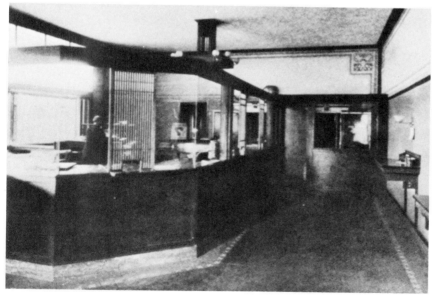

CAREFUL FUNCTIONING
OF THE REAL ELEMENTS
DEVELOPS A NATURAL
PLAY BETWEEN WALL
TEXTURE AND WINDOWS,
OR BETWEEN WINDOW
TEXTURE AND WALL AS
THE CASE MAY BE, AND
THE RESULTING ARCHI-
TECTURAL FORMS SYN-
CHRONIZE ACCURATELY
WITH THE BUSINESS OF
THE STRUCTURE :: ::

BUNGALOW
CRANE ESTATE

WOODS HOLE
MASSACHUSETTS

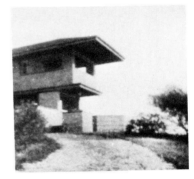

BUNGALOW DESIGNED TO OCCUPY A POINT OF
MAINLAND REACHING INTO THE SEA, WITH
VIEWS TOWARD WOODS HOLE, NOBSKA POINT
AND THE SOUND. :: :: :: :: :: :: :: :: :: ::

THE PLAN WAS ORGANIZED FOR THE SITUA-
TION. WALLS ARE PRACTICALLY ELIMINATED
FROM THE GROUND FLOOR. STRUCTURAL
UNITS UNITED WITH GREAT WINDOW SYSTEMS
FORMING THE ENCLOSURE. :: :: :: :: :: :: ::

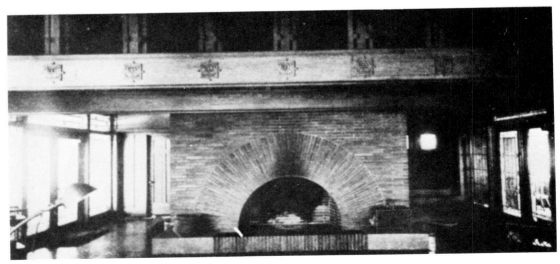

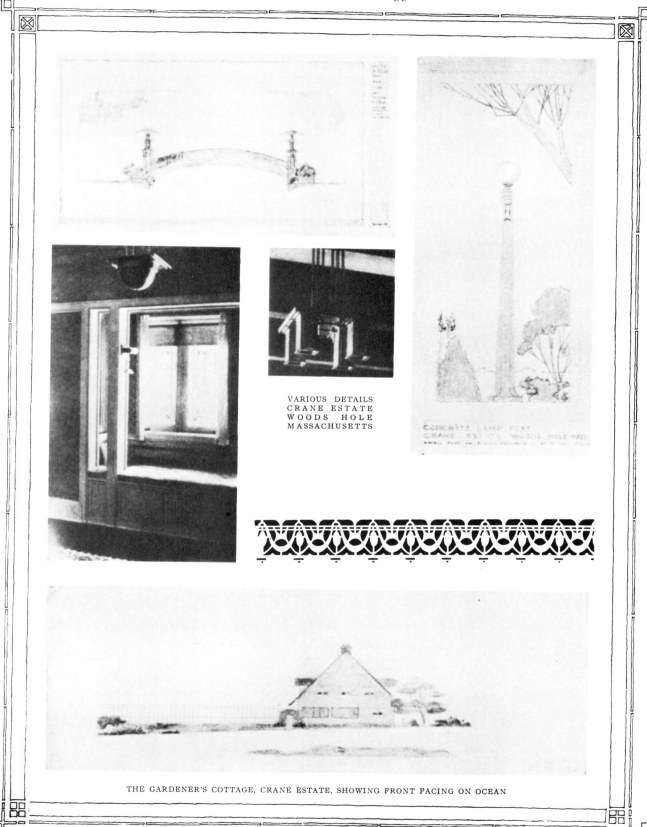

VARIOUS DETAILS
CRANE ESTATE
WOODS HOLE
MASSACHUSETTS

THE GARDENER'S COTTAGE, CRANE ESTATE, SHOWING FRONT FACING ON OCEAN

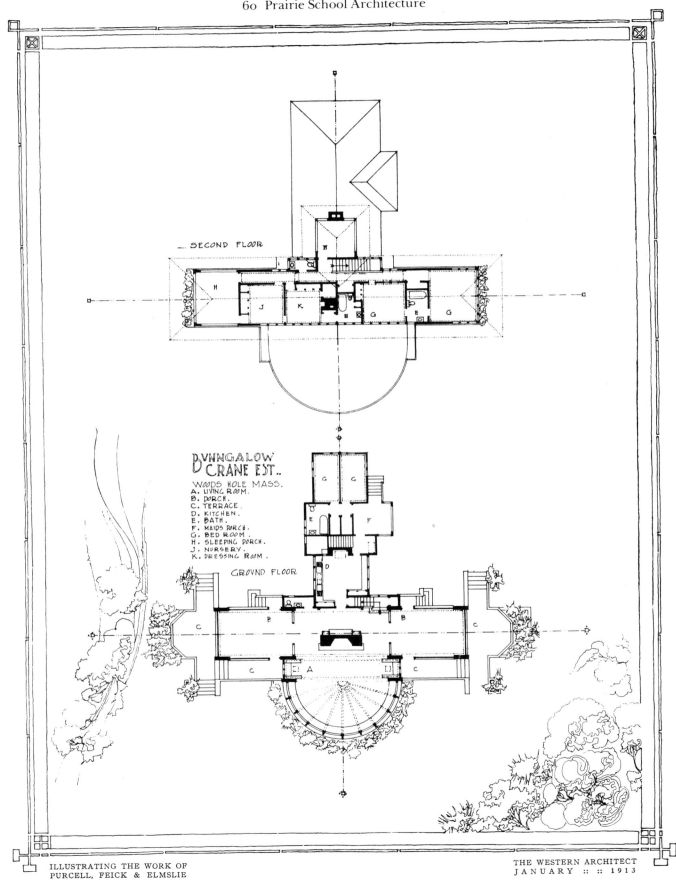

SECOND FLOOR

BVNNGALOW
CRANE EST..
WOODS HOLE MASS.
A. LIVING ROOM.
B. PORCH.
C. TERRACE.
D. KITCHEN.
E. BATH.
F. MAIDS PORCH.
G. BED ROOM.
H. SLEEPING PORCH.
J. NURSERY.
K. DRESSING ROOM.

GROVND FLOOR

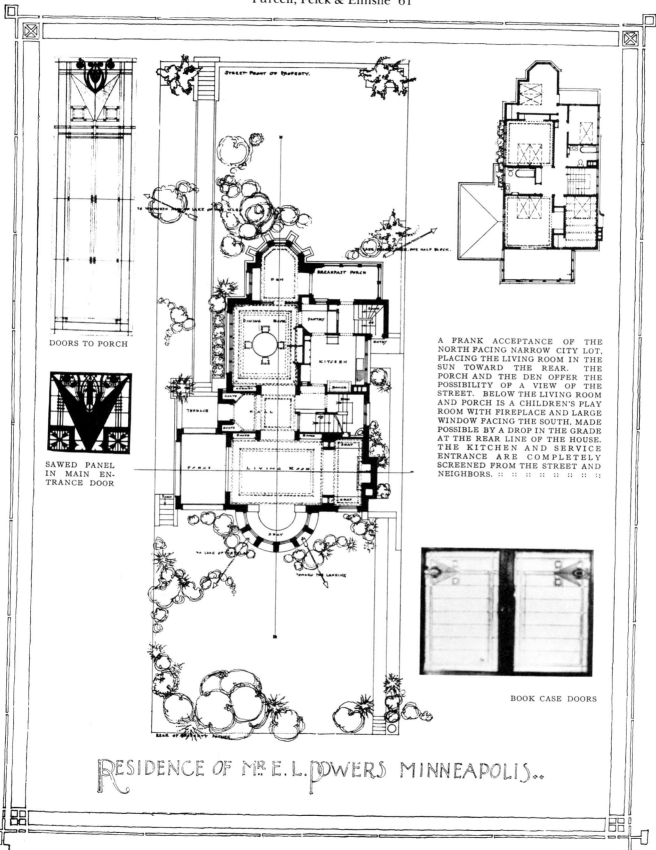

DOORS TO PORCH

SAWED PANEL
IN MAIN EN-
TRANCE DOOR

A FRANK ACCEPTANCE OF THE
NORTH FACING NARROW CITY LOT,
PLACING THE LIVING ROOM IN THE
SUN TOWARD THE REAR. THE
PORCH AND THE DEN OFFER THE
POSSIBILITY OF A VIEW OF THE
STREET. BELOW THE LIVING ROOM
AND PORCH IS A CHILDREN'S PLAY
ROOM WITH FIREPLACE AND LARGE
WINDOW FACING THE SOUTH, MADE
POSSIBLE BY A DROP IN THE GRADE
AT THE REAR LINE OF THE HOUSE.
THE KITCHEN AND SERVICE
ENTRANCE ARE COMPLETELY
SCREENED FROM THE STREET AND
NEIGHBORS. :: :: :: :: :: :: :: ::

BOOK CASE DOORS

RESIDENCE OF MR E. L. POWERS MINNEAPOLIS..

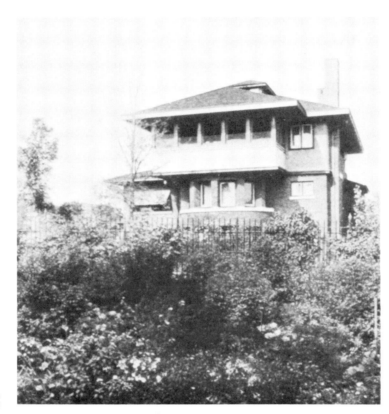

DWELLING FOR
MR. E. L. POWERS

VIEW OF SOUTH-
ERN EXPOSURE
AT THE REAR
SHOWING SLEEP-
ING PORCH ABOVE
LIVING ROOM, BAY
WINDOWS, WHICH
O V E R L O O K
GARDENS AND
LAKE OF THE
ISLES ONE BLOCK
AWAY :: :: :: :: ::

THESE STENCILS IN SEVERAL
COLORS ARE APPLIED IN EXTREMELY
DELICATE VALUES SO THAT IN
CERTAIN LIGHTS THEY PRAC-
TICALLY DISAPPEAR. :: :: :: :: ::

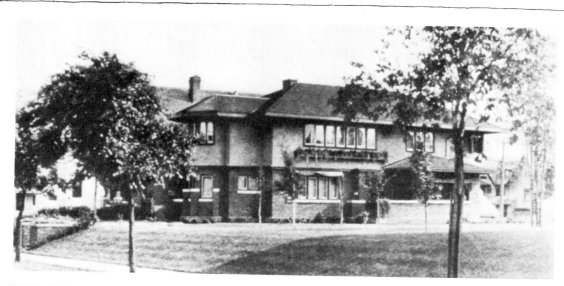

WEST ELEVATION E. L. POWERS' DWELLING. GREENISH-BROWN TEXTURE BRICK, BROWN WOODWORK AND A FLOATED SURFACE BUFF PLASTER WITH A DECIDEDLY PINK TONE

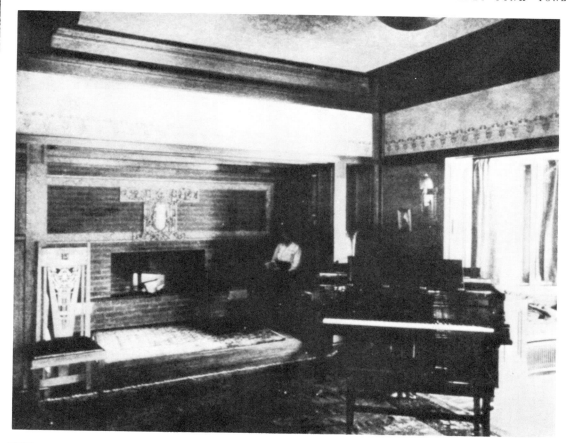

VIEW IN POWERS' LIVING ROOM LOOKING TOWARD FIRE-PLACE SHOWING RAISED TREATMENT OF HEARTH

NORTH ELEVATION OF POWERS' DWELLING, FACING STREET SHOWING KITCHEN PORCH

VIEW IN POWERS' DINING ROOM, SHOWING PLASTIC FRAMING-IN OF WALL SURFACES BY NARROW MARGINS OF WOOD WITH CONTINUOUS MOULDED BACK BANDS

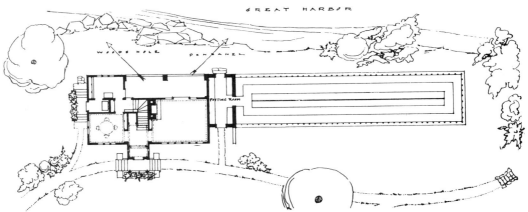

GARDENER'S COTTAGE AND GREENHOUSE, CRANE ESTATE, WOODS HOLE, MASSACHUSETTS

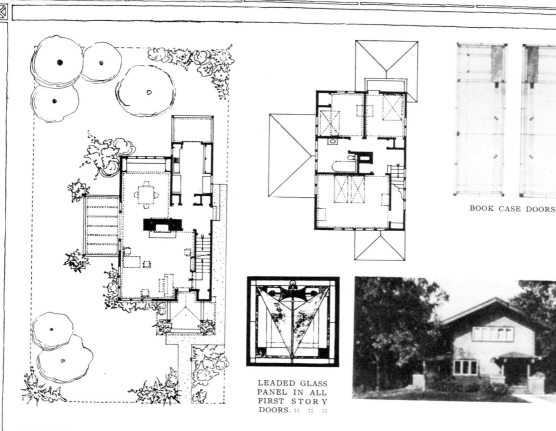

BOOK CASE DOORS

LEADED GLASS
PANEL IN ALL
FIRST STORY
DOORS. :: :: ::

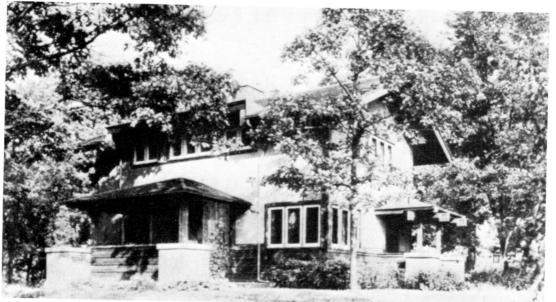

DWELLING FOR MR. HAROLD E. HINELINE, MINNEAPOLIS, MINNESOTA. A VARIATION
OF THE TYPE OF PLAN SHOWN ON PAGE 8, DESIGNED ORIGINALLY FOR A 40-FOOT CITY LOT

THE EXPECTED ARRANGEMENT WOULD BE TO DIVIDE THE PROPERTY IN HALF AND USE THE AREA AT THE CORNER FOR BANK AND THE INSIDE HALF FOR STORE. NO MERCHANT AT PRESENT WITHOUT A PERMANENT LOCATION IN THE CITY OF RHINELANDER COULD HAVE USED SO MUCH SPACE EFFICIENTLY NOR HAVE PAID THE RENTALS: THE ONLY QUESTION AS TO THE PRACTICABILITY OF THE PRESENT SOLUTION WAS THE DISTANCE FROM THE STREET TO THE BANK. ONE CAN SEE INTO THE BANKING ROOM FROM A NUMBER OF POINTS ON THE STREET SIDEWALKS. THE ENTRANCES ARE CONVENIENT AND ARE GIVEN SPECIAL EMPHASIS AND THE ENTIRE BANKING ROOM IS VERY OPEN TO VIEW AS SOON AS ONE PASSES THE MAIN VESTIBULE. THE EVERYDAY USE OF THE ARRANGEMENT HAS JUSTIFIED THIS UNUSUAL PLAN ANALYSIS OF AN EVERYDAY PROBLEM. THIS ARRANGEMENT FURTHER ALLOWS FOR A HIGH CEILING IN THE BANKING ROOM WITH NO INCREASE IN THE NUMBER OF STEPS TO THE OFFICE FLOOR. ::

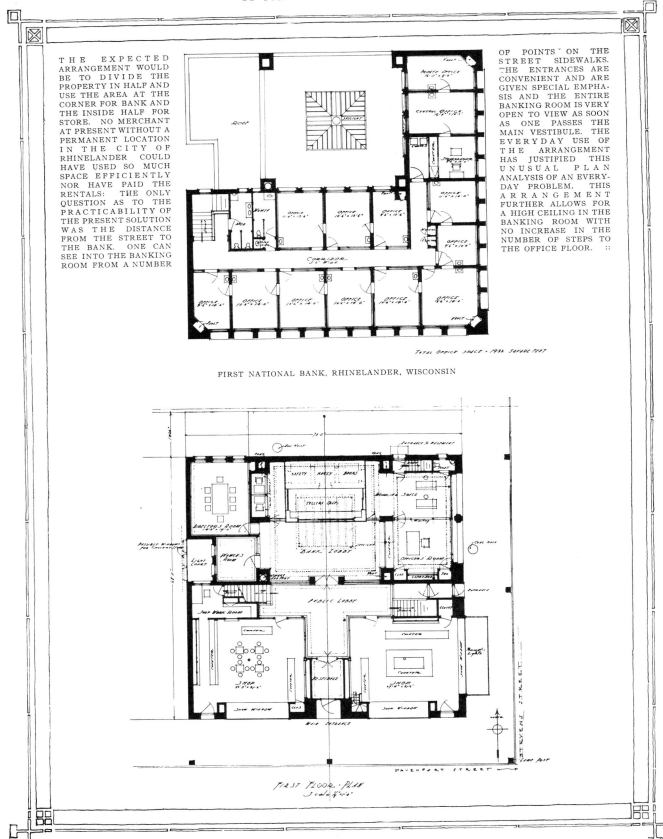

FIRST NATIONAL BANK, RHINELANDER, WISCONSIN

FIRST NATIONAL BANK RHINELANDER

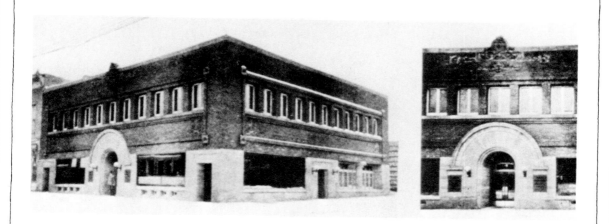

IN A BUILDING OF THIS TYPE THE PRACTICAL CONSTRUCTIVE MATTERS ARE NOT OF ANY CONSIDERABLE POWER AND EXCEPT WHERE SOME ESPECIAL CONDITION GAVE OPPORTUNITY FOR A VIGOROUS STRUCTURAL STATEMENT THE ARCHITECTURAL STORY HAS BEEN TOLD WITH A GENERALLY PLASTIC HANDLING OF AREAS AND TEXTURE. THE USE OF SIMPLE BUILDING BLOCKS OF STONE AS A CONCLUSION TO THE BRICK WALLS AT THE TOP, DEFINITELY ARRESTING THEIR UPWARD MOVEMENT FORMS AN INTERESTING CONTRAST TO THE USUAL USELESS VERBIAGE OF AN APPLIQUE "CORNICE." :: :: :: :: :: :: :: :: :: :: :: ::

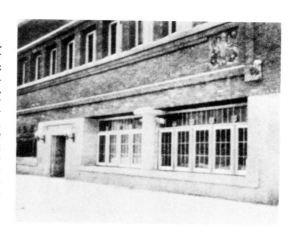

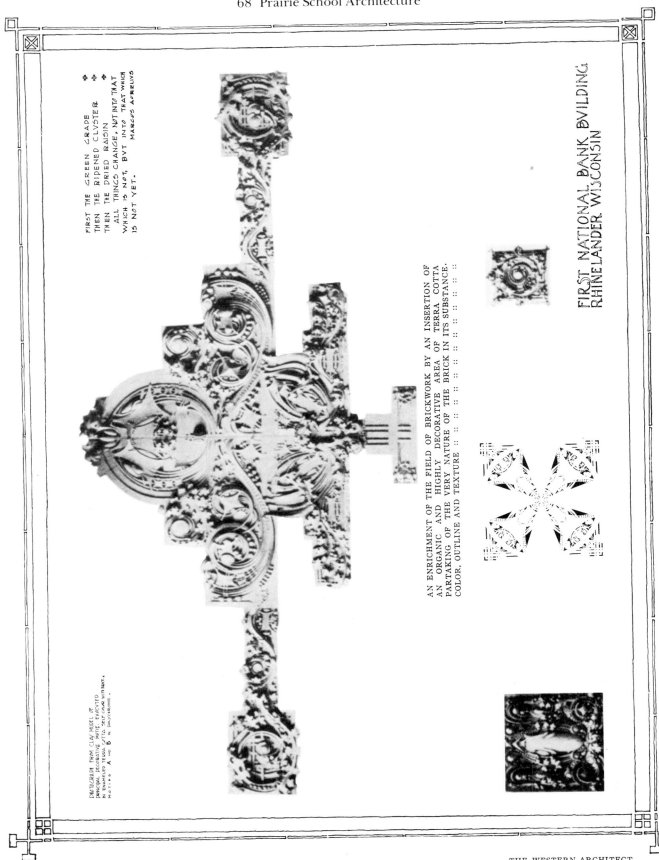

FIRST THE GREEN GRAPE ✥ ✥
THEN THE RIPENED CLUSTER ✥
THEN THE DRIED RAISIN
ALL THINGS CHANGE, NOT INTO THAT
WHICH IS NOT, BUT INTO THAT WHICH
IS NOT YET. MARCUS AURELIUS

AN ENRICHMENT OF THE FIELD OF BRICKWORK BY AN INSERTION OF
AN ORGANIC AND HIGHLY DECORATIVE AREA OF TERRA COTTA
PARTAKING OF THE VERY NATURE OF THE BRICK IN ITS SUBSTANCE.
COLOR, OUTLINE AND TEXTURE :: :: :: :: :: :: :: :: :: :: :: :: :: :: ::

FIRST NATIONAL BANK BUILDING
RHINELANDER WISCONSIN

DIAGRAM FROM CLAY MODEL OF
PRINCIPAL DECORATIVE MOTIF EXECUTED
IN ENAMELED TERRA COTTA, SELF-COLOR WITH BRICK
MOTIFS A AND B IN POLYCHROME.

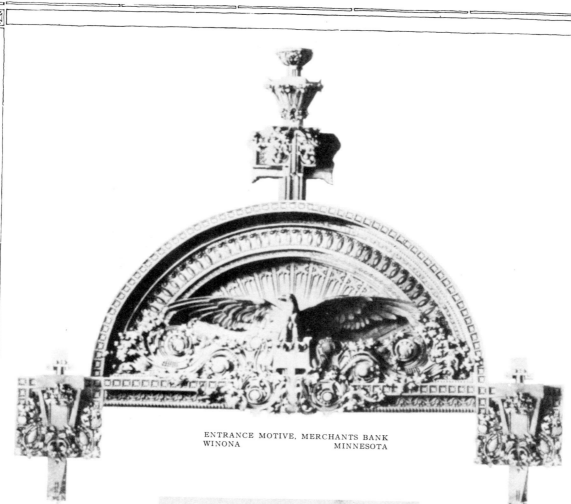

ENTRANCE MOTIVE, MERCHANTS BANK
WINONA MINNESOTA

THIS PENCIL DRAWING IS GIVEN TOGETHER WITH THE PHOTOGRAPH FROM THE CLAY MODEL TO SUGGEST THE WAY IN WHICH THIS CHARACTERISTIC DECORATIVE MATERIAL IS DEVELOPED. THESE MOTIFS ARE DESIGNED AS AN ORGANIC PART OF A STRUCTURE, AN EFFLORESCENCE OF THE IDEA REPRESENTED IN THE BUILDING ITSELF. SINCE EACH BUILDING REPRESENTS A DEFINITE IDEA FITTED TO A CERTAIN USE THE ORNAMENT IS CONCERNED WITH THIS IDEA AND NOTHING ELSE. WHILE THE DESIGN OF THE BUILDING IS BEING WORKED OUT THUMB-NAIL MOTIFS FOR THE DECORATIONS ARE ALSO BEING WORKED OUT AND FILED AWAY SO AS TO PRESERVE

THE ORIGINAL IMPULSE. THE ORNAMENTS, THEMSELVES REPRESENT THE EXPANSION OF A SINGLE GERMINAL IDEA AND MAY BE SEVERE, RESTRAINED, SIMPLE OR AS ELABORATELY EVOLVED AS DESIRED FOR PLACE AND CIRCUMSTANCE. AFTER THE MOTIF IS ESTABLISHED THE DEVELOPMENT OF IT IS AN ORDERLY PROCESSION FROM START TO FINISH. IT IS ALL INTENSELY ORGANIC, PROCEEDING FROM MAIN MOTIF TO MINOR MOTIFS, INTERBLENDING, INTERRELATING AND TO THE LAST TERMINAL, ALL OF A PIECE. IT IS THE PLAY WORK IN THE ARCHITECT'S DAY, HIS HOUR OF REFRESHMENT. :: :: :: :: :: ::

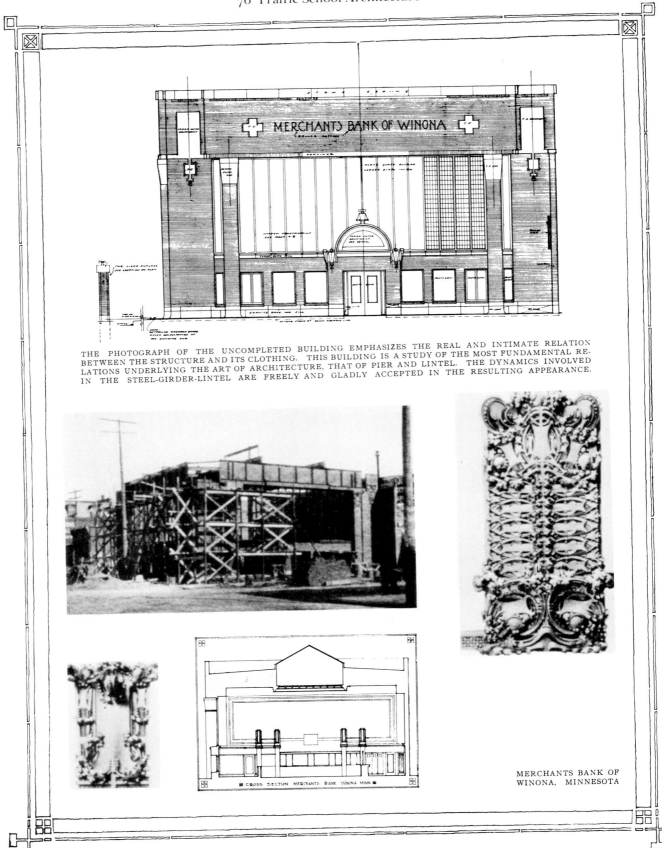

THE PHOTOGRAPH OF THE UNCOMPLETED BUILDING EMPHASIZES THE REAL AND INTIMATE RELATION BETWEEN THE STRUCTURE AND ITS CLOTHING. THIS BUILDING IS A STUDY OF THE MOST FUNDAMENTAL RELATIONS UNDERLYING THE ART OF ARCHITECTURE, THAT OF PIER AND LINTEL. THE DYNAMICS INVOLVED IN THE STEEL-GIRDER-LINTEL ARE FREELY AND GLADLY ACCEPTED IN THE RESULTING APPEARANCE.

MERCHANTS BANK OF
WINONA, MINNESOTA

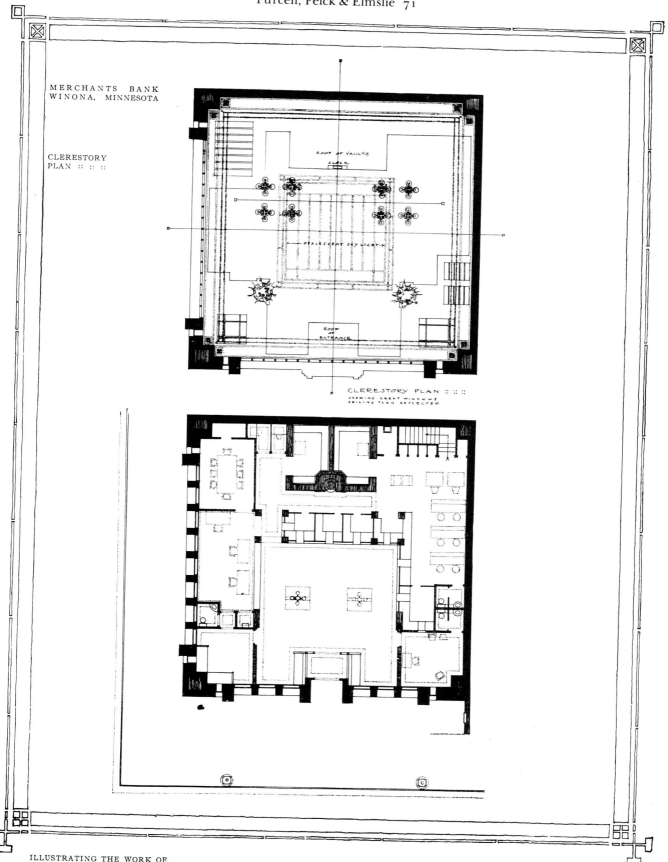

MERCHANTS BANK
WINONA, MINNESOTA

CLERESTORY
PLAN :: :: ::

CLERESTORY PLAN :: :: ::
SHOWING GREAT WINDOWS
CEILING PLAN REFLECTED.

DWELLING OVERLOOK-
ING LAKE MINNE-
TONKA FOR MR.
CHARLES W. SEXTON

ILLUSTRATING THE
OPENING UP OF AN
OLD SUMMER HOME
TO THE SUNSHINE
AND BREEZES

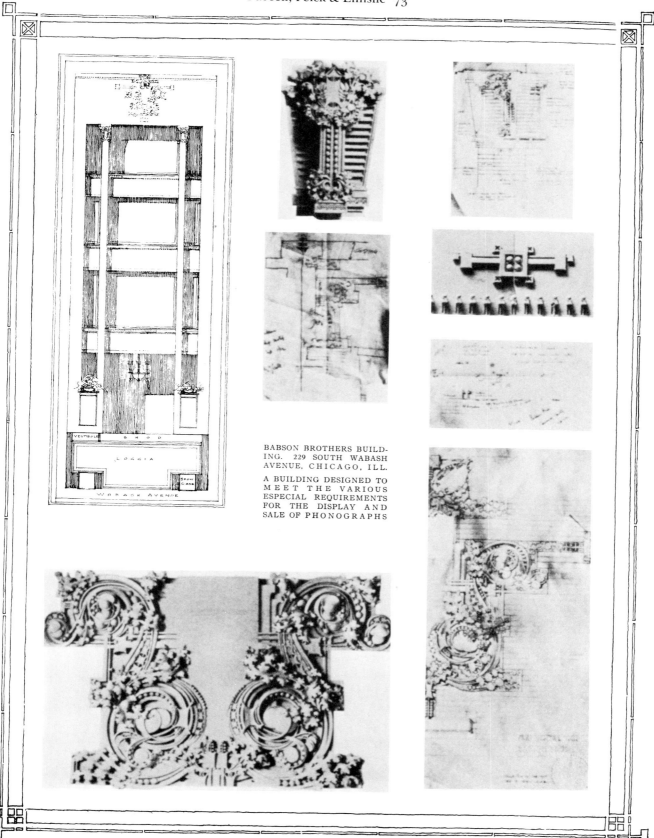

BABSON BROTHERS BUILD-
ING. 229 SOUTH WABASH
AVENUE, CHICAGO, ILL.

A BUILDING DESIGNED TO
MEET THE VARIOUS
ESPECIAL REQUIREMENTS
FOR THE DISPLAY AND
SALE OF PHONOGRAPHS

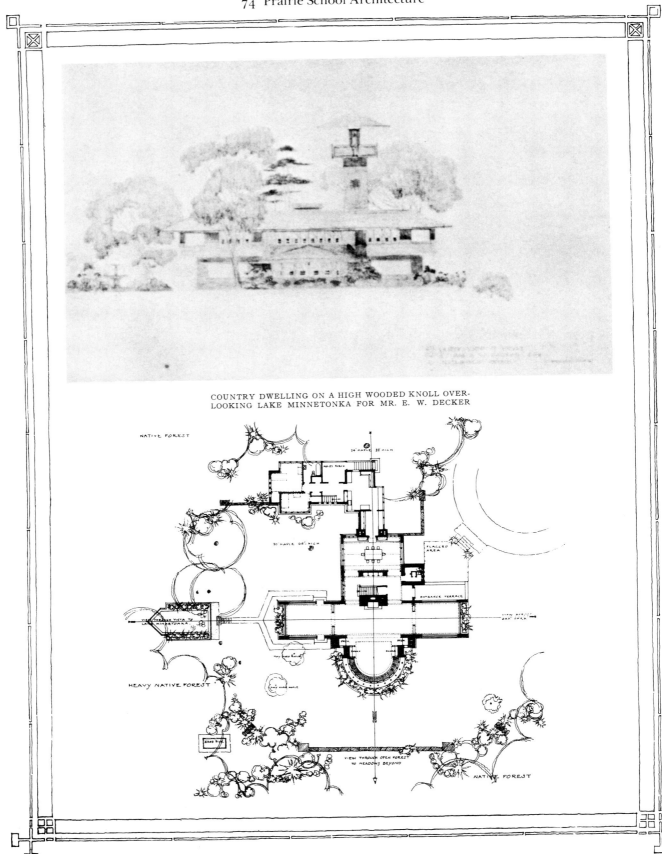

COUNTRY DWELLING ON A HIGH WOODED KNOLL OVER-
LOOKING LAKE MINNETONKA FOR MR. E. W. DECKER

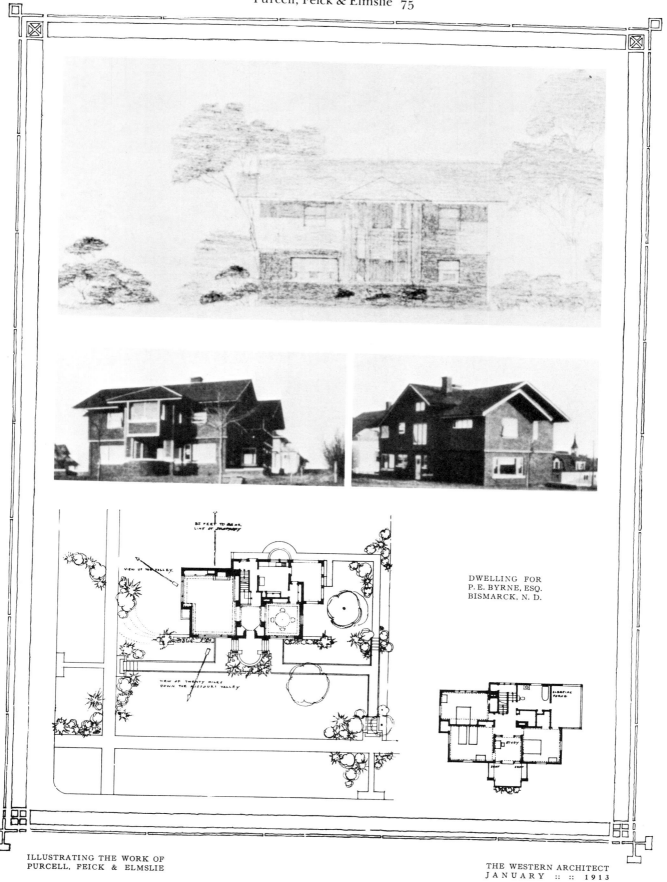

DWELLING FOR
P. E. BYRNE, ESQ.
BISMARCK, N. D.

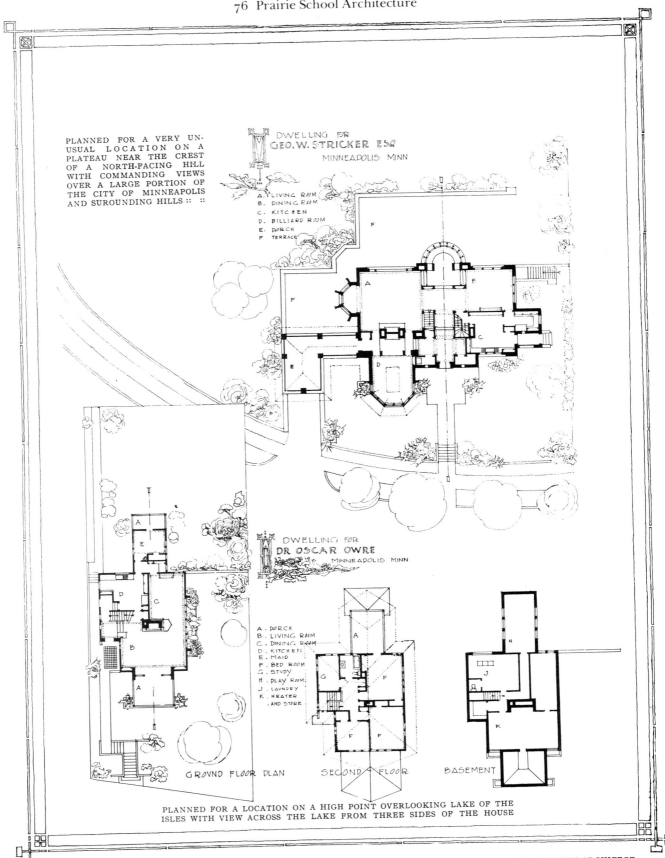

PLANNED FOR A VERY UN-
USUAL LOCATION ON A
PLATEAU NEAR THE CREST
OF A NORTH-FACING HILL
WITH COMMANDING VIEWS
OVER A LARGE PORTION OF
THE CITY OF MINNEAPOLIS
AND SUROUNDING HILLS :: ::

DWELLING FOR
GEO. W. STRICKER ESQ
MINNEAPOLIS MINN

A . LIVING ROOM
B . DINING ROOM
C . KITCHEN
D . BILLIARD ROOM
E . PORCH
F . TERRACE

DWELLING FOR
DR OSCAR OWRE
MINNEAPOLIS MINN

A . PORCH
B . LIVING ROOM
C . DINING ROOM
D . KITCHEN
E . MAID
F . BED ROOM
G . STUDY
H . PLAY ROOM
J . LAUNDRY
K . HEATER
. AND STORE

GROUND FLOOR PLAN SECOND FLOOR BASEMENT

PLANNED FOR A LOCATION ON A HIGH POINT OVERLOOKING LAKE OF THE
ISLES WITH VIEW ACROSS THE LAKE FROM THREE SIDES OF THE HOUSE

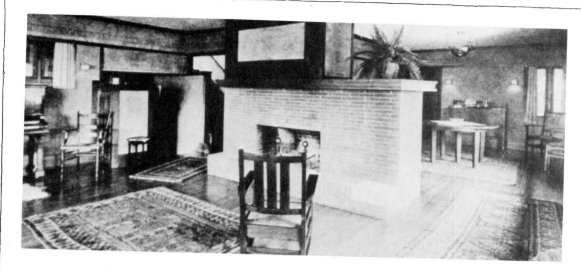

DWELLING OF
OSCAR OWRE, M. D.
2625 NEWTON AVE. S.
MINNEAPOLIS
MINNESOTA

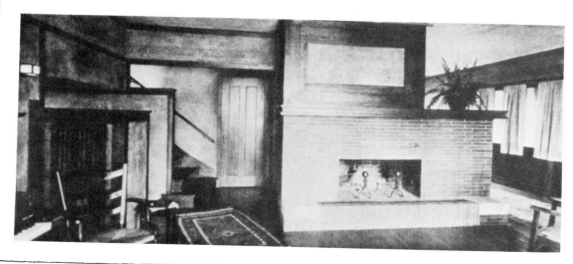

ILLUSTRATES ONE TREAT-
MENT OF THE SCHEME OF
PLAN, SEVERAL VARIATIONS
WHICH ARE SHOWN ON PAGE 8

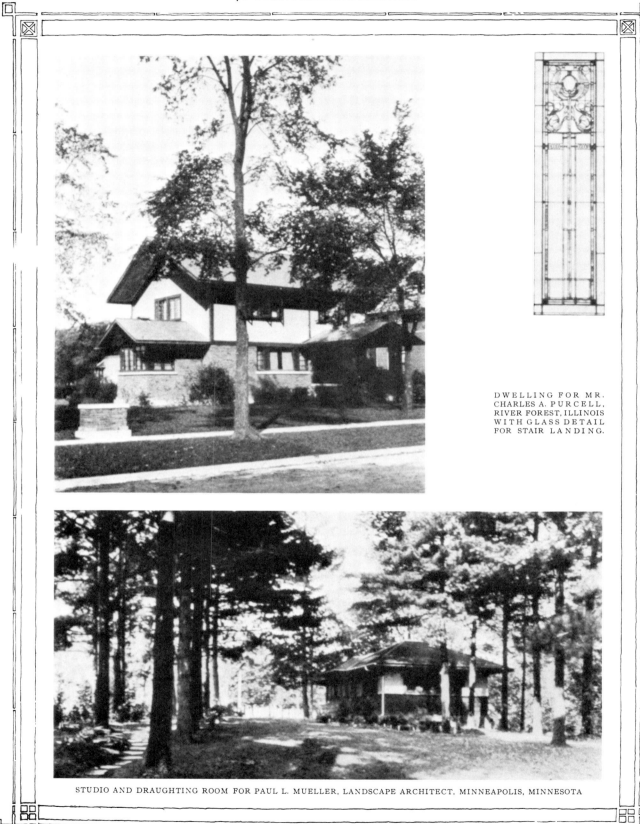

DWELLING FOR MR.
CHARLES A. PURCELL,
RIVER FOREST, ILLINOIS
WITH GLASS DETAIL
FOR STAIR LANDING.

STUDIO AND DRAUGHTING ROOM FOR PAUL L. MUELLER, LANDSCAPE ARCHITECT, MINNEAPOLIS, MINNESOTA

ENRICHMENT IN SAWED WOOD FOR
THE GABLE OF A LIVING PORCH. THE
PATTERN IS GIVEN ITS FOURTH DIMEN-
SION BY A GAY SYSTEM OF POLYCHROME
WHICH THE PHOTOGRAPH ONLY SUG-
GESTS. :: :: :: :: :: :: :: :: :: :: ::

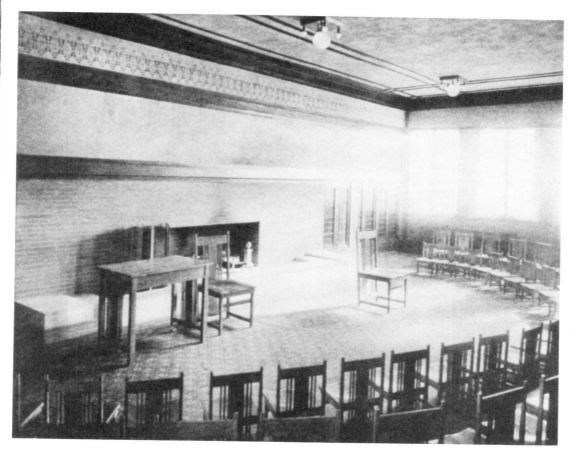

SUNDAY SCHOOL KINDERGARTEN,
WESTMINSTER CHURCH, MINNEAPOLIS,
MINNESOTA. :: :: :: :: :: :: :: :: ::

:: :: :: HE WISHED HIS MUSIC TO BE AN ART OF COMMUNION WITH OTHER MEN. THERE IS NOT A VITAL ART SAVE THAT WHICH IS LINKED WITH THE REST OF HUMANITY. :: :: :: YOU ARE ADDRESSING ALL MEN; USE THE LANGUAGE OF MEN. :: :: :: :: :: :: THERE ARE NO WORDS NOBLE OR VULGAR; THERE IS NO STYLE CHASTE OR IMPURE, THERE ARE ONLY WORDS AND STYLE WHICH SAY OR DO NOT SAY EXACTLY WHAT YOU HAVE TO SAY. BE SOUND THROUGH AND THROUGH IN ALL YOU DO; THINK JUST WHAT YOU THINK AND FEEL JUST WHAT YOU FEEL, LET THE RHYTHM OF YOUR HEART PREVAIL IN YOUR WRITINGS. THE STYLE IS THE SOUL. :: :: :: LET US AVOID LIKE THE PLAGUE ANY ARTISTIC LANGUAGE THAT BELONGS TO A CASTE LIKE THAT OF SO MANY WRITERS AND ESPECIALLY OF SO MANY FRENCH MUSICIANS OF TO-DAY. WE MUST HAVE THE COURAGE TO SPEAK LIKE MEN, NOT ARTISTS.　ROMAINE ROLLAND IN "JEAN CHRISTOPHE."

ILLUSTRATING
IN THIS ISSUE THE WORK OF

P U R C E L L AND E L M S L I E
ARCHITECTS

CHICAGO, ILLINOIS
MINNEAPOLIS, MINNESOTA

 WM. GRAY PURCELL
GEORGE G. ELMSLIE

The Editor of the WESTERN ARCHITECT had the privilege last year of following both sides of a most interesting correspondence, extending over some little time, between the authors of the work illustrated in this issue and a well known Eastern Architect. These letters gave him an unusually clear idea of just what the word "Architecture" means to Messrs. Purcell and Elmslie. The suggestion that letters from their current files would supply a most lively and effective exposition of the architectural work being done by them, brought forth these letters which we have been privileged to print below, and also an unusual office scrapbook from which selections have been made.

December 23rd, 1910
Mr. P. F. C., New York City, N. Y.
My dear Mr. C.:—
¶ * * *

"Have we an American Architecture?" Just look out your window at the backs of any of the great structures. The architect has busied himself applying distorted replicas of what *was* architecture to buildings that might *be* great architecture if he would let them speak. But the rear of these buildings is real, expressive; use regulates the proportions which are vital, the "Five Orders" have not been dragged into view.

"Architecture is the need and power to build" and the need and power to build has to do with "here" and "now". Egyptian Architecture *was*; Gothic Architecture *was*; Colonial Architecture *was*; while American Architecture *is*, vibrant, conclusive and all around you.

It is getting to be that the only way we can enjoy our buildings is to take a walk over into the factory districts—or just plain sneak around at night with a poet like Kipling. American Architecture would be more in evidence in New York if it were left to its own resources. Cook's tours and the "Beaux Arts" have covered the buildings with the husks of forms that outlived their usefulness centuries ago.

Says Mr. K., in reply to your query: "There is no American Architecture at all * * * A column is a

column, isn't it? A window opening can be square, circular, or pointed; you can't invent a new window opening?"—Were the Egyptians ashamed of the Pyramids because they showed no columns, or the Greeks of the Parthenon because it has no windows? A church is a church, isn't it? Is a Roman temple a bank? Well, usually in New York! Does Mr. K. consider that the last word has been said in Architecture? What about the other Fine Arts? Are there to be no creative voices in Architecture? No Whistlers? No Wagners? No Whitmans? No Rodins? Think of America with its amazing triumphs and not a voice in Architecture but an echo of the past.
¶ * * * *

Yours very sincerely.

Mr. N. H.:—
New York City, N. Y.　　January 15th, 1912
My dear Mr. H.:—

We were much interested in the editorial outcome of our recent correspondence and interview, just come to hand. * * * * * *

Originality is of secondary consideration. That will care for itself, except as defined by Goethe. Certainly the porch of * * * in Boston would not stand this test. It is a literal but rather unsypathetic copy by * * * of a Romanesque porch in Southern France. The cause of Architecture as set forth in Chicago has been most hurt because people insisted on believing that the aim was originality, when that was not a part of the program of any of these architects.

If only this education—the architectural schools— would teach familiarity with the architecture of the past and make their students intimate with the great art that has been. Our technique cries out for such understanding, but the schools don't give it. What I know of Greek and Gothic of the Roman and Mediaeval times has been almost wholly gained since my graduation from the department of Architecture at Cornell University.

I do not recall a school problem in a four years' course calling for the study of a Greek work, and Gothic was simply taboo in 1900 since it had not then become fashionable, and no "Vignola" had reduced it to a formula.

¶ * * * * *

We share your admiration of the Marshall Field Wholesale building in Chicago, which is noble architectural work. The Pennsylvania Terminal in New York is its antithesis architecturally. The one is real; the other a colossal but splended sham.

If conditions bring masonry and steel together in a structure they can work joyously and in harmony as skeleton and covering. But let us have done with pretense! Yours very cordially.

Mr. T. H. S., Chairman,
Dear Sir:—

¶ * * * * *

We recognize in your program a new call—a call for action of a new and definite kind toward making all the people in your community more useful and serviceable one to another. And to this end you desire a building that will dedicate itself to a fresh, beautiful and sane form of activity, a center of social influence in all the varying and often bewildering conditions of our American life.

It is apparent that this program is the result of pressure from within the spiritual aspirations of your community, and it defines in precise terms certain fundamental needs that have been gradually assuming clear cut and definite form. A building embodying such a spirit and with such essentials would inevitably open up a new chapter, not only in the history of architecture, but the reaction on the individual and the community would be a great factor in the now rapidly spreading movement toward social efficiency.

Our idea of approching a problem of this nature for interpretation is to revert to the old law that in every problem, complex or simple, dwells the solution; that the problem speaks and tells its own story in simple terms. To interpret and properly nurture the problem, we are constrained to put aside any preconceived idea of what such a building should be like; to put aside historic architecture with all its beauty and its glory, as being beside the point; and instead to put our faith in your simple statement as being the voice of your needs and so as truly as we may, to plan and design a building at once simple, direct and candid, fulfilling your requirements not literally, but as we think, in a wholesome spirit.

There are three ideas set forth in your program:—
 a The idea of a place of worship.
 b The idea of a place of education.
 c And a social idea, relating each to the other and all to everyday life. The problem of uniting these elements to form the most serviceable and practical building is a study in organization.

After the size, shape and disposition of the integral parts have been determined with a fair degree of accuracy and in accordance with the conditions and demands of your program, the whole organism is subjected to a process of arranging, relating and articulating so that the result will tell the story of your needs and aspirations.

This is not the usual method of procedure, where a "Motive" or "Feature" pleasing to the eye, has been arbitrarily selected as "architecturally correct", within which unwilling necessaries are forced and misshapen to fit,—in their turn distorting the imposed motive until it is no longer correct.

We have previously noted that the solution of all problems of this or any other nature resides within themselves. Thus the study of this building naturally develops various forms. These forms arising from the heart of a problem take on shape definitely associated with their use. This result is elemental in its significance and brings us face to face with Form and Function, the Primal Law underlying all created things. Where there is no function or use, no form can arise, and conversely, no form should exist without its use or function being definitely expressed.

This idea has been followed in organizing your plans, not in a barren and merely scientific manner,—but in a vital and living manner, charged, we trust, with reasonableness and sincerity.

Yours very respectfully.

My dear Mr. R.:— February 19th, 1913.

¶ * * * * *

Your last letter was very interesting and I was mightily interested in reading your comments on the Lincoln Memorial. Have you noticed the publicity the problem, as interpreted, was and is getting in the press and among the architects of these western states? The * * * voted unanimously to send a document of protest against the use of the Greek forms to serve as a fitting tribute to the memory of the great modern man. One architect remarked, "We will be the laughing stock of the artistic world." It is more serious than that; to be laughed at is a mild matter and easily forgotten.

There is so much of this feeling in the air nowadays. It seems as though a springtime is really coming to the ill-fated art of architecture in America and we believe this is so, that a new era is beginning, but it is handicapped in its arrival by great odds, an appalling lack of interest among people who could do so much to welcome another springtime to this, the noblest of arts.

What can we do as simple citizens to further the cause that contains so much profound interest? What did the Greeks do, the lordly and classical Greeks with their superb interpretative power? They developed within their own group of islands the most benign architecture of which we have definite record. They did all of this from the well-spring of their life. They lived and did. They were not disturbed by doing this or that. They were not concerned with this or that having to stand the test of time, as to whether or not it was a fitting memorial for the Olympian Zeus or Pallas Athene. We must remember that the flow of life through the ages is one continuous process. Since we are the heirs of the Greeks and the barbarians are we not as well constituted as they were to fittingly memorialize the great man of our civilization without having to ponder the question of the test of time?

There is no such thing as the test of time in the arts. If the thing is bad it needs no time to test it and if good

the untold ages may not mar its intrinsic glory or increase its beauty. A genuine art work is eternal even after it has disappeared, its power is within the human heart and it will appear, disappear and appear again in the process of centuries.

¶ * * * * *

Once the art of architecture was so alive that all the people had a cordial and daily interest in the work of the builders. They were making fresh, simple, joyous things every day and the people rejoiced because they were given what they could feel and given it in such a way that they felt, as they practically were, part of it.

¶ * * * * *

Are you going up to * * soon? The decorations are being put in place now; soon it will be finished and ready to be occupied. In two or three weeks it should be well on toward the final touches. * * * * * *

Very cordially.

Minneapolis, Minnesota, June 17th, 1913
C. C. C., Esq., Chicago, Illinois
My dear Mr. C.:—

¶ * * * * *

What I desire is to amplify the basis on which our small field of operations is builded so that you may see the impulse behind it.

We believe that on the healthy development and stability of the Arts and Crafts rests much that the people need for the normal and natural expression of their lives.

The modern sociologist teaches that the welfare of a people and its Arts are knitted together with infinite closeness, that no line of demarkation may be drawn that would lead to other than grave disaster.

The history of the rise and fall of the Arts among the various races indicates with overwhelming evidence that a normal people develop a normal Art and that when the seeds of decadence enter into the spirit of a people, Art becomes a trival matter fit only for scorn and contumely.

So in our small way we endeavor to seek our guidance through study of the people. We believe in them. We are not afraid of the choice. As between the heart of a man and a civilization that *is*, and the thumbed-over book concerning a man and a civilization that *was* we choose the living man and the eternal new time and leave the book for the archaeologist.

We do believe in the fairness and candor and wholesomeness of the people—and desired to give them not so much what they want, as all peoples have ever been more or less inarticulate when it comes to voicing their desires —but some of the things, simply done, of which they undoubtedly dream and hope will come to pass. In some such way we may say that a child would never consciously ask for a rose, but where is the child that doesn't dream about a rose and rejoice when given one? That may sound more pictorial than real but it isn't a bit.

There is so much subjective romanticism in the average human that it should be the purpose of all of us to make it more objective, more tangible, more useful to him. What we are striving to accomplish is only a phase of a progressive movement that is in evidence in practically all the Arts excepting Architecture which is usually considered a sealed book, inviolable and not to be tampered with, by most of us who practice it. Your own building is quite alive with craftsmen engaged in this movement in the Arts, consciously or unconsciously, it doesn't matter, the impelling desire is the same. The people are awakening to the fact that some of their ideals are coming true. They are going to have arts that are representative of them, not of antiquity. It will be a fine and fair day for the country when all the Arts and all the Crafts come really home to us and to remain with us.

¶ * * * * * Sincerely yours.

November 22nd, 1912
My dear Mr. D.:— * * * * * *

You seem to be pretty thoroughly impressed with what the idea of a living and indigenous architecture may mean.

You know that of all the Fine Arts, the Art of Architecture alone presents itself to view these days as something complete, in the sense that no creative imagination is required to fittingly design any modern building, a structure whose nature is quite different from anything that ever occurred before.

This belief is so general, it is hard to combat and we find it difficult to so place the reality of what Architecture fundamentally means before people who are led to conceive that all things Architectural have been finished these hundreds of years.

We would be amused at the painter who spent all of his life copying old masters and letting the flowering prairies of America go unpainted. We would be amused at the musician who conceived that the early music masters wrote all there is to write of music. So with the sculptor who would spend all his life studying antiques.

But the other Fine Arts are saved to us, in painting, by such men as Winslow Homer, Whistler, Millet, Sorolla; in music, by Brahms, Bschaikowski, Elgar, Debussey, and a brilliant host of others; sculpture by such men as Rodin, Munier and Borglum.

In literature our best men live and write to interpret our lives in their works. In literature copying is left to the student and no one takes such work more seriously than a work of prepration, but the man who copies a Roman Temple or a Gothic Church sets it forth as a serious and final statement in the Art of Architecture. Well, you know all that just as well as we do. The point I want to emphasize is that we as a people must start somewhere and simply, cleanly, practically and beautifully to develop an architecture in which future generations may rejoice. While we build as archaeologists and not as architects we shall not give much pleasure for those who are to come after.

¶ * * * * * Yours very truly.

December 13th, 1912
My dear Mr. S.:—

I am aware of the fact that you have an interest in the arts. I have no wish to approach your understanding merely on that basis; but on the simpler basis of real human optimism not specially in regard to architecture

but to the field of activity of which architecture is a manifestation.

We have no intention of doing anything specifically to your bank, that is not the problem, to be quite free and candid.

The fundamental proposition is what your building as a problem demands itself from its interpreters.

Every building whether cabin or palace is inviolate in the virtue of its own integrity as a function seeking a form. We are not operating on the building; the reverse is the truth. It is not what we say or anybody else says, it is what your proposed building says and says persistently—"I am an American Banking Institution."

What one expects a bank to appear like is entirely out of the question. It is what the bank itself desires to look like. How are we to suspect that an American bank wants to look like a Greek temple? Every genuine art work throughout our earth represents in its form color, texture or bloom the desire behind that form to appear true to itself, from that vantage point to look abroad the world of living things.

That is why the Sistine Madonna, the Angelus, or Turner's Venice look as they do; why Giotto's Campanile looks as it does; why Paestum looks as it does; why the tomb of the Moguls looks as it does; why all the noble human interpretations look as they do.

How in simple reason can we surmise that an American bank has no soul of its own seeking expression, or by what mental process are we going to ignore the deep fundamental principle underlying true art and say our building has no soul, and to believe that whether we clothe it as a Greek temple or a Roman temple makes no difference. Well, poor little bank! We believe we represent a philosophy that is wide enough to include a bank with a human being, with a picture, with a statue, with a steel bridge, with an automobile or any fittingly executed work of the artist or artisan. We do not differentiate because there is no room to differentiate.

Whether the work is beautiful or not is of no special consequence. The cathedral builders never thought of beauty. They thought not so much of what they were doing, I fancy, but *how* they did it was the burden of their daily toil.

¶ * * * * *

To appeal to the beautiful from merely the sensuous is not part of the true workman's belief. But we do contend that the man who genuinely cares for a rose, a gentian or field flower, has these blossoms within his heart, the spirt behind the flowers ministers to him; to this gift of the Great Spirit to man we gladly appeal.

¶ * * * * *

Yours very truly.

June 4th, 1912

My dear Mr. P.:—

Let me give you a little "picture" of a very significant event connected with the success of a capable young architect; a friend and co-worker in the architectural movement with which I have put you in touch—look over the enclosed. That tells the material facts.

[Referring to Walter Burley Griffen and his winning of the competition for the Australian Capital City of Canberra.]

What is *not* told in the accompanying article, however, can be best told by comparing this winning plan with the winning plan in the last great world competition among architects—that for the New University of California in 1900, won by M. Benard, the foremost architect of France. M. Benard's plan (and most of the 110 others submitted) concerned itself with the real situation, lay of the land, possibilities of the site and demands of the University only in the most casual and unreal way. It was admittedly impossible of realization. It demanded that the entire topography of the tract be reformed to suit the esthetic formulae imposed by the designer. The enormous cost of such a proceeding was prohibitive. Its merits were approved by a body of experts in design, who reviewed the "plans" very much as one would consider an Oriental carpet; with reference to composition, line, "color," disposition of masses, control of pattern, technique of presentation, style and monumental character; an academic decision based on a system of values predetermined from thousands of former "school competitions" and abstract design problems, and without relation to the real values existing for this particular problem, by reason of the Man and Nature elements which it contained.

¶ In short Benard's plan was a finality, its goal was within itself. :: ::

Mr. Griffen's achievement is the complete reverse of this process, as was also the method of review. In the enormous area to be developed the amount of regrading that will be required is practically nil! The solution seizes every natural situation *as it really exists*, and uses it as it *is!* The arrangement of the parts of the plan, instead of being determined as *spots* in "monumental (word has come to have a special technical meaning when used with architectural plan presentations) planning" are located with reference to a most accurate understanding of *alive* cities as they *are.* Their transportation, play grounds, housing, health and public service problems as they have been studied and developed for ten years were known factors in Mr. Griffen's mind, and determined the plan adjustments with such scientific precision that the plan as it stands is practically as much alive as if it represented an existing city that had actually grown up under an enlightened democratic government.

¶ In contrast with that of Benard, Griffen's plan is but a means —with the city *to be* as goal. ::

Mr. Griffen is one of the two or three younger men who have been thoroughly trained for the new movement in architecture, and who have kept carefully and thoughtfully to the work in hand, refusing to be led aside by novelty, desire to be original, or personal egotism. He has worked hard, and struck uncompromisingly to his ideals, in the face of repeated discouragements, and richly deserves this recognition of his abilities.

Yours very truly.

My dear Mr. A.:—

We were very much interested in your letter telling about your visit to the bank at Owatonna.

Sullivan's work goes more thoroughly into the relations between needs, materials, methods, cost and their general effect on the result so that it is impossible in a letter to more than suggest answers to your very pertinent questions. The "Craftsman" article, of which I wrote you, will give you the clearest idea of what the Owatonna Bank stands for. I will only add that the commercial idea behind this kind of work is efficiency. Briefly, the round sum to be spent should be apportioned so that space, use, materials, labor, advertising qualities obtained, and probable life of the structure—so that these often conflicting elements shall be made to play into the hands of one another.

You will note that in connection with the Owatonna work a good deal is said about "form and function" and that the one is determined by the other. "Function" concerns not only the way the materials are put together—the "architectural" part of the building, but it also means the "practical" workings of any building, the machinery (architectural) for making a building serve its purpose. The functions (uses—requirements) determine the form of a building.

This means that the architect of a successful building is really not a designer, an originator—but an organizer, a discoverer, one who tries to find something that already exist (i.e. to find the building that is already determined by certain hard and fast conditions.)

But more important, it means that when an architect ignores or fails to meet a single practical, useful demand that the building makes upon him, he not only hurts the usefulness of the building but he injures its beauty as well. You cannot sacrifice a practical requirement of any sort to beauty because it is these elements of use *that are* the beauty. Unless the various utilities and needs cause the resulting form and appearance—why is a church different from a court house? Consider for intasnce, a modern sleeping-car—a modern automobile a—steel bridge—each a beautiful thing, not "designed" but envolved by hard and fast conditions. I imgaine that the idea of utility, not interfering with beauty sounds strange coming from an architect.

There is the idea that lies behind the Owatonna bank and upon which we base our work. There is no attempt to be original, no idea of launching a new idea or theory —but merely to apply to Architecture exactly the same sort of cause and effect reasoning by which one conducts a banking or manufacturing business.

Yours very truly.

Dear Mr. G.:—

Do you recall the two or three lines of quotation lettered in one of the gallery rail panels in W's.—studio? I did not know where they came from, but last night I ran across them. The immediate context gives the idea even more significantly and as for the entire poem, you will recognize Kipling's "McAndrew's Hymn;" it ought to be recognized as the architect's poem. I am going to stick up these two verses anyway where I can see them.

> "—an' at the last says he:
> 'Mister McAndrews, don't you think steam
> spoils romance at sea?
> Damned ijjit! I'd been doon that morn to
> see what ailed the throws,
> Manholin', on my back—the cranks three
> inches from my nose.
> Romance! Those first-class passengers they
> like it very well,
> Printed and bound in little books; but
> why don't poets tell?
> I'm sick of all their quirks an' turns—
> the loves an' doves they dream—
> Lord, send a man like Robbie Burns to
> sing the Song o' Steam!
>
> My seven thousand horse-power here. Eh,
> Lord! They're grand—they're grand!
> Uplift am I? When first in store the
> new-made beasties stood,
> Were Ye cast down that breathed the Word
> declarin' all things good?
> No so! O' that warld-liftin' joy no
> after-fall could vex,
> Ye've left a glimmer still to cheer the
> Man—the Arrtifex!
> That holds, in spite o' knock and scale,
> o' friction, waste an' slip,
> An' by that light—now, mark my word—
> we'll build the Perfect Ship."

How is that for 1894? Only one year after the Transportation Building first stood forth to face the patent plaster facade of the Italian Temple dedicated to Ben Franklin's genius.

Where are we going to find a few architects who can realize that a building is no less a building because it runs around on wheels or scoots through the sky? A building doesn't have to have an architect's name attached to it to be great architecture, and we ought to be able to persuade some architects that a Pullman Sleeper is really vital architecture even if up to the present time no firm of architects has been given the opportunity to put a Colonial porch on each end or insert a couple of Palladian niches to balance up with the wash room windows and make a really symmetrical facade. (May be a car hasn't any facade [¿] I never saw a rendering of one.)

Yours.

FOLLOWING ARE VARIOUS SELECTIONS FROM THE SCRAP-BOOK RELATING TO THE MATERIAL IN THE LETTERS ABOVE:

"Burckhardt even puts the question in his fine work on the Italian Renaissance—'Why did the Italian architects look back at Rome, and not at Greece? For Roman architecture showed a weakness, when it did not apply the pilaster and the column in a purely constructive manner, as the Greeks did, but put them, cut through entirely or half way, against the wall by way of ornamentation, without the least endeavor to find an aesthetic solution for the ornament of the capital (column head).

"It was this, which made Goethe exclaim: 'Have a care not to use the column in an improper way; its nature

is to stand free; woe betide those who have riveted its slender form on to heavy walls.'

"And Hegel, in his 'Aesthetical Considerations,' analyzes this mistake even more keenly, by saying, that split pillars are simply repulsively ugly, because in them, two distinctly opposite intentions are put into juxtaposition without any intrinsic necessity, for merging them into one another. How much weaker, therefore, was an architecture doomed to become, which after a lapse of a thousand years, tried to revive an architectural scheme, that itself had been so weak."

H. P. Berlage, "Western Architect," March, 1912.

"As for the architecture, the architect must rise to the demands and possibilities of the hour. The dominant Americanism shines forth in many of the older tall buildings despite the drapery of dead forms of the Old World architecture with which they are covered.

"Because a sensible Greek or Goth made a thing of beauty of a waterspout by carving it into a lion's head or a gargoyle, must America forever have copies of these strewn over her buildings? The poverty of imagination and inspiration with which some of our architects have responded to the Gift of time in The sky-scraper is pitiable. *Long have they been learning that art is not something apart, but is the caress of an inspiring imagination to the work of the hour.*

"In the future the tall buildings will, no doubt, continue to maintain their supremacy in scientific safety and convenience, and when interest revives in the heigth record, after a period of rest, no doubt they will go higher still in the form of towers. Now that the scientific side of their development is highly perfected, one *may* naturally *expect* to see *an effort to make* them marvels of art as well as of scientific construction.

"To achieve this, the architect must give way to the engineer or *must once again gain* the common touch, must know processes and products, the vital energies, the laboratory, even the dust of the trades as did Phidias, Angelo and Leonardo da Vinci.

"Then may be expressed the posibilities, the aspiration, the genius of his period, and the transplanted architecture of Europe will appear exotic, and America come into the heritage of Time and of the Ages,—American Art—virile, true, fundamental as the life processes of the nation, characteristic as the glories of her predecessors in the pageant of history.

Then will the tall buildings of the future take place not only among the world's greatest feats of engineering, but *become* also worthy monuments of the life of their time, become works of art and take rank with the greatest architecture of the past." Mr. David H. Ray, Sc.D., Chief Engineer Bureau of Buildings and Consulting Engineer in New York City.

Professor Schumacher, of Dresden, expresses himself in an interesting article as follows: "The kernel of modern ideas concerning architecture is, to replace this kind of style architecture by a quest after a reality style, which tries to derive its beauty from the purely realistic, practical solution of the problem, as much as possible; from the manner in which one shapes and groups, and not in which one ornaments and decorates. And so it would be an intrinsic lie when one tried to cover modern buildings with an idealistic cloak; and it would not be a sign of culture when one should clothe these structures artistically in order to give them an agreeable aspect. Many an important work has doubtless been originated from a kernel of practical necessity, framed in a certain style; but this means would never work with purely practical buildings, which, by the influence of social conditions, were pushed to the forefront of the building industry. In such, the meager remnants of a style, developed for other objects, became a caricature."

So this architect, too, arrives at the conviction that especially in architecture a tendency toward being "business like" makes it appearance, exactly as, generally speaking, the really modern element in art is circumspection. This does not sound artistic either, and may lead the layman to believe that formerly architecture might perhaps, have been counted among the arts, but that with such a tendency, this is no longer the case.

And yet it is just the reverse; for architecture was not business-like when she copied the ancient forms, whilst the return to the business-like is the very condition for its development into a great art. Moreover, does this tendency in architecture accord with the general intellectual movement of our time—that of organization?

¶ * * * * *

And, after all, this same business-like element in the spiritual movement has loftier intentions than simply of satisfying necessities, so that not alone, is this matter-of-factness, this circumspection in art, not inartistic, but it represents a closely related loftier intention.

H. P. Berlage, Western Architect, March, 1912.

 :: :: :: :: :: :: BUT IF I STAND BEFORE IT VIBRATING AT SIGHT OF ITS COLOR AND FORMS, IF EVER SO LITTLE AND FOR EVER SO SHORT A TIME, UNHAUNTED BY ANY DEFINITE PRACTICAL THOUGHT OR IMPULSE—TO THAT EXTENT AND FOR THAT MOMENT IT HAS STOLEN ME AWAY OUT OF MYSELF AND PUT ITSELF THERE INSTEAD; HAS LINKED ME TO THE UNIVERSAL BY MAKING ME FORGET THE INDIVIDUAL IN ME, AND FOR THAT MOMENT, AND ONLY WHILE THAT MOMENT LASTS, IT IS TO ME A WORK OF ART. :: :: :: :: :: SO ART IS THAT WHICH HEARD, READ, LOOKED ON, WHILE PRODUCING NO DIRECTIVE IMPULSE, WARMS ME WITH UNCONSCIOUS VIBRATION. :: :: :: BUT . . . WHAT IS THE ESSENTIAL QUALITY THAT GIVES TO ART THE POWER OF EXCITING THIS UNCONSCIOUS VIBRATION, THIS IMPERSONAL EMOTION? IT HAS BEEN CALLED BEAUTY! AN AWKWARD WORD—A PERPETUAL BEGGING OF THE QUESTION; TOO CURRENT IN USE, TOO AMBIGUOUS ALTOGETHER; NOW TOO NARROW, NOW TOO WIDE—A WORD, IN FACT, TOO GLIB TO KNOW AT ALL WHAT IT MEANS. . . . BUT THIS ESSENTIAL QUALITY OF ART HAS ALSO, AND MORE HAPPILY, BEEN CALLED RHYTHM. AND WHAT IS RHYTHM IF NOT THAT MYSTERIOUS HARMONY BETWEEN PART AND PART, AND PART AND WHOLE, WHICH GIVES WHAT IS CALLED LIFE, THAT EXACT PROPORTION, THE MYSTERY OF WHICH IS BEST GRASPED IN OBSERVING HOW LIFE LEAVES AN ANIMATE CREATURE WHEN THE ESSENTIAL RELATION OF PART TO WHOLE HAS BEEN SUFFICIENTLY DISTURBED. THIS . . . IS SURELY WHAT THE WESTERN WORLD HAS BEEN REDISCOVERING. THERE HAS CREPT INTO OUR MINDS ONCE MORE THE FEELING THAT THE UNIVERSE IS ALL OF A PIECE. EQUIPOISE SUPREME; AND ALL THINGS EQUALLY WONDERFUL AND MYSTERIOUS AND VALUABLE. WE HAVE BEGUN, IN FACT, TO HAVE A GLIMMERING OF THE ARTIST'S CREED, THAT NOTHING MAY WE DESPISE OR NEGLECT— . . .
JOHN GALSWORTHY

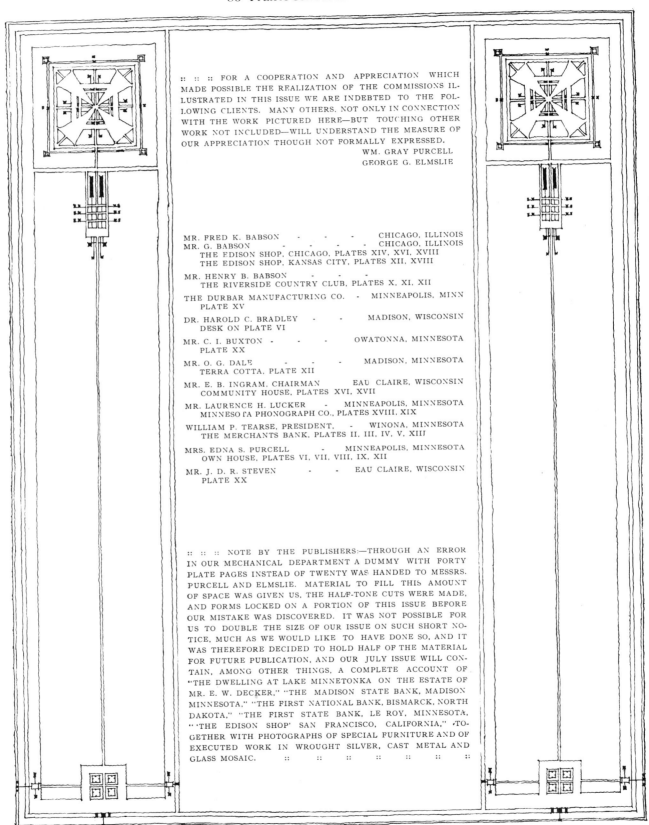

:: :: :: FOR A COOPERATION AND APPRECIATION WHICH MADE POSSIBLE THE REALIZATION OF THE COMMISSIONS IL- LUSTRATED IN THIS ISSUE WE ARE INDEBTED TO THE FOL- LOWING CLIENTS. MANY OTHERS, NOT ONLY IN CONNECTION WITH THE WORK PICTURED HERE—BUT TOUCHING OTHER WORK NOT INCLUDED—WILL UNDERSTAND THE MEASURE OF OUR APPRECIATION THOUGH NOT FORMALLY EXPRESSED.

WM. GRAY PURCELL
GEORGE G. ELMSLIE

MR. FRED K. BABSON - - - CHICAGO, ILLINOIS
MR. G. BABSON - - - CHICAGO, ILLINOIS
 THE EDISON SHOP, CHICAGO, PLATES XIV, XVI, XVIII
 THE EDISON SHOP, KANSAS CITY, PLATES XII, XVIII

MR. HENRY B. BABSON - - -
 THE RIVERSIDE COUNTRY CLUB, PLATES X, XI, XII

THE DURBAR MANUFACTURING CO. - MINNEAPOLIS, MINN
 PLATE XV

DR. HAROLD C. BRADLEY - - MADISON, WISCONSIN
 DESK ON PLATE VI

MR. C. I. BUXTON - - - OWATONNA, MINNESOTA
 PLATE XX

MR. O. G. DALE - - - MADISON, MINNESOTA
 TERRA COTTA, PLATE XII

MR. E. B. INGRAM, CHAIRMAN EAU CLAIRE, WISCONSIN
 COMMUNITY HOUSE, PLATES XVI, XVII

MR. LAURENCE H. LUCKER - MINNEAPOLIS, MINNESOTA
 MINNESOTA PHONOGRAPH CO., PLATES XVIII, XIX

WILLIAM P. TEARSE, PRESIDENT, - WINONA, MINNESOTA
 THE MERCHANTS BANK, PLATES II, III, IV, V, XIII

MRS. EDNA S. PURCELL - MINNEAPOLIS, MINNESOTA
 OWN HOUSE, PLATES VI, VII, VIII, IX, XII

MR. J. D. R. STEVEN - - EAU CLAIRE, WISCONSIN
 PLATE XX

:: :: :: NOTE BY THE PUBLISHERS:—THROUGH AN ERROR IN OUR MECHANICAL DEPARTMENT A DUMMY WITH FORTY PLATE PAGES INSTEAD OF TWENTY WAS HANDED TO MESSRS. PURCELL AND ELMSLIE. MATERIAL TO FILL THIS AMOUNT OF SPACE WAS GIVEN US, THE HALF-TONE CUTS WERE MADE, AND FORMS LOCKED ON A PORTION OF THIS ISSUE BEFORE OUR MISTAKE WAS DISCOVERED. IT WAS NOT POSSIBLE FOR US TO DOUBLE THE SIZE OF OUR ISSUE ON SUCH SHORT NO- TICE, MUCH AS WE WOULD LIKE TO HAVE DONE SO, AND IT WAS THEREFORE DECIDED TO HOLD HALF OF THE MATERIAL FOR FUTURE PUBLICATION, AND OUR JULY ISSUE WILL CON- TAIN, AMONG OTHER THINGS, A COMPLETE ACCOUNT OF "THE DWELLING AT LAKE MINNETONKA ON THE ESTATE OF MR. E. W. DECKER," "THE MADISON STATE BANK, MADISON MINNESOTA," "THE FIRST NATIONAL BANK, BISMARCK, NORTH DAKOTA," "THE FIRST STATE BANK, LE ROY, MINNESOTA, "'THE EDISON SHOP' SAN FRANCISCO, CALIFORNIA," ·TO- GETHER WITH PHOTOGRAPHS OF SPECIAL FURNITURE AND OF EXECUTED WORK IN WROUGHT SILVER, CAST METAL AND GLASS MOSAIC. :: :: :: :: :: :: ::

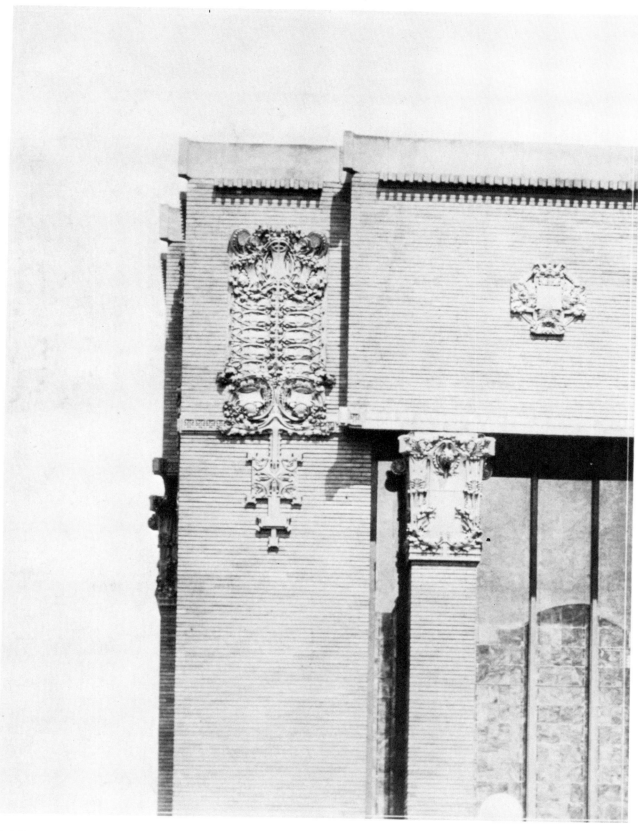

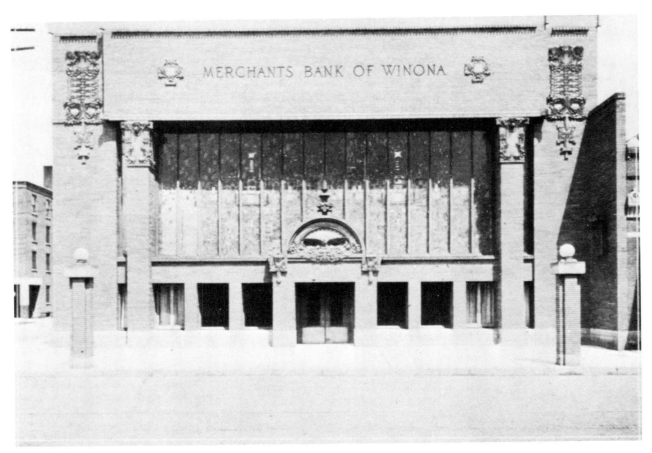

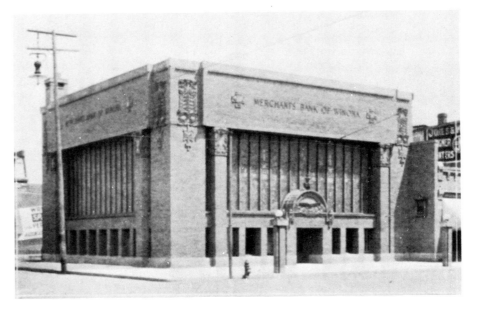

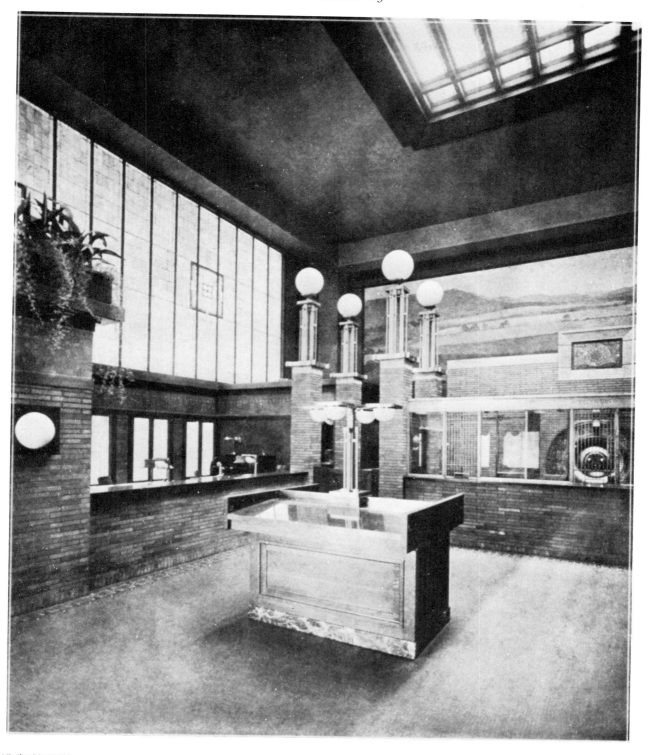

:: :: :: "THINGS MUST NOT HAVE THE APPEARANCE OF BEING BROUGHT TOGETHER BY CHANCE OR FOR A PUR-
POSE, BUT MUST HAVE A NECESSARY AND INEVITABLE CONNECTION. I DESIRE THAT THE CREATIONS WHICH I DE-
PICT SHALL HAVE THE AIR OF BEING DEDICATED TO THEIR SITUATION, SO THAT ONE COULD NOT IMAGINE THAT
THEY WOULD DREAM OF BEING ANYTHING ELSE THAN WHAT THEY ARE. A WORK OF ART OUGHT TO BE ALL ONE
PIECE, AND THE MEN AND THINGS IN IT SHOULD ALWAYS BE THERE FOR A REASON. IT WERE BETTER THAT
THINGS WEAKLY SAID SHOULD NOT BE SAID AT ALL, BECAUSE IN THE FORMER CASE THEY ARE ONLY AS IT WERE
DEFLOURED AND SPOILED. BEAUTY DOES NOT CONSIST SO MUCH IN THE THINGS REPRESENTED, AS IN THE

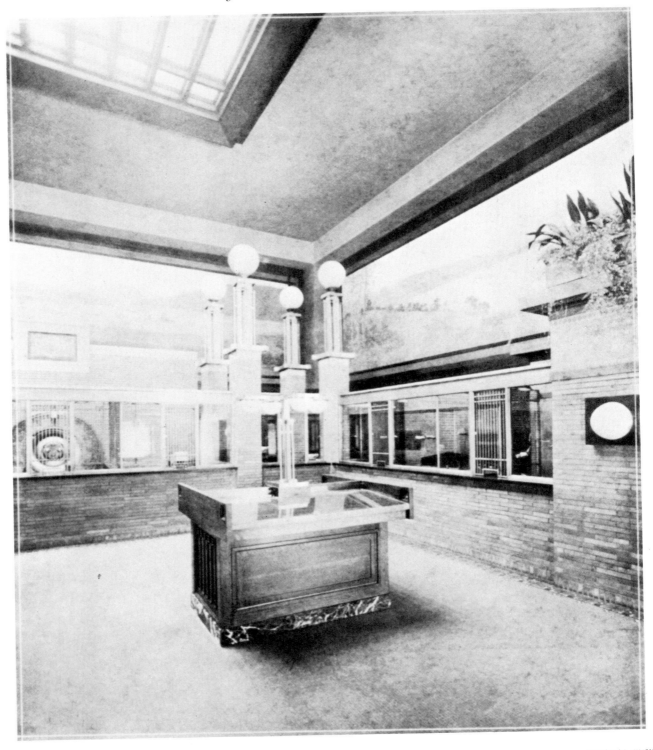

NEED ONE HAS HAD OF EXPRESSING THEM; AND THIS NEED IT IS WHICH CREATES THE DEGREE OF FORCE WITH WHICH ONE ACQUITS ONESELF OF THE WORK. ONE MAY SAY THAT EVERYTHING IS BEAUTIFUL PROVIDED THE THING TURNS UP IN ITS PROPER TIME AND ITS OWN PLACE; AND CONTRARIWISE THAT NOTHING CAN BE BEAUTI-FUL, ARRIVING INAPPROPRIATELY. LET APOLLO BE APOLLO, AND SOCRATES SOCRATES. WHICH IS THE MOST BEAUTIFUL, A STRAIGHT TREE OR A CROOKED TREE? WHICHEVER IS THE MOST IN PLACE. THIS THEN IS MY CONCLUSION. THE BEAUTIFUL IS THAT WHICH IS IN PLACE." JEAN FRANCOIS MILLET, LETTER TO PELLO-QUET :: :: :: :: :: :: :: :: :: :: :: :: :: :: :: :: :: ::

PLATE
FIVE

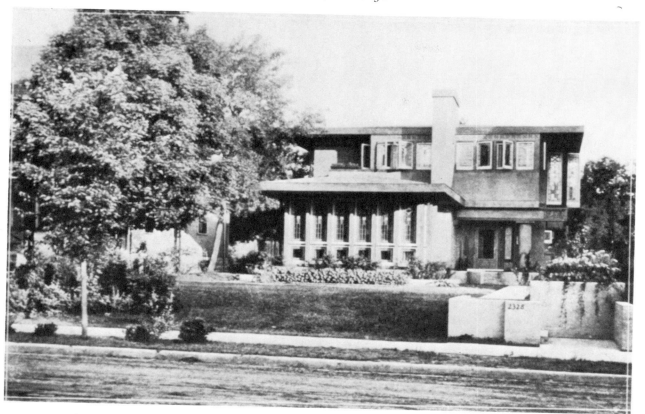

:: :: :: :: :: "ONLY THAT IS SPIRIT-
UAL, WHICH MAKES ITS OWN FORM; ART
ONLY BEGINS WHERE INITIATION ENDS."
OSCAR WILDE. :: :: :: :: :: :: :: :: ::

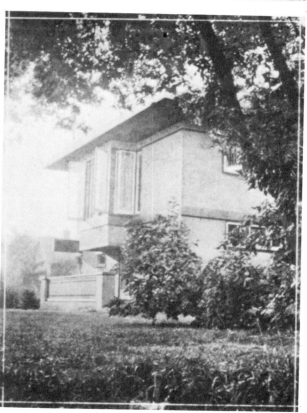

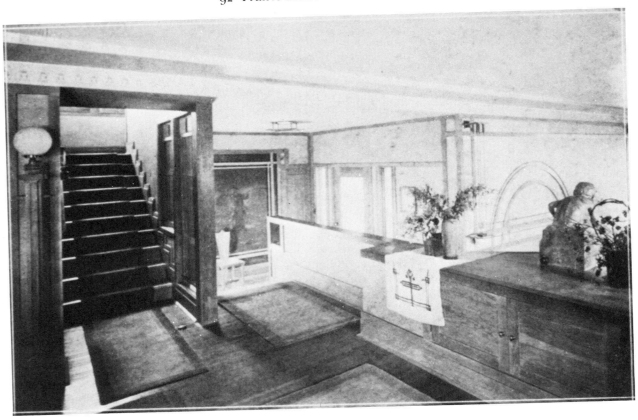

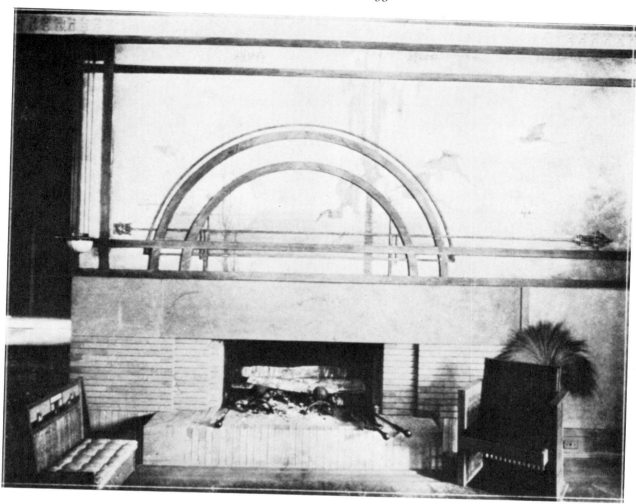

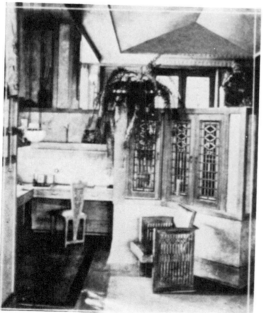

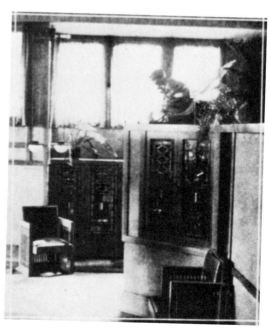

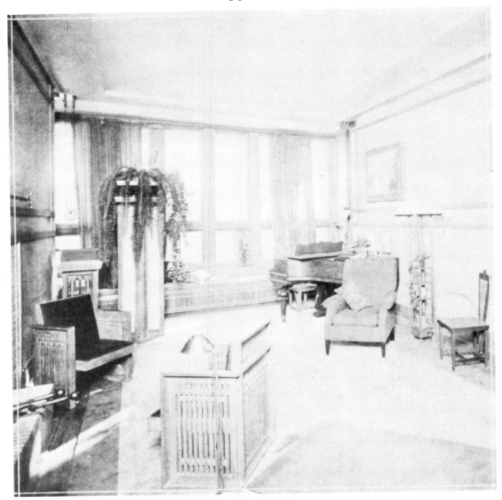

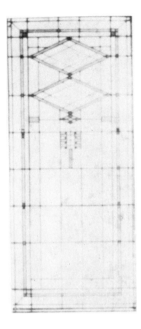

:: :: :: " NEED BEING AT THE ROOT OF THINGS, AT THE OTHER POLE WE FIND FASHION AND CUSTOM *·* *, [WITHOUT NEED] ART DE-GENERATES INTO MANNER-ISM,—YE LACK BELIEF, BE-LIEF IN THE NECESSITY OF WHAT YE DO! NOT YE WISE MEN THEREFORE ARE THE TRUE INVENTORS, BUT THE FOLK, (AND BY THE FOLK I MEAN) THE EPITOME OF ALL THOSE WHO FEEL A COM-MON AND COLLECTIVE NEED." RICHARD WAGNER, FROM A LETTER DISCUSSING THE FUNDAMENTALS OF MU-SIC. :: :: :: :: ::

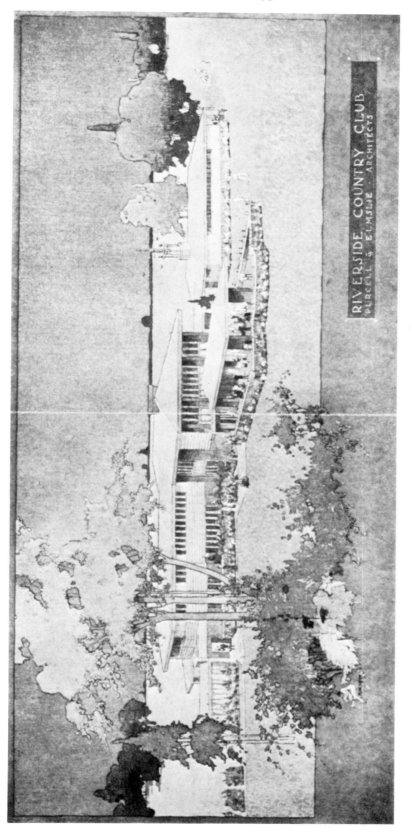

RIVERSIDE COUNTRY CLUB
PURCELL & ELMSLIE ARCHITECTS

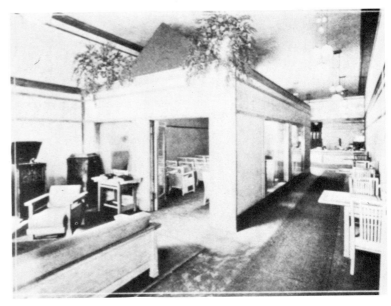

:: :: :: THE DETAIL AT THE LEFT IS PHOTOGRAPHED FROM THE CLAY MODEL, THE TERRA COTTA ITSELF IS IN POLYCHROME. :: :: ANOTHER INTERIOR OF THE EDISON SHOP SHOWN ON THIS PAGE WILL BE FOUND ON PLATE EIGHTEEN. :: :: THE PLAN BELOW IS THAT OF THE CLUB HOUSE, ILLUSTRATED ON THE PRECEDING PAGE. :: :: THE INTERIOR AT THE RIGHT IS A DETAIL OF THE ROOM ILLUSTRATED ON PLATE NINE.

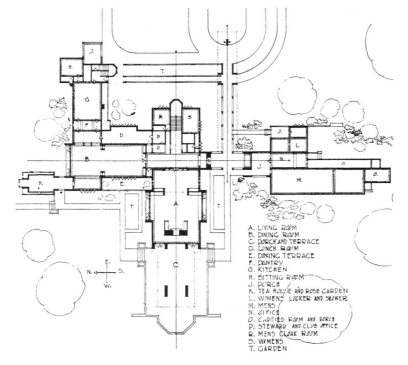

A. LIVING ROOM
B. DINING ROOM
C. PORCH AND TERRACE
D. LUNCH ROOM
E. DINING TERRACE
F. PANTRY
G. KITCHEN
H. SITTING ROOM
J. PORCH
K. TEA HOUSE AND ROSE GARDEN
L. WOMENS LOCKER AND SHOWER
M. MENS
N. OFFICE
O. CADDIES ROOM AND PORCH
P. STEWARD AND CLUB OFFICE
R. MENS CLOAK ROOM
S. WOMENS
T. GARDEN

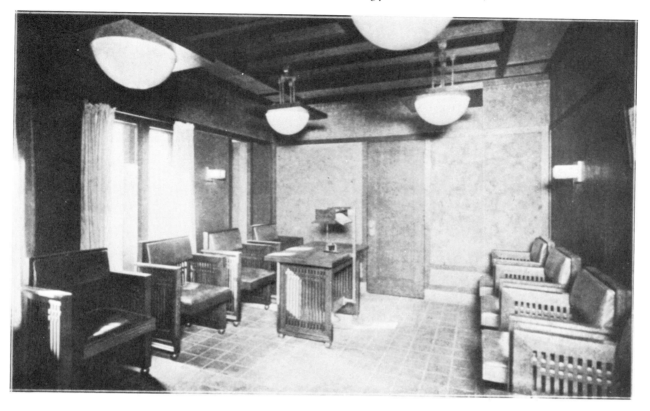

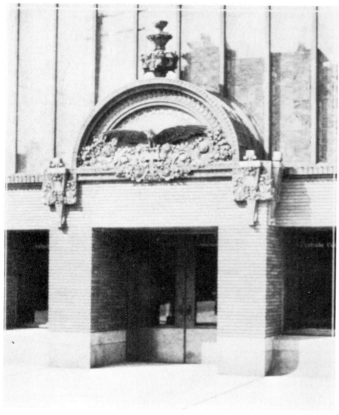

:: :: :: THEN THERE ARE A VAST NUMBER OF PEOPLE WHO DO NOT DISTINGUISH BETWEEN "GREEK" AND "CLASSICAL." BY "CLASSICS" THEY UNDERSTAND CERTAIN TYRANNOUS CONVENTIONS AND STILTED AFFECTATIONS AGAINST WHICH EVERY FREE-MINDED SOUL LONGS TO REBEL. THEY DISTINGUISH THE CLASSICAL ELEMENT IN MILTON AND KEATS AS RESPONSIBLE FOR ALL THAT IS DULL AND FAR-FETCHED AND UNNATURAL. CLASSICISM REPELS MANY PEOPLE OF EXCELLENT TASTE, AND GREEK ART IS APT TO FALL UNDER THE SAME CONDEMNATION. IT IS ONLY IN THE LAST GENERATION THAT SCHOLARS HAVE BEEN ABLE TO DISTINGUISH BETWEEN THE TRUE GREEK AND THE FALSE MIST OF CLASSICISM WHICH SURROUNDS IT. TILL THEN EVERYBODY HAD TO LOOK AT THE GREEKS THROUGH ROMAN AND RENAISSANCE SPECTACLES, CONFOUNDING PALLAS WITH MINERVA AND THINKING OF GREEK ART AS REPRESENTED BY THE APOLLO BELVEDERE AND THE LAOCOON. WE ARE NOW ABLE, THANKS TO THE LABORS OF SCHOLARS AND ARCHAEOLOGISTS, TO SEE THE GREEKS AS THEY WERE, PERFECTLY DIRECT, SIMPLE, NATURAL AND REASONABLE, QUITE AS ANTAGONISTIC TO CLASSICISM AS MANET AND DEBUSSY THEMSELVES. "THE GLORY THAT WAS GREECE". J. C. STOBART :: :: :: :: :: :: :: THE ILLUSTRATIONS ON THIS PAGE ARE FURTHER DETAILS OF THE MERCHANTS BANK ILLUSTRATED ON PLATES II, III, IV AND V. :: ::

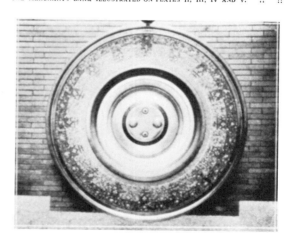

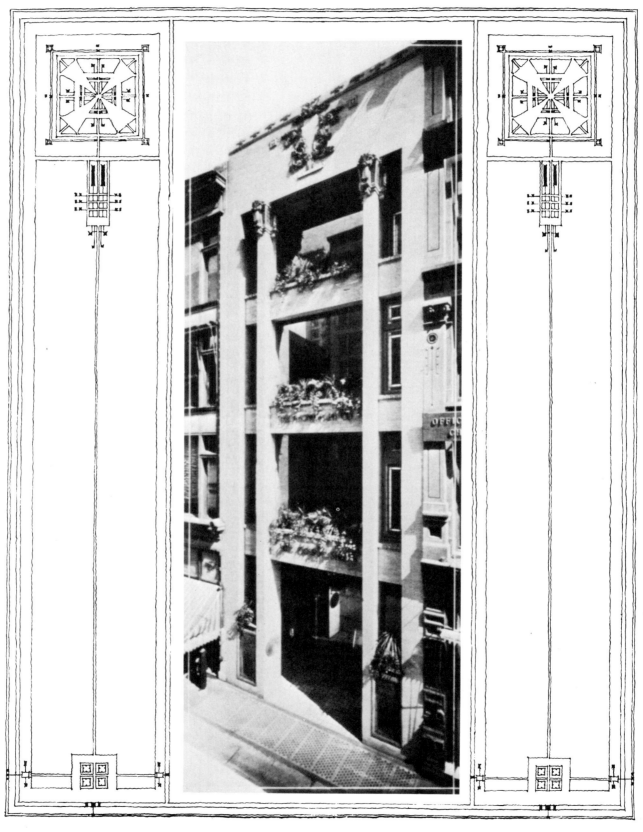

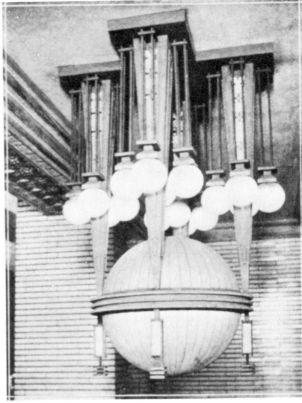

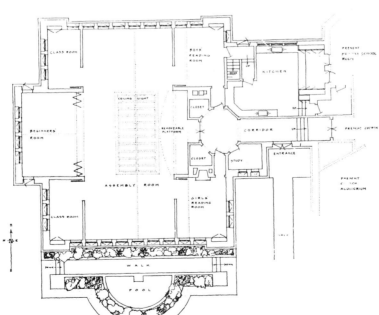

:: :: :: "MEN OFTEN ASK ABOUT THE NEW ARCHITECTURE, WHAT AND OF WHAT SORT IT IS GOING TO BE. BUT TO SUCH A QUESTION THERE CAN BE NO ANSWER TILL A NEW UNDERSTANDING OF LIFE HAS ENTERED INTO PEO PLE'S MINDS, AND THEN THE ANSWER WILL BE CLEAR ENOUGH. FOR AS THE GREEK TEMPLES AND THE GOTHIC CATHEDRALS WERE BUILT BY PEOPLE WHO THEMSELVES LIVED BUT FRUGALLY AS WE SHOULD THINK, AND WERE READY TO DEDICATE THEIR BEST WORK AND CHIEF TREASURE TO THE GODS AND COMMON LIFE; AND AS TODAY WHEN WE MUST NEEDS HAVE FOR OURSELVES SPACIOUS AND LUXURIOUS VILLAS, WE SEEM UNABLE TO DESIGN A DECENT CHURCH OR PUBLIC BUILDING; SO IT WILL NOT BE TILL WE ONCE MORE FIND OUR MAIN INTEREST AND

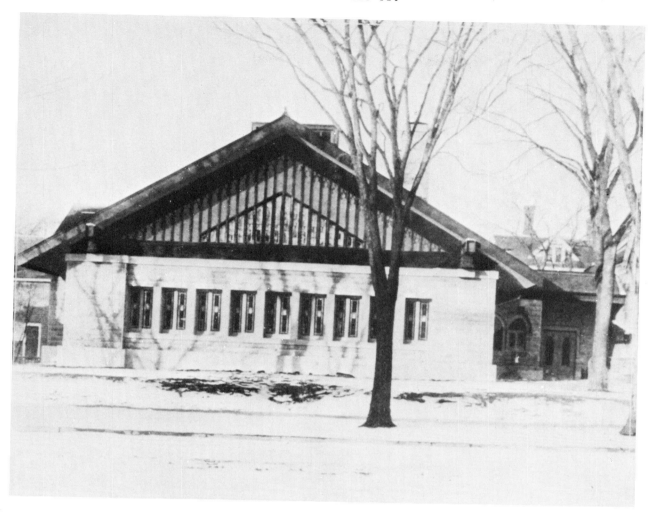

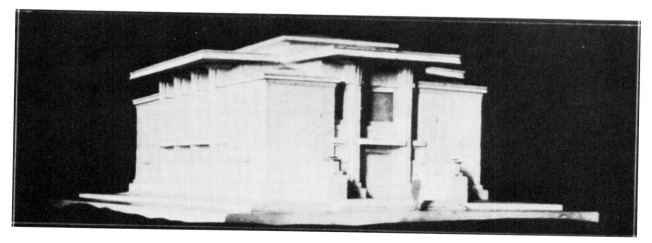

LIFE IN THE LIFE OF THE COMMUNITY AND THE GODS THAT A NEW SPIRIT WILL INSPIRE OUR ARCHITECTURE. THEN
WHEN OUR TEMPLES AND COMMON HALLS ARE NOT DESIGNED TO GLORIFY AN INDIVIDUAL ARCHITECT OR PATRON,
BUT ARE BUILT FOR THE USE OF FREE MEN AND WOMEN, TO FRONT THE SKY AND THE SEA AND THE SUN, TO SPRING
OUT OF THE EARTH, COMPANIONABLE WITH THE TREES AND THE ROCKS, NOT ALIEN IN SPIRIT FROM THE SUNLIT GLOB
ITSELF OR DEPTH OF THE STARRY NIGHT—THEN I SAY THEIR FORM AND STRUCTURE WILL QUICKLY DETERMINE THEM-
SELVES, AND MAN WILL HAVE NO DIFFICULTY IN MAKING THEM BEAUTIFUL * * * * AND GIVING THEM FORM BY A LAW
UNFOLDING FROM WITHIN."—EDWARD CARPENTER "CIVILIZATION, ITS CAUSE AND ITS CURE," WRITTEN IN 1889. :: ::

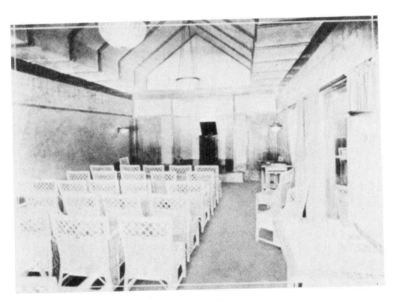

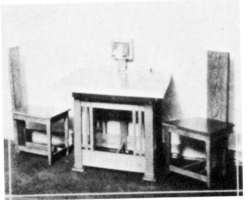

:: :: :: THE ENGINEER WHO DOES NOT EXPRESS HIS WORK IN A LIVING ART-FORM, BUT REGARDS ONLY COST AND MATERIAL, SPEAKS TO ALL MANKIND WITHOUT SYMPATHY FOR THEM; ON THE OTHER HAND THE ARCHITECT'S POINT OF VIEW REMAINS INCOMPREHENSIBLE TO EVERY ONE WHEN IN CREATING HIS ART-FORM HE DOES NOT LET IT ARISE FROM CONSTRUCTION. BOTH ARE IN GREAT ERROR. THE ART-FORM MUST BE ALWAYS DEVELOPED FROM THE CONSTRUCTION WHERE IT LIES PERFECT BUT CONCEALED. THE FUNDUMENTAL CONCEPTION OF THE ARCHI-TECTURAL WORKS OF OUR TIME MUST CHANGE; AND WE CAN COMFORT OURSELVES WITH THE ASSURANCE THAT THE ONLY FOUNDATION FOR OUR FUTURE ARCHITECTURAL CREATIONS IS TO BE SECURED SOLELY THROUGH AN

PLATE
EIGHTEEN

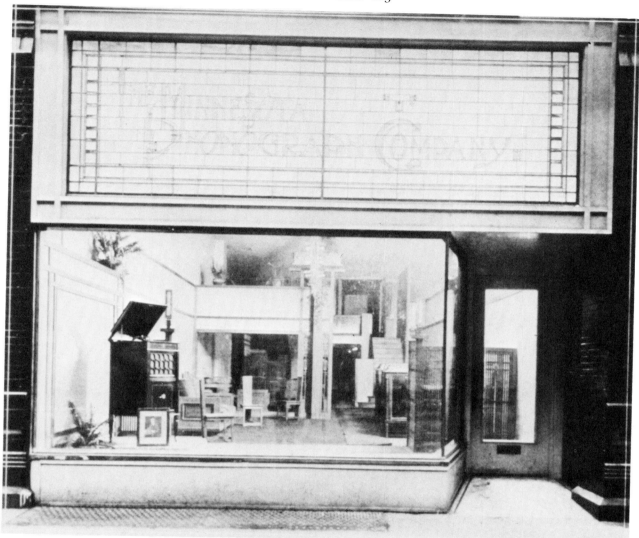

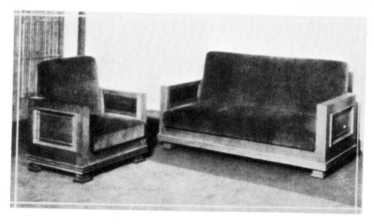

INTUITIVE UNDERSTANDING OF MODERN LIFE AS IT IS. * * * IT IS IMPOSSIBLE FOR ART TO GO ON IN THE BROADLY TRAMPLED OUT AND WORN DOWN ROADWAY OF THE "COPY". NO! WITH RIGHTEOUS PURPOSE ART MUST WORK OUT FOR ITSELF A CONCEPTION OF BEAUTY FIT TO SURVIVE IN THIS SCIENTIFICALLY CRITICAL AGE WHERE THE FORCE AND WEIGHT OF REASON AND LOGIC ARE GIVEN FULL VALUE. THROUGH THE IMPULSE OF MODERN ARCHITECTURE, "TRADITION" HAS REGAINED ITS TRUE VALUE, CASTING OFF ITS FICTITIOUS VALUE; ARCHAEOLOGY HAS SETTLED DOWN TO BE A SCIENTIFIC LANDMARK OF ART ONLY, WHICH WE HOPE IT WILL PERMANENTLY REMAIN. OTTO WAGNER, 1902, WAGNER-SCHULE, VIENNA. :: :: :: :: :: :: :: :: :: :: :: :: ::

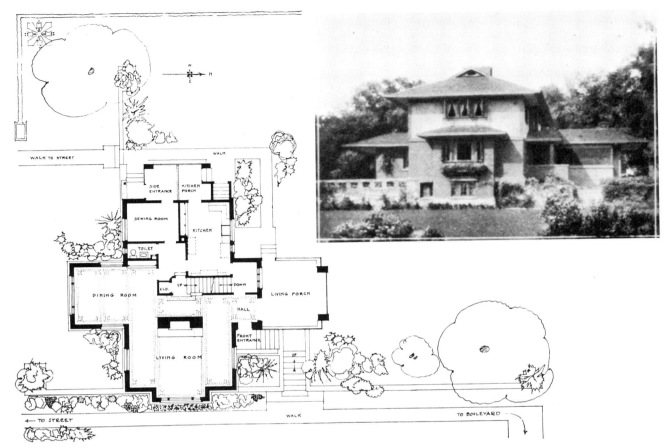

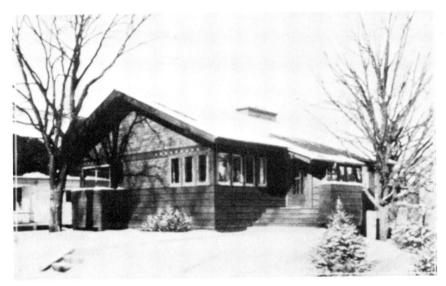

:: :: :: " THE TROUBLE WITH YOU, MY DEAR BRIM, IS, I SAY, (ON PAPER, AFTERWARDS, AS THE TRAIN SPEEDS AWAY), THAT YOU HAVE A FALSE-CLASSIC OR STUCCO-GREEK MIND. THE GREEKS, THE REAL GREEKS, WOULD HAVE LIKED ALL THESE THINGS—TROLLEY CARS, CABLES, LOCOMOTIVES,—SEEN THE BEAUTIFUL IN THEM, IF THEY HAD TO DO THEIR LIVING WITH THEM EVERY DAY, THE WAY WE DO. YOU WOULD SAY YOU WERE MORE GREEK THAN I AM, BUT WHEN ONE THINKS OF IT, YOU ARE JUST GOING AROUND LIKING THE THINGS THE GREEKS LIKED 3000 YEARS AGO, AND I AM AROUND LIKING THE THINGS A GREEK WOULD LIKE NOW, THAT IS, AS WELL AS I CAN. I DON'T FLATTER MYSELF I BEGIN TO ENJOY THE WAY PLATO WOULD IF HE HAD THE CHANCE, AND ALCIBIADES IN AN AUTOMOBILE WOULD GET A GREAT DEAL MORE OUT OF IT, I SUSPECT, THAN ANYONE I HAVE SEEN IN ONE, SO FAR; AND I SUSPECT THAT IF SOCRATES COULD TAKE BLISS CAR-MAN AND, SAY, WILLIAM WATSON AROUND WITH HIM ON A TOUR OF THE GENERAL ELECTRIC WORKS IN SCHENECTADY THEY WOULDN'T EITHER OF THEM WRITE SONNETS ABOUT ANYTHING ELSE FOR THE REST OF THEIR NATURAL LIVES."—GERALD STANLEY LEE "THE VOICE OF THE MACHINES" (WRITTEN ABOUT 1905) :: :: :: :: :: :: :: :: :: :: :: :: :: :: :: ::

MADISON STATE BANK ::
MADISON, MINNESOTA ::

THE WESTERN ARCHITECT
PAGE 4 :: JULY, 1915

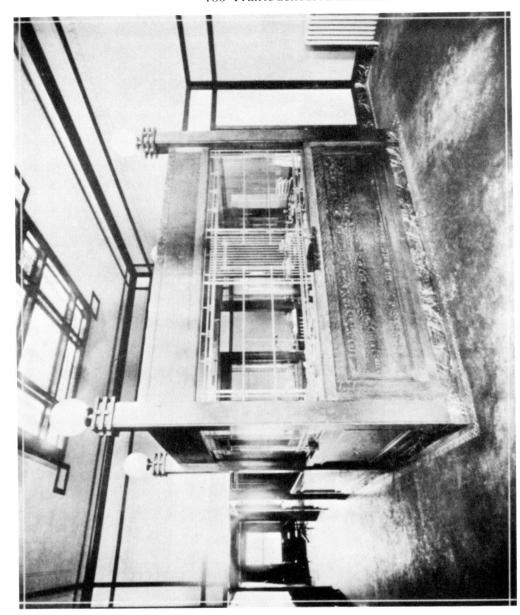

MADISON STATE BANK ::
MADISON. MINNESOTA ::

THE WESTERN ARCHITECT
PAGE 5 :: JULY, 1915

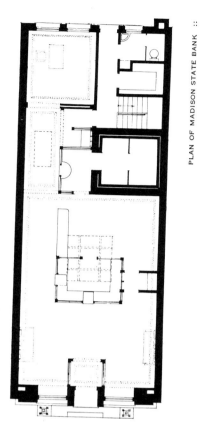

PLAN OF MADISON STATE BANK ::

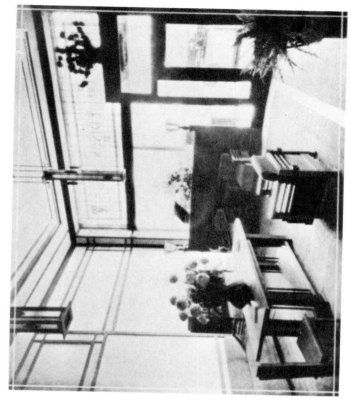

:: :: THE EDISON SHOP
SAN FRANCISCO, CALIFORNIA

:: THE WESTERN ARCHITECT
:: PAGE 6 :: JULY, 1915

:: MADISON ■ MINNESOTA

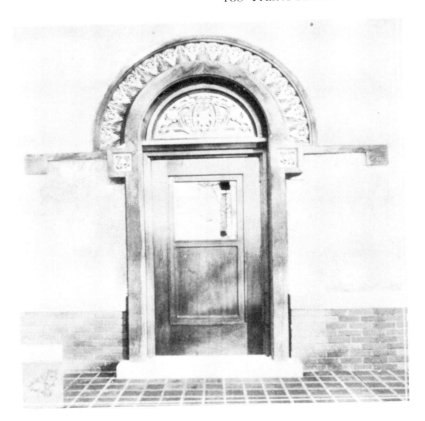

 DOORWAY, PARKER DWELLING
PRESIDENT ANGEL LOVING CUP
THE WESTERN ARCHITECT ::
PAGE 7 :: JULY, 1915 ::

DWELLING FOR MR. HARRY S. PARKER
MINNEAPOLIS, MINNESOTA :: ::

THE WESTERN ARCHITECT :: ::
PAGE 8 :: :: :: JULY, 1915

MAHOGANY CLOCK
FOR MR. HENRY B. BABSON, RIVERSIDE, ILLINOIS
THE WESTERN ARCHITECT
PAGE 9 :: JULY, 1915

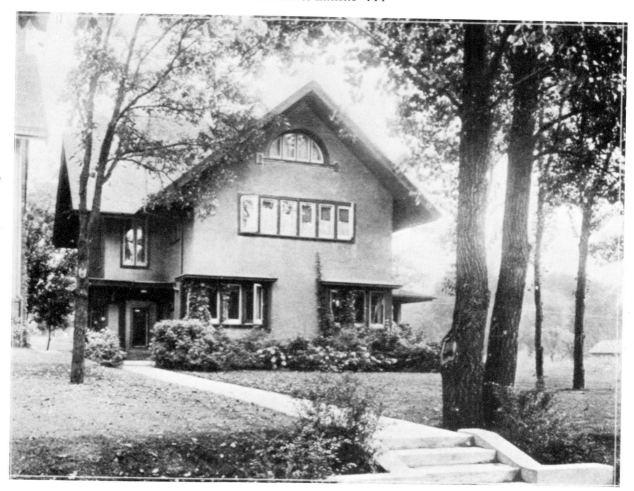

DWELLING FOR DR. WARD BEEBE
SUMMIT AVENUE :: ::
ST. PAUL, MINNESOTA ::
BELOW SIDE VIEW OF SAME ::

THE WESTERN ARCHITECT
PAGE 10
JULY, 1915

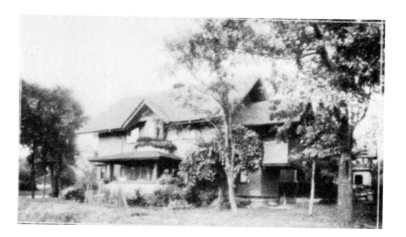

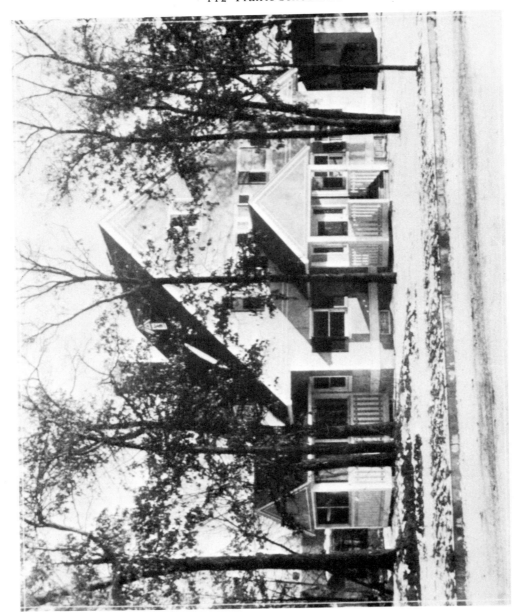

PARSONAGE :: ::
FIRST CONGREGATIONAL CHURCH :: :: ::
EAU CLAIRE, WISCONSIN :: :: ::

THE WESTERN ARCHITECT, PAGE 11 JULY, 1915

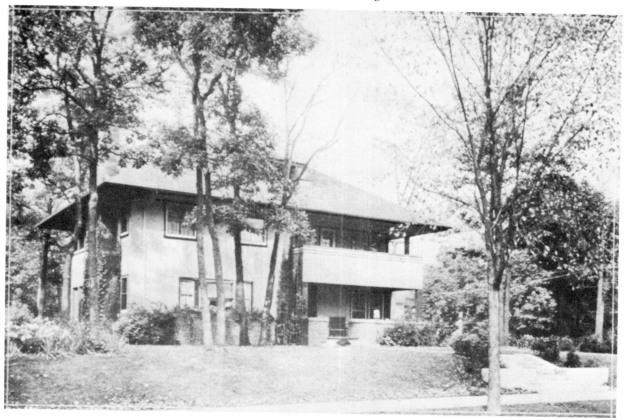

LYMAN E. WAKEFIELD DWELLING
MINNEAPOLIS, MINNESOTA ::

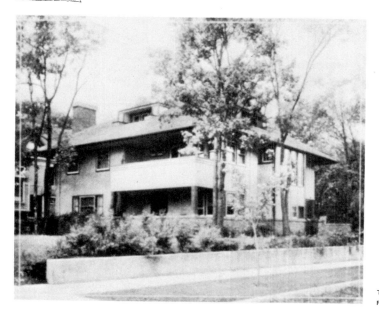

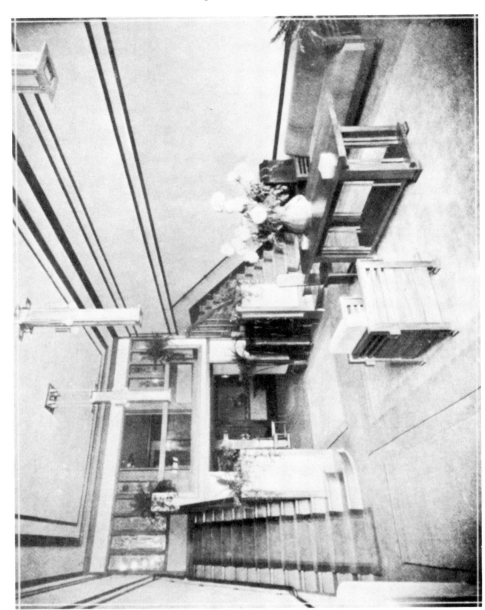

THE EDISON SHOP :: :: ::
SAN FRANCISCO, CALIFORNIA

THE WESTERN ARCHITECT ::
PLATE 1 :: JULY 1915 ::

SEASHORE BUNGALOW FOR MRS. HAROLD C. BRADLEY
VIEW FROM MAIN HOUSE :: :: :: :: :: ::
CRANE ESTATE, WOODS HOLE, MASSACHUSETTS :: ::

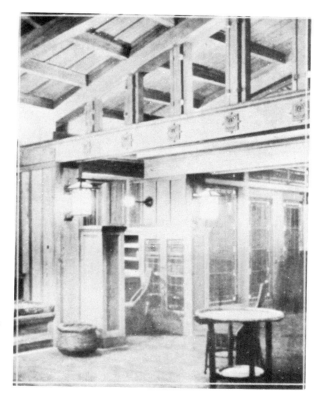

BRADLEY BUNGALOW :: ::
INTERIOR OF LIVING ROOM

:: :: BRADLEY BUNGALOW
VIEW LOOKING NORTHEAST

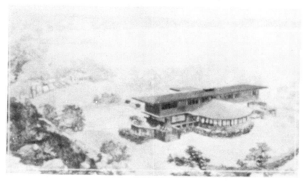

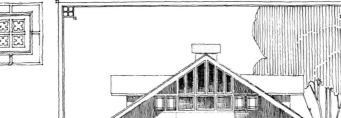

DWELLING FOR :: ::
MRS. T. LEWIS WALLER
SHATTUCK AVENUE
BERKELEY, CALIFORNIA

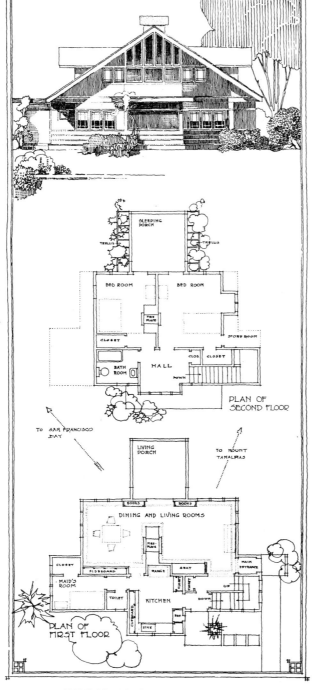

PLAN OF
SECOND FLOOR

TO SAN FRANCISCO
BAY

TO MOUNT
TAMALPAS

PLAN OF
FIRST FLOOR

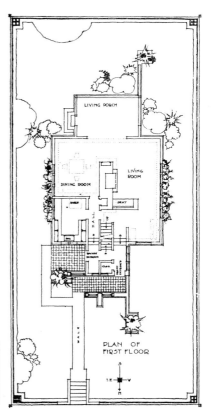

PLAN OF
FIRST FLOOR

THE PLAN TO THE RIGHT IS THAT FOR
THE RALPH D. THOMAS DWELLING ::
MINNEAPOLIS, MINNESOTA :: ::

THE WESTERN ARCHITECT :: ::
PLATE 3 :: :: :: JULY, 1915

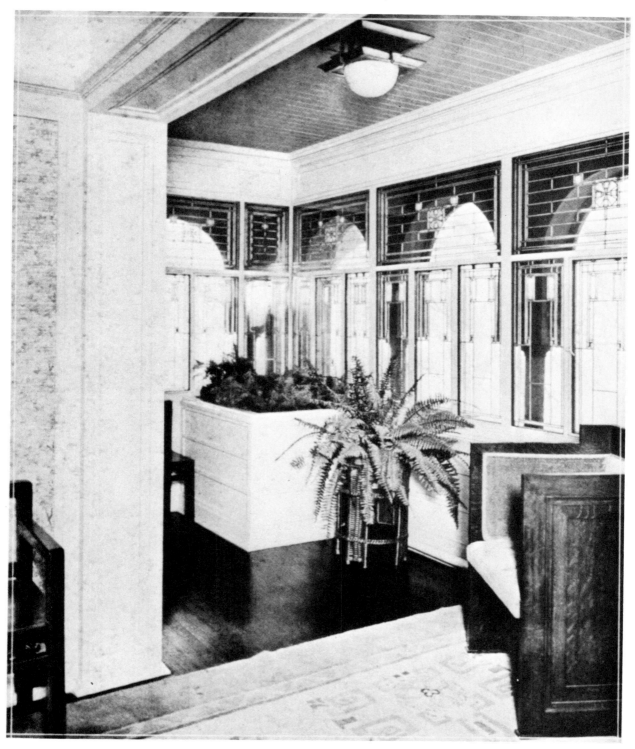

SITTING ROOM BALCONY
FOR MR. HENRY B. BABSON
RIVERSIDE, ILLINOIS ::

THE WESTERN ARCHITECT
PLATE 4 :: JULY, 1915

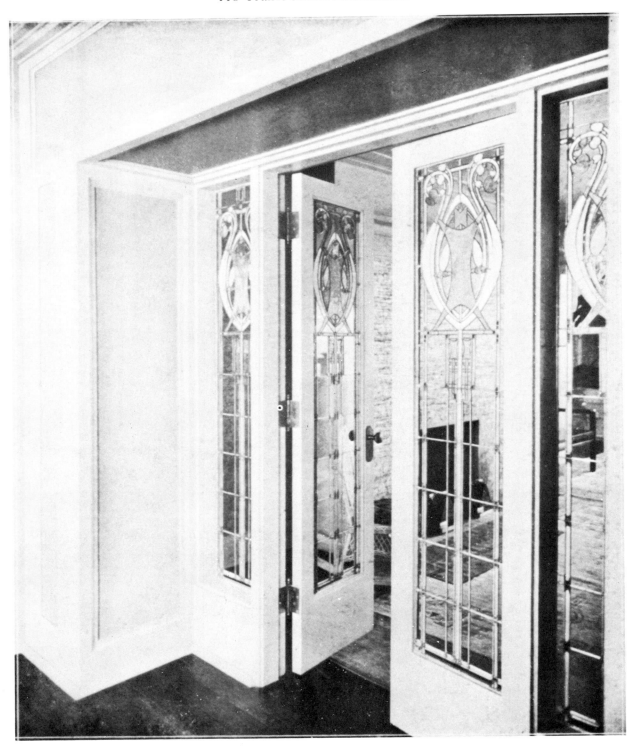

SITTING ROOM DOORS ::
FOR HENRY B. BABSON ::
RIVERSIDE, ILLINOIS ::

THE WESTERN ARCHITECT
PLATE 5 :: JULY, 1915

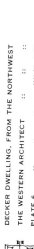

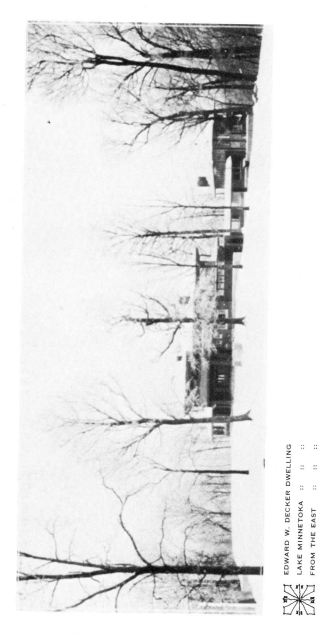

EDWARD W. DECKER DWELLING :: :: ::

LAKE MINNETOKA :: :: :: ::

FROM THE EAST

DECKER DWELLING, FROM THE NORTHWEST

THE WESTERN ARCHITECT :: :: ::

PLATE 6 :: :: :: JULY. 1915

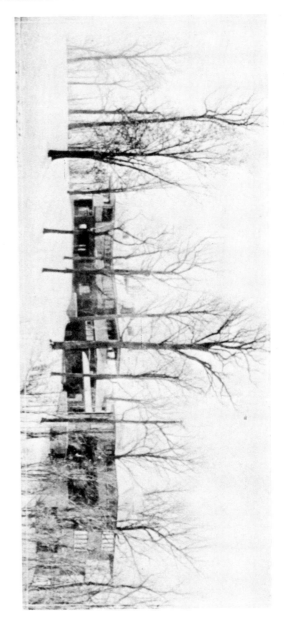

EDWARD W. DECKER DWELLING
LAKE MINNETONKA :: ::
FROM THE NORTHEAST ::

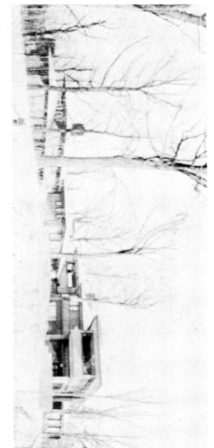

DECKER DWELLING FROM THE SOUTHWEST
THE WESTERN ARCHITECT
PLATE 7 JULY, 1915

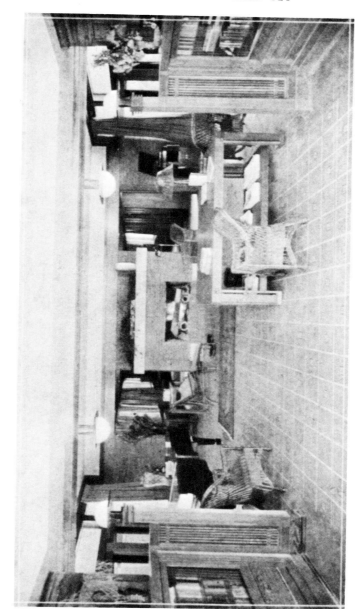

EDWARD W. DECKER DWELLING
LAKE MINNETONKA :: :: ::
LIVING ROOM :: :: :: ::

THE WESTERN ARCHITECT :: ::
PLATE 8 :: JULY, 1915 ::

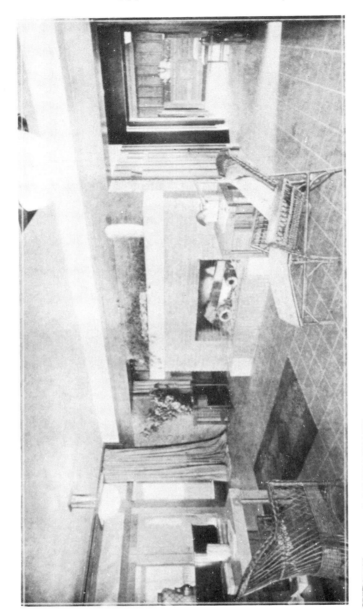

EDWARD W. DECKER DWELLING
LAKE MINNETONKA :: ::
LIVING ROOM :: :: ::

THE WESTERN ARCHITECT ::
PLATE 9 :: JULY 1915 ::

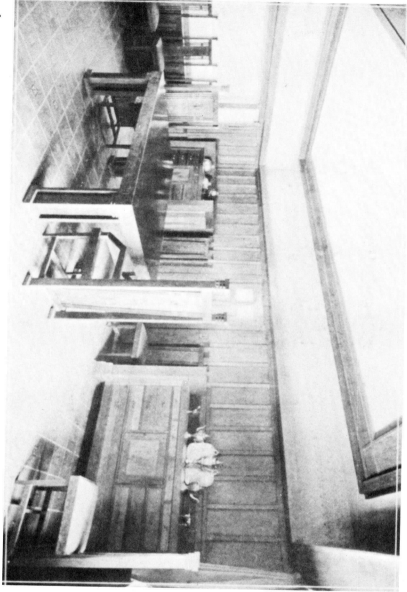

EDWARD W. DECKER DWELLING
LAKE MINNETONKA :: :: ::
DINING ROOM :: :: ::

THE WESTERN ARCHITECT ::
PLATE 10 :: :: JULY, 1915

ANDIRONS :: ::
BABSON DWELLING

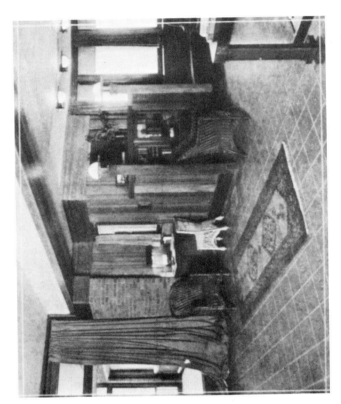

EDWARD W DECKER DWELLING
LAKE MINNETONKA :: ::
CORNER IN LIVING ROOM

THE WESTERN ARCHITECT ::
PLATE 11 :: JULY, 1915

ANDIRONS ::
BABSON DWELLING

ANDIRONS :: ::
BABSON DWELLING

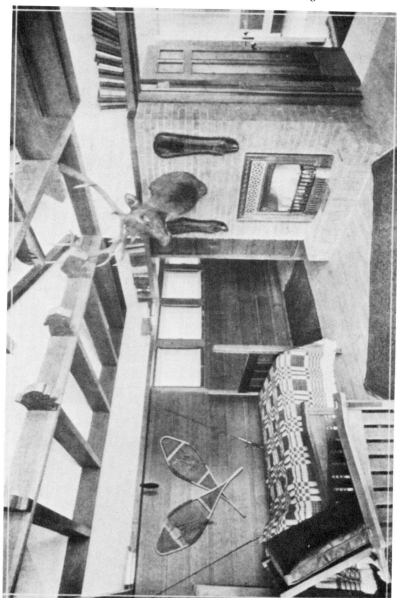

EDWARD W. DECKER DWELLING
LAKE MINNETONKA :: ::
SON'S ROOM ::

THE WESTERN ARCHITECT :: ::
PLATE 12 :: JULY, 1915

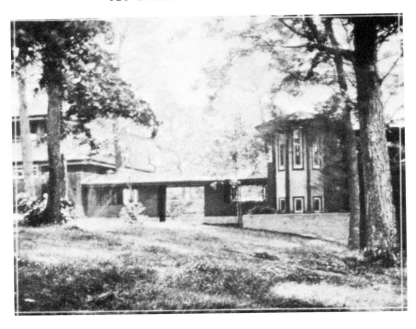

 DECKER DWELLING
LAKE MINNETONKA
GARAGE :: ::

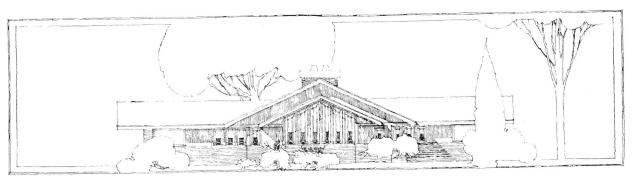

 FRANCIS BUZZELL HOUSE
LAKE BLUFF, ILLINOIS ::

THE WESTERN ARCHITECT
PLATE 13 :: JULY, 1915

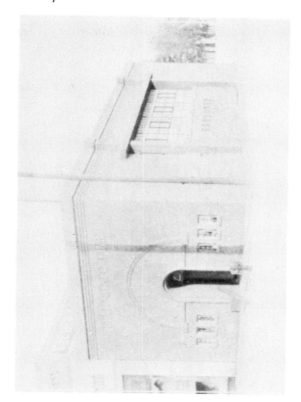

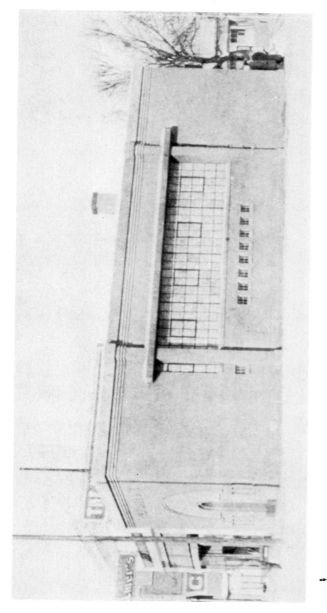

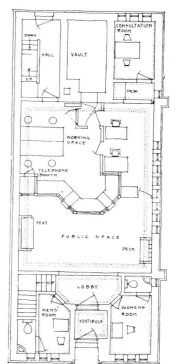

FIRST STATE BANK ::
LE ROY, MINNESOTA ::

THE WESTERN ARCHITECT
PLATE 14 :: JULY, 1915

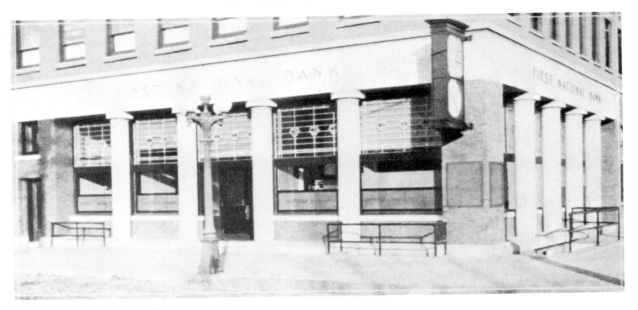

FIRST NATIONAL BANK
BISMARCK, NORTH DAKOTA

INTERIOR OF SAME BELOW

THE WESTERN ARCHITECT
PLATE 15 :: JULY, 1915

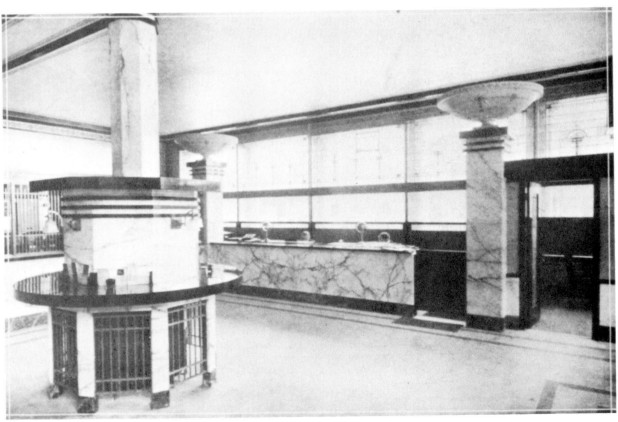

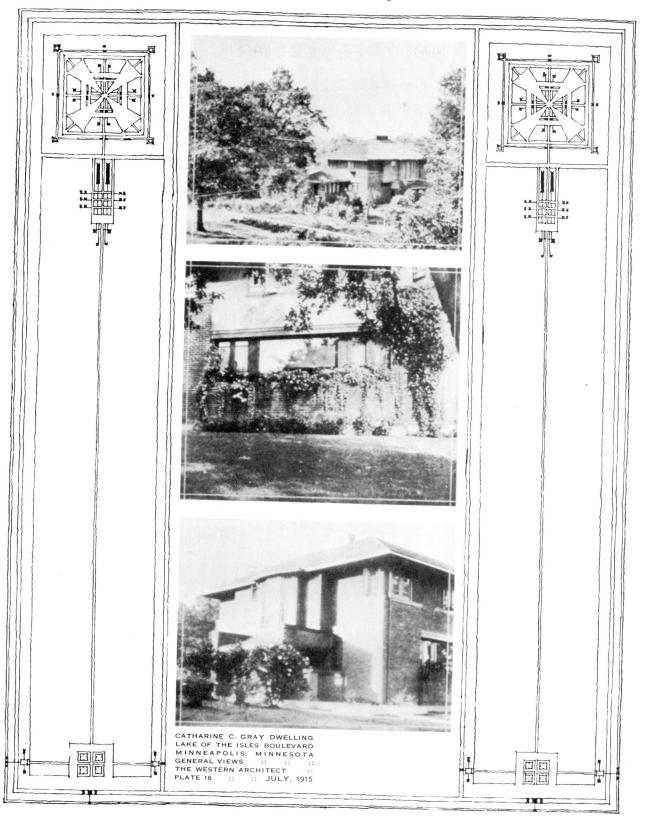

CATHARINE C. GRAY DWELLING
LAKE OF THE ISLES BOULEVARD
MINNEAPOLIS, MINNESOTA
GENERAL VIEWS :: :: ::
THE WESTERN ARCHITECT ::
PLATE 16 :: :: JULY, 1915

WOODBURY COUNTY COURT HOUSE

SIOUX CITY, IOWA

WILLIAM L. STEELE, ARCHITECT

PURCELL & ELMSLIE, ASSOC. ARCHITECTS

A public building—
Built without graft—
Built at the sacrifice of legitimate profit on the part of everybody concerned from the architect to the wielder of the final brush applied to the mural paintings!

Built in the face of a rising market by enthusiastic folks who were willing to lose money rather than spoil the job—

And some of them did lose money.

But Woodbury County, Iowa, was the gainer, and stranger still, they have a court house, as the result of the foregoing program, which is a splendid demonstration of modern common sense and architectural achievement.

February 24th, 1914, the Board of Supervisors passed a resolution to submit the question of erecting a new court house to the voters. In June of that year the vote was taken and was favorable. The next question to be settled was the site, and in September the Board of Supervisors resolved to submit that question to a vote at the general election in November. The proposition for a new site carried, but, unfortunately, only a quarter of a block was purchased. January 5th, 1915, William L. Steele, of Sioux City, a member of the American Institute of Architects, a graduate of the Architectural Department of the University of Illinois, and formerly a draftsman in the office of Louis H. Sullivan, was chosen architect. Mr. Steele immediately made arrangements with his friend, Mr. George Grant Elmslie of the firm of Purcell & Elmslie, of Chicago, for collaboration in this work. An organization was effected whereby Mr. Steele was to be executive head, Mr. Elmslie was to have charge of the planning and designing, Mr. Paul D. Cook, the structural engineering, and Mr. B. A. Broom, the mechanical engineering.

The work was soon under way and acceptance by the Board of Supervisors of preliminary sketches was secured on March 23rd, 1915. The work was carried on in the Sioux City office during the spring, summer and fall, with a large force of draftsmen. Numerous conferences were held with the supervisors and explanations of the design were made to various civic bodies. Opposition to what were felt to be radical innovations finally burst in the fall of that year, taking the shape of

heated attacks upon the Court House design in the local press and at public meetings. A thorough lack of understanding of what the Board of Suprevisors and the architects were trying to do was manifest. The lack of sound and convincing argument on the part of the opposition merely had the effect of confirming the supervisors in their conviction that they were in the right, and on December 7th, 1915, the drawings and specifications were officially accepted.

Bids on the general construction were received on February 7th, 1916 and on February 15th the contract was awarded to Splady, Albee and Smith of Minneapolis, who carried out the work in the face of difficult conditions with the utmost fidelity and in a splendid spirit of co-operation.

On July 10th, 1916, the corner stone was laid. The ceremony was presided over by the Chairman of the Board of Supervisors, Mr. E. C. Copeland. The principal address was given by Secretary of Labor W. B. Wilson. The building was finished and occupied by the County, March 1st, 1918.

Sioux City is a thriving little city of some seventy thousand inhabitants situated on the Missouri river in the northwest corner of Iowa, where the plains of South Dakota and Nebraska roll to meet the Iowa hills. It is in the center of perhaps the richest agricultural territory in the world. It has many things in common with all our hustling American cities, its peculiarities being that it has experienced both the heights and the depths of the results of our curious economic system, prosperity beyond the wildest dreams of avarice, following a zero point depression which resulted from the deflation of the "boom" of some thirty years ago. Its architecture shows the same general types as most of our middle-western cities. Here are Roman Temple banks, perforated-box warehouses, plate-glass store fronts, business-like (in varying degrees) office-buildings, busy streets congested by automobiles. One out of every six persons in Sioux City rides in a car.

When you find the Court House just north of an Uncle Sam transmogrification of the Palazzo Vecchio or the Palazzo Publico (I forget which), the Post Office; just northeast of the rock-faced Romanesque City Hall, east (across the street) from an ugly, barnlike structure dignified by the name of "Auditorium,"

Page 13

southeast from a new fireproof automobile storage building, and south from a billboard with its promise for the future that Richard Roe will build there, you are conscious of a halting of the breath and a tightening at your throat.

Serene, almost impudent it stands there. You feel a sense of illusion about its reality which leaves you presently to be followed by the feeling that the building itself is the only reality and its surroundings are the phantoms. Unconsciously you find yourself eliminating the incongruous environment and seeing the building surrounded by a kind of Elysian field from which goes up to the unclouded Iowa sky a gentle murmur that can only be caused by grown-ups happily at work, and, yes, you can hear also the sweet voices of children at play.

A fine ripple of movement plays along the west front. What classic colonnade was ever finer than this stately row of brick, (yes, brick) piers with a charming interplay of ornament, light and shadow? The entrance is at once the focal point, with the majestic Mosaic figure which can mean none other than the mighty spirit of the LAW. To him as he stands there, aged and slumbrous, but strong armed and mighty, flow the tide of human life as it exists in organized society. All types are there, the old and the young, the soldier, the laborer, the father, the mother, the mystic, the poet, the man of affairs, the gay and the irresponsible and they who have known grief. Above on the great quiet space which crowns the sequence of piers, we read, "Justice and Peace have met together. Truth has sprung out of the Earth." Amen. Let us hope, we say to that, and pass around to the north side where two great, elemental figures adorn the entrance, the man and the woman. The woman bears tenderly a little child. At once you see the connection and the symbolism. Here is the social unit, the Family, and we saw a moment ago Society as constituted under Law. Alfonso Iannelli of Park Ridge, Illinois, was the sculptor. We are impressed by the splendid spiritual quality of his work. It is elemental but not crude. It is worked out with fine dignity and restraint. It is not *applied* sculpture. It is organic and belongs in very truth to this building and nowhere else. What higher praise can be given to architectural sculpture?

We walk slowly around the building, though to do so we must traverse alleys on two sides. It is intensely interesting in its articulation and challenges our careful thought. Admiration grows as we gaze. We see a stately building of Roman brick, granite at the base and at the copings, enlivened with wonderfully modeled polychrome terra cotta, the entrance enriched with vivid mosaic and bronze doors and grilles. The windows are a study in their simple unity of scheme and interesting variation in form. Above, at a height of about sixty feet, is the sheer granite coping, and the eye rests there and follows back along the horizontal bands that terminate the lower portion of the structure, before following the fascinating appeal of the "tower." This latter impresses one as a building of glass saved from the appearance of frailness by the powerful treatment of piers and corners. The great eagle (Iannelli's work) stretching westward is emblematic of the spirit of progress which made this building possible. A little later we see on the east side of the building, great bison heads, a gentle tribute to the earlier days, these latter modeled by Schneider.

The general color tones are a rich, light brown, too deep for buff, pleasantly varied and meeting congenially the color of the granite and the unglazed, natural burned-clay color of the terra cotta. This latter has been interspersed judiciously with a rich rendering of the same material in polychrome. The colors run the gamut of the primary tones, but so deftly are they handled that the eye is conscious only of a fine brilliance in the whole texture. The windows and their frames are metal and are enameled in a vivid blue with the sash picked out in a delicate gray which has almost the value of white in contrast. The sash throughout are of the casement type and filled with leaded glass of a very open and free pattern with beautifully regulated color spots giving an excellent over all value to the building as a whole.

We are made eager by what we have seen to go inside and see what it is all about, so different is our feeling from the ordinary impression gained from looking at a public building. In the usual case, after seeing the exterior we feel that the story is told, but not so with this Sioux City building. Here we feel that the most interesting part is still to come. Before we go inside, however, let us stop a bit and in the shadow of this earnest and sincere-looking building discuss its reason for being.

For the philosophy underlying the working out of the particular problem presented by this building no extended research is necessary. It represents the fearless application of logic and common sense to the problem, and its solution in conscientious accord with the fundamental principles of art. Ancient traditions have been dealt with in respect to what they stand for and really mean. The spirit of emulation of the past is here, not the veiled "we love the classic so" that ever seems to serve as a cloak to shield the inapt and the lazy in the development of this great art of building. So it would seem to the layman.

The Court House problem here was studied in its historic unfolding and brought squarely down to date. Did space permit it would be interesting to trace the history of the administration of justice in England and

America. The Court of Common Pleas in England as a result of Magna Charta was the first step toward the establishment of the independent judiciary which we now possess. It has been the custom in this country far beyond the memory of the oldest inhabitant to provide a building in each county for the holding of court sessions and the housing of the county officials. In early days these buildings were very primitive, in many cases a log-house sufficed, or court would be held in a school house or in a church. Soon, however, a definite architectural expression of the court house began to take form along the Atlantic seaboard and the traditional "Old Colonial" court house was the result. That this sane and dignified solution of the problem, well suited to its own day and the people, has been worked overtime by later generations does not in any sense detract from the quiet dignity of the original buildings. It were well, however, to consider how highly complicated the problem, once so relatively simple, has become, and ask ourselves if the times we live in have not outgrown the old type of design.

In reviewing the past, mention should be made of the Richardsonian departure from tradition, which by sheer virility and power caused a host of imitation "Richardson" court-houses to spring up all over the east and middle-west. But the planning of these Richardsonian buildings was not especially analytical. In frankness it must be admitted that in all the years that have passed there has been little or no attempt to differentiate between the major and the minor functions to be housed within the Court House. There has been the large, very large, court room, and if the building were an expensive one, several large court rooms. In fact all the rooms were large irrespective of their use. There was the immense rotunda, with dizzily winding and much ornamented stairs, the wide, long and gloomy, marble-lined corridors, the carefully camouflaged and rarely-operated elevator, the lack of usable, well-lighted working space in the offices, the lack of ventilation and adequate toilet facilities, the absence of planning, real planning, for the plan was forced to meet the predetermined conditions of the exterior appearance. If you sought a petty official or even the janitor of the building, you were likely to find him in as capacious and highly finished an office as the most important judge on the circuit. And how often one found the trail of that slimy thing, "graft!"

In preparing for the study of the Sioux City Court House a careful survey of the available data was made. The Board of Supervisors were shown that the typical court house, which is fast becoming "standardized" in the hands of so-called specialists, is a delusion and a snare. They were convinced that the economical procedure would be to develop a plan suited as nearly as possible to the County's needs, and

let the exterior appearance grow out of the plan. Visits were made to other court houses and sketches were prepared showing the application of the so-called Classic design to the terms of Woodbury County's problem. The result was that when the preliminary sketches were finally approved the Supervisors were enthusiastic over the evidence that the Woodbury County Court House would have more actual square feet of working space for the money than any court house previously built. Upon this very practical working basis the design was developed, and most interesting and fascinating was the working out thereof. The main functions were housed in the lower part of the building and the entire available area was used. The offices most frequently sought by the general public are those of the auditor, treasurer, recorder and clerk. These four offices are placed on the main floor and are inter-communicating as well as being grouped about a commodious lobby or rotunda. Let us go in through the Seventh street entrance. We hardly pause to note the beautifully modeled terra cotta walls, the continuity of the treatment of the outer walls which passes in with us and accompanies us throughout, now as a repetition, and again as a reminiscence. We do not wait to read the bronze-framed bulletins but hurry up the steps for we have caught a vista of alluring charm.

The effect upon entering the rotunda, no matter how disagreeable the weather outdoors, is that of a delightful, radiant warmth. Photographs cannot do more than faintly suggest the glowing color. Someone's comment was: "This is like entering a spacious living room with a hospitable fire on the hearth."

The floors are a rich buff quartzite tile, the walls and piers Roman brick with great plastered spaces holding vivid mural paintings framed and enriched with delicately modeled cream terra cotta, which, in its turn, is made sparkling with colored inlays of glass mosaic. The eye travels upward, and sees wonderful terra cotta terminals of the supporting piers engaging a spreading canopy of beautifully ornamented plaster, and carrying as a great crown a wonderful glass dome designed as a great light reflector and distilling medium. The dome is lighted by clerestory windows above the main roof, and through it at all times of day comes a flood of richly tinted light.

The mural paintings, done by John W. Norton of Chicago, are especially beautiful and noteworthy. The artist has definitely applied his genius to the work to be done in this particular spot. He has preserved the sense of wall and does not lead the eye through and beyond the building. The architects took him into their confidence and told him of their dreams and

he embraced their ideas with enthusiasm. There are four great murals. Over the main entrance is the expression of the idea of the administration of justice—the primitive court. The remote Past and the ever hopeful Future join hands in this picture. Here is simple Justice, portrayed not as we often see it, invested *with* and impeded by official red tape, but without any factitious pomp and circumstance. There is a freedom and a suggestion of the great out-doors about it, while the power and strength of Law and Government are expressed by the men with *halberds* who stand guard. One of them is talking quietly with an aged advocate. Emancipated woman is there laying her cause before the judge in simple but earnest fashion. Not restricted to formal forensic oratory, she stands at his elbow and points out the passages of the Law to which she would direct the judicial attention. Everyone may make his own interpretation of these pictures, but to me the glowing orb at the back of the group is the sun of Justice and Enlightenment.

The woman standing waiting for the word of wisdom may be a prisoner or she may not. Suffice it is to say that one feels that justice and a kindly justice will be dealt out in her behalf, and that of the babe she holds. Justice herself is there, but the ancient scales are merely used as a decoration for her place of honor. She herself has discarded the old blind-fold, and using all her faculties, she brings her fine intellectual and spiritual equipment to bear upon the issue to be decided. In her hand she holds a human heart emblematic of the hopeful tendency to interpret justice as dealing with the problems of human beings and not merely their property, goods and chattels.

The colors cannot be described save by a better pen than mine. They are rich, primary colors, mostly, and handled with the utmost skill, so that the final impression is a rich, luminous effect. They are gorgeous but there is no overloading of the canvas. The grand manner is achieved by the most simple means. The small panels in the advancing four corners of the balcony are plain surfaces covered with gold leaf, very satisfying to the eye and yet not prominently noticeable.

On the south wall of the balcony is the farm life of the community. Here is the air of quiet contentment, of full harvests, of happy homes. The young farmer has come up to the stable yard with his load of hay; the young mother with her child has come to the gate to tell him doubtless that dinner is ready. It is simple, with a classic beauty, and the theme continues over and into the big Court picture with two happy young people in the harvest field.

On the north is Urban Life, which, in Iowa, is free from the curse of phenomenally large cities. Here the group is out on one of the hills which are so much a feature of the local topography. The city with its tall buildings is in the distance. The human figures are grouped under a great tree. The old woman busy with her memories, has taken the child aside and sits with him dreamily. The young man and woman are frankly interested in each other. The boys are looking eagerly at the city and discussing, no doubt, their hopes and ambitions for the future. Their mother, coming up with a basket of Iowa apples pauses a moment to look at them with pardonable maternal pride and anxiety.

On the east and over the stairway is a picture suggested by the troubled time during which this Court House was built. It is a tribute to what our women and our men did in the war. On the right the spirit of the high endeavor of the soldier, on the left sacrifice and the love of the mother, the sister, the nurse. On a gold back ground are emblazoned in vivid blue the names of the great battles in which our boys had part. The selection of these names was almost prophetic because the war was on when the picture was painted, and no one knew whether or no a still further list of historic names would be enrolled. But the Armistice was signed before the picture was put on the wall, and the record stands approved.

Passing into the offices on the main floor we note the county clerk or the clerk of the court on the northwest corner of the building. The clerk is required by law to maintain his office at the county seat, "to attend the sessions of the district court either in person or by deputy and to keep the records and papers of each case, record the proceedings of the court." He shall have, and does have in this building, spacious quarters, and ample vault room for storage of the important documents mentioned. He is constantly obliged to hunt up references for the attorneys, etc., and must have a very practical filing system to facilitate the quick finding of any document. He does not need a great space for the public, but he does require a large working space, private office, cloak room, toilet, etc., and a very large storage space or vault. All of these requirements, together with the basic one of plenty of light and air, seem to be admirably met in the Sioux City court house.

Across the Seventh street entrance on the south side of the building we find the treasurer and the auditor, with the board of supervisors in the rear or east side of the building. These offices have private means of communication with each other, a great convenience, as they are closely inter-related both with relation to the general public and to each other.

Most of the people who visit the court house do so to pay taxes, secure automobile licenses, or to trans-

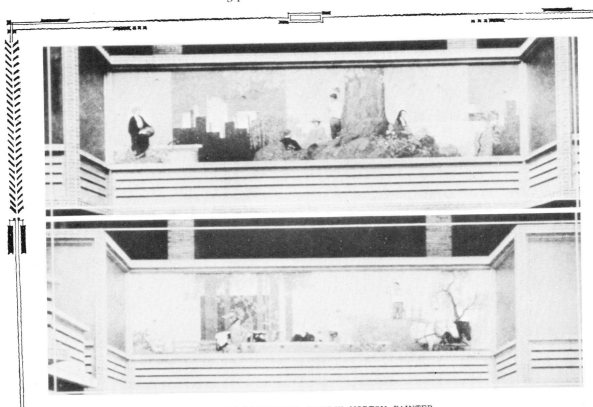

MURALS IN ROTUNDA, JOHN W. NORTON, PAINTER

FIGURE AT LEFT OF SIDE ENTRANCE FIGURE AT RIGHT OF SIDE ENTRANCE
ALFONSO IANELLI, SCULPTOR

WOODBURY COUNTY COURT HOUSE, SIOUX CITY, IOWA
WILLIAM L. STEELE, ARCHITECT ::
PURCELL AND ELMSLIE, ASSOCIATE ARCHITECTS

Page 17

THE WESTERN ARCHITECT
FEBRUARY :: 1921

act financial business. These people visit the treasurer. The county treasurer receives all money payable to the county and disburses it, but "only upon warrants signed by the auditor." Contrary to the popular notion, the treasurer does not need a large money vault, as most of the funds are held on deposit in the various banks. Some day, perhaps, when our people decide to do their own banking, the treasurer will be a real banker, and his office will require all the appurtenances of a real bank. At present, however, the main thing is to provide space for the filing of the tax books and records, working space for the clerks, and plenty of room for the accommodation of the public when they come in to pay their taxes. In this building a long counter (brick-faced with the same Roman brick we have been looking at, but marble trimmed), is provided and a large crowd can be handled. Folks come in at one large door, take a place at the counter, get a statement from a clerk, step to a desk conveniently nearby, write a check and present it at the cashier's cage, where they get a receipt and pass out at another door. Here again we note plenty of room, light and air. Unfortunately, some of the occupants of the building seem to have a desire to add to its beauty by sticking unsightly calendars, and notices on the walls, and in the treasurer's office we note that the very handsome and practical shades have been removed from the lighting fixtures.

The auditor is secretary of the board of supervisors and he must in person, or by deputy, attend all meetings of the board, keep full entries of "all its resolutions and decisions," sign all orders, keep a record of the county treasurer's reports, preserve and file all accounts acted upon by the board, issue warrants for payment by the treasurer, etc. By law he is the custodian of the court house building. He must keep account of and make reports on statistics of crime. He must keep "plats" or maps of all the property in the county, and these "must be drawn to a scale of not less than four inches to the mile." He must keep records of ditch proceedings, road and bridge maps, etc. He must have a descriptive index of all the property in the county. He is a busy official, and in a large and prosperous community he requires a small army of clerks. He needs a large work space, plenty of room for filing, and commodious means for public access to the various plat-books, maps, etc. These requirements are well taken care of here. We note the agreeable, sunshiny atmosphere. The walls are tinted a pleasant shade of light yellow. The light brown Roman brick again appears here as a wainscoting. The filing cases are metal, colored the same vivid blue which we noted outside and which follows the iron and steel work all through the building. The floors are a light terrazzo with battle ship linoleum in the working spaces. Here also are private offices with mezzanine above. The main offices on

this floor have very high ceilings and the beams and columns are treated quietly but effectively with ornamental plaster.

Passing through to the supervisors section we find two principal rooms, one for private consultation, and one for the public meetings. The latter is very effective, long, with a barrel-vaulted ceiling cut by slender ribs, lighted at the sides, and brick wainscoted with marble and metal trim. The minor conveniences of the supervisors are well taken care of.

The recorder's office fills the most of the remaining space on the main floor. Here the abstractors work, for the recorder "shall record at length and as speedily as possible all instruments in writing which may be delivered to him for record * * * in the manner directed by law." Here is a name index of all the property owners, a record of all mortgages, deeds, liens, and a generous amount of recording, filing, and storage space is required. The great vault here is open to outside light through strongly barred windows, and it seems that the county's filing needs have been taken care of for many years to come.

Crossing the rotunda to take the elevator to go upstairs we see the public information counter and public telephone booths and an inviting drinking fountain decorated in glass mosaic.

On the second floor, reached from the balcony of the rotunda are the four principal court rooms, each on one of the corners of the building, and each fully equipped with all the necessary subsidiary rooms for the judge, bailiff, attorneys, witnesses. Quarters are provided so that the jury can be comfortably housed for all night sessions in a mezzanine floor immediately above. In addition to the great windows, a large skylight is provided in each court room. In the course of time tall buildings may be built upon the adjacent property, and to guarantee light in the court rooms for all time the upper portion of the building is confined to the space directly over the rotunda. This permits the placing of a large skylight over each court room and leaves room in the rear for the develop-

ment of the jail above the sheriff's offices.

The court rooms are splendid. There is an air of dignified serenity and peace about them. The eye is soothed by the pleasant color scheme which runs from the black and gold marble, through the warm brown of the brick and the blue of the metal work to a quiet silvery gray on the seats and desks. The lighting fixtures are beautiful in their design. Free use of the "trough" system of indirect lighting is noted here as well as elsewhete in the building.

The great problem in the administration of justice nowadays seems to be to get through the heavy

dockets in time. One court room used to fill all the available court space. In the Woodbury County court house there are four standard court rooms as previously stated and with a fifth, smaller one for the Court of Equity. At the present time only three of the court rooms are used normally as there are only three judges on the "circuit." The fourth court room, by reason of its connection with the jail, is generally used for the trial of criminal cases.

An extremely sociable and pleasant feature of the old-fashioned court house was the use of the big court

room for public town meetings of all sorts. The need for such a meeting place is not so great nowadays when every town of any pretensions has its auditorium or opera house. A feature of our early democratic days, which Dickens saw and exaggerated, and which we have not entirely out-grown, was the disposition to treat a public building as public property, with a kind of good-natured disrespect. In the Sioux City court house, if the need for a public assembly hall remains, it is filled by the impressive and commodious rotunda. Several meetings have been held there with success, and the Vatican Singers from Rome sang there a years ago with thrilling effect. The court rooms provide seating accommodations for about a hundred visitors in each. This is amply sufficient in all save sensational cases, to which a great crowd of the idly or vulgarly curious is attracted. Such assemblages of people with vulture minds ought to be discouraged. Again is it not better for the attorneys to be able to make their arguments without resorting to shouting and ranting? Is it not better for the cause of justice that our legal friends be constrained into mildness, calmness, and judicial dignity in their behavior before the bench? The lighting, ventilation and acoustics of these court rooms are almost perfect.

Especial attention has been given the comfort and convenience of the jurors. They are not obliged to pass through the public space in the court rooms in going to and from their station. They are seated in comfortable, swivel chairs on a platform of easy steps so that all can see. Their backs are to the public. The witness sits facing them and also the judge, and the court reporter sits between the judge and the witness. In this way it is relatively easy to catch every word, to note its accompanying facial expression, and the jury, not seeing what is going on in the audience, is not distracted from the business of the hour. The light falls upon the face of the witness, but not into the eyes of the judge and jury.

Two assembly rooms are provided for the jurors who ordinarily must appear at the court house at a fixed time and loaf about the court room or the cor-

ridors until they find out whether or no they must go on duty. The assembly rooms afford them places where they may smoke, read or talk while they are waiting and the bailiff can readily find them when they are wanted.

The jurors' suite for each court room with consultation room, dormitory, toilet, bath, is on a mezzanine floor above the judges' and attorneys' rooms. This suite is commanded by a bailiff's room in each case. There is ample provision for toilets, both public and private, and there is a rest room for women on the court floor.

The sheriff's office is also on the court floor and contains the normal means of communication between the courts and the jail. The latter is located in the building and is self-contained with its own means of ingress and egress. It has a completely modern equipment of sanitary, steel, tool-proof, cells grouped in tiers and sections so that the segregation of the various types of prisoners may be successfully managed. The jail elevator is automatic and the outside means of communication with the jail is through the alley. There are detention cells for male, female and juvenile prisoners and a matron's room for the latter, of course thoroughly private. The jailor has a well-appointed modern apartment for his living purposes. Food for the prisoners is prepared in the jail kitchen in the basement and served by means of automatic, electric dumb waiters. There is a laundry in connection with the jail equipment.

The tower is really a little office building with elevator service, and houses the minor functions—county attorney, county engineer, superintendent of schools, court reporter, law library, etc. In these upper offices there is permanent light, ventilation, convenience, and quiet, ideal conditions for good work.

The need of providing for future growth is commonly overlooked and subsequently regretted. There are at least two floors in the "tower" of the Sioux City building which today are unassigned space. They were used to splendid advantage by the Red Cross for

work rooms during the last year of the war. One of the unassigned floors it is expected will develop into an art gallery and has so been planned.

In a building of this kind a lack of space is usually encountered for the storage of rapidly accumulating records. It is appalling to step into the basement of the average "old" court house and see the immense quantity of records stored there without adequate provision for proper filing or protection against dampness and mold. It is a prime requisite to have a good basement, and, no matter how well ventilated mechanically, to have provision, also, for

Page 19

natural ventilation by means of windows. Some day some "economical" board of supervisors may decide to cut down expenses by shutting off the fans. This condition has been met in the building we are discussing. The basement extends beyond the building lines to the street curb, is both naturally and artificially ventilated, and, besides a modern heat, light and power plant, contains some very satisfactory minor offices, janitor's quarters, etc., and a great volume of space for future storage purposes. The space is arranged so that each department may overflow its storage space into the basement as needed. For example, the clerk of the courts occupies the northwest part of the building. His office for the general public is on the first floor and here also is his great vault for the court records. His office for convenience when court is in session is on the courts, or second floor, and his overflow vault space is directly below in the basement. He has an automatic electric elevator for his own use in passing up and down within his own "zone of influence."

The building as a whole is strictly fireproof. The only woodwork is a little for ornamental purposes, and the desks and chairs. All doors, windows, filing cases, are metal. Floors are all terrazzo, tile, cork or linoleum. Marble is used with fine effect in the rotunda and court rooms and sparingly elsewhere. There is evidence on every hand throughout the building that the selection of materials was very carefully made and the inspection and workmanship of the highest order. There is a sense of the fitness of things not often manifested in a public building. The cost of the building was relatively low. The contracts were let before prices had advanced to anywhere near their present level.

The building was completed for about $850,000.00, and it is safe to say that it could not be duplicated at the present time for less than a million and a quarter. Roughly the building contains about 1,600,-000 cubic feet and cost a little over 50 cents per cubic foot completely equipped ready for use.

In closing we would venture to predict that the successful court house of the future will have to meet comparison with the high standards set by this building of Woodbury County, Iowa. The architect for a public building should face the conditions of his problem with the same fairness and thoroughness with which he has so successfully met the conditions of the commercial building problem, and the residence problem. The Woodbury County court house proves what we have been contending for lo, these many years, namely, that it is not necessary nor is it right to force a design into terms of bygone days We venture to predict that the time is fast approaching when no longer will it be possible for an architect to "get by" with scholastic plagiarism, however thoroughly studied or romantically set forth.

We once heard a pupil of the great Richardson say regretfully that it was not satisfactory to attempt to make a modern museum out of an old Italian palace, yet he was trying his best to do so at the time he said it. We have a new form, as befits the new function, in the case of the office building or "skyscraper." Cold logic, or common sense, does not suggest that it is irreverent to attempt to put new life into what has been so long held sacred as purely monumental and therefore classical. Let us hope that democracy may not be made to pause tongue-tied at the very gates of a more beautiful freedom of expression. Let it make every brick and every stone in our public buildings "proclaim liberty throughout the land and to all the inhabitants thereof." For in what does liberty chiefly inhere? In the knowledge of the truth, and in the expression of that same dear truth, "For ye shall know the truth and the truth shall set you free."

RHYTHM IS LAW. WE CLOSE OUR EYES
TO RHYTHMIC LIGHT WAVES FROM THE SKIES;
WE BEAT ON DRUMS AND DULL OUR EARS
TO SILENT MUSIC OF THE SPHERES.—*W. L. S.*

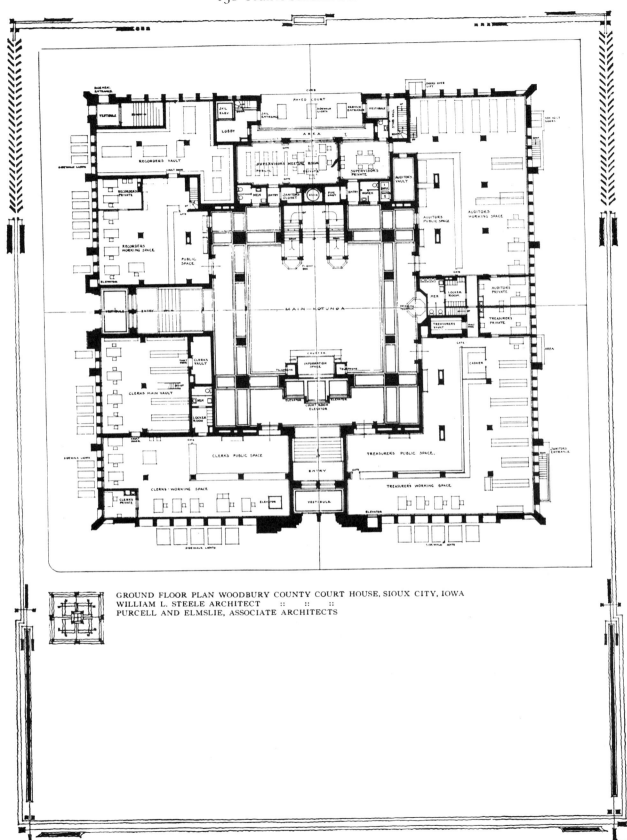

GROUND FLOOR PLAN WOODBURY COUNTY COURT HOUSE, SIOUX CITY, IOWA
WILLIAM L. STEELE ARCHITECT :: :: ::
PURCELL AND ELMSLIE, ASSOCIATE ARCHITECTS

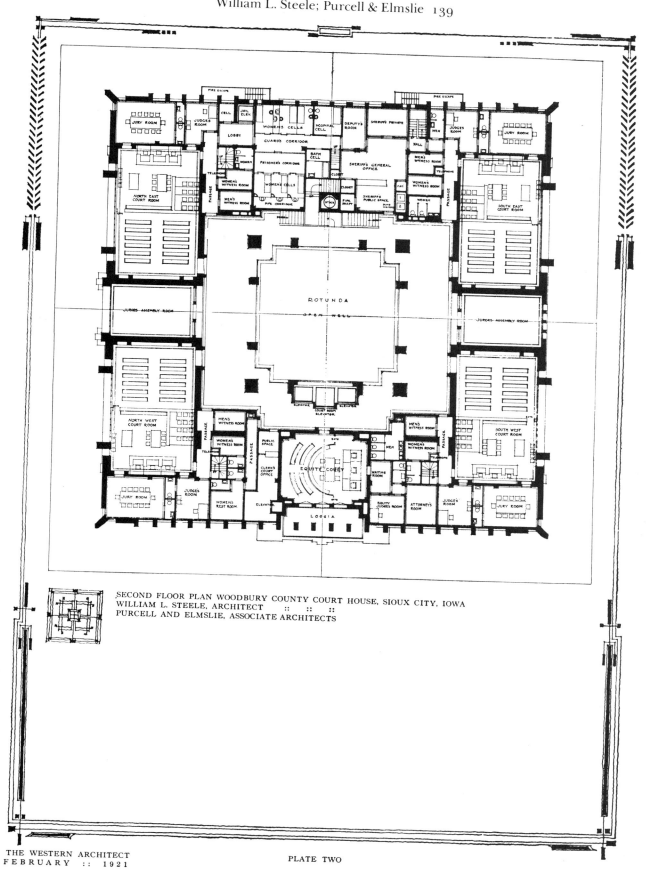

SECOND FLOOR PLAN WOODBURY COUNTY COURT HOUSE, SIOUX CITY, IOWA
WILLIAM L. STEELE, ARCHITECT :: :: ::
PURCELL AND ELMSLIE, ASSOCIATE ARCHITECTS

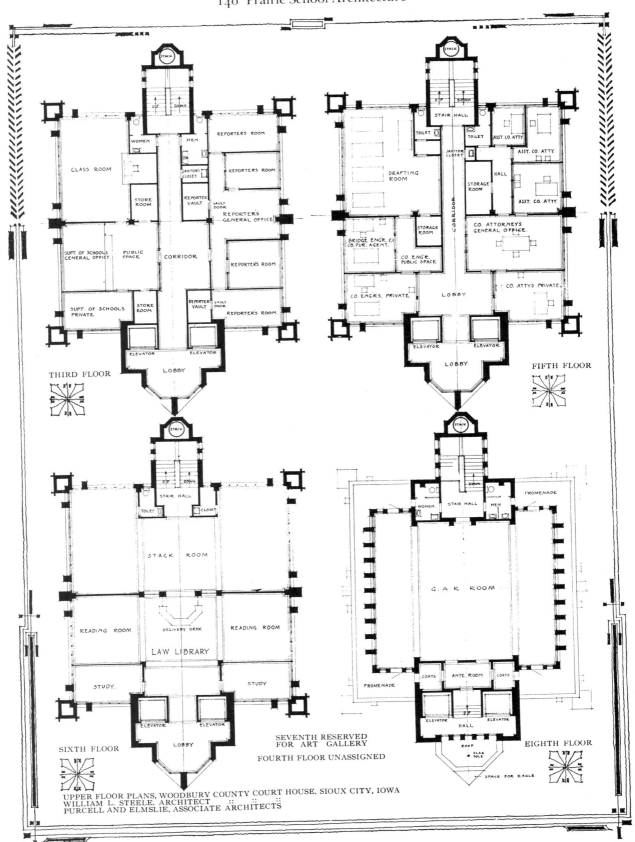

THIRD FLOOR

FIFTH FLOOR

SIXTH FLOOR

SEVENTH RESERVED
FOR ART GALLERY
FOURTH FLOOR UNASSIGNED

EIGHTH FLOOR

UPPER FLOOR PLANS, WOODBURY COUNTY COURT HOUSE, SIOUX CITY, IOWA
WILLIAM L. STEELE, ARCHITECT
PURCELL AND ELMSLIE, ASSOCIATE ARCHITECTS

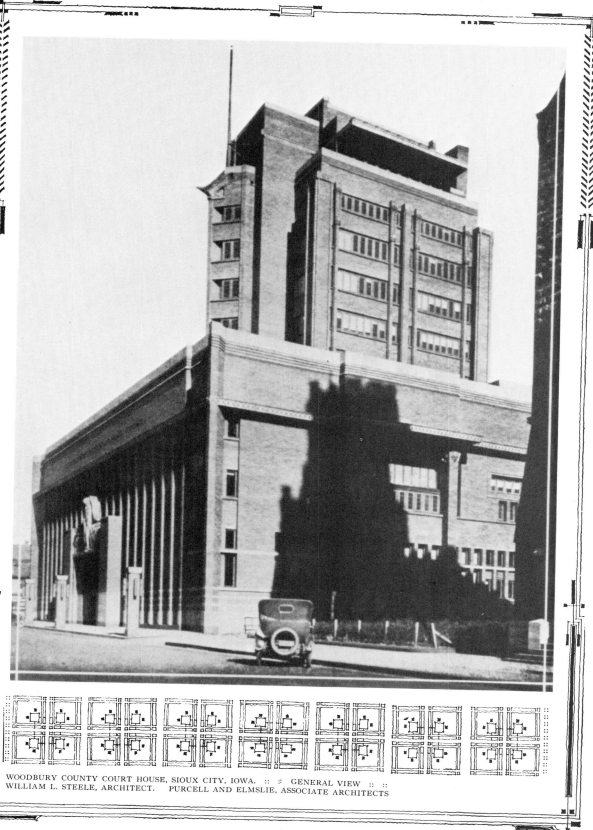

WOODBURY COUNTY COURT HOUSE, SIOUX CITY, IOWA. :: : GENERAL VIEW :: ::
WILLIAM L. STEELE, ARCHITECT. PURCELL AND ELMSLIE, ASSOCIATE ARCHITECTS

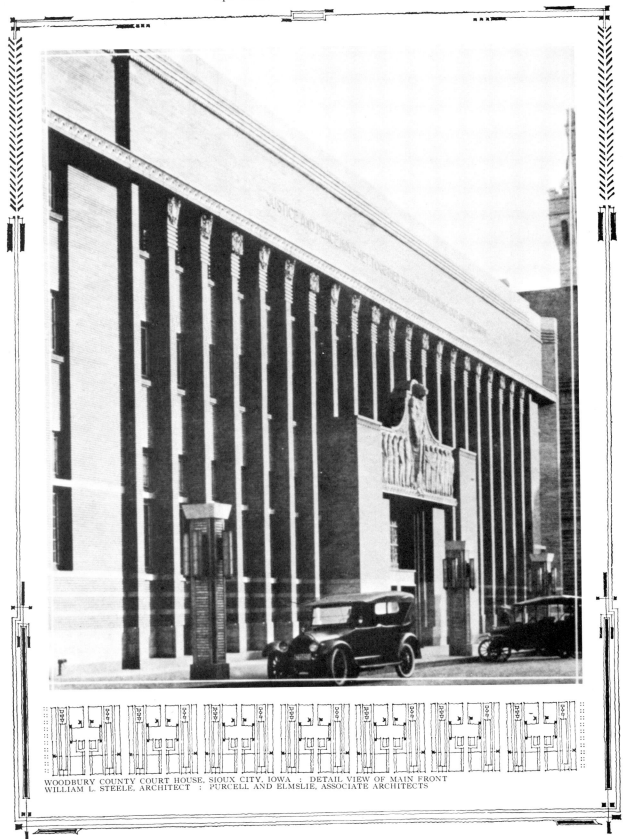

WOODBURY COUNTY COURT HOUSE, SIOUX CITY, IOWA : DETAIL VIEW OF MAIN FRONT
WILLIAM L. STEELE, ARCHITECT : PURCELL AND ELMSLIE, ASSOCIATE ARCHITECTS

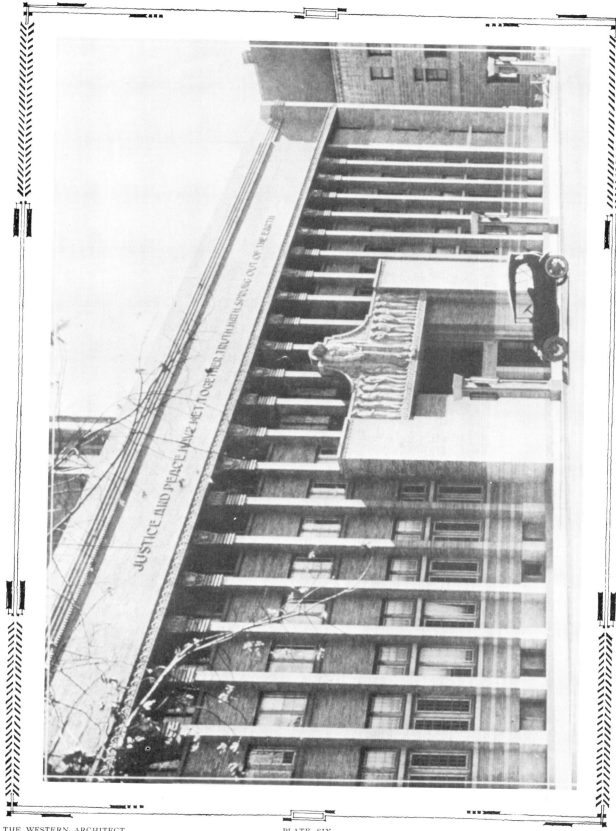

JUSTICE AND PEACE HAVE MET TOGETHER TRUTH HATH SPRING OUT OF THE EARTH

WOODBURY COUNTY COURT HOUSE, SIOUX CITY, IOWA DETAIL VIEW OF MAIN FRONT : WILLIAM L. STEELE, ARCHITECT : FURCELL AND ELMSLIE, ASSOCIATE ARCHITECTS

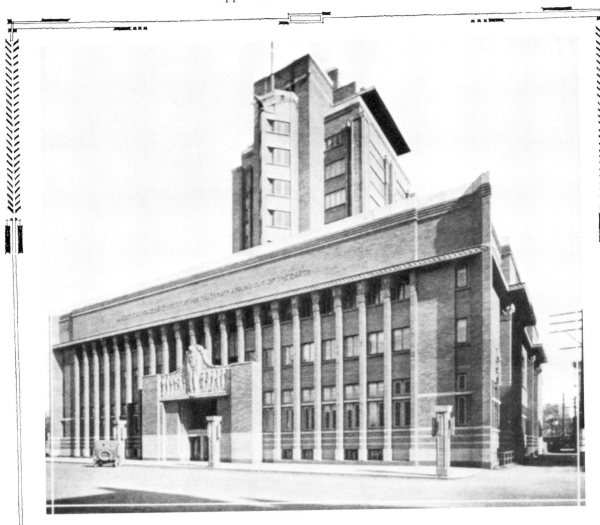

GENERAL VIEW OF BUILDING

WOODBURY COUNTY COURT HOUSE, SIOUX CITY, IOWA
WILLIAM L. STEELE, ARCHITECT : PURCELL AND ELMSLIE, ASSOCIATE ARCHITECTS

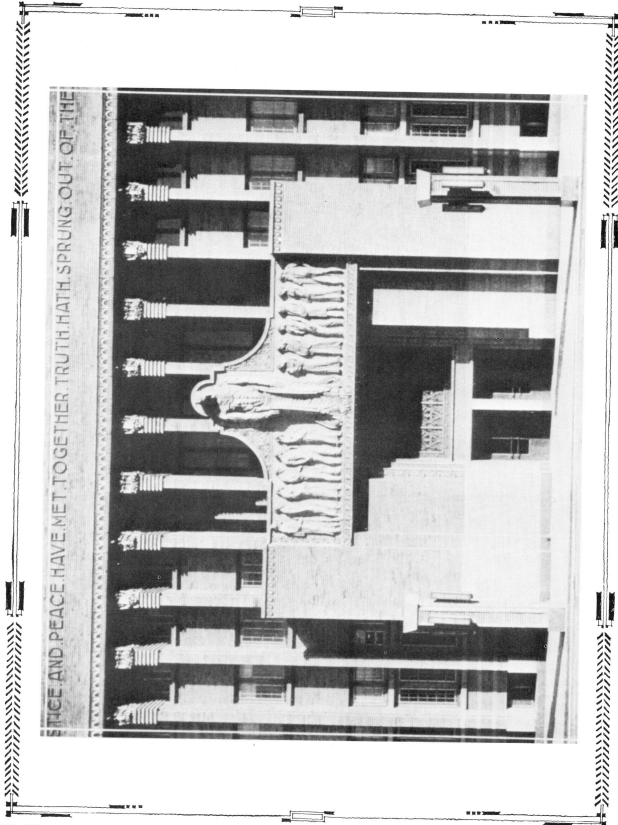

STICE.AND.PEACE.HAVE.MET.TOGETHER.TRUTH.HATH.SPRUNG.OUT.OF.THE

WOODBURY COUNTY COURT HOUSE, SIOUX CITY, IOWA. :: MAIN ENTRANCE :: WILLIAM L. STEELE, ARCHITECT. PURCELL AND ELMSLIE, ASSOCIATE ARCHITECTS

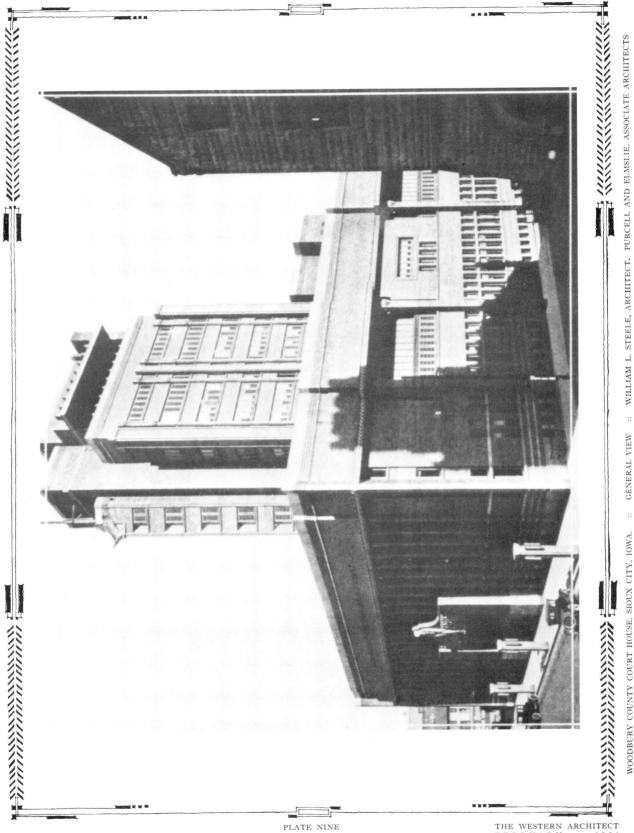

WOODBURY COUNTY COURT HOUSE, SIOUX CITY, IOWA. :: GENERAL VIEW :: WILLIAM L. STEELE, ARCHITECT. PURCELL AND ELMSLIE, ASSOCIATE ARCHITECTS

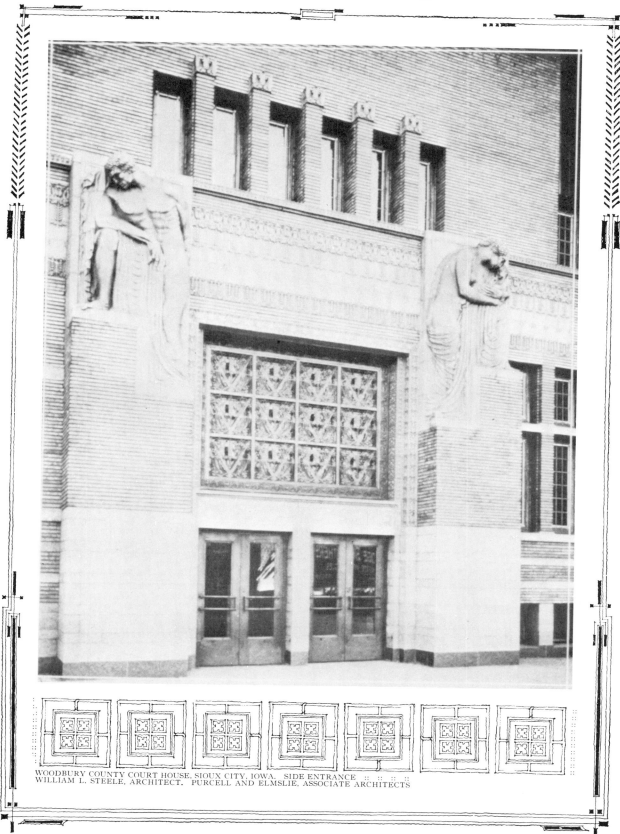

WOODBURY COUNTY COURT HOUSE, SIOUX CITY, IOWA. SIDE ENTRANCE :: :: ::
WILLIAM L. STEELE, ARCHITECT. PURCELL AND ELMSLIE, ASSOCIATE ARCHITECTS

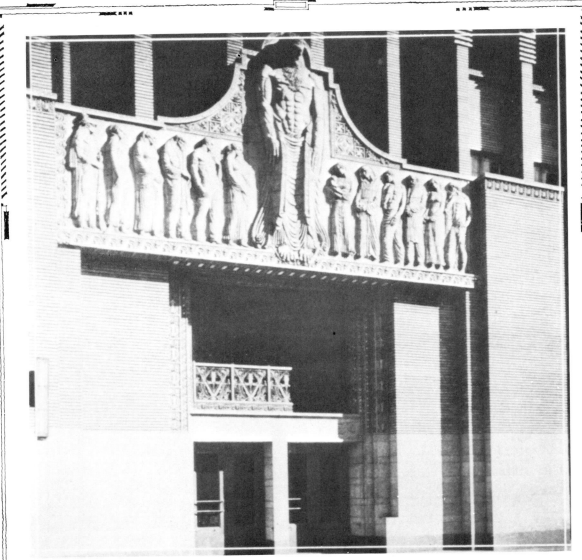

MAIN ENTRANCE

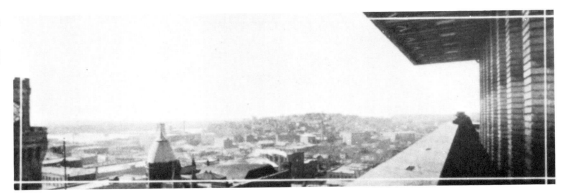

WOODBURY COUNTY COURT HOUSE, SIOUX CITY, IOWA. PANORAMA VIEW FROM TOP FLOOR
WILLIAM L. STEELE, ARCHITECT. PURCELL AND ELMSLIE, ASSOCIATE ARCHITECTS :: :: :: ::

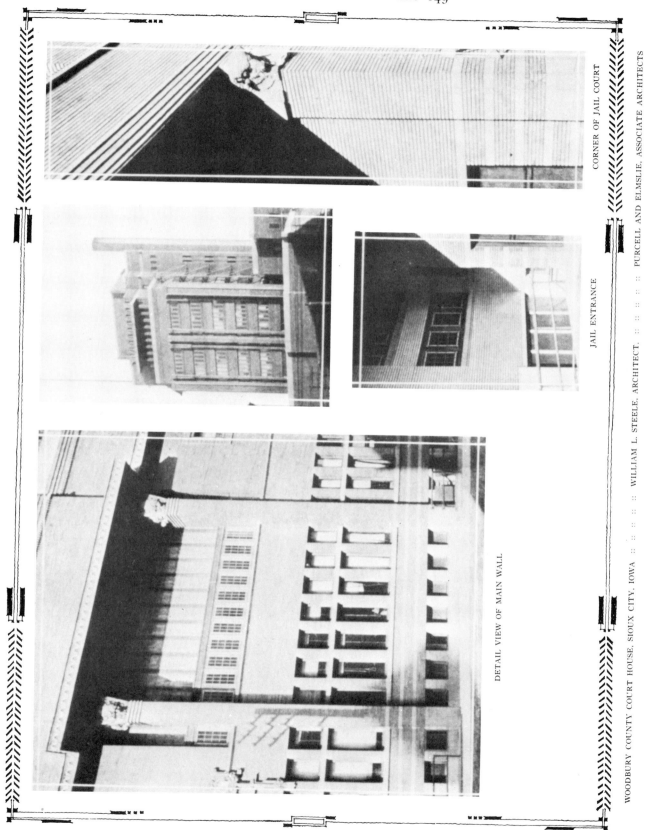

CORNER OF JAIL COURT

JAIL ENTRANCE

DETAIL VIEW OF MAIN WALL

WOODBURY COUNTY COURT HOUSE, SIOUX CITY, IOWA :: :: :: :: WILLIAM L. STEELE, ARCHITECT. :: :: :: :: PURCELL AND ELMSLIE, ASSOCIATE ARCHITECTS

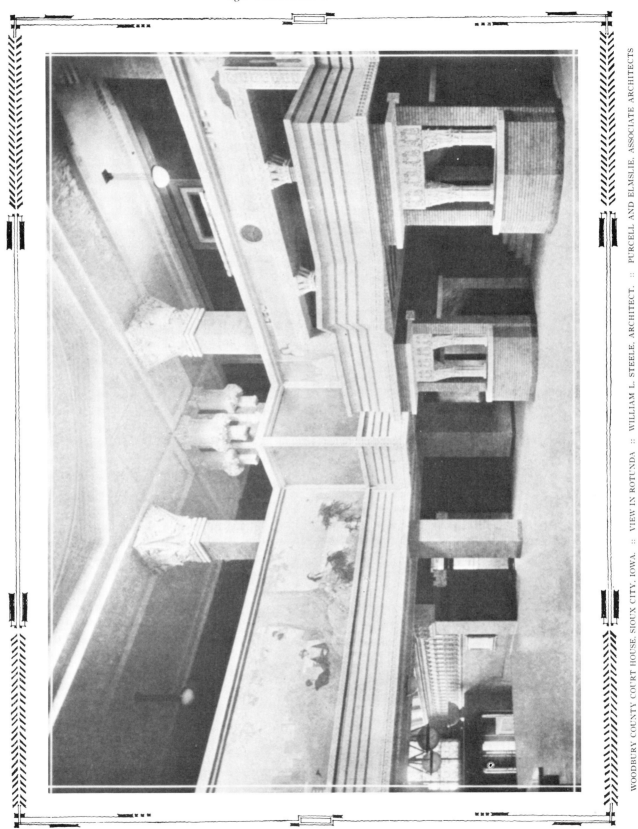

WOODBURY COUNTY COURT HOUSE, SIOUX CITY, IOWA. :: VIEW IN ROTUNDA :: WILLIAM L. STEELE, ARCHITECT. :: PURCELL AND ELMSLIE, ASSOCIATE ARCHITECTS

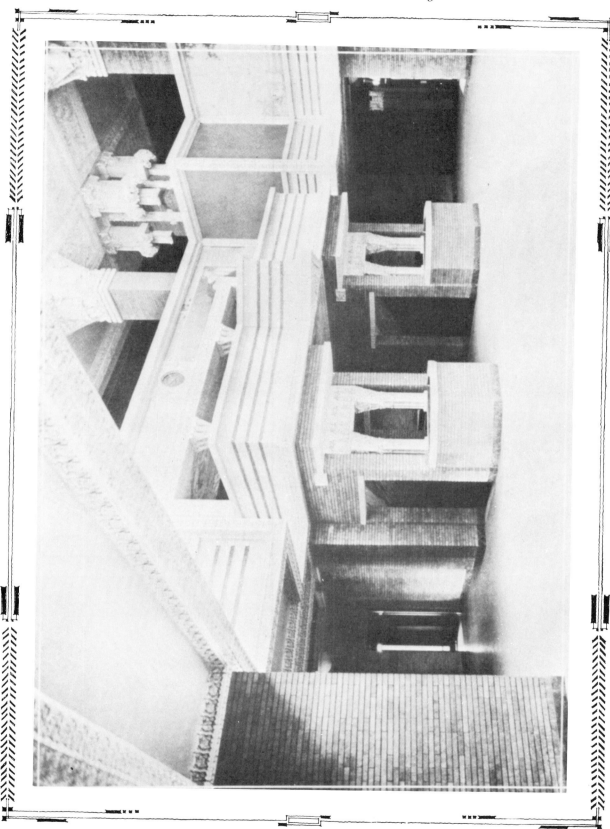

WOODBURY COUNTY COURT HOUSE, SIOUX CITY, IOWA. :: VIEW IN ROTUNDA :: WILLIAM L. STEELE, ARCHITECT. :: PURCELL AND ELMSLIE, ASSOCIATE ARCHITECTS

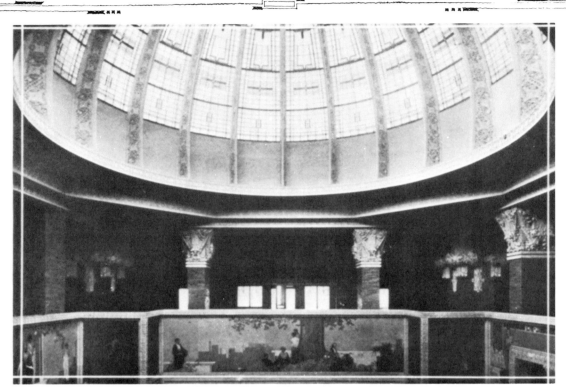

VIEW IN ROTUNDA

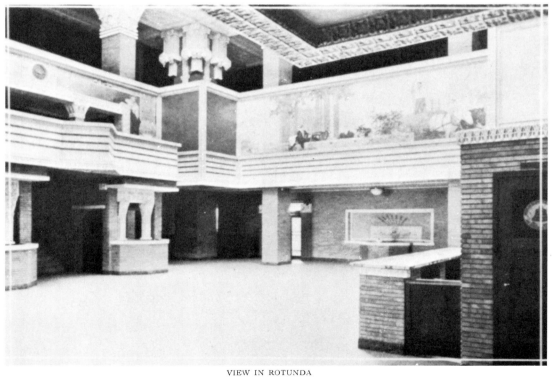

VIEW IN ROTUNDA

WOODBURY COUNTY COURT HOUSE, SIOUX CITY, IOWA. :: :: :: :: :: :: :: ::
WILLIAM L. STEELE, ARCHITECT. PURCELL AND ELMSLIE, ASSOCIATE ARCHITECTS

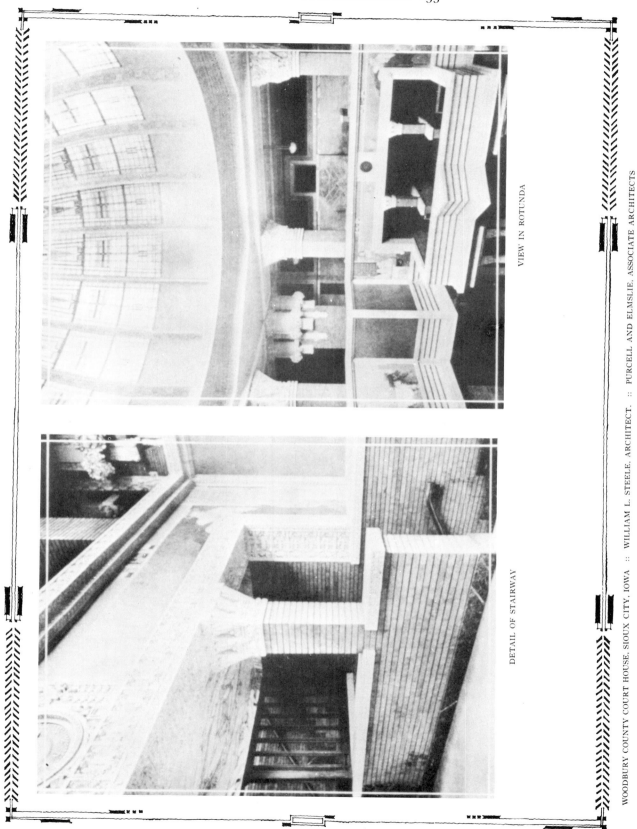

VIEW IN ROTUNDA

DETAIL OF STAIRWAY

WOODBURY COUNTY COURT HOUSE, SIOUX CITY, IOWA :: WILLIAM L. STEELE, ARCHITECT. :: PURCELL AND ELMSLIE, ASSOCIATE ARCHITECTS

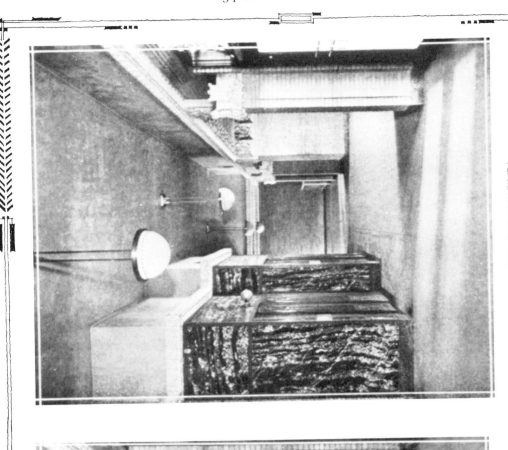

SIDE AISLE IN ROTUNDA

SIDE AISLE IN ROTUNDA

WOODBURY COUNTY COURT HOUSE, SIOUX CITY, IOWA :: WILLIAM L. STEELE, ARCHITECT. :: PURCELL AND ELMSLIE, ASSOCIATE ARCHITECTS

PLATE SEVENTEEN

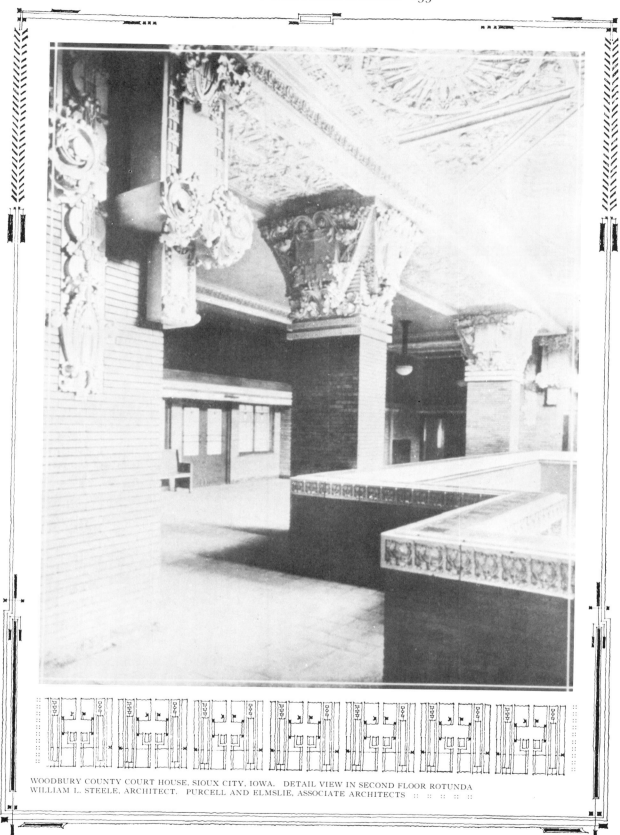

WOODBURY COUNTY COURT HOUSE, SIOUX CITY, IOWA. DETAIL VIEW IN SECOND FLOOR ROTUNDA
WILLIAM L. STEELE, ARCHITECT. PURCELL AND ELMSLIE, ASSOCIATE ARCHITECTS :: :: :: :: ::

WOODBURY COUNTY COURT HOUSE, SIOUX CITY, IOWA. :: VIEW IN ROTUNDA :: WILLIAM L. STEELE, ARCHITECT. :: PURCELL AND ELMSLIE, ASSOCIATE ARCHITECTS

DRINKING FOUNTAIN AND POOL

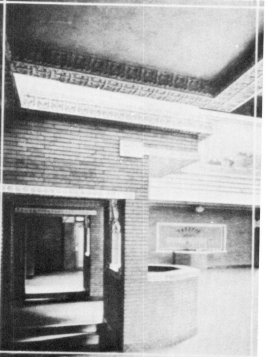

LOCAL VIEW IN ROTUNDA STAIRWAY DETAIL

WOODBURY COUNTY COURT HOUSE, SIOUX CITY, IOWA :: :: :: :: :: :: :: ::
WILLIAM L. STEELE, ARCHITECT :: PURCELL AND ELMSLIE, ASSOCIATE ARCHITECTS

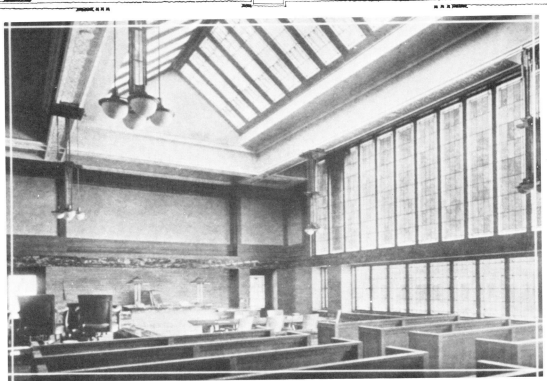

COURT ROOM LOOKING TOWARD JUDGE'S BENCH

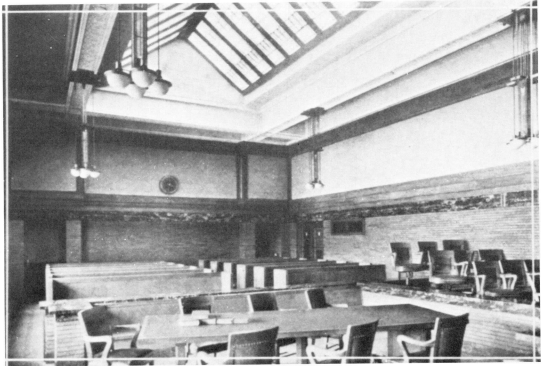

COURT ROOM LOOKING TO REAR

WOODBURY COUNTY COURT HOUSE, SIOUX CITY, IOWA :: :: :: :: :: :: :: ::
WILLIAM L. STEELE, ARCHITECT. PURCELL AND ELMSLIE, ASSOCIATE ARCHITECTS

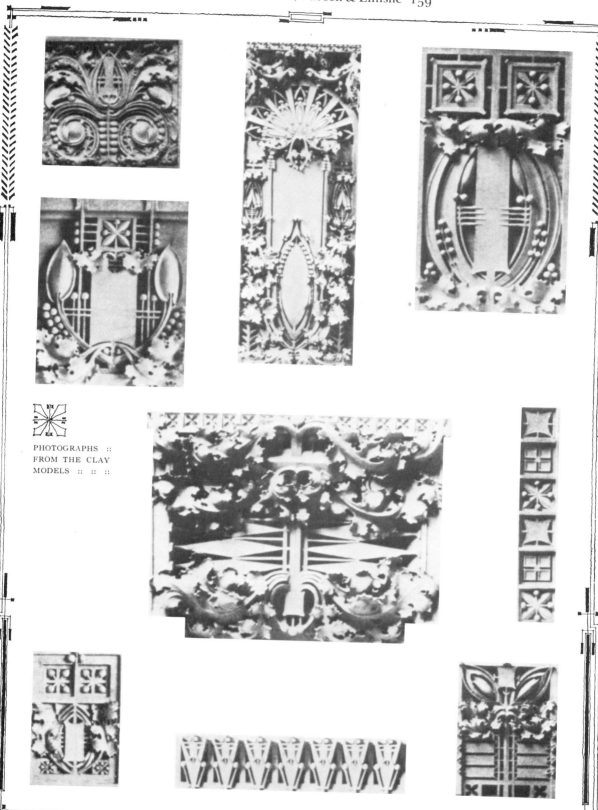

PHOTOGRAPHS ::
FROM THE CLAY
MODELS :: :: ::

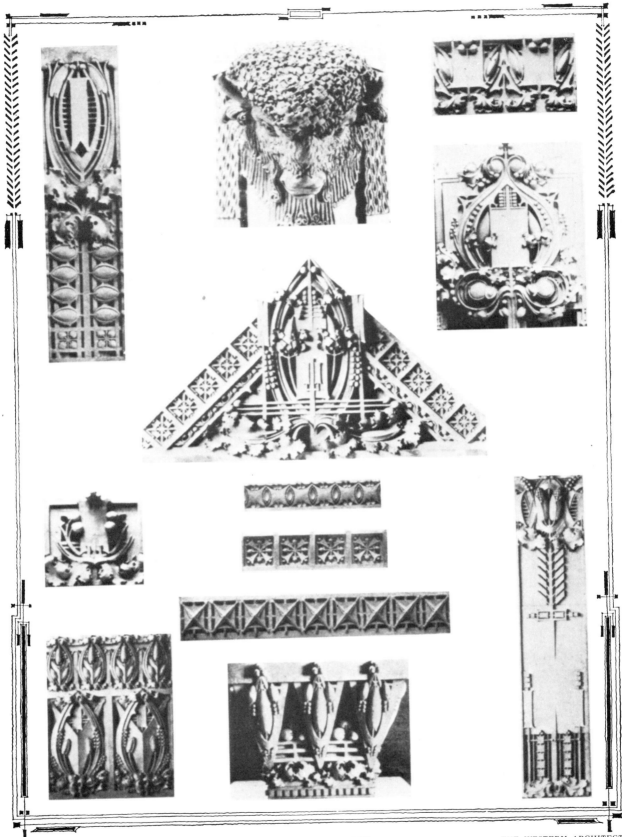

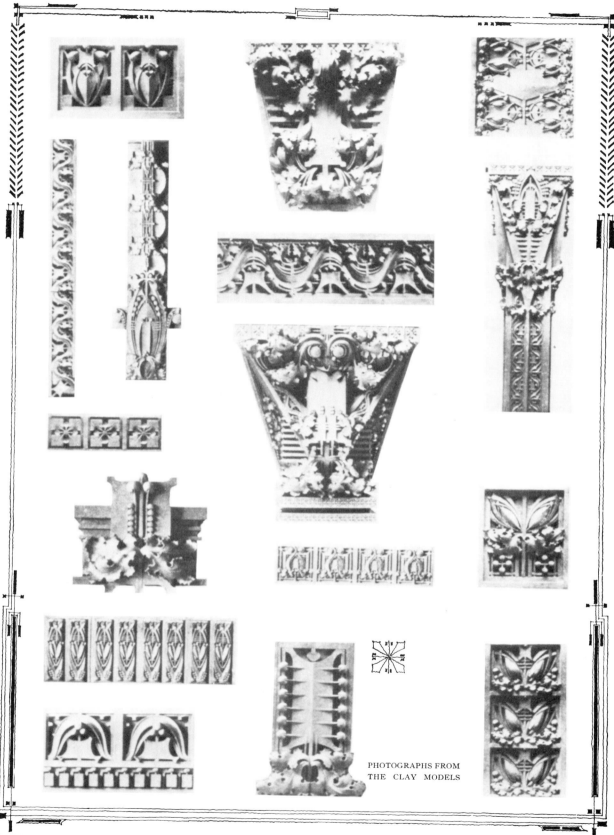

PHOTOGRAPHS FROM
THE CLAY MODELS

GEO. W. MAHER,
a *democrat* in Architecture

To come close to humanity and render it a real service, is a relation that forms one of the fundamentals of democracy. To stand apart and "hand out" things which the "hander" believes the "handed" needs is the mark of aristocracy. The former relation between an architect and his client will result in a democratic architecture. The latter, adapted forms which are meaningless and have no part in the development of the architect, the community or the nation.

Democracy in architecture is a fine sounding expression and frequently used where its meaning is not understood nor its conceptions followed. Deep in the heart of every man there is a desire to make his fellow's life happier and to contribute to society something of himself. And when this altruistic individual happens to be an architect, naturally his most effective contribution is in the realm of architecture. And this contribution will be democratic, that is more of the people, the better he understands their needs and desires. Witness the growth of architectural styles in the

OWN RESIDENCE OF GEO. W. MAHER

architecture of the homes of different peoples the world over in comparison with the more monumental commercial structures.

The progressive movement in architecture is nothing more or less than the simple advancement of architectural thought keeping pace with the thoughts and lives of society to whom it ministers and democratic architecture is the result. Democratic government is one conducted for all the people with equal opportunities and no special privileges, a democratic society exists when each individual recognizes the rights of every other, and respects them and a democratic architecture underlying which are the same fundamentals, is evolved by a close and constant relation between the architect and his client, the people, which results in a complete understanding as to the latter's needs and a sympathetic co-operation to create forms which will produce comfort and all around improved conditions of living and working for the individual and his neighbor. Its all very simple. Instead of "handing" a client an "exquisite little colonial" or a "magnificent Italian Renassiance" our democratic architect must know his client's habits, the climate in which he lives, the location, possibilities of his site and its other relations, more or less complicated and with a proper understanding of all, work out a solution that is

both practical, sensible and which, without effort, will possess beauty. With such an understanding there need be no struggle for originality in style. It is there without being sought and the democratic spirit of the artist has produced it. This is the spirit which brings itself into evidence through the works of George W. Maher.

In presenting a selection of designs executed by George W. Maher the character of the design will be better understood by some reference to the characteristics of the man, his ideals and aspirations.

Fundamentally Mr. Maher believes in a democracy in Art and Architecture. This he interprets to mean that buildings should be erected to fit the actual needs of the people who inspire them, adhering closely to the principle that each proposition should be different, dependent upon the needs and conditions presented.

This is a large contract to honestly carry out if examined to its last analysis. On one side is the training which, with every architect over forty, was received as a basis for his profession. It commenced with Greek and Latin in school, a repetition of these in design in the architectural school or office, followed by more or less copying and adapting in early practice. It takes bravery and a high conception of Art with a spirit of self sacrifice as well, to defy the gods of archiological precedent. On the other hand is the hidebound prejudice of ignorance of the client. It is here that the architect is compelled to choose between his ideals and the expressed wish of this client. There may be the middle course, that of diplomatically leading him to see that which he really wants is incorporated in the architects design. That his attitude does not really grow out of his knowledge, but through a reverence for ancient forms, or an impression made upon him by some work of celebrity and beauty perhaps, but incongruous in its relation to present requirements. All architects however are not diplomats, and are disposed to leave such work to those who will sacrifice principle to expediency.

Perhaps Mr. Mahers' viewpoint in regard to architecture in general can be approached best scanning an abstract from the descriptive note submitted with his design in the Northwestern University competition in which he said: "Democracy forms the underlying principle of this plan, namely the establishing of each building

as a unit, and so placed and arranged as to become a part of a general scheme and thus enhancing unity and harmony of the entire campus growth. This principle is an evolution of many of the University groupings of buildings where the English quadrangle plan is used creating closed quadrangles thus effectively surrounding the campus. This method of planning is medieval in its inception, and was an outgrowth of these tempestuous

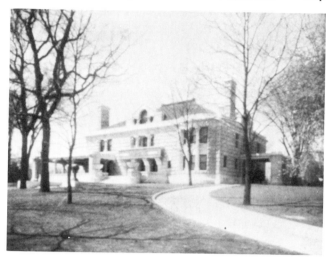

RESIDENCE OF JAMES A. PATTON, EVANSTON, ILL.
GEO. W. MAHER, ARCHITECT

times. The plan in no wise destroys campus seclusion. This is made possible by a spacious parkway extending parallel with the lake through the grounds. From this parkway beautiful vistas can be obtained of the lake and the grounds. The parkway extends in front of the public hall and terminates or focuses at the Chapel building. Processions and festival occasions can be encouraged by means of this great esplanade. The plan further encourages the spirit of democracy by inviting the public to enter into the center of the campus, obtaining a beautiful view of it and Lake Michigan and then out to the public street without intruding upon the privacy of the University grounds located on either side of this central public entrance. The view of the college buildings from the lake would be as attractive and monumental as the view of them from the Sheridan drive. The lake can at all times be seen from this famous public driveway through the vistas formed between the buildings. The dormitory arrangement of four loose quadrangles thus carrying out the theory of democracy in the arrangement of Fraternity houses and Dormitories in close proximity to each other, each building being a unit also forming a part of the quadrangle but with space between each building. The proposed elevations for these buildings were to embody strictly original and American lines and detail similar to the architecture of the Swift Hall of Engineering and the Northwestern

Gymnasium. All of these buildings border on Lake Michigan and therefore the necessity of employing horizontal lines and broad, simple stone surfaces in order to bring the architecture into harmony with the broad strong outlook and horizon of the great lake adjoining toward the east. It was thought that by erecting this type of architecture on a University campus that it would inspire the student to foster Art ideals akin to their own country and assist the movement for an indigenous art so much longed for and needed by the great American people. It is conceded that a great country should foster its own literature, poetry or art, therefore it would seem that our seats of learning should encourage in every possible way ideals that are part of this life."

It will be noted in this declaration of principles contained in this University program that democracy in art interests Mr. Maher more than any other phase of our art development. It seems to indicate his belief that while the architecture of buildings that evolve from a single source cannot help but be related, yet they should be as different as the needs of the people for whom they are erected, and as the condition of the country in which they are created, since the inspiration should naturally come from these circumstances and surroundings. In following out this thesis it is apparent that one of the problems before the architects of this country is

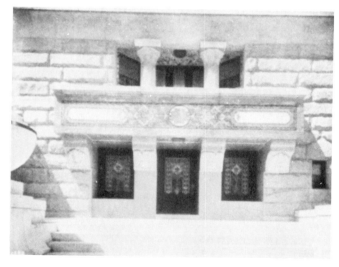

DETAIL OF ENTRANCE, JAMES A. PATTON RESIDENCE
GEO. W. MAHER, ARCHITECT

how to incorporate symmetry and harmony along a single street or avenue or where monumental work is proposed and not make the effect too monotonous. In consonance with this it will be observed that Mr. Maher's designs are not alike and in their variety seek to express the individuality of the owner, and to fit the conditions in which they are placed.

Mr. Maher is not an apostle of a new cult or even

expressing a new theory, but is one in a world-wide movement of democracy in design that, breaking away from a parasitic, imitative and devitalized art in every country from Finland to Scotland and Germany to America, is seeking to meet modern conditions with modern design. He is one of that constantly increasing number that are seeking for a logical expression of modern thought to meet modern conditions, particularly in the honest use of materials in building and a candid acknowledgment of purpose in each design. Relegating the orders to the classroom and drawing inspiration from the splendid works that have endured with time, these apostles of a new architectural epoch are using this heritage of the past as an inspiration that is as alive as the concrete form is dead in relation to modern requirements in purpose and form.

As one of these the work of George W. Maher shows how purpose in design has worked out in its practical application in the hands of one seeker after truth expression in which precedent becomes subservent to function. The work of Mr. Maher like that of the ever increasing number of those who are endeavoring to raise their profession to a plane of democratic independence, is always interesting, and when viewed in a spirit of tolerance is found to be based upon a logical and practical conception of true design.

Two of the buildings here illustrated may be described as typical of the organized system of plan and design followed by Mr. Maher in all his works of this character. The Patton Gymnasium building represents a new theory of gymnasium plan and construction. The idea was to erect a building that would answer all kinds of purposes, not only covering the gymnasium work but for concerts and large gatherings as the case requires. The plan is so arranged that it is convenient for the boys and girls to occupy the building without interference with each other in their exercises. This principle has been carefully worked out since Northwestern University is a Co-educational Institution. In plan organization the front portion of the building includes the Troply hall, Administrative offices, social rooms, shower rooms, pool room and the large gymnasium for general work on a maple floor, also fan room and locker rooms in basement. The rear portion of the building is the indoor-outdoor field, the floor being of earth with a track around same of ten laps to the mile. This large space can be used for foot ball practice, base ball and all exercises usually carried on in the open air. This indoor-outdoor field is converted into a music hall and also used for commencements by means of a temporary wood floor with seats which are placed in vaults provided for same immediately outside of the Gymnasium walls. This temporary arrangement accommodates a chorus of one thousand voices and has a seating capacity for five thousand people on one floor. The acoustics in this large hall have been pronounced equal to any music hall in this country.

The J. R. Watkins Administration Building at Winona has been pronounced one of the most perfectly equipped Administration buildings in this country. Every feature of office, desk, lighting fixtures, hard-

ware, etc. have been especially designed to fit this building, following the theory of design and motifs which continually appear throughout the work. The very best materials have been used, for instance the walls srruounding the rotunda at the entrance of the building are lined with genuine Monastery Sienna marble. The dome over this rotunda is faced with Venetian glass with original and unique designs worked into it. The large windows are of art and stained glass typifying the beautiful landscape which surrounds Winona. It is not generally understood that business in operation can be made to appear in an artistic manner but as one views the organized methods of arrangement from the private offices which are on a higher level than the working space, the scene has a symphonic quality due to the harmony of design and arrangement of aisles and desks, which is fascinating to see. There are three distinct lighting features in this building—first the utilitarian illumination, second the general illumination—third the artistic illumination; so that as occasion demands the building can be used for other purposes in addition to business. The purpose of the second floor for instance, is that it will respond to such matters that refer to the discussion of the methods of good banking and the various forms of investments. The exhibit rooms are for prize farm products or any other objects that represent the wealth of the surrounding country. The womens' department is designed to be especially attractive and for their enlightenment in banking and money matters.

A unique factor enters into the design of the Winona Savings Bank building at Winona, Minnesota, illustrated by a pen and ink sketch executed by Mr. Maher. This is called an "Institutional Bank" for the reason that it differs materially from any other bank. The plan is arranged for many purposes; that is money will be recognized as the medium of exchange and all facilities are arranged to do this properly on the main floor with the best outside lighting features. That which produces the money inclusive of soil, farm produce, etc., will be introduced on the second floor. Also rooms will be provided for lectures to explain the wealth producing medium of the surrounding country; also rooms to educate the public; for instance, the women in the realm of business, banking, etc., or any other line of educational enlargement will be incorporated in this bank which will broaden out the real fundamental principles which lie back of all safe banking. The broad and generous manner in which the President and officers of this bank have met Mr. Maher half way in his endeavor to produce advanced results that go far beyond the ordinary compass of bank designs show that these bankers are thoroughly alive to the possibilities of modern banking as it should be carried on in these modern times.

The Joseph Sears School building erected at Kenilworth, Ill., is a modern expression of school architecture. It is American in design and shows the possibilities of school construction in this direction. Such buildings should not only be practical in every way, but artistic and Kenilworth School emphasizes this fact in its design. The plan is simple and direct, the class rooms are arranged to be on the south side of the building for warmth and

pleasant effect. The utilitarian features of the plan are on the north side. The public hall is wide and directly accessible to all rooms, entrances and exits. The assembly hall, due to its central location and close proximity to the public hall, can be enlarged when so desired by taking in the public hall space by opening the large sliding doors between the two. The kindergarten is one of the main features of the plan, having its own entrance with fewer steps up to the floor level than the main building, also its own toilet and dressing rooms, etc., especially designed for the little ones. The exterior treatment of the kindergarten also is special in order to make it distinct. The practical features of the plan consist of the lighting, also the heating and ventilating. The lighting is by means of the saw-tooth skylight construction on the roof arranged for north light. This north light is diffused over the entire area of the room through the ceiling sash. These ceiling sash conceal the saw-tooth construction above. This method of lighting prevents shadows or sun spots in any portion of the room, on the other hand all is equally light. The windows to the south are principally used for view of the exterior and also have flower boxes under same for the artistic effect of the interior. The heating and ventilating is modern and mechanical. There are no direct radiators in the school rooms, the outside air is brought into the respective rooms heated and moistened automatically. The interior of the building is designed in harmony with the exterior architecture. The desks and furniture are especially designed and made for this school. The wood finish is simple and of weathered oak and together with the decorations make of the interior a soft and harmonious effect of color. The exterior is of texture brick. The saw-tooth skylights are concealed by a long low parapet above the main cornice line. The dominant note in the design is expressive of simplicity and breadth of outline with freedom of detail.

RESIDENCE GEORGE B. CALDWELL, OAK PARK, ILLINOIS. GEORGE W. MAHER, ARCHITECT.

DETAIL ENTRANCE SIMPSON RESIDENCE, GLENCOE, ILLINOIS. GEORGE W. MAHER, ARCHITECT. :: ::

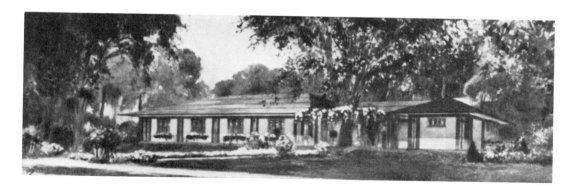

KENILWORTH ASSEMBLY HALL, KENILWORTH, ILLINOIS
George W. Maher, Architect, Chicago, Illinois

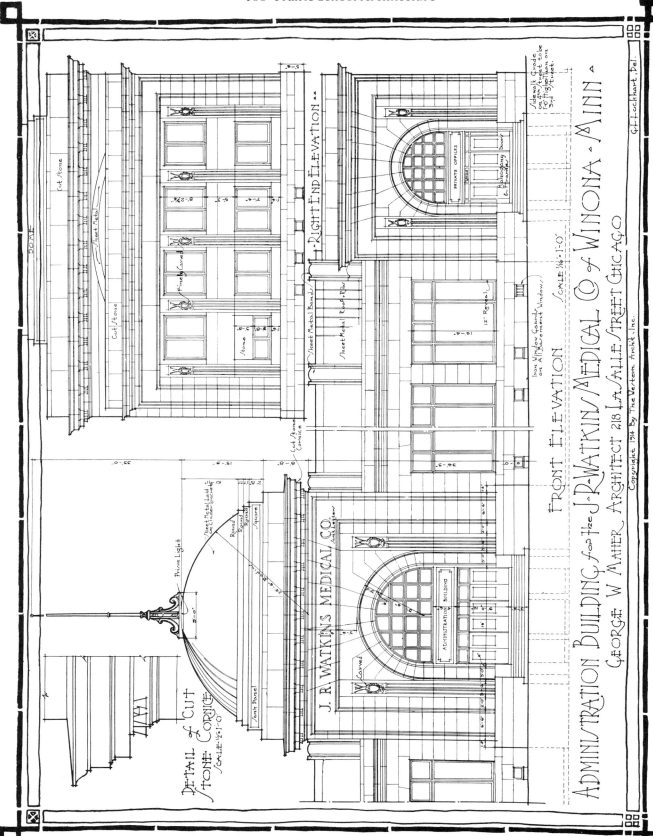

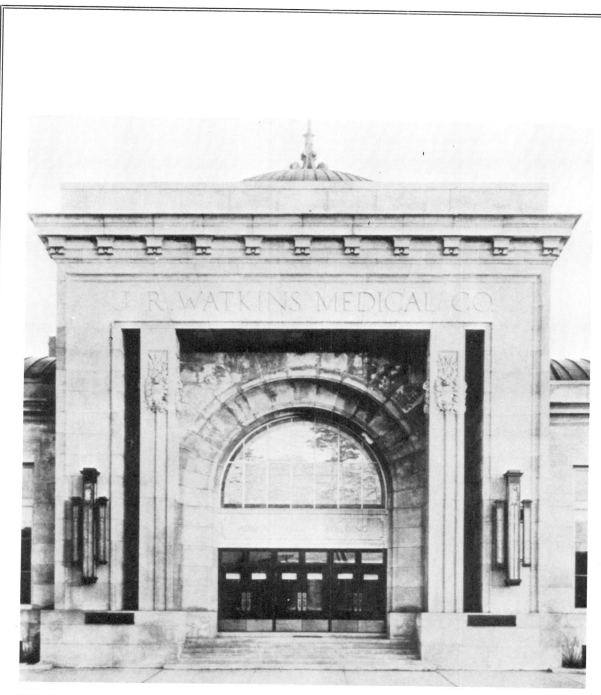

MAIN ENTRANCE ADMINISTRATION BUILDING.
THE J. R. WATKINS MEDICAL CO., WINONA, MINN.
GEORGE W. MAHER, ARCHITECT, CHICAGO, ILL.

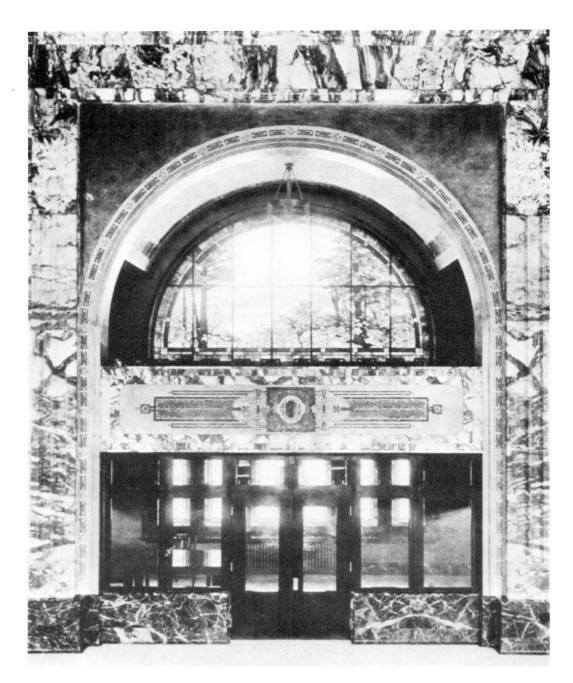

INTERIOR VIEW---DETAIL OF STAINED GLASS WINDOW OFF ROTUNDA
ADMINISTRATION BUILDING, THE J. R. WATKINS MEDICAL CO.
WINONA, MINN. GEORGE W. MAHER, ARCHITECT, CHICAGO, ILL.

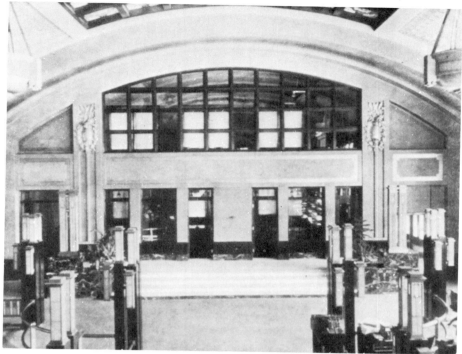

INTERIOR VIEW--LOOKING TOWARD ADMINISTRATION OFFICES
ADMINISTRATION BUILDING, THE J. R. WATKINS MEDICAL CO.,
WINONA, MINN. GEORGE W. MAHER, ARCHITECT, CHICAGO

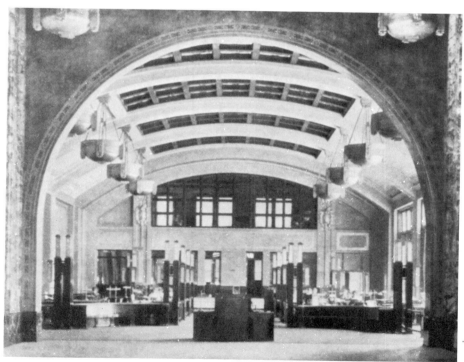

INTERIOR VIEW, GENERAL OFFICES, ADMINISTRATION
BUILDING, THE J. R. WATKINS MEDICAL CO., WINONA, MINN.
GEORGE W. MAHER, ARCHITECT, CHICAGO :: :: ::

EXTERIOR ADMINISTRATION BUILDING, J. R. WATKINS MEDICAL CO.
WINONA, MINN :: :: :: :: :: :: :: :: :: :: :: :: ::

THE WESTERN ARCHITECT
MARCH :: :: :: 1914

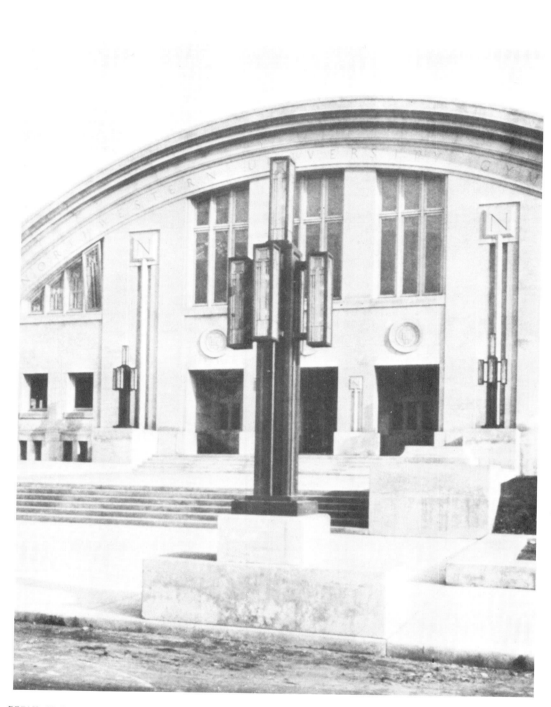

DETAIL OF ENTRANCE AND BRONZE ELECTRIC LIGHT STANDARDS,
NORTHWESTERN UNIVERSITY GYMNASIUM, EVANSTON, ILLINOIS,
GEORGE W. MAHER, ARCHITECT, CHICAGO :: :: :: :: :: :: ::

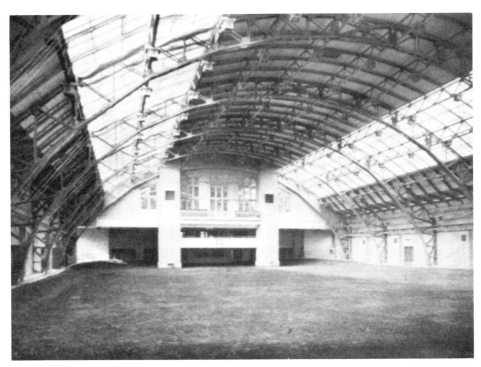

OUT DOOR-INDOOR FIELD. SHOWING PRACTICE AREA ON EARTH FLOOR FOR TENNIS, BASEBALL AND FOOT-
BALL PRACTICE. THE RUNNING TRACK EXTENDS AROUND AREA, MAKING 10 LAPS TO THE MILE. NORTH-
WESTERN UNIVERSITY GYMNASIUM, EVANSTON, ILLINOIS. GEORGE W. MAHER, ARCHITECT CHICAGO

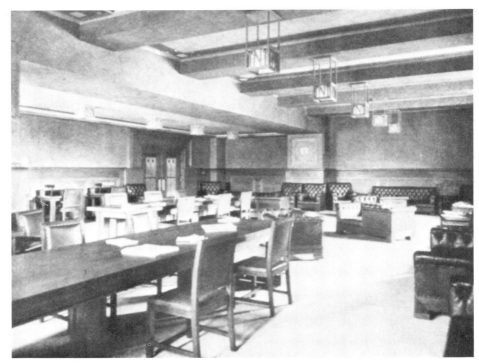

MEN'S SOCIAL ROOM, NORTHWESTERN UNIVERSITY GYMNASIUM,
EVANSTON, ILLINOIS. GEORGE W. MAHER, ARCHITECT, CHICAGO

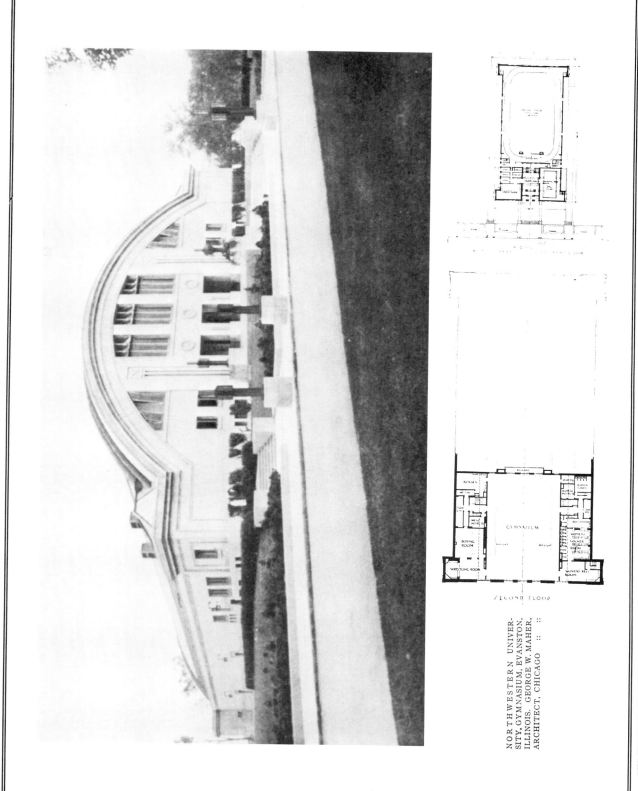

NORTHWESTERN UNIVER-
SITY, GYMNASIUM, EVANSTON,
ILLINOIS. GEORGE W. MAHER,
ARCHITECT, CHICAGO :: ::

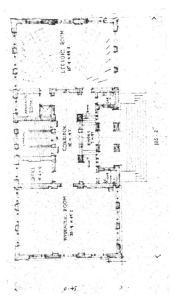

SWIFT ENGINEERING HALL, NORTHWESTERN UNIVERSITY, EVANSTON, ILLINOIS. GEORGE W. MAHER, ARCHITECT, CHICAGO :: :: ::

THE WESTERN ARCHITECT
MARCH :: :: 1914

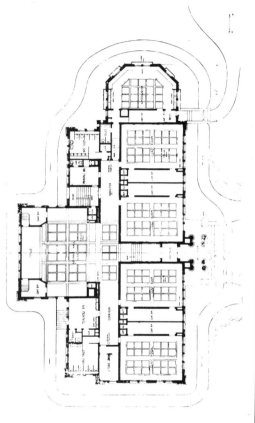

THE JOSEPH SEARS PUBLIC SCHOOL,
KENILWORTH, ILLINOIS. GEORGE W.
MAHER, ARCHITECT, CHICAGO. :: ::

JOSEPH SEARS SCHOOL
AT KENILWORTH · ILL ·
GEORGE W. MAHER · ARCH'T.

Section of Porch

Half Front Eleva. of Porch

Plan of Entry Porch Ceiling.

Plan of Porch Floor

Sec. Thru Flower Box.

Plan of Porch Floor
Paving Brick Floor

G.L. Lockhart·Arch·Del·

Copyright 1914 Western Archt., Inc.

Scale 1/4"=1'-0"

"ROCKLEDGE" SUMMER HOME OF MR. E. L. KING, WINONA, MINN.
GEORGE W. MAHER, ARCHITECT, CHICAGO :: :: :: :: :: :: :: ::

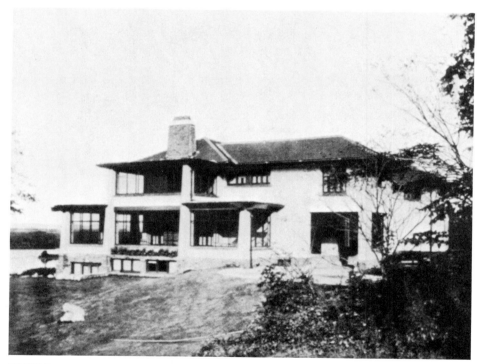

"ROCKLEDGE" SUMMER HOME OF MR. E. L. KING, WINONA, MINN.
GEO. W. MAHER, ARCHITECT, CHICAGO :: :: :: :: :: :: :: ::

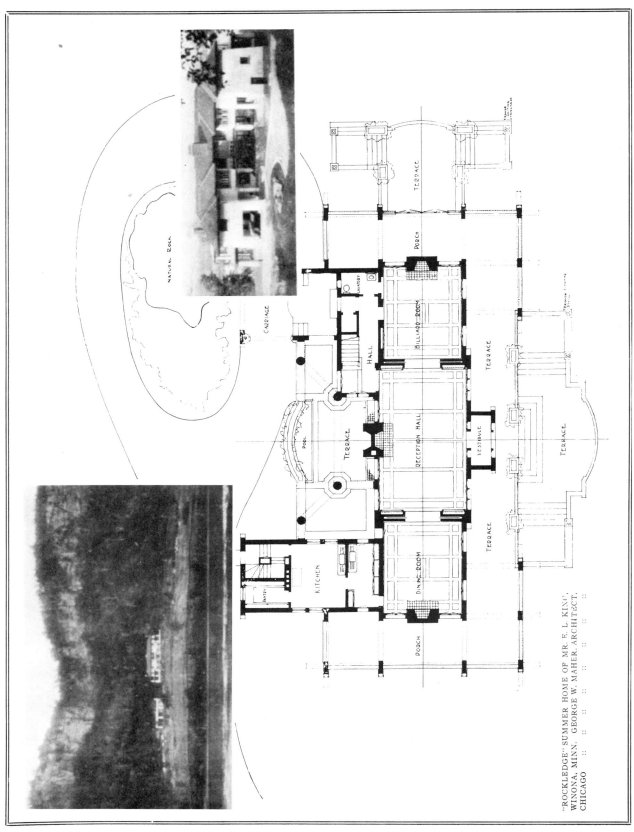

"ROCKLEDGE" SUMMER HOME OF MR. E. L. KING,
WINONA, MINN. GEORGE W. MAHER. ARCHITECT,
CHICAGO :: :: :: :: :: :: :: ::

THE WESTERN ARCHITECT
MARCH :: :: 1914

STAIR HALL "ROCKLEDGE" SUMMER HOME OF MR. E. L. KING, WINONA, MINN. GEORGE W. MAHER, ARCHITECT, CHICAGO ::

CHAMBER "ROCKLEDGE" SUMMER HOME OF MR. E. L. KING, WINONA, MINN. GEORGE W. MAHER, ARCHITECT, CHICAGO

RECEPTION ROOM "ROCKLEDGE" SUMMER HOME OF MR. E. L. KING, WINONA, MINN. GEORGE W. MAHER, ARCHITECT, CHICAGO :: ::

RECEPTION ROOM "ROCKLEDGE" SUMMER HOME OF MR. E. L. KING, WINONA, MINN. GEORGE W. MAHER, ARCHITECT, CHICAGO :: ::

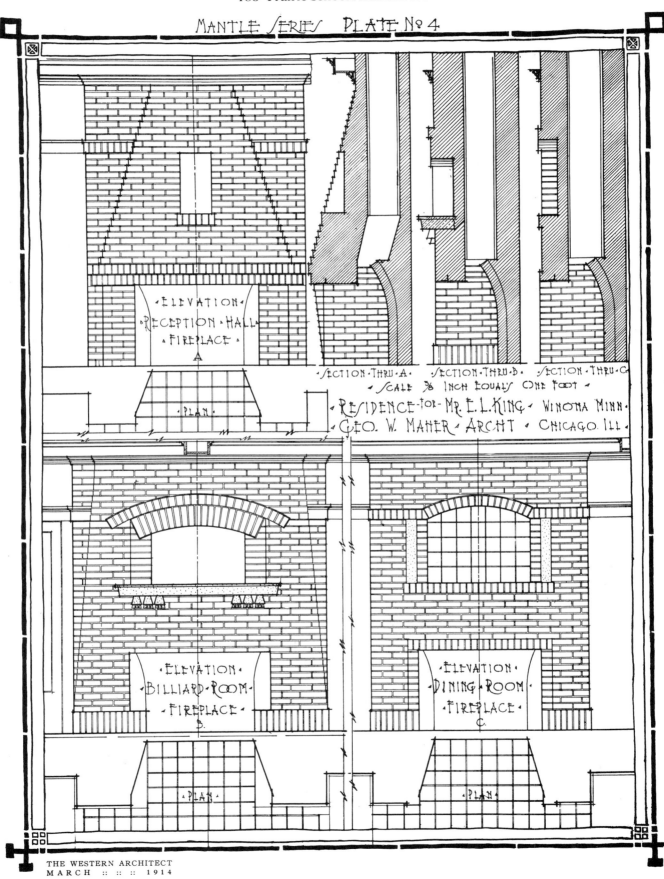

MANTLE SERIES PLATE No 4

ELEVATION
RECEPTION HALL
FIREPLACE
A

PLAN

SECTION THRU A SECTION THRU B SECTION THRU C
SCALE ⅜ INCH EQUALS ONE FOOT
RESIDENCE for MR. E. L. KING WINONA MINN
GEO. W. MAHER ARCHT CHICAGO ILL

ELEVATION
BILLIARD ROOM
FIREPLACE
B

ELEVATION
DINING ROOM
FIREPLACE
C

PLAN PLAN

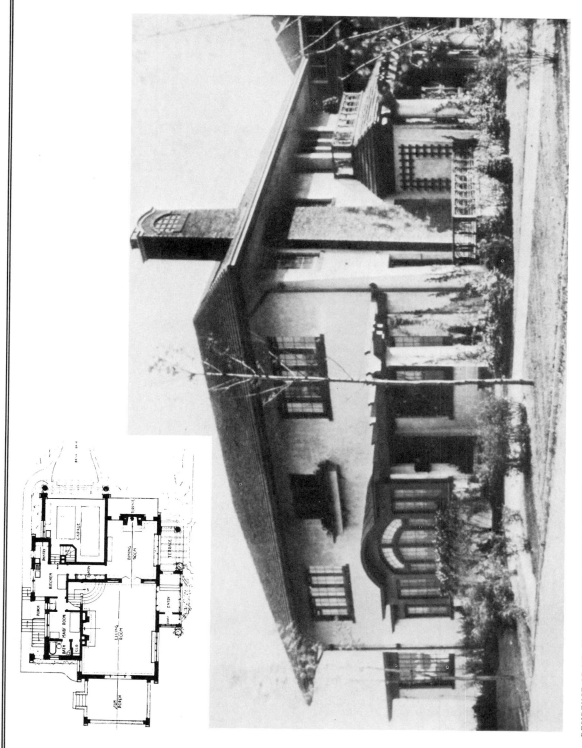

RESIDENCE OF MR. SIDNEY OSSOSKI, CHICAGO, ILLINOIS
GEORGE W. MAHER, ARCHITECT :: :: :: :: ::

THE WESTERN ARCHITECT
MARCH :: :: 1914

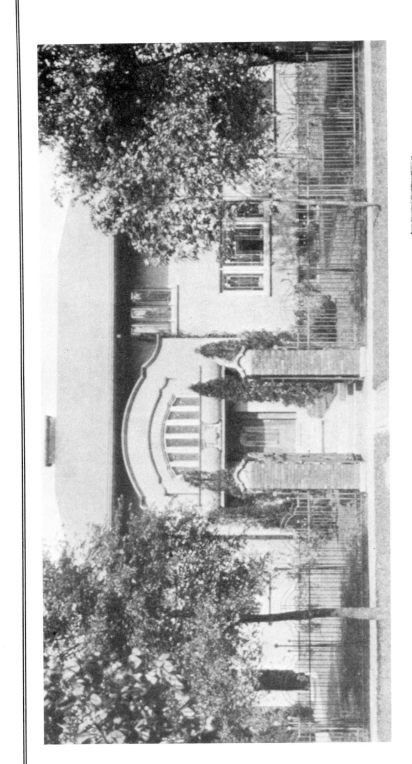

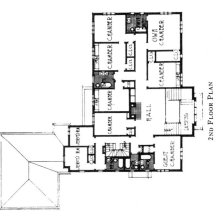

2ND FLOOR PLAN

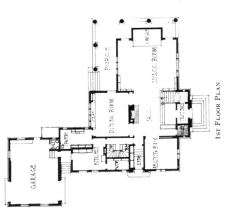

1ST FLOOR PLAN

RESIDENCE OF MR. C. R. IRWIN, OAK PARK, ILLINOIS
GEORGE W. MAHER, ARCHITECT, CHICAGO. :: ::

THE WESTERN ARCHITECT
MARCH :: :: 1914

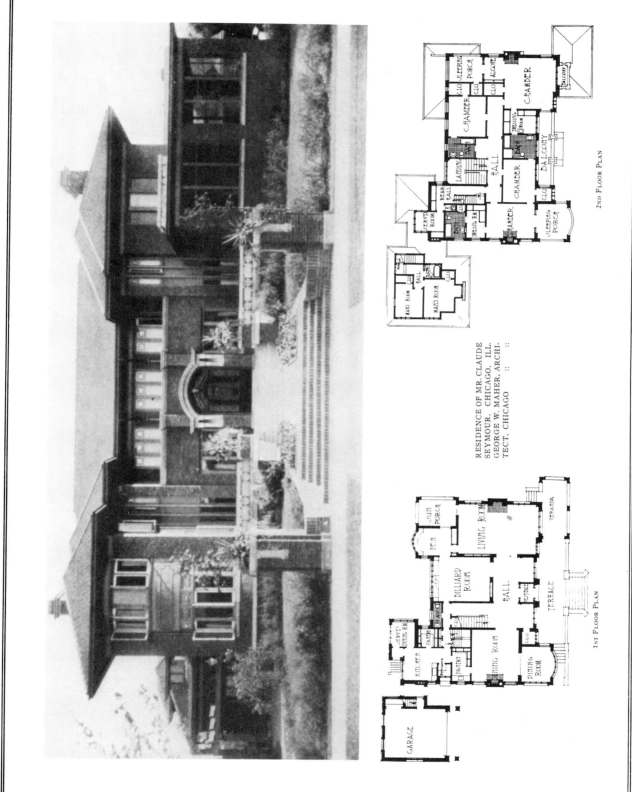

RESIDENCE OF MR. CLAUDE
SEYMOUR, CHICAGO, ILL.
GEORGE W. MAHER, ARCHI-
TECT, CHICAGO :: ::

1ST FLOOR PLAN

2ND FLOOR PLAN

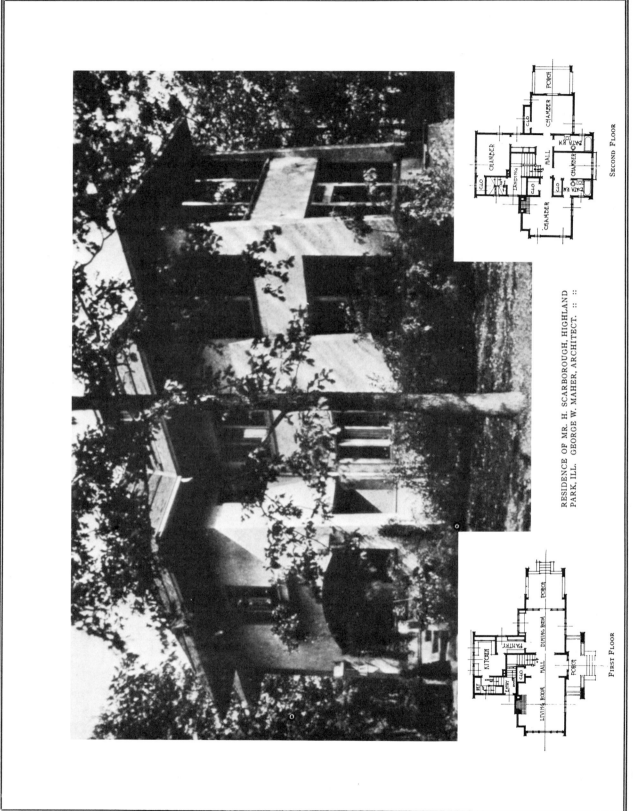

RESIDENCE OF MR. H. SCARBOROUGH, HIGHLAND PARK, ILL. GEORGE W. MAHER, ARCHITECT. :: ::

SECOND FLOOR

FIRST FLOOR

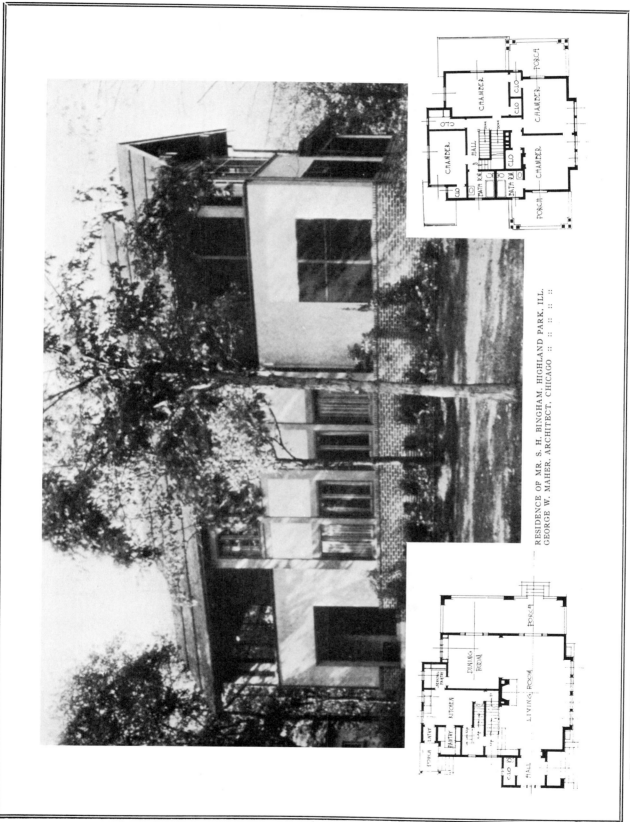

RESIDENCE OF MR. S. H. BINGHAM, HIGHLAND PARK, ILL.
GEORGE W. MAHER, ARCHITECT, CHICAGO :: :: :: :: ::

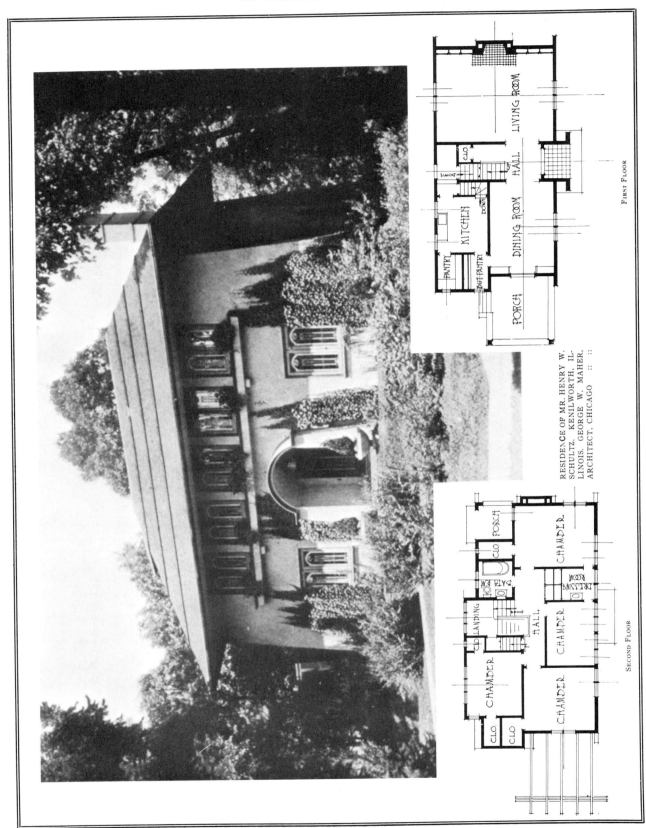

FIRST FLOOR

SECOND FLOOR

RESIDENCE OF MR. HENRY W. SCHULTZ. KENILWORTH, IL-LINOIS. GEORGE W. MAHER, ARCHITECT, CHICAGO :: ::

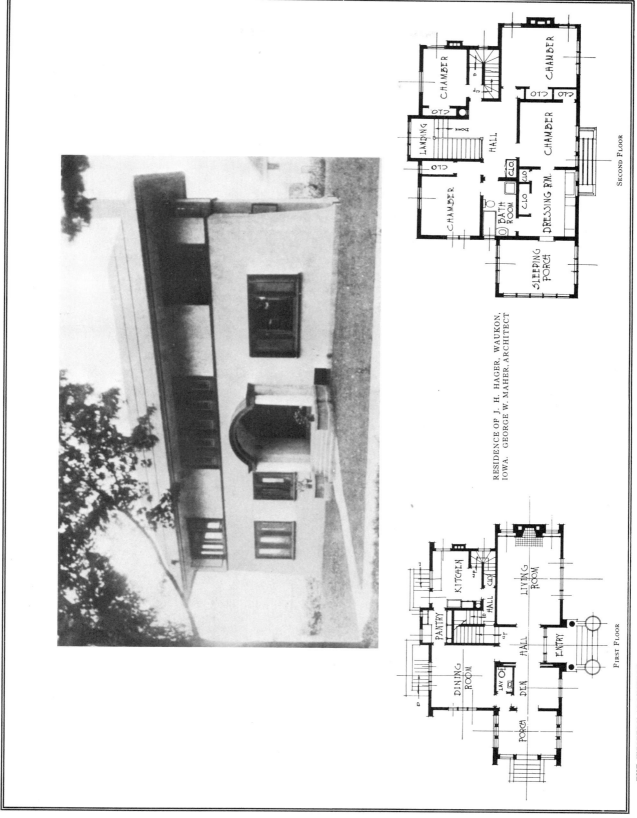

RESIDENCE OF J. H. HAGER, WAUKON,
IOWA. GEORGE W. MAHER, ARCHITECT

SECOND FLOOR

FIRST FLOOR

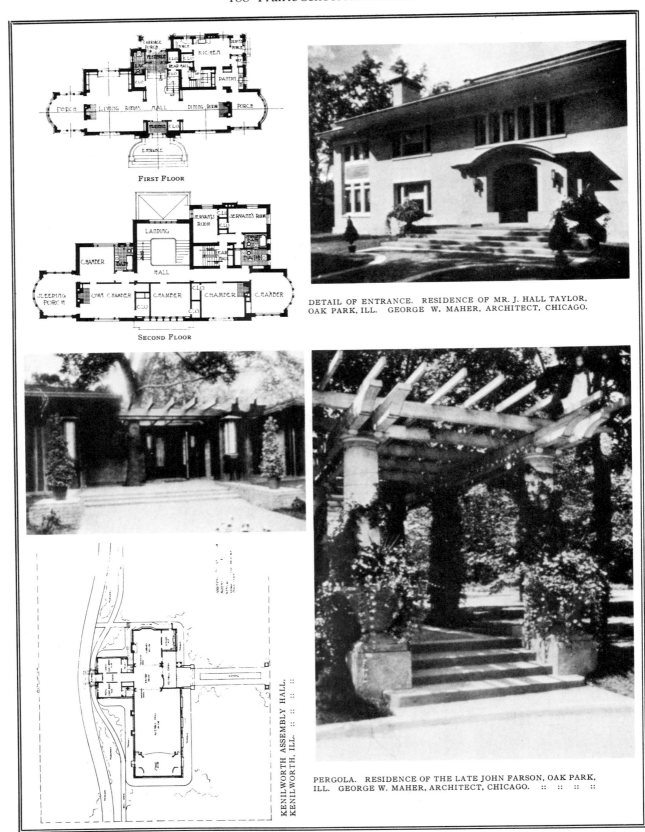

FIRST FLOOR

SECOND FLOOR

DETAIL OF ENTRANCE. RESIDENCE OF MR. J. HALL TAYLOR, OAK PARK, ILL. GEORGE W. MAHER, ARCHITECT, CHICAGO.

KENILWORTH ASSEMBLY HALL. :: :: :: ::
KENILWORTH, ILL. :: :: :: ::

PERGOLA. RESIDENCE OF THE LATE JOHN FARSON, OAK PARK, ILL. GEORGE W. MAHER, ARCHITECT, CHICAGO. :: :: :: ::

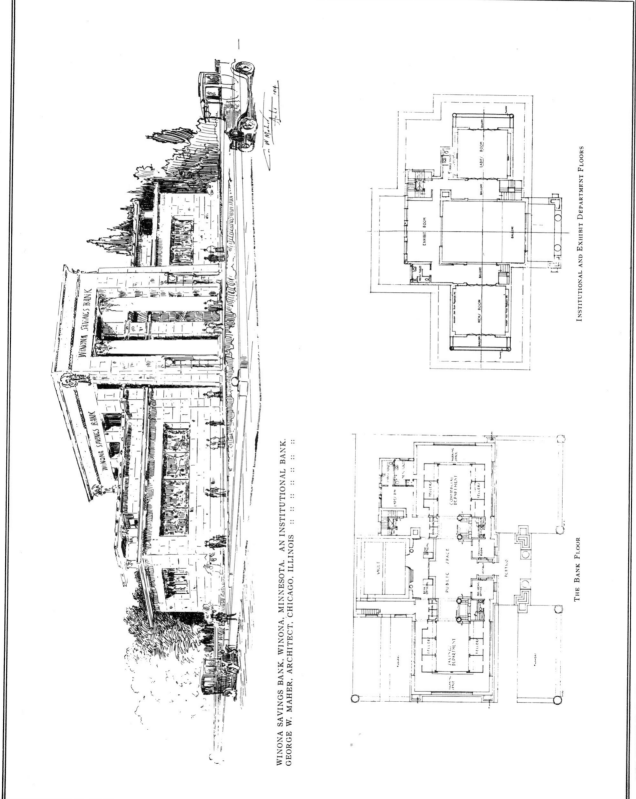

WINONA SAVINGS BANK, WINONA, MINNESOTA. AN INSTITUTIONAL BANK.
GEORGE W. MAHER, ARCHITECT, CHICAGO, ILLINOIS :: :: :: :: ::

INSTITUTIONAL AND EXHIBIT DEPARTMENT FLOORS

THE BANK FLOOR

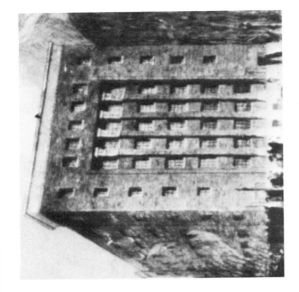

WAREHOUSE OF THE J. R. WATKINS MEDICAL CO. MEMPHIS, TENNESSEE. GEORGE W. MAHER. ARCHITECT, CHICAGO :: :: :: :: :: :: :: ::

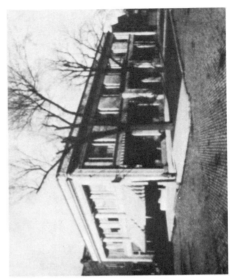

STORE AND APARTMENT BUILDING, EVANSTON, ILLINOIS GEORGE W. MAHER, ARCHITECT, CHICAGO :: :: ::

ENTRANCE TO STORE AND APARTMENT BUILDING, EVANSTON, ILLINOIS. GEORGE W. MAHER, ARCHITECT, CHICAGO :: :: :: :: ::

SPENCER & POWERS, ARCHITECTS
By William Gray Purcell

"Clever, but quite lacking in restraint."

"Restrained? But no imagination."

"Well! We do not approve of stunts."

"Oh! This is forced—affected!"

"Too dry and pedantic."

"Effeminate."

"Too Little."

"Too Big, too This, too That—There is the sort of thinking that we have served up as criticism. This seems to be the extent of the ideas of the professional critic with a reputation to uphold, reaching for his trusty tools and proceeding to apply them, not stopping to consider that a little daylight with some sunshine in it may be all that the case requires.

This "too long", "too short" sort of criticism, and we get little else, dressed out of course in all sorts of obscuring sauces and creams, is never going to get us anywhere.

If we are going to disintegrate a particular exhibit, let us give some evidence of recognizing the integers when we get them separated.

If we are going to examine and study any record of architectural work, let us please study what it is and not build up an elaborate consideration of what it is not.

I must say, however, that the few words of mine that are going to trickle along between these charming photographs of charming works of Western Art are not going to be of a critical nature. I had intended that they should be. I had always known that there

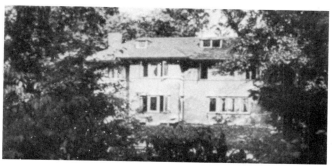

MR. SPENCER'S HOUSE FROM THE GARDEN

was "something about the work of Spencer and Powers that I did not like," until I came right down to make myself familiar with it. I then discovered that it was not qualities of their work to which I took exception, but qualities that were not their work that I was expecting to criticise. You have seen imitations of Mr. Spencer's work? Of course, you have and did not know it. Study these pictures and know the genuine from now on.

It may be that "an appreciation" of a series of works differs from "a critique" only in degree of understanding. If you know enough about the subject it is an appreciation, if it is all a mystery to you—turn on the hot faucet, conceal the whole affair in a cloud of steam and calmly wipe your shell rimmed glasses while the public tries to make out what it all means.

One gathers at once that such work as is illustrated

in this issue is produced in a very personal sort of a way. The buildings show a consistent spirit and type form and the detail at once indicates close personal attention and interest. This analysis is justified for us when we know how the buildings come into being, in an office which is like a big family. Mr. Powers in one little corner place of the draughting room and Mr. Spencer in the other, with a group of assistants that have grown up in the office and feel that they are a part of it. They feel that this personal quality which they bring to all that they do is the element that is going to solve most of our ills and we can heartily agree with them. As Mr. Powers says, there are hundreds of young men who would make active minded, enthusiastic designers, but they are largely to be found in business offices rather than in the draughting room and the architectural school. Creative minds are going where creative imagination is wanted. Mr. Spencer makes a distinctive between what he calls the creative spirit and the craftsman spirit which affords opportunity for much speculation. As he expects to set forth his views in print at no distant date I will merely leave the suggestion with you and you may apply it in analysis to the result of this idea as it may appear in the architecture itself.

I imagine that the authors of these works have no small amusement as a result of using architectural words that sound very familiar, that look quite innocent until you begin to realize that they say something quite different from what a too great familiarity with the outward forms of historic architecture makes us so readily assume.

May I inquire, gentle reader, in the case of the block of apartments for example, how many of you do you suppose, would have had the temerity to let your building rest so completely upon its own identity; to allow it to announce its completion with a simple band of brickwork and permit its lintels to begin their existence without a flourish of voussoirs. You may also be more quick than I was to notice that the composition is neither necessarily nor actually quite symmetrical. Note the series of nice little balcony floors indicating the reason for each Gothic looking, buttress-like setback, and a further drop back in the reverse sense, very obvious now that it is done, but which has to be felt for when one is thinking buildings before the material insistence upon two dimensions made by a sheet of

white paper. The idea involved here suggests an interesting aspect of the methods of study which Mr. Spencer and Mr. Powers have mutually developed. It is one that could be used with profit by us all. You will note the accurate and photographic quality of the perspective renderings of projected buildings. They are made not merely to give the client a good idea of his building, but as an attempt to investigate the actual values as they will appear in the complete work. The interest is all in the building to be. Out doors, length, breadth and thickness. The water color drawing is but a means to a real end, and that end—the building itself. Plan and paper values are eliminated. Tricks and "effects" of architectural rendering, which we know evaporate in the complete building are not a part of this work. Mr. Powers showed me a number of water color drawings and beside them photographs of the completed buildings, taken from the same point of view. The parallel in mass and detail was complete. To design and evolute a building itself, rather than a conventional image of it on paper, is an achievement.

A friend with whom I have been discussing this collection of photographs of the work of Spencer and Powers seemed to be troubled, because although he *liked* (our old friend again) the work and thought it good, he could not place it in any "style"; none of his labels seemed to fit either as to what it was, or where it might have come from. He even thought that Spencer's work ought to be "Chicago-like", "New", "Progressive", or something of that kind—"but it didn't look it". "How could one belong to that crowd up on the top floor of Steinway Hall for so many years and not show it in his work?

Dear! Dear! is this sort of thing contagious? I suppose it is, only it apparently produces a different brand of enthusiasm in different individuals. Well, a few of us believe, and the architectural statements of these gentlemen would indicate the same idea, that anything in the way of a building to which you can really attach a "style" label, is really not Architecture. Such buildings may come near being good Literature; the more clever of them are annoyingly near it.

Mr. Powers, who is most conscientious about establishing an accurate Form and Function relationship in structure and materials, brings out clearly the difference between the "half timber" suggestion that some of his designing brings to mind for those who know something of historic architecture and the "half timber effect" which is generally sought after. The integrity and honesty of the result are tested by the intent. The regularly accepted method is an attempt to deceive and much machinery in the way of false braces, peg heads and brackets are forced into the design to cover up the evidence of falsity. In these buildings the intent is nothing more than a reasonable desire to panel or divide up an area of wall, or to make the natural panels, which windows are, form a pattern with other panels arranged to suit the fancy. The few misguided attempts to build actual "half timber" houses in this age; framed structures filled with brick masonry as in the old days, are false in quite another way. They make positive statement of social, economic and technical conditions which do not exist and contradict present methods, materials and craftsmanship. They serve at least as material evidence by which we can come to distinguish between architecture that is real and that which has only a literary value.

And so, here and there in these photographs we seem to see traces or recollections of familiar architectural forms, and many good friends who love the good, evident, incontestible outsides of things, will fondly cling to these incidental recollections with a sigh of relief, that here at least is one of those Westerners who isn't going to make us think.

You are not going to be let off so easily, however, for these reminiscences of historic architectural forms are little more than our dear old "Once upon a time—", and what follows or lies within, to drop our fairy tale metaphor, is really potential with Western feeling. That word may characterize this work as well as anything—potential—one doesn't begin to realize just what vitality and interest it has until he knows it thoroughly, and the Eastern Critics do not become really exasperated by it, because it looks so innocent and is so inexpensive that they never give it enough attention to find out how vigorously such a pernicious and dangerous departure should be put down.

Mr. Spencer tells of an amusing conversation between himself and a couple of classical architects who were demanding to know why, if our *new* Architecture in the West had any claim to be on earth, we could not show some really big Architecture, like Senator Clark's house, for instance, the New York Public Library, or the Pennsylroman Bathway Station,—something really expensive. Mr. Spencer gathered, between his apologies for not having anything really important to show, that if a building cost enough and was designed by a sufficiently well known firm, for a very much talked

STUCCO CEILING PIECES FOR
PENDANT ELECTRIC FIXTURES
MR. SPENCER'S HOUSE :: ::

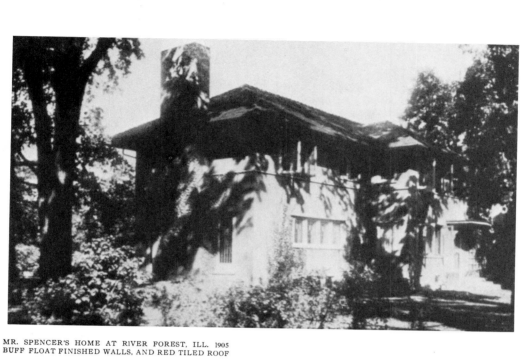

MR. SPENCER'S HOME AT RIVER FOREST, ILL. 1905
BUFF FLOAT FINISHED WALLS, AND RED TILED ROOF

LIVING ROOM
GLAZING

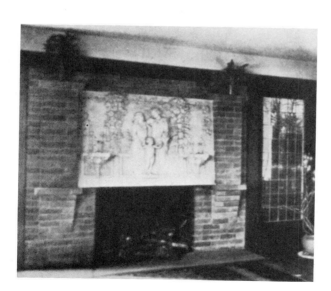

DINING ROOM
GLAZING

THE LIVING ROOM FIREPLACE
A. L. VAN DEN BERGHEN, SCULPTOR

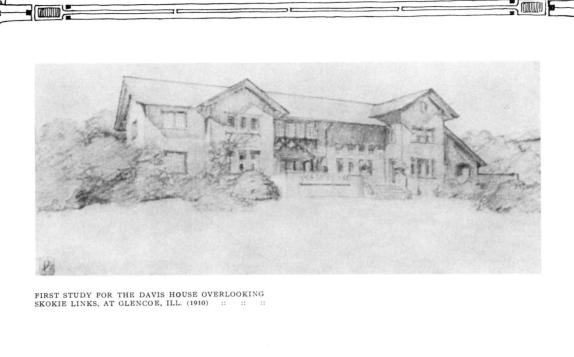

FIRST STUDY FOR THE DAVIS HOUSE OVERLOOKING
SKOKIE LINKS, AT GLENCOE, ILL. (1910) :: :: ::

TYPICAL GLAZING
FIRST STORY :: :: ::

TYPICAL GLAZING
SECOND STORY :: ::

ADAMS (NOW LILLY) HOUSE, INDIANAPOLIS 1903
MERIDIAN STREET FRONT :: :: :: ::

about citizen of the only town of any consequence, that it could then claim to be high art.

It would be nice occasionally not to lose through lack of funds, some of the fun and the possibilities in the schemes which hold so much interest in prospect for us and our clients, but we can be content with Stobart when he says in his "Glory that was Greece" — "He that cannot *see* the Parthenon in the most obscure vase made by some humble potter of the Ceramcikos cannot really *see* the Parthenon at all".

Whatever is to be the architectural "style" of this time of ours in which we are living, whatever name it is to carry when we are gone long enough for people to have forgotten enough of what we really were and show ourselves to have been —to give our work a style title, we do not know, but we do know that these quiet, earnest, s i n c e r e, m o d e s t buildings will be found to have each held their little

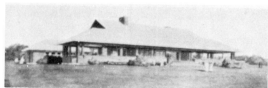

STUDY FOR LUTHERAN CHURCH 1906

fill of the essence of what the true building art of this time may be.

It would be wholly redundant to make detailed descriptions of these photographs.

They tell their own story.

But they tell no story to him who takes his copy of *The Western Architect* in between draughting table and the morning mail and runs over the leaves with the usual,—

"Interesting—"

"Clever, but—"

"Punk!"

"Say Jim, look at that for "Tudor"—Humph!"

"Trying to be original, I suppose. That's the way with these so-called Progressive architects, wanting to throw overboard the glorious past and make us speak in a new language." Etc. Etc.

Any such consideration of a man's lifework is not going to give you much idea about it, whether it be really vital or not vital.

But that is about the sort of consideration we all give to the other fellow's work, unless he is heavily advertised, is it not?

If we don't see at the first glance about the same "treatment" (Oh, these buildings with treatments) that *we* would give the problem, we turn over the leaf and think no further.

Let us turn over a new kind of a leaf.

Let us assume that possibly the real value of work of architecture does not rest in what you see when you look at it. For we see only with that which we bring. And the authors of these buildings have brought to

them a whole, friendly, cheerful, life full of enthusiastic, earnest days and if you will stop looking at the material outsides of this Architecture, stop inspecting the little beliefs, mannerisms, deferences, reminiscences, and get right into the spirit and religion of it all taken as a whole, thought about and not merely looked at, then you will surely make your own something that you can bring to even the casual looking at the next vital work you come across.

This determination to admit no incidental matters, no evidences of things that are only immediate and not universal, is a most difficult one to acquire. The practise of it is usually referred to as "having a perspective". With respect to individual works, especially such as these where the material reality of windows, doors, roofs and chimneys array themselves before the eye, it is not perspective but intuition that is needed.

Did you expect that appreciation was praise? No more than criticism is condemnation. It has come to seem that Appreciation is judgment by an optimist who is going to sift out the good kernels though the chaff be as a little hill, and that criticism is judgment by a gloomy but important person who will find the error and show it though it be as a broken needle in the haystack.

But appreciation and criticism are neither of these conditions, neither are they merely the two faces of Judgment. Largely are they the desire to put others in tune with the character of an author as revealed in his work. Education doesn't mean telling people facts and formulae—but bringing them to where they can see clearly for themselves. Appreciation and criticism are most effective, not in dissection, but as a sort of harmless X-ray that lets us understand the true inwardness that the eye cannot reveal.

Under any other conditions this text would be superfluous. If the running notes of thoughts and feelings which these photographs have given me will encourage you to give the time and sympathy necessary to understand and enjoy them, then our friends, the authors of these interesting buildings, can ask of *The Western Architect* no more effective appreciation,.

COUNTRY CLUB. SEDALIA. MO. (1909)

HOUSE AT ROCK ISLAND, ILL. DESIGNED AND BUILT (1909-10) FOR
SUE DENKMANN, (NOW MRS. J. H. HAUBERG.) AN IDEAL CLIENT.
THE WALLS ARE GRAY BUFF ST. LOUIS MANGANESE BRICK OF
NORMAN SHAPE; ROOFS, CLOVER PORT RED SHINGLE TILE. CON-
STRUCTION, FIREPROOF. JENS JENSEN WAS THE LANDSCAPE
ARCHITECT. :: :: :: :: :: :: :: :: :: :: ::

PUBLIC PARK

DEPRESSED
SERVICE YARD.

ROSE-
GARDEN

SERVICE DRIVE

CONSERVATORY

LAWN

RESIDENCE

STREET
END.

GARAGE & STABLE

DRIVE.

S

E — W.

N

0' 20' 40' 60' 80' 100'

SCALE 1 IN. = 20 FEET.

GATE.
STREET
END.

PLOT PLAN OF PART OF
MRS. SUE. DENKMANN-HAUBERG'S
PROPERTY AT ROCK ISLAND ILL

TERRACED VEGETABLE GARDEN

PERGOLA 480' LONG.

SPENCER AND POWERS
ARCHITECTS

JENS JENSEN
LANDSCAPE ARCHITECT.

FROM THE FACE OF THE BLUFF ABOVE THE DRIVE.
AN HONEST HOMELIKE HOUSE, SUGGESTING STABILITY
AND RESTFULNESS :: :: :: :: :: :: ::

FIRST FLOOR PLAN

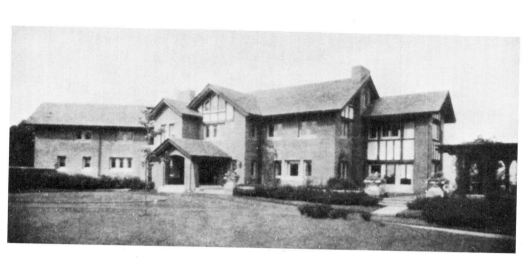

LOOKING WESTWARD ACROSS THE LAWN

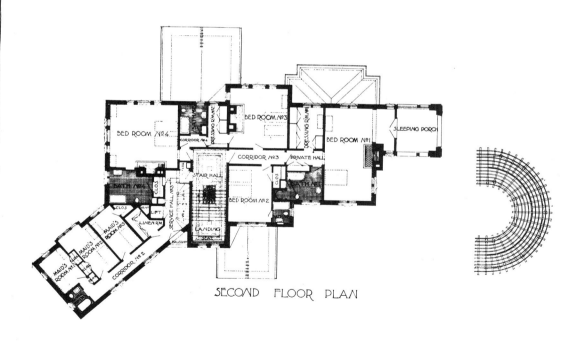

SECOND FLOOR PLAN

THE HAUBERG LIVING ROOM (AEOLIAN BAY AND SCREENED PIPE CHAMBERS AT LEFT) WITH GLASS MOSAIC FIRE-PLACE, RUG, TABLE, DAVENPORT AND ORGAN CONSOLE DESIGNED BY THE ARCHITECTS :: :: :: :: :: ::

THE HAUBERG LIBRARY. GRAYS ARE THE DOMINANT TONES, RELIEVED BY RICH COLORING. FURNITURE, RUG AND DECORATION EXECUTED BY NIEDECKEN AND WALBRIDGE, AND DESIGNED BY THE ARCHITECTS ALONG WITH ELECTRIC FIXTURES AND GLAZING :: :: :: :: ::

THE WESTERN ARCHITECT
APRIL :: :: 1914

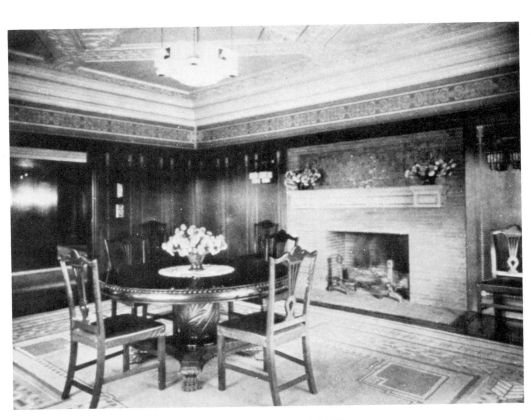

THE HAUBERG DINING ROOM.
BROWN MAHOGANY WAINSCOT
DELICATELY ENRICHED WITH
GOLD AND COLOR :: :: :: ::

TYPICAL WINDOW
CONVENTIONALIZED
TULIP MOTIF IN ZINC
BAR, ACCENTED
WITH ETRUSCAN
AND IRIDESCENT
GLASS :: :: :: :: ::

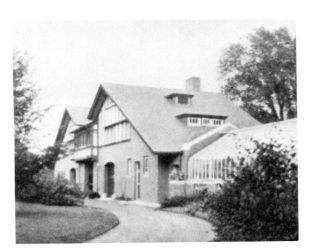

STABLE, GARAGE AND GREENHOUSE
FROM SERVICE DRIVE :: :: :: :: ::

ENTRANCE PORCH
LAMP :: :: :: ::

THE HAUBERG GARAGE, STABLE AND GREEN-HOUSE FROM PAVED TERRACE OF HOUSE

THE WESTERN ARCHITECT
APRIL :: :: 1914

INDIRECT LIGHTING FIXTURE AND RELATED STUCCO
CEILING TREATMENT IN LIVING ROOM---HAUBERG HOUSE

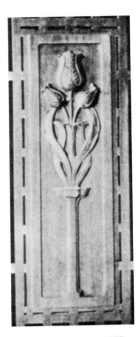

TULIP MOTIVE REPEATED
IN ORGAN SCREEN :: ::

CAST STONE URN, ENRICHED WITH TULIP MOTIVE
HAUBERG HOUSE, ROCK ISLAND :: :: :: ::

STONE INSERT IN
ENTRANCE PORCH

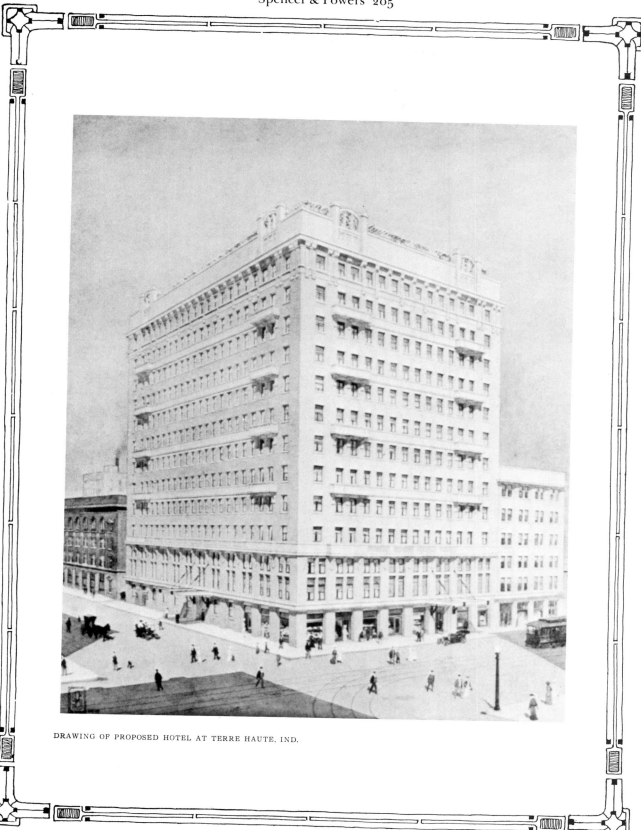

DRAWING OF PROPOSED HOTEL AT TERRE HAUTE, IND.

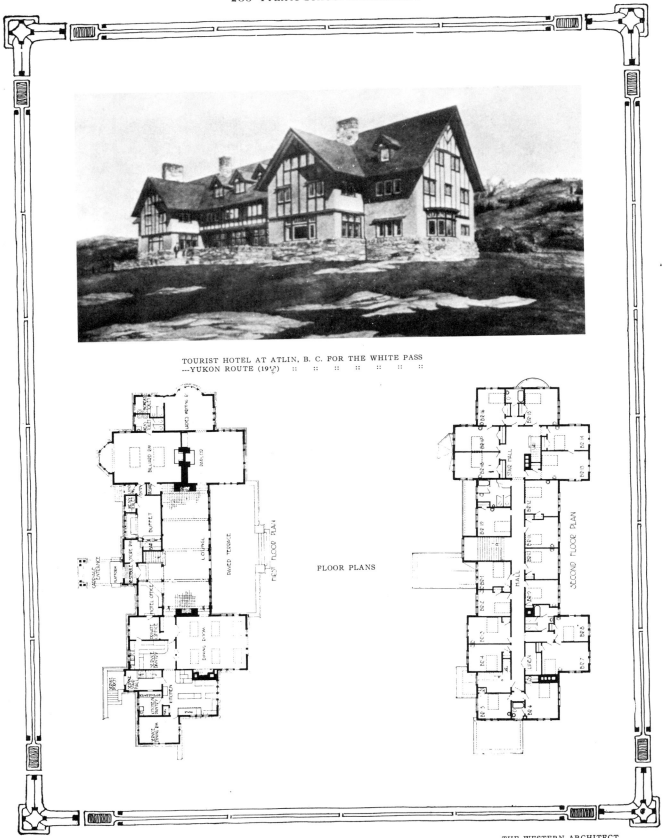

TOURIST HOTEL AT ATLIN, B. C. FOR THE WHITE PASS
---YUKON ROUTE (1912) :: :: :: :: :: :: :: ::

FLOOR PLANS

"OVERBROOK"---COUNTRY ESTATE OF FRED B. SMITH AT ALLENDALE NEAR TERRE HAUTE, IND. (1910) :: :: ::

WALLS OF DANVILLE, ILL. BRICK. ROOFS OF CLOVER PORT, KY. RED SHINGLE TILE :: :: : :: :: :: ::

VIEW OF HOUSE AND GARDEN TERRACE WALLS FROM SIDE OF BLUFF :: ::

JENS JENSEN, LANDSCAPE ARCHITECT ASSOCIATE :: :: :: :: :: ::

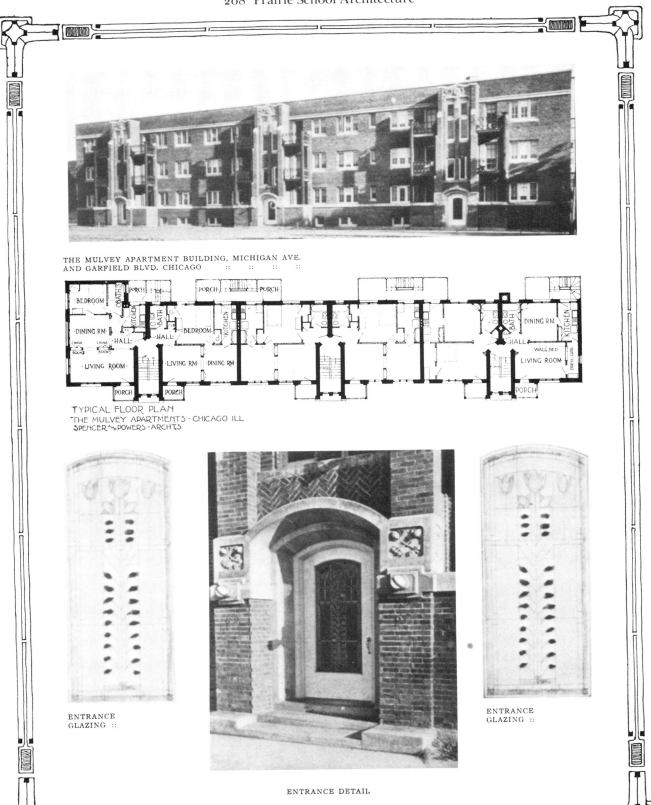

THE MULVEY APARTMENT BUILDING, MICHIGAN AVE.
AND GARFIELD BLVD. CHICAGO :: :: :: ::

TYPICAL FLOOR PLAN
THE MULVEY APARTMENTS - CHICAGO ILL
SPENCER ᴀɴᴅ POWERS - ARCHTS

ENTRANCE
GLAZING ::

ENTRANCE
GLAZING ::

ENTRANCE DETAIL

OAK PARK HIGH SCHOOL, 1905.
ASSOCIATE ARCHITECTS N. S. PATTON AND R. C. SPENCER, JR.

MAIN ENTRANCE, OAK PARK HIGH SCHOOL

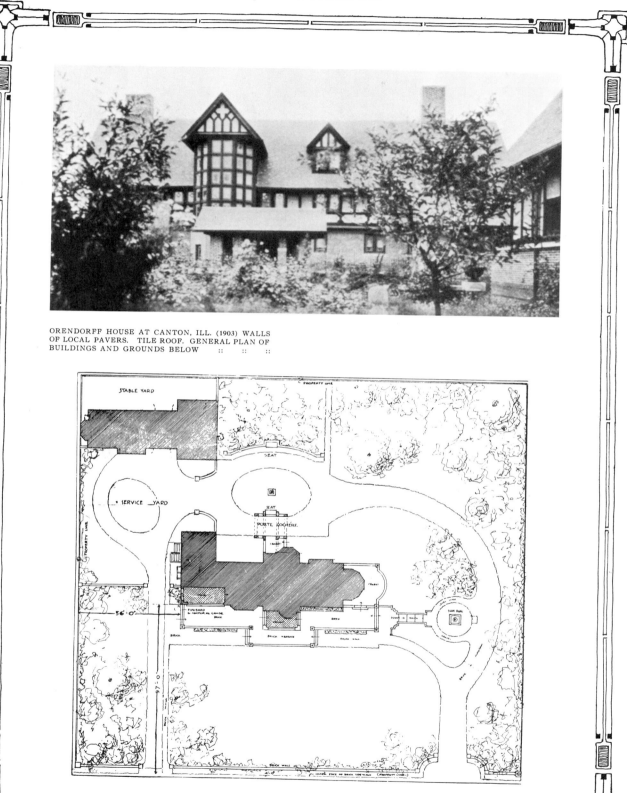

ORENDORFF HOUSE AT CANTON, ILL. (1903) WALLS
OF LOCAL PAVERS. TILE ROOF. GENERAL PLAN OF
BUILDINGS AND GROUNDS BELOW :: :: ::

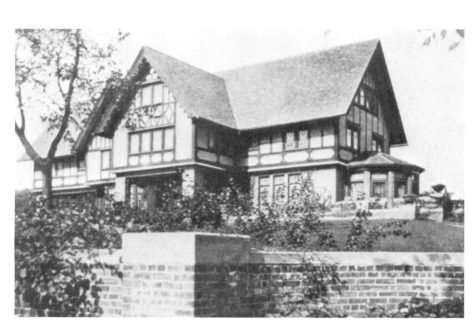

ORENDORFF HOUSE FROM SOUTH EAST

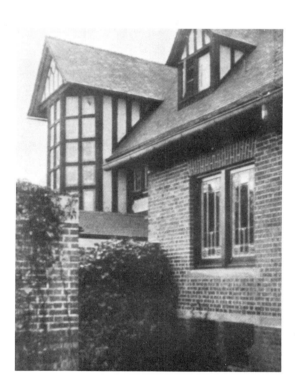

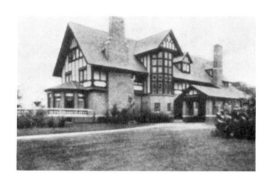

THE NORTH SIDE

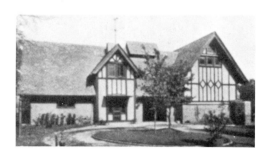

DETAIL OF STAIR BAY

THE STABLE AND GARAGE

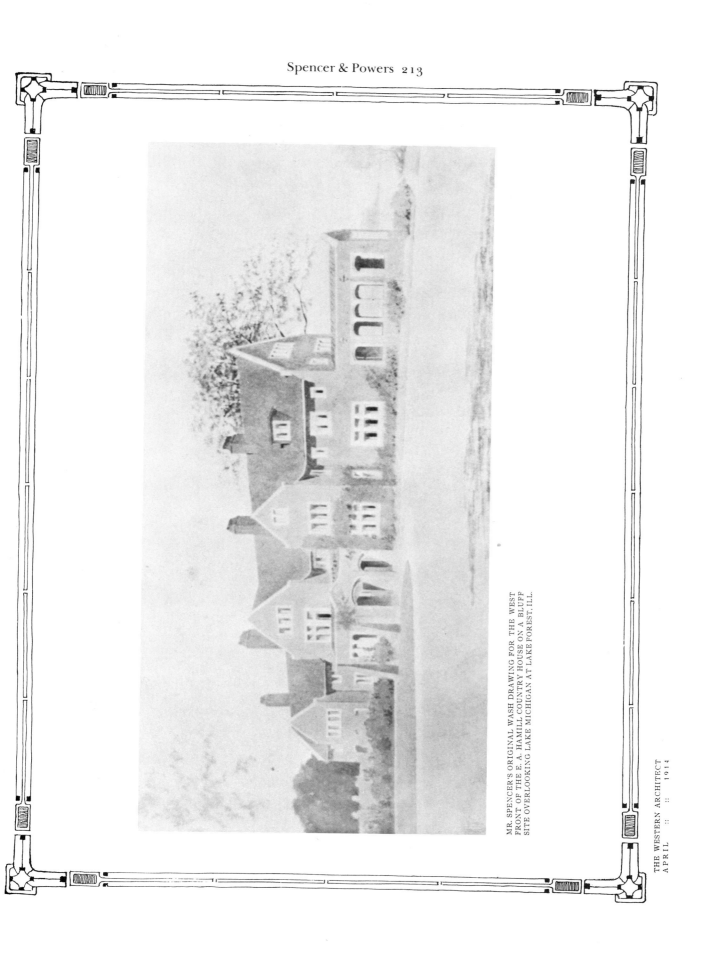

MR. SPENCER'S ORIGINAL WASH DRAWING FOR THE WEST
FRONT OF THE E. A. HAMILL COUNTRY HOUSE ON A BLUFF
SITE OVERLOOKING LAKE MICHIGAN AT LAKE FOREST, ILL.

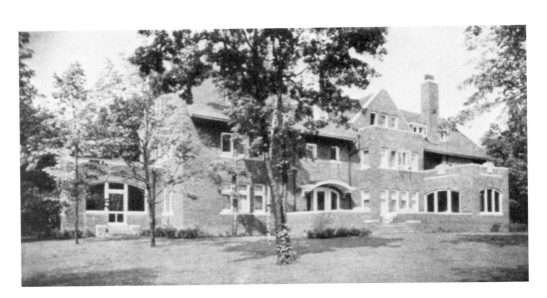

E. A. HAMILL HOUSE, LAKE FOREST 1905
FROM THE LAKE SIDE. DULL RED PAVERS.
RED TILE ROOF :: :: :: :: ::

THE GARDENER'S COTTAGE AND
GATE LODGE :: :: :: ::

STABLE, GARAGE AND COACHMAN'S HOUSE
OLMSTEAD BROTHERS, LANDSCAPE
ARCHITECTS :: :: :: :: :: ::

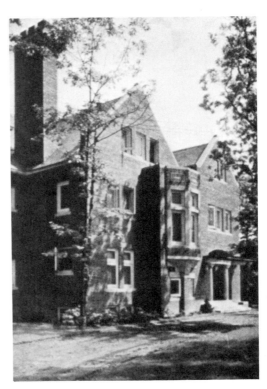

DETAIL OF ENTRANCE SIDE

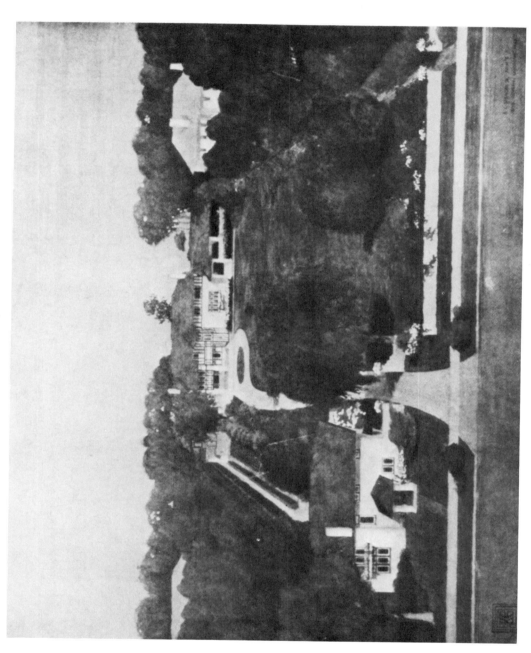

BIRDS'-EYE
VIEW OF
MAGNUS
PLACE, OVER-
LOOKING
LAKE MICHI-
GAN AT WIN-
NETKA :: ::

JENS JENSEN,
LANDSCAPE
ASSOCIATE

WATER
COLOR
BY MR.
SPENCER

MAGNUS HOUSE ON THE LAKE SHORE AT WINNETKA, ILL. (1905)

· FIRST FLOOR PLAN ·

PORCH ·

LIVING ROOM ·

DINING ROOM ·

SERV PANTRY

BILLIARD RM

HALL UP

LAV

ENTRANCE PORCH ·

KITCHEN

MAIDS' D·R

PANTRY

COOL RM

ICE

SERV'TS PORCH

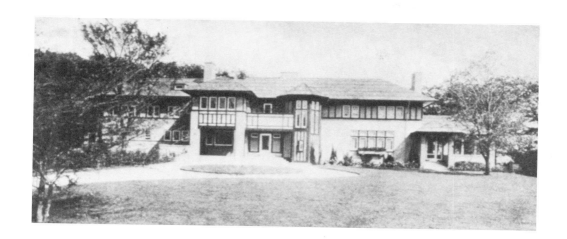

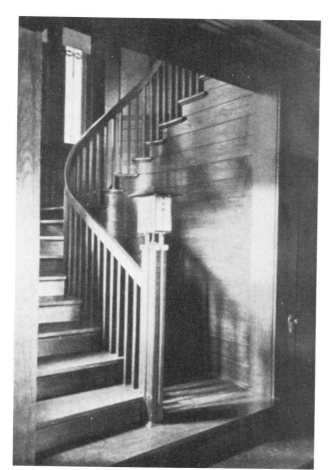

THE WEST FRONT AND
THE STAIRCASE :: ::

MAGNUS HOUSE. THE NATIVE
HAWTHORN CONVENTIONALIZED
IS THE DECORATIVE MOTIVE IN
ALL THE WINDOWS AND IN THE
LIVING ROOM CEILING. BEAUTI-
FUL SPREADING HAWTHORN ARE
A STRONG HORIZONTAL NOTE IN
THE PLANTING :: :: :: ::

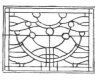

TYPICAL
GLAZING

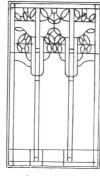

SECOND STORY

HAWTHORN
IN LEAF ::

FIRST STORY

HAWTHORN
LEAFLESS ::

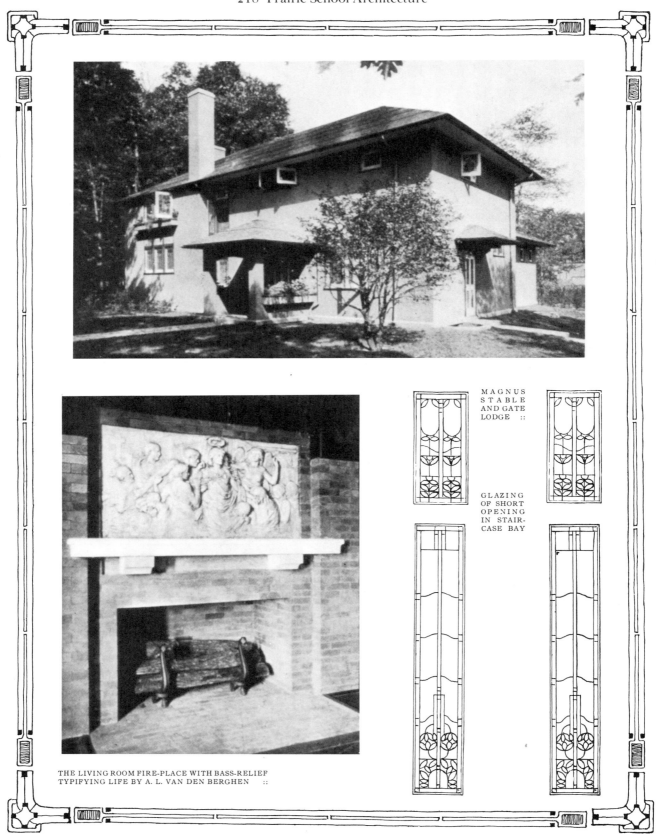

MAGNUS
STABLE
AND GATE
LODGE ::

GLAZING
OF SHORT
OPENING
IN STAIR-
CASE BAY

THE LIVING ROOM FIRE-PLACE WITH BASS-RELIEF
TYPIFYING LIFE BY A. L. VAN DEN BERGHEN ::

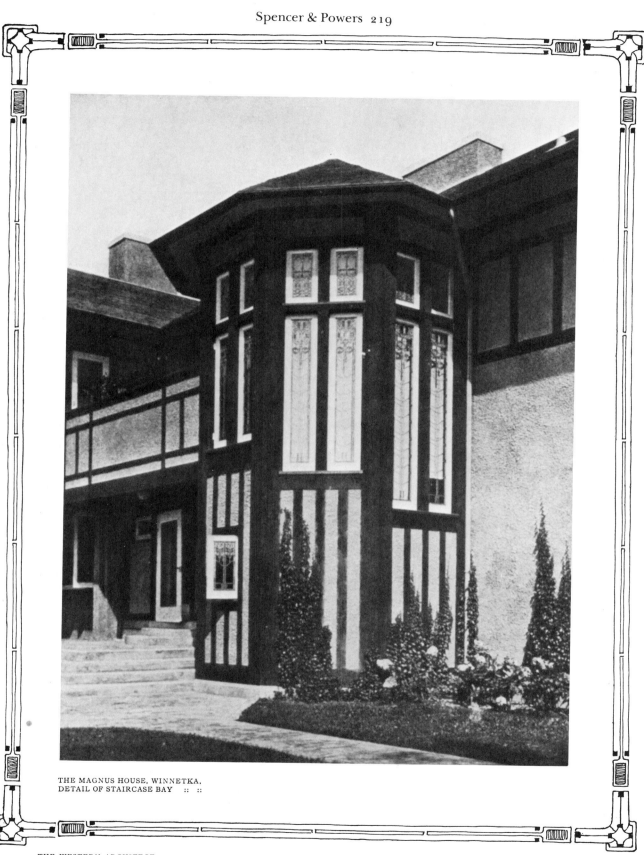

THE MAGNUS HOUSE, WINNETKA,
DETAIL OF STAIRCASE BAY :: ::

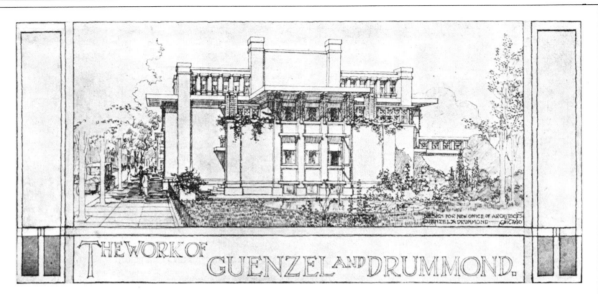

THE WORK OF GUENZEL AND DRUMMOND.

Editor's Note: "An architect should speak through his work. If that lacks expression then he is compelled to tell what it means, where derived and why it is germane." This was the answer we received when asking Messrs. Guenzel and Drummond to furnish us with a description of their work. Nevertheless, later, Mr. William Drummond volunteered to write an article just to air some of his "shop" thought. The following article is the result. We feel that Mr. Drummond has delivered a message which will be read with pleasure even by those who are usually least interested in architecture, while to the professional reader he has given much food for thought. :: ::

ON THINGS OF COMMON CONCERN

The design of buildings and their appurtenant surroundings must, of course, always be considered as resting on universal need. Shelter and structural utilities of every sort and kind, except the very simplest, spring from the need of the many and everywhere symbolize something of social significance, whether they be "designed" or not. This is self-evident.

In speaking of architecture, everything depends on the viewpoint as things are today. A layman usually thinks of an architect merely as one who can assist him in getting his buildings up—sometimes he thinks of him also as a trustworthy adviser in the selection of "style," but sometimes when he has thought over his problem he "approaches" his architect with an open mind. In this event he may be glad to have the fact pointed out that buildings are not in themselves things that are by social dictate, so to speak, "assembled" from parts taken from a stored-up set of forms which have been "halo-ed" by long ages of usage. This is what the schools claim, but fortunately for art's sake the ordinary layman of the West does not yet recognize his own "ignorance"—instead he instinctively feels an individual need, not related to former time or place. He wants "individuality" and a harmonious disposition of the elements that go to make his problem unique.

The typical "Westerner" may request of his architect a building, "a little out of the ordinary." In other words, by way of protest against the present tendency toward "style" mongering, he is saying that he does not care for templesque or cathedralesque or for any expression of "style" intended to recall these by the use of derived forms. The architect may assure him that style may well take care of itself, provided he wants his buildings so designed as to be suitable to the

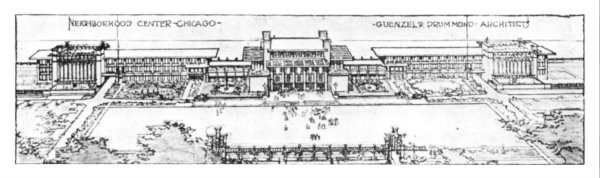

NEIGHBORHOOD CENTER ·CHICAGO· ·GUENZEL & DRUMMOND· ARCHITECTS

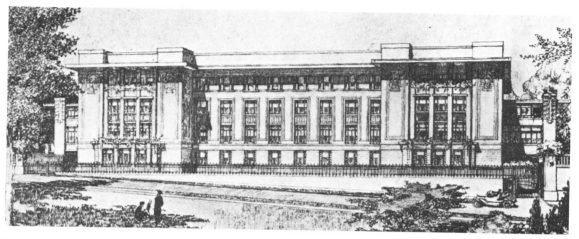

:: :: :: COMPETITION DESIGN FOR GERMAN EMBASSY BUILDING, WASHINGTON, D. C. :: :: ::

limitations of actual conditions and to nicety of use, and is willing that the architect may have free opportunity to work within the scope of these restrictions. He will explain that a true expression of individuality is more or less a certain outcome where the owner and the architect meet on definite terms, the one with a clear idea of his need, the other with a clear idea of how to satisfy this man's need in a practical and wholly complete manner.

To satisfy the requirements of a structural problem by the employment of such form as is best suited to needs, to develop the aspect of unity in such builded forms and to show forth such beauty as the employed materials may possess by arrangement of contrasts and special treatment, is "shop" work of a kind that must give to the eye of the beholder more or less of appreciative pleasure and intellectual satisfaction in the things thus brought about.

The aspect of unity—the speaking quality—of a composition is the greatest quality a building can possess, for then we see it separate from that of which it is made, as we see a tree or a person,—it is individualized. The idea of unity is best expressed perhaps by the words, seeming indivisibility.

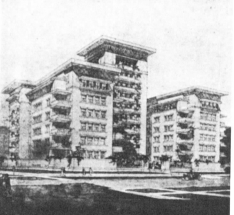

:: DESIGN FOR A CHICAGO APARTMENT BUILDING ::

So then, any construction which purports to be a whole must inevitably have that organization of parts which is best explained by the idea of subordinate units arranged in series of different kinds, each indispensable to the whole, yet each having the appearance of unity within their own separate sphere of influence. Where separation or union must occur between parts, each part shows to best advantage where it maintains its individuality. For we started out to convey an idea in a special way and cannot violate the essential need of a showing of unity as opposed to a showing of confusion, by departing from our idea and introducing a contrary order; for instance, a blending where a separation is required. A wall and a ceiling, where blended by a curving surface, never conveys a beautiful thought. A column, which is part wall, part column, is always offensive to the instinct which looks for structural truthfulness. A beam, obviously unnecessary, but a part of a ceiling resting on such a false column, is manifestly absurd. Yet, almost entirely of such confused absurdities is the Renaissance style composed.

If the idea of organic structural arrangement is clear in the mind of the designer, then what influence should natural environment have on his creative impulse? The earth's surface is composed of plains, water levels and hills or mountains; that is, level, oblique and broken surfaces. Since there is no absolute standard of the beautiful, it follows and is apparently true and usual that the appearance of any hill or broken feature of the landscape can be agreeably modified by the introduction of trees, walks, roads, fences or the walls and roofs of buildings.

We can treat the hill, or slope or cliff in a large way as part of our "composition,"—we organize an arrangement. The slope, the contour or the silhouette, may be emphasized or modified by the lines with which we join, or the spaces by which we separate the elements of our composition. Groups of build-

ings, trees or other features become units. The group can then be composed with an eye to a subordinate arrangement of units. Color of building material and of natural surfaces and richness of verdure may be effective in producing thrilling contrasts.

Now, the flat or level prairie creates an entirely different problem as far as opportunity of modification is concerned, for we are extremely limited as to viewpoints compared to conditions, as outlined above, where the whole composition is seen from many viewpoints. To see the flat city you must be in the midst; for, if outside, you see only a silhouette which can but hint at an order of arrangement, and the nearby view is lost. It would seem, that by using three or four different houses for the building of a whole city, placed in constantly changing arrangement of grouping and planting, there would be local character and more variation of aspect than is possible today where endless rows of houses of all sorts and kinds toe right to a line in a most monotonous and deplorable similarity. Such is the inevitable result where freedom of arrangement, our only opportunity for play of artistic impulses, is impossible because of our social condition where everyone seems more anxious to conform to a hard and fast equality in appearance, however ridiculous it may actually be, than to seek individuality in a free atmosphere where changing circumstance would at least develop a variation of aspect.

If environment places on the architect only such restraint in the design of the particular as is consistent in a broad arrangement of all the natural and artificial features of a composition; then, of course, with respect both to the eye of the beholder and to practical requirements, he is limited as to one best possible solution of every problem; so, in the nature of things architecture really starts and ends with arrangement. He then must have some method of conveying this information by which order is established in the prosecution of any building operation; so, how shall the architect word his exact meaning?

We use a line to signify a separation or a joining. Where an edge or termination occurs it is spoken of as a line. We speak of emphasizing lines—vertical lines—oblique lines and horizontals. To answer a significant question as to whether the dominant horizontal line is peculiarly appropriate to the level or the rolling prairie land, we should say: that the repetition of the lovely line where the land and the sky meet is the most appropriate, that it assures the most of a quiet reposeful ensemble, because it remains always subordinate in relation to the whole view, that the great arching

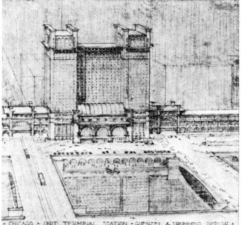

· CHICAGO · UNIT TERMINAL STATION · GUENZEL & DRUMMOND PROPOSAL ·

dome overhead appears still more vast and wonderful because of the harmony and subjective quality of the repeated horizontal lines. But freedom, within such certain broad limitation or "straight line restraint," is not sufficient for some of the nearer sighted designers who will say: "yes, but man always craves the thing which nature did not provide; he wants the high tower or the pyramid to 'relieve' the landscape of monotony." Let him prove his theory and we shall find that in his work he has used the horizontal because he had to. That people cannot live in towers and pyramids, is self-evident; so, he tried to use a combination of the oblique with all manner of curved make-shifts in order to escape the insistence of the horizontal. "Besides," he will say, "you designed the horizontals for the prairie and then you use them on the hill top and mountain side where they look ever so much better than they did on the level prairie." "Why, of course!" we answer, "for you can see them from many more viewpoints which do but exhibit their real character in greater measure." He blundered in thinking that he had proof that we were wrong in the first place; and so, by a sort of left-hand self-deception, he is equally sure that the use of the "styles" must be right. But, is it not true with all the heat of our clash of opinion, that while the horizontal is peculiarly at home on the prairie, it is actually a rectifier of vision on the oblique or broken site?

We are built to stand on plumb lines or lines polar to the earth and our eyes pair absolutely on the level. So for this and for other obvious reasons, it is an instinctive need that man expresses when he lays out his building on the level, swings its axis at a right angle to the sun's path and builds his walls perpendicular. Since the light is from above, his horizontals, or horizontals in combination with obliques, always give a shadow or emphasis to the level line. So, his generous roof line, in creating shelter from an inclement sky, exhibits that sweet and intimate quality of shelter inseparable from the idea of "home." The buildings of the native Bhutanese and Swiss have visualized this quality perhaps more markedly than those of any other people. Of course, conditions of site fix the orientation of these buildings as is seldom the case where people build on level lands. Even while the horizontal is the most reposeful as compared with the vertical and the oblique, conditions must always compel the exercise of reason in its use for the kind of building required. A tall building with accentuated horizontal lines is an incongruity evidencing confusion of thought, because a tall feature or tall building

stands contrary to the broad base of repose and contrary things always tend to destroy one another.

In nature there exists an ever changing condition; the expanding cloud majestically rising against the blue, the slow motion of the glacier, the quick rush of storm, the drift of sand or snow before the wind, or the action of vibrant sunlight as it splits up in changing into the growing plant; these do but exhibit, in most impressive form, the endless transition of which we are ourselves but a part.

In building, then, the decorative line, form and color, must symbolize the desire of the inner being to see and feel as opposed to the obvious inertia of a structural necessity; an element which is free moving and accentuative of direction, something which has the feeling of a continuation. It is necessarily subsidiary to the structural motive. The decorative line which emphasizes the structural form, is always the most exquisitely beautiful where its subtle influence works for unity of the whole. In architecture we seek to reflect the condition or aspect of things of nature which always must be external to our building. But in skillful organization the parts seem sometimes to so eloquently answer their law that you have a subconscious impression that they must have flown together by a sort of magnetic attraction for one another.

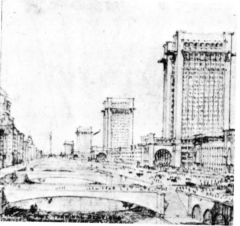

The study of nature's ways and moods is necessary that man's work may complement and set forth her wondrous charms. Thus may he harness her subtle strength to his humor. The architecture of the past, so much of it a meaningless expression, a ceremonial jumble, was a secret, exclusive art. It has been essentially a timidly nursed, privately owned, autocratically developed, effusion, as witness: the temple, the court, the palace; it was not a consciously aspirant social expression. Ancient and medieval architecture could not help but discover and develop, through use, certain forms and orders of arrangement which must always be of influence in the design of buildings; but the spirit that guided and worked results was not as a rule that which felt for nature's support. Each kind was a wave of specialized usage; a limited, arbitrary impulse based on some particular practical limitation or intellectual attitude of the day. We won't quarrel any longer about diameters or other non-essentials.

On this, the eve of a widespread change in the feeling for and care of the things of the common good, we are awakening to a conscious desire for expression. It is evident in literature, music, the plastic and the graphic arts. Why not in architecture? Our people

are turning to the purposeful work of building up the standard of citizenship. Blood of a strain common to all the sadly confused fatherlands of Europe, is here and now mingling in the commonwealth and seeking through her institutions a certain prophetic fulfillment of ideality. It has bequeathed to us an impelling desire to be free and strong in our creative endeavor. We can, if we will, open our eyes to the need and our hearts to the love of the beautiful as witnessed in the appearance of all builded things; the use thereof being glorified because of the more ideal forms in which our imagination clothes them. There is no authority but our own and our demand for a recreated world can and should be of an all-inclusive, permanently operative, kind.

The lesson of all past ages of expressive effort shows that each age had its own conscious "moment" and with this its own peculiar mode of artistic expression. The style we see resultant of that momentary effect was inspired by a certain standard of life. Emphasis is placed on shapes, which show more often a weakness of conviction and feeling, than they show a feeling of strength and purpose. Our perception of this fact puts the creative architectural efforts of the past into proper perspective. In such critical retrospect of history we read the cause and then turn and see the result in each style of a period, so we come to realize more pertinently the need of an artistic response to our own modern social "moment."

In America, and especially in the Middle West, life exhibits without a doubt a fullness of vision, a purposeful attitude and consciousness of inter-dependent power, such as has never before in history been true of any people of any other time or place. This power is taking hold and endeavoring to so limit the shaping effect of social conditions as to bring about a freer opportunity in life environment for all than has ever been hinted at before.

It seems certain that a sober and reasonable creative expression must be forthcoming in architecture through which all would speak and feel. It must be a true reflection of our real condition, a simple statement of the broad, yet intimate relation which we see in things today, whether they be things of state, or things of science, or things of nature. At present our undeveloped and wrongly developed educational method seems to stand in the way of progressive change. We are trained to curb spontaneous impulses which would lead to profound desires. The main thing is to come into our own and let it do for us, so that we, as free men,

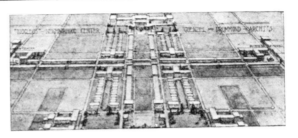

may leave our own record as we pass along the great highway of life.

The art of architecture in the new West hopes to generate a feeling of reverence for the hill and valley, the cliff and shore line, the great smiling sunlit prairie. It especially recognizes the need of conforming to certain limitations. Materials selected for and cast in forms suitable to functions—constructions, which while being shelters fit for special use are also unmistakably pertinent, inside fulfilling outside promise, outside reappearing or penetrating inside with positive meaning, both outside and inside lending themselves to refinement of workmanship, of color, of decorative sculptured form and of furnishings exquisitely harmonized in-door and out. Thus will human expression through architecture be clear, true, relevant and consequently immensely more eloquent than it has been in the past. Simple truth will take the place of ''philosophies,'' of thrice removed ''inspiration,'' of computed and classified ''laws'' of composition, of explanation in meaningless ''technical,'' scholarly words, of that which is not obvious to the eye, therefore non-existent. The sophistical reactionary tendency leads not to the ideal, but to the final result of a stupifying monotony of existence.

If architecture mirrors the soul, then why should any building be anything but beautiful or reasonable? Ugliness is evidence of sin, stupidity, wastefulness, chaos and confusion of thought. Out of the realm of art come the things that are of more moment than the things of the mere material world; mere possession is coin to the multitude—it is empty and without value here. The realm of art is antipodal to that of the operatives machine—like labor or the sweaty toil of the harvest hand; yet, one is as necessary to man's existence as the other; each is an overlapped part of the other. The world which knows culture has always striven toward the attainment of that condition which would develop a certain balance between the two extremes. For each man to be as much artist as he is farmer, and vice versa, would be the ideal existence, but this, of course, is still a proven impossibility, though it may come some day.

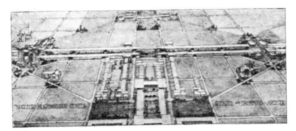

DESCRIPTIVE NOTES :: :: :: :: ::

HOUSING SCHEME:
ON THIS PAGE IS ILLUSTRATED A SCHEME WHICH IS DESIGNED TO BRING ABOUT A RECONSTRUCTION OF OUR SOCIAL AND POLITICAL URBAN LIFE. :: :: :: :: THE SCHEME AIMS AT A PRONOUNCED ''INDIVIDUALIZATION'' OF NEIGHBORHOOD DISTRICTS IN CITIES. A WHOLE CITY LIKE CHICAGO WOULD BE COMPOSED OF ''UNITS,'' EACH HAVING A NEIGHBORHOOD CENTER OR ''LITTLE CAPITOL.'' IN THE DEVELOPMENT OF NEW AREAS INTO NEIGHBORHOODS, CERTAIN STREETS WOULD BE BUILT UP WITH CORRELATED GROUPS OF APARTMENT BUILDINGS, SEMI-DETACHED AND SINGLE DWELLINGS, THIS ARRANGEMENT BEING A ''NUCLEUS'' OR FIRST STAGE. THE REMAINING AREAS (SHOWN VACANT IN ILLUSTRATION ABOVE) WOULD BE DEVOTED TO PERMANENT SITES FOR THE MORE EXPENSIVE INDIVIDUAL DWELLINGS. :: :: :: :: :: AS A COMPLETE ''PLANT'', THE ''LITTLE CAPITOL'' WOULD HAVE A LARGE PUBLIC MEETING HOUSE, SCHOOL ROOMS, A LIBRARY AND HALLS FOR EXHIBITION AND RECREATION, AS WELL AS GYMNASIA AND CONTIGUOUS PARK AND PLAY SPACE. SEE ILLUSTRATION OF NEIGHBORHOOD CENTER AT BOTTOM OF PAGE 11. :: :: :: :: :: THE ABOVE SCHEME IS BEING PUBLISHED BY THE CITY CLUB OF CHICAGO IN A VOLUME CONTAINING OTHER HOUSING SCHEMES. IT WILL APPEAR FULLY EXPLAINED AND ILLUSTRATED. :: :: :: :: ::

RAILWAY TERMINAL:
THE CITY CLUB IS ALSO PUBLISHING A BOOKLET ENTITLED ''THE RAILWAY TERMINAL PROBLEM OF CHICAGO''. FROM WHICH THE ILLUSTRATIONS APPEARING ON THE CENTERS OF THE TWO FOREGOING PAGES WERE TAKEN. THEY ILLUSTRATE SOME OF THE OUTSTANDING FEATURES OF A GREAT RAILWAY TERMINAL SCHEME, WHICH HELPED TO BRING ABOUT SUCH A CHANGE IN PUBLIC OPINION IN CHICAGO, THAT IN COMING TO AN AGREEMENT WITH SOME OF THE RAILROADS FOR A NEW TERMINAL, MANY MILLIONS OF DOLLARS WERE SAVED TO THE CITY. :: :: :: :: THE TALL STRUCTURES SHOWN ARE INTENDED TO ''MARK'' OR INDIVIDUALIZE A SERIES OF GREAT STATIONS ALONG A RAIL ''HIGHWAY'' WHERE ALL THE ROADS ENTERING THIS GREATEST RAILROAD CITY, WOULD HAVE AMPLE OFFICE AND STATION ACCOMMODATION. :: :: :: :: :: IN TRAIN OPERATION, THERE WOULD BE NO GRADE CROSSINGS AND SO LITTLE WASTE MOTION, THAT A RIGHT OF WAY HERE AT THE CENTER OF THE CITY OF LESS THAN 200 FEET WIDTH, WOULD PROVIDE TRAIN SERVICE FOR A CITY FIVE TIMES AS GREAT AS CHICAGO. :: :: :: ::

ARCHITECTS' STUDIO:
SINCE IT IS EXTREMELY DIFFICULT TO SECURE SATISFACTORY OFFICE SPACE IN DOWN-TOWN CHICAGO WHERE ANY EXPRESSION OF INDIVIDUALITY IS POSSIBLE, THE FIRM HAS DECIDED TO ERECT FOR ITS OWN EXCLUSIVE USE THE OFFICE BUILDING ILLUSTRATED IN THE FIRST CUT OF THIS PRESENTATION. IT IS TO BE LOCATED IN A PROMINENT STREET, SOMEWHAT REMOVED FROM THE CENTER OF ACTIVITIES. :: :: :: :: :: ::

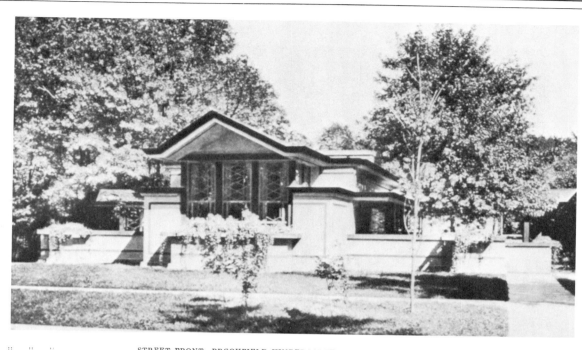

STREET FRONT—BROOKFIELD KINDERGARTEN, BROOKFIELD, ILLINOIS

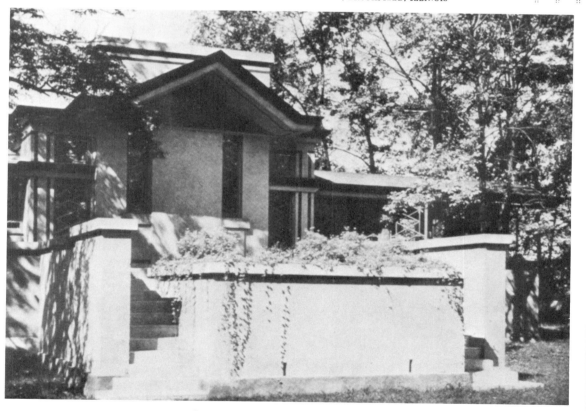

GARDEN TERRACE—BROOKFIELD KINDERGARTEN, BROOKFIELD, ILLINOIS

ENTRANCE VIEW—BROOKFIELD KINDERGARTEN, BROOKFIELD, ILLINOIS

PLATE
TWO

THE WESTERN ARCHITECT
FEBRUARY :: :: 1915

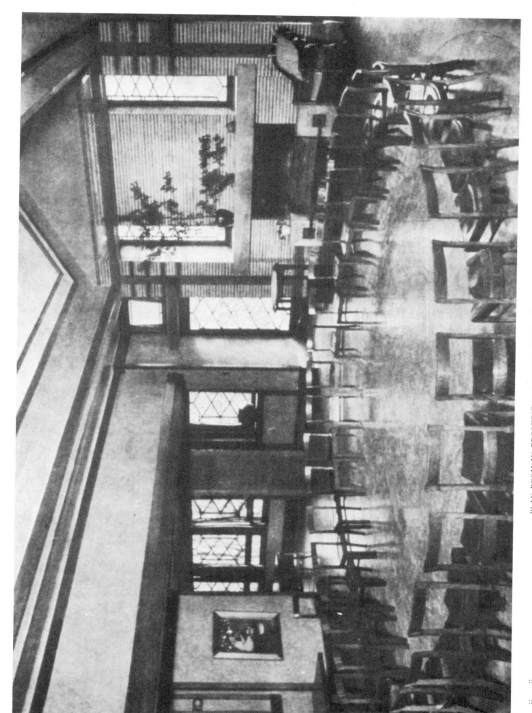

PLAY ROOM IN BROOKFIELD KINDERGARTEN (CLASS ROOM BEYOND)

PLATE
THREE

THE WESTERN ARCHITECT
FEBRUARY :: :: 1915

:: :: ENTRANCE AND TOWER VIEW—RIVER FOREST METHODIST CHURCH, RIVER FOREST, ILLINOIS :: ::

FRONT VIEW—RIVER FOREST METHODIST CHURCH, RIVER FOREST, ILLINOIS

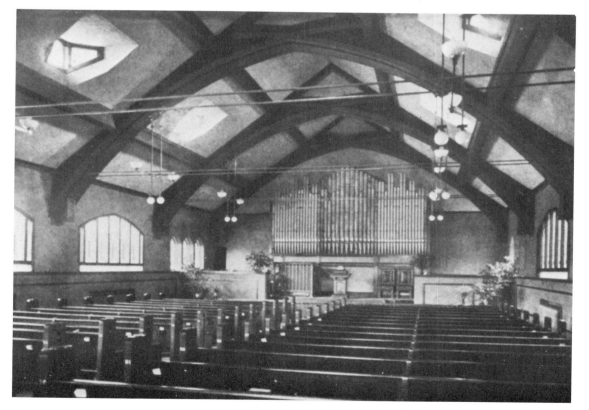

AUDITORIUM OF RIVER FOREST METHODIST CHURCH, RIVER FOREST, ILLINOIS

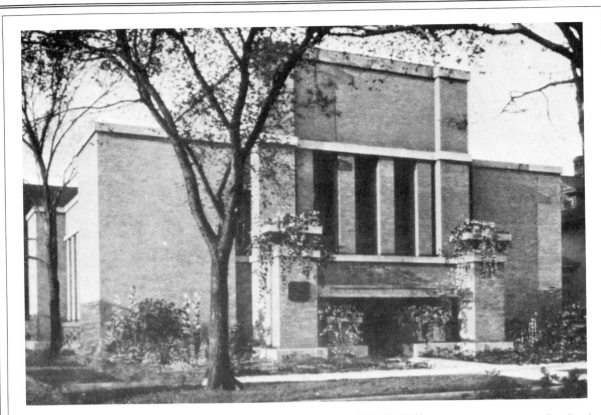

FIRST CONGREGATIONAL CHURCH, AUSTIN, ILLINOIS

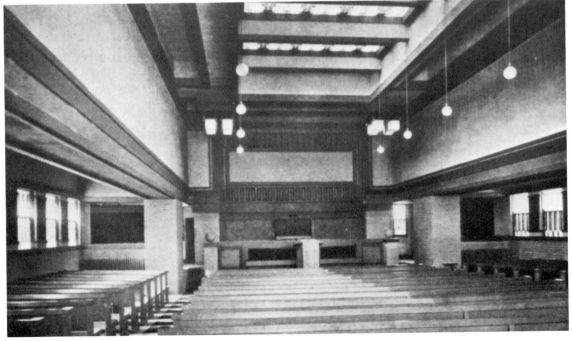

AUDITORIUM OF FIRST CONGREGATIONAL CHURCH, AUSTIN, ILLINOIS

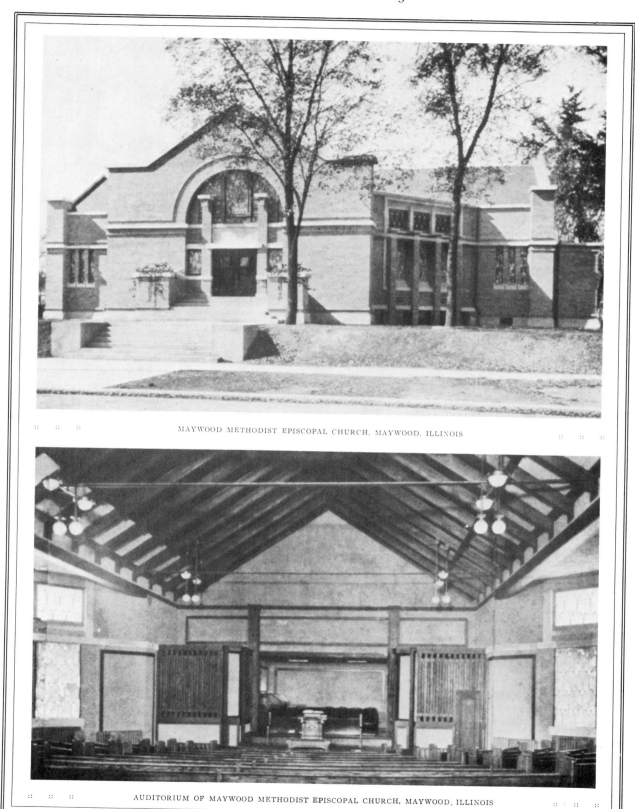

MAYWOOD METHODIST EPISCOPAL CHURCH, MAYWOOD, ILLINOIS

AUDITORIUM OF MAYWOOD METHODIST EPISCOPAL CHURCH, MAYWOOD, ILLINOIS

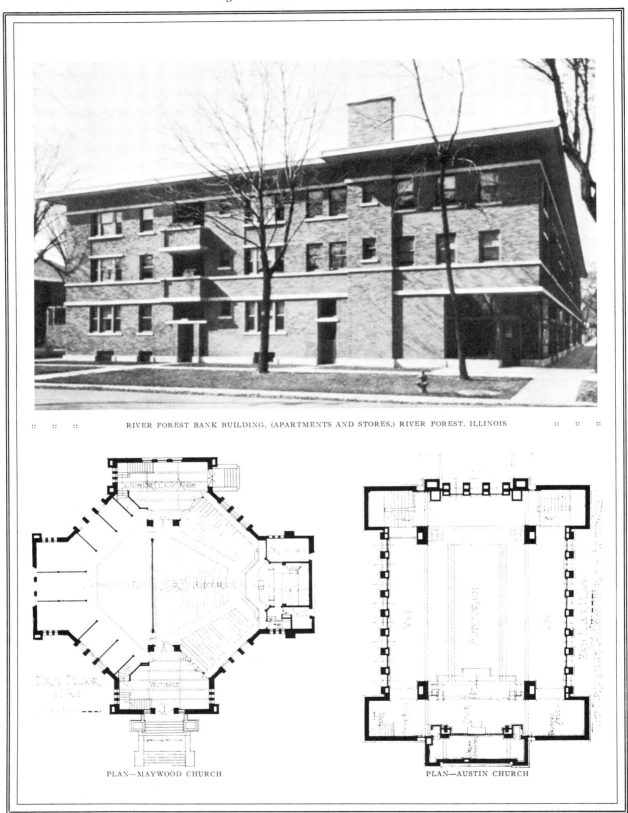

:: :: :: RIVER FOREST BANK BUILDING, (APARTMENTS AND STORES,) RIVER FOREST, ILLINOIS :: :: ::

PLAN—MAYWOOD CHURCH

PLAN—AUSTIN CHURCH

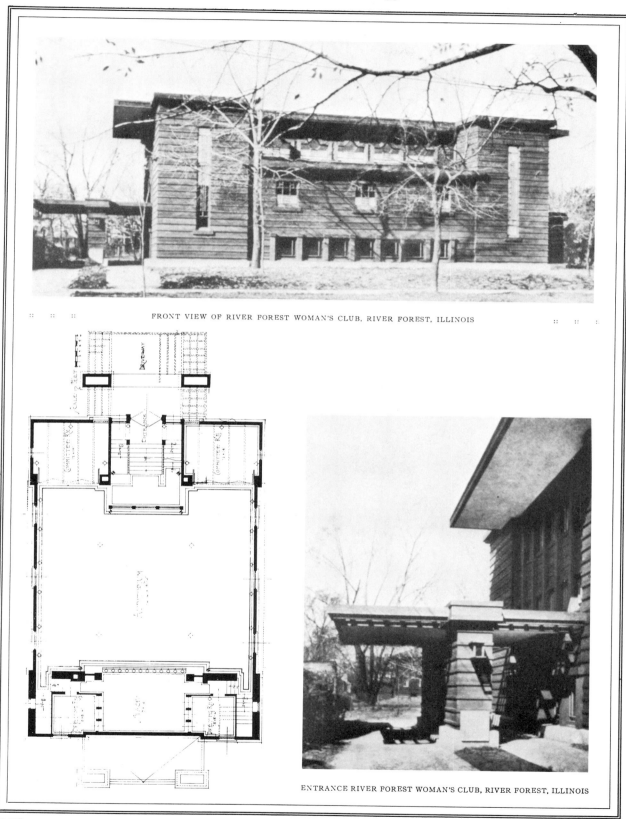

FRONT VIEW OF RIVER FOREST WOMAN'S CLUB, RIVER FOREST, ILLINOIS

ENTRANCE RIVER FOREST WOMAN'S CLUB, RIVER FOREST, ILLINOIS

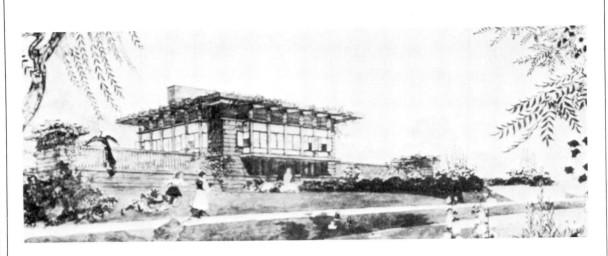

SKETCH FOR SMALL KINDERGARTEN AND COMMUNITY HOUSE

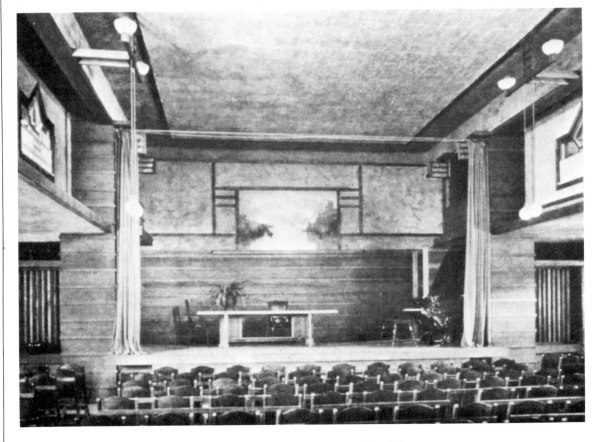

AUDITORIUM OF RIVER FOREST WOMEN'S CLUB

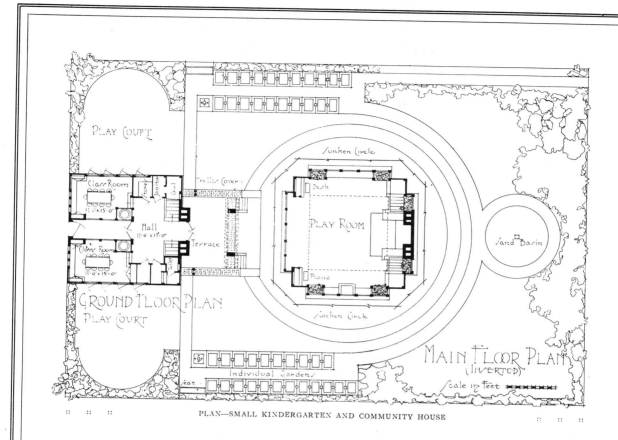

PLAN—SMALL KINDERGARTEN AND COMMUNITY HOUSE

THE LORIMER MEMORIAL BAPTIST CHURCH, CHICAGO, ILLINOIS

OAK PARK COUNTRY CLUB, OAK PARK, ILLINOIS

DANISH OLD FOLKS HOME (IN COLLABORATION WITH MR. JENS JENSEN, LANDSCAPE ARCHITECT)

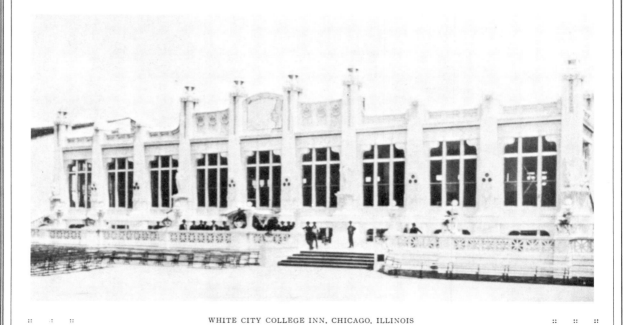

WHITE CITY COLLEGE INN, CHICAGO, ILLINOIS

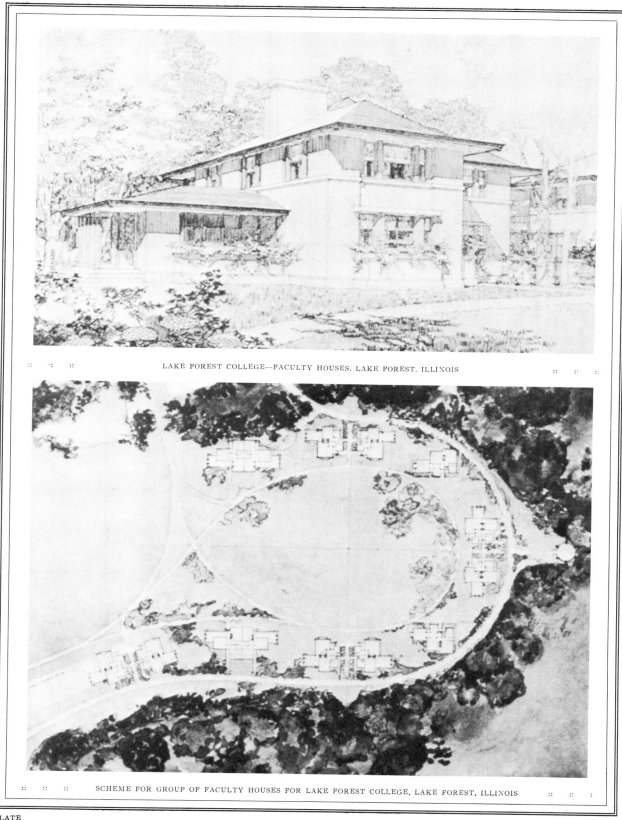

LAKE FOREST COLLEGE—FACULTY HOUSES, LAKE FOREST, ILLINOIS

SCHEME FOR GROUP OF FACULTY HOUSES FOR LAKE FOREST COLLEGE, LAKE FOREST, ILLINOIS

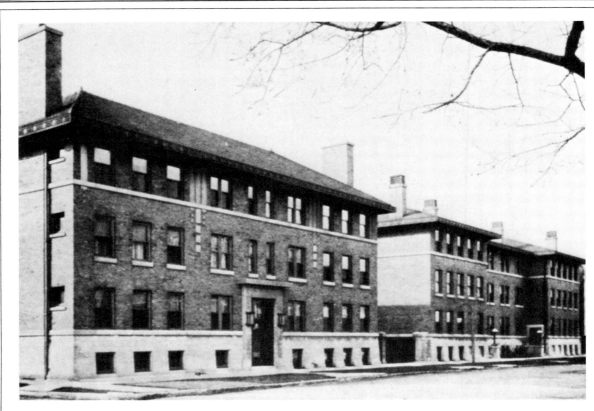

:: :: :: HEALY AND BIGOT APARTMENTS, CHESTNUT STREET, CHICAGO, ILLINOIS :: :: ::

:: :: :: OFFICE BUILDING FOR CHICAGO MILL AND LUMBER COMPANY, CHICAGO, ILLINOIS :: :: ::

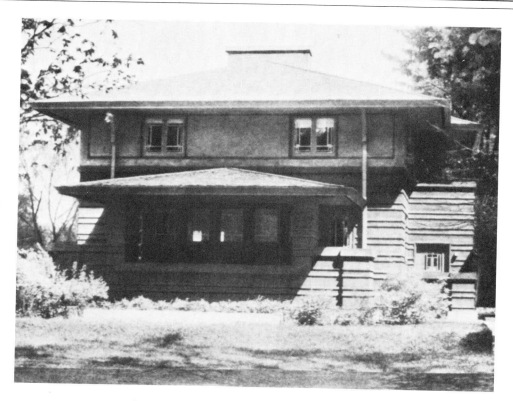

RESIDENCE OF MR. CHAS. J. BARR, RIVER FOREST, ILLINOIS

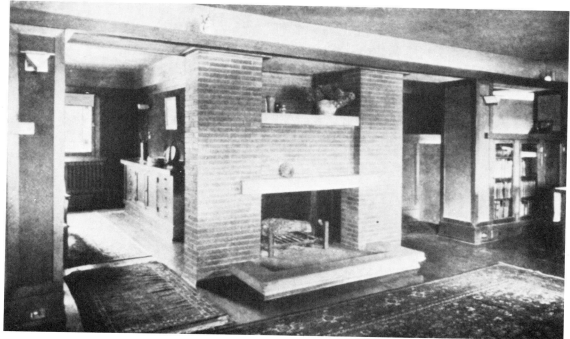

DINING ROOM—RESIDENCE OF MR. CHAS. J. BARR, RIVER FOREST, ILLINOIS

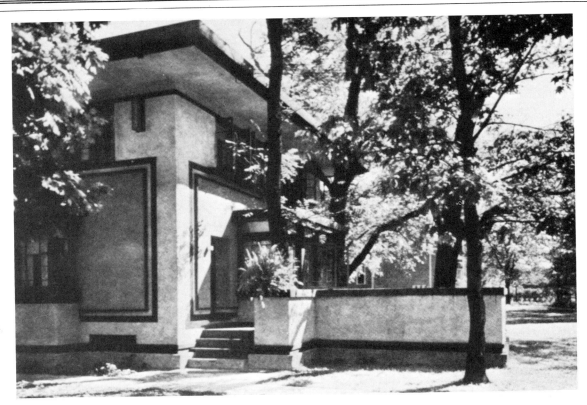

ENTRANCE AND TERRACE—RESIDENCE OF MR. WM. DRUMMOND, RIVER FOREST, ILLINOIS

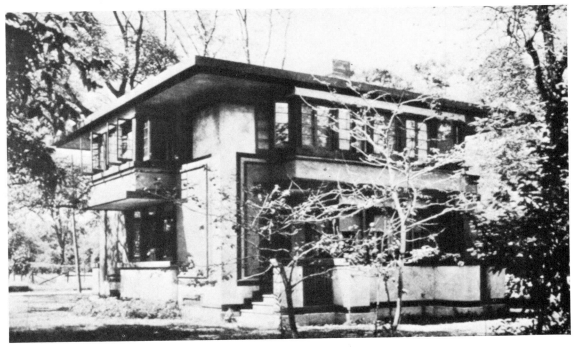

VIEW FROM GARDEN—RESIDENCE OF MR. WM. DRUMMOND, RIVER FOREST, ILLINOIS

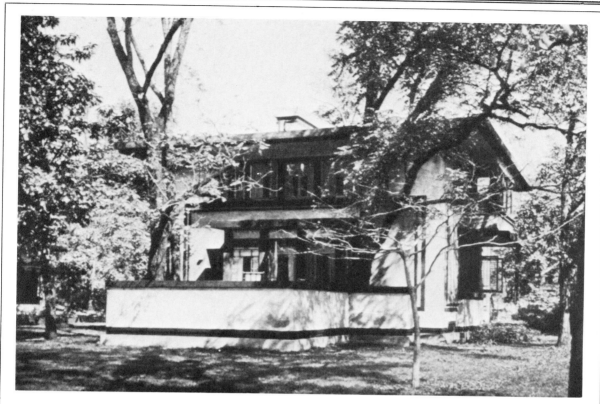

:: :: :: STREET VIEW—RESIDENCE OF MR. WM. DRUMMOND, RIVER FOREST, ILLINOIS :: :: ::

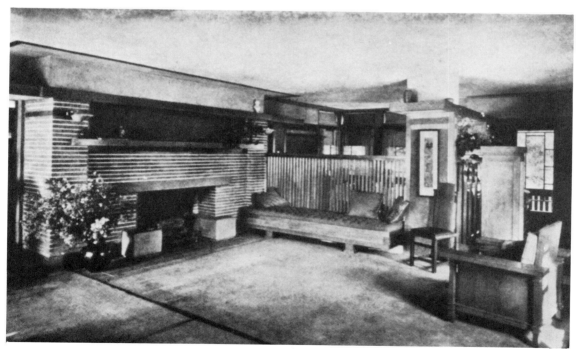

:: :: :: LIVING AND DINING ROOM—RESIDENCE OF MR. WM. DRUMMOND, RIVER FOREST, ILLINOIS :: :: ::

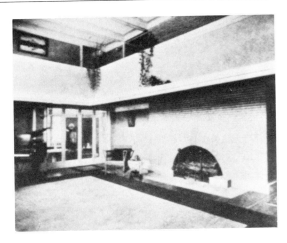
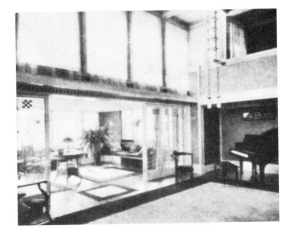

LIVING ROOM LOOKING TOWARDS DINING ROOM :: :: LIVING ROOM LOOKING TOWARDS SUN PORCH ::

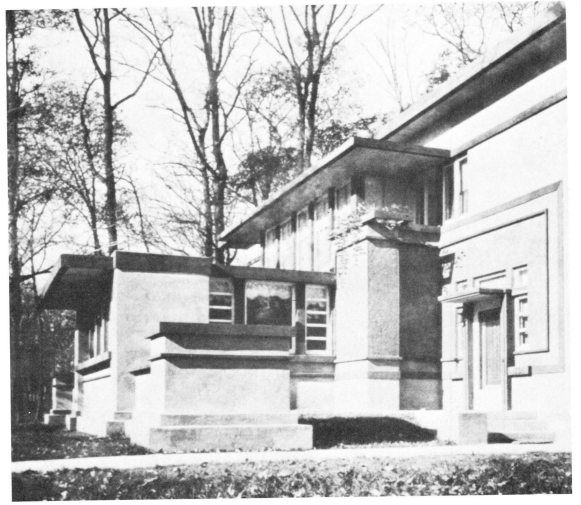

:: :: :: ENTRANCE DETAIL—RESIDENCE OF MR. RALPH S. BAKER, WILMETTE, ILLINOIS :: :: ::

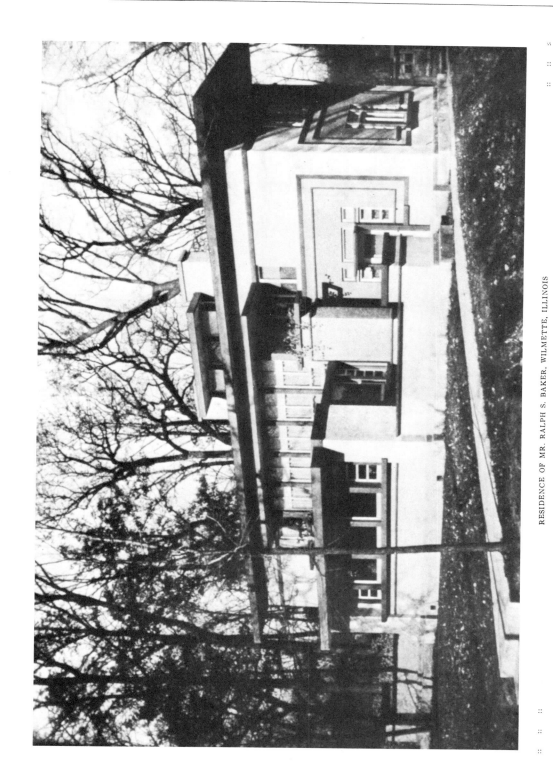

RESIDENCE OF MR. RALPH S. BAKER, WILMETTE, ILLINOIS

PLATE
NINETEEN

THE WESTERN ARCHITECT
FEBRUARY :: :: 1915

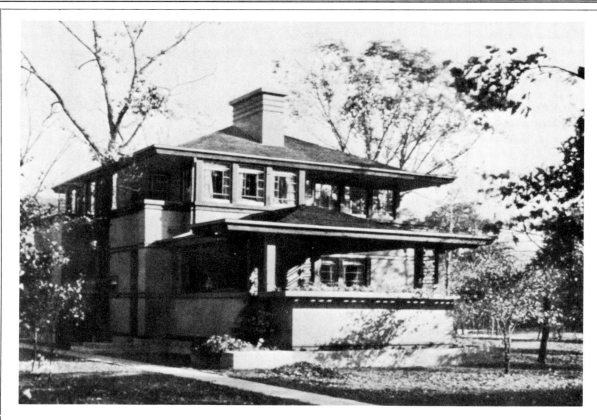

:: :: :: "THORNCROFT".—A DWELLING AT RIVERSIDE, ILLINOIS :: :: ::

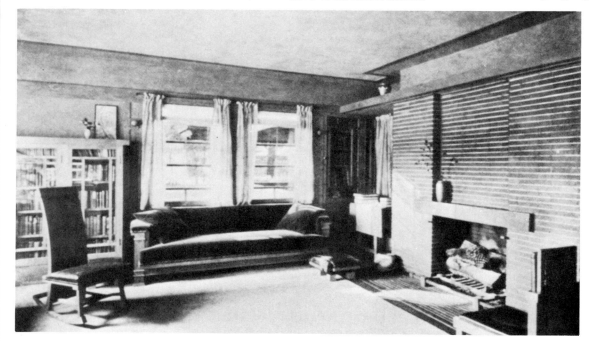

LIVING ROOM—"THORNCROFT", A DWELLING AT RIVERSIDE, ILLINOIS :: :: ::

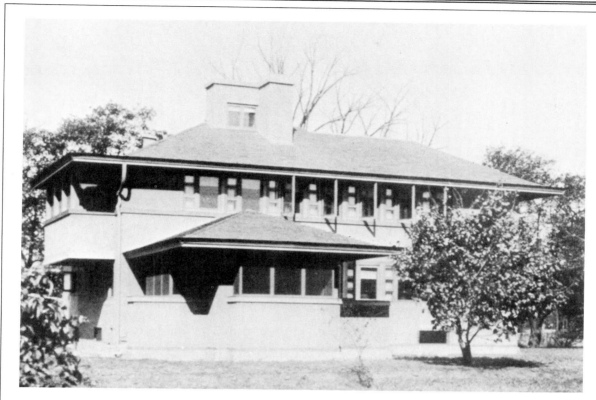

RESIDENCE OF A. W. MUTHER, RIVER FOREST, ILLINOIS

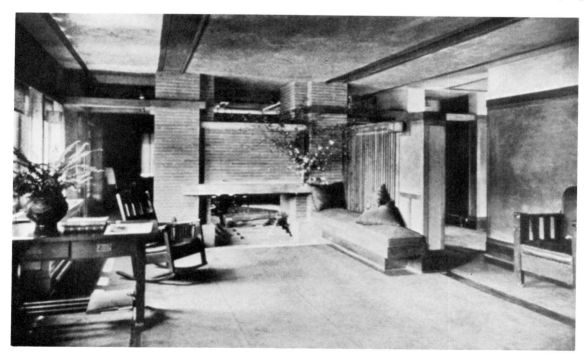

LIVING ROOM AND FIRE PLACE—RESIDENCE OF MR. A. W. MUTHER, RIVER FOREST, ILLINOIS

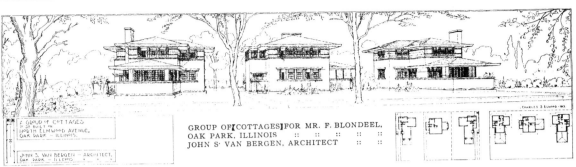

GROUP OF COTTAGES FOR MR. F. BLONDEEL,
OAK PARK, ILLINOIS :: :: :: :: ::
JOHN S· VAN BERGEN, ARCHITECT :: ::

A PLEA FOR AMERICANISM IN OUR ARCHITECTURE

BY JOHN S. VAN BERGEN, ARCHITECT

Certain communities throughout our country, while striving to advance beyond the accepted architectural forms of our predecessors, to the natural, suitable, better adapted to the needs and materials of the present day, are gradually creating an architecture distinctively American.

Early in our land, after the pressure of Old England had been thrown off and true freedom was established, the people began to express themselves in their buildings. Living at that time was mid-way between the the luxuries of Europe and the frontier of the mountains and the plains, and the new found liberty inspired in the people the desire to do something of their own. Their desires, as the desires of the mother countries from which they came were thoughtfully worked out to a logical conclusion which resulted in a living art of their needs. Both the New England and the Southern Colonies produced an architecture particularly adapted to their mode of living. Why can not we of the present day produce a type or types distinctive of our times? Our life is one very different from that of the eighteenth century and our works cannot stand on their old foundations. Our needs are of an entirely different type and should likewise be met by us ourselves as they demand

a service that was undreamed of when our "National" architecture was developed. It is therefore our duty as well as our privilege to look at our conditions as they are and to plan accordingly. The "Colonial" was the type that met the needs of a hundred years ago, but don't we need something more vital, something that more nearly portrays the life we live? The haughtiness of the past must surely give way to the better understanding of the future. The olden styles suited the time for which they were designed. Do they satisfy the present?

The steadily growing democracy of our land demands that our surroundings conform to its ideals. Formality must give way to simplicity and sham to the genuine. The times are changing fast and those who adhere too rigidly to the old will sooner or later be swept under. It is therefore the duty of the planners of things to make clear the way for a future more glorious than the past. The days of ancient Greece and Rome can never compare with the days that are to come, when love of democracy and fair play has been born in the hearts of men. These days are not long distant and at present the entire world is revolving as never before to a realization of its possibilities. When men once see for themselves, nothing can hold back the tide that will follow and arts and works of every good kind will flourish as never before. Greece and Rome

GROUP OF COTTAGES FOR MR. F. BLONDEEL, OAK PARK, ILLINOIS
JOHN S. VAN BERGEN, ARCHITECT :: :: :: :: :: ::

flourished, but in an unnatural way. The master and the slave can never exist beyond their day and as, "The many for the few," was the slogan of the past, "Each for each other," will be the cry of the future.

As our times progress and a more general learning develops, "Made in America" will have the standing of the other makes and Americans will be proud to know that they are of the new world where things are done with a plan and a purpose. The old world will, if hostilities continue at their present rate, be swept back into the Dark Ages, where each man considered his neighbor his enemy. A period is coming when not only our Architecture but our every need will be furnished by Americans from America. It will then be our task to lead the worn-out nations to the realizations of their own. What hope is there for an efficient leadership if we are merely reflectors and are nothing in ourselves? How can we teach the vital things of life, if honesty and thoroughness are not found among our works? America has the opportunity. Will she accept?

Architecture is not the only attainable end as many of my profession sometimes seem to think. It is only one means by which this new Americanism can

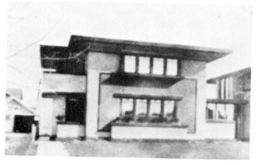

COTTAGE FOR MR. PHILLIP GRIESS, OAK PARK, ILLINOIS
JOHN S. VAN BERGEN, ARCHITECT :: :: :: ::

be made possible. It has, as we of the guild are proud to feel, a very vital relation to all civilization of the past, present and future, with a field that reaches out in some way to nearly every phase of human life. The architect must be a democrat at heart if he is to create a work in sympathy with present and future conditions. As the politician must study the signs of the times so the architect must be alive to new and changing requirements.

America, and especially Chicago and vicinity, has produced a school of men of peculiar trend of mind, who were able to look ahead and see a golden future for the architect and his work. They saw a time when the best in everything would be appreciated and when honest intent and talent could create to their full. With these bright horizons in their mind's eye they have been able to launch an architecture for and of the future America. Under these environments one of its younger architects, Walter Burley Griffin, has been chosen to plan and build the world's most modern

city, Canberra, Federal Capital of Australia. This city could not have been planned as it has except that its creator was a modern, living in a modern America. His knowledge of present and future political issues, the hopes of the masses, the feeling that goes with a people on a new continent, and the growing needs of a regenerated humanity, gave him the fundamentals upon which to lay out his great work. This idea of city planning is progressive and developing rather than fixed and completed. His city will be the first to fully

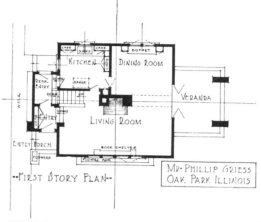

JOHN S. VAN BERGEN, ARCHITECT

meet the requirements of a growing community with expanding ideals in government and private life. This work could never have come from the old world, though at places, previous to the outbreak of war, democracy seemed to be further advanced than in the United

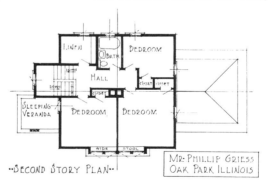

JOHN S. VAN BERGEN, ARCHITECT

States. There is little doubt but that nearly all the cities of the future, and I speak of the industrial as well, will follow Canberra's lead and demand comprehensive city planning, thereby saving themselves many sorrows of their parents. The planners of these future cities will undoubtedly be chosen not from the old school of reaction but rather from the new of progression. There will of course be halts and reverses for the time being in this era of betterment, but on the whole the world is open for the advanced.

The young architect must acquaint himself not only with a knowledge of construction, strength of materials, value of colors and proportion, but must also be a student of the times, political and industrial. The forces that make for a better country in which to live make for a better place in which to work. An architecture that can be understood and appreciated by all will enrich all in many ways.

Beauty in architecture is of the highest importance and should be acquired above all when allied with usefulness and honesty. A thing of beauty is a useful thing and the work of the architect is not only to build but to build beauty in utility. Everything in nature is beautiful and no one class of men has defaced this beauty more than that of the architect. He must turn and take up the work entrusted to him in a true constructive spirit that will in a measure recompense for the damage done. As destruction takes place in the old world, may the architects of America more fully realize their position of help and strive to produce in our land an American architecture representing an extended study of American requirements. May a zealous generation grow up to do the thing better than ever before, for the world having advanced in great leaps and bounds

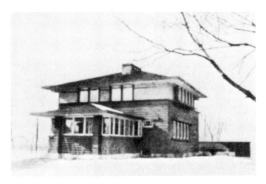

COTTAGE FOR MR. HUDSON B. WERDER, BERWYN, ILLINOIS

now demands a service of which our fathers knew nothing.

Two distinct groups of architecture, domestic and public, will at once present themselves each in turn to be divided and sub-divided into smaller groups worthy of separate treatment. The purpose of this article is to set forth some of the fundamentals regarding these.

Domestic would embody everything in the architectural field used by individuals or families of individuals for their private welfare, distinct from uses more collective in their nature. It includes habitations and their appurtenances, from dwellings of the rich to hovels of the poor, large apartments and closely packed tenements, shelters for domestic animals, garages and landscape treatments. There is a certain homely feeling to be made that must predominate if the project is to be a success. Costly or shabby furnishings, large or small dimensions, do not suffice. There must exist a uniting of the entire scheme toward a definite end. Exterior and interior must conform, room to room

arrangement must be considered, and the whole worked out with the knowledge of sanitation, light, heat and general comfort. A costly residence may, from the standpoint of a real home if carelessly handled, be ruined beyond repair. This has happened so often that it is rather the rule, while the small inexpensive building

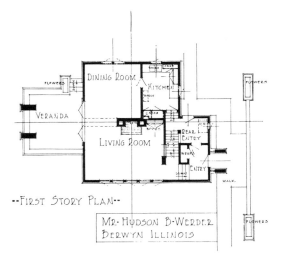

--FIRST STORY PLAN--

MR· HUDSON B·WERDER
BERWYN ILLINOIS

very often becomes ideal. Too many times our wealthy men are discontented with things American and think it necessary to call on the old world for the adornment of their buildings, thus giving the truly Americanized

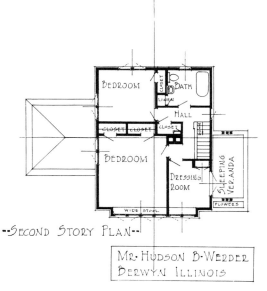

--SECOND STORY PLAN--

MR· HUDSON B·WERDER
BERWYN ILLINOIS

architect very little support. Today a brighter future presents itself and as a general awakening of conscience has beckoned some of our monied men, there is a hope that ere long many more will follow. Much encouragement is seen at present in the west and

central portion of the country and at times evidences on the eastern borders. The once very popular black walnut furniture with its intricate carvings, sawed designs, and general embellishment, has almost entirely disappeared and in its wake has come a type better suited to American life of today. At times as the designing has been overdone in this quest for simplicity, on the whole an advance in our furniture has been made. The present attitude toward the "Colonial" and the "Periods" taken by the leading decorators, while in most cases not American, will undoubtedly leave the people on higher levels. So will the ideas of uniformity very rapidly gain ground. Here, with the decorators there is apt to be trouble as many are blinded by the sale of certain materials rather than their need. This attitude is gradually disappearing as they consult and are being directed by the architect, who is usually better acquainted with the requirements. It has been too customary for the architect to design the structure and then turn it over to another to decorate. The architect if correctly following out his scope of work should direct the project from start to finish and should, where it is possible, attend to all color schemes, furniture, coverings and hangings.

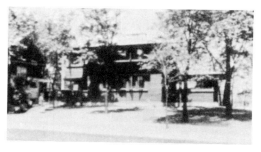

RESIDENCE FOR MRS. CHAS. YERKES, OAK PARK, ILLINOIS
JOHN S. VAN BERGEN, ARCHITECT :: :: :: ::

A type of collective domestic architecture is fast gaining popularity as many people unable to live on separate patches of ground still want the comfort of the home. High class apartment buildings have sprung into being as a result and often, and it is possible in nearly every case, have been built with the home idea so prominent that the inhabitants enjoy nearly every benefit. Even our poorer city tenements have been greatly bettered in the past few years. Sanitary laws, fire protection, and general decency combined have brought to our less fortunate people housing conditions that would never before have been possible. The architect here has rendered a real human service by advising and directing city authorities in the right paths.

The workingman's cottage is also being revolved into a collective body and a number of families can enjoy their former privileges with far less expense. Party walls, single foundations and roofs, larger orders of materials and labor, make buildings of this type quite economical and in many cases add greatly to

the general appearance. In Europe, dwellings of this kind are very popular as laborers of the same nation find it quite possible to respect the rights of their countrymen and enjoy each other's comradeship. Here it is different for when numbers of nationalities come under a single roof a new problem presents itself, which to this date has not been thoroughly solved.

A community suggestion, as proposed by a number of our social thinkers, would have the families living in one or more nearby buildings share the expense of heating and service and do such work as cooking, washing and the like in a central plant. This idea has been carried out with a marked success under certain conditions but there is doubt about it ever becoming universal. If done in a right way, a great deal of money as well as labor can be saved, but the main difficulty is getting different families to unite in a central benefit.

Thus the problem of properly housing our various kinds and classes of people, while largely in the past was left to itself, is now being studied as of great importance, requiring the best of the most thorough and highly trained architects.

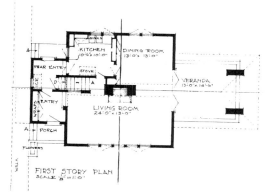

INTERIOR, RESIDENCE FOR MRS. CHAS. YERKES

The second great group of architecture, the public, lends itself to an ever widening field. While in the past, things public were usually paid for by the public but enjoyed by a very few, today all are beginning to receive the benefits. As our democracy grows, and especially here in America where no government holding families exist, the people as a body are demanding and receiving most wonderful profits on invested public properties. Our institutions being founded on a new freedom, America has an opportunity to advance given to no other country. If she is satisfied to stand still and will not push forth, her birth-right will surely be withdrawn and other struggling and harder oppressed peoples will seize the occasion and reap the rewards. Therefore our public, to preserve itself as the American public, must ever keep itself informed and be abreast of the times. Since the American architect has a great opportunity as a leader of the people toward honesty, simplicity and directness, he can educate their tastes and control, to a great extent, their morals and happi-

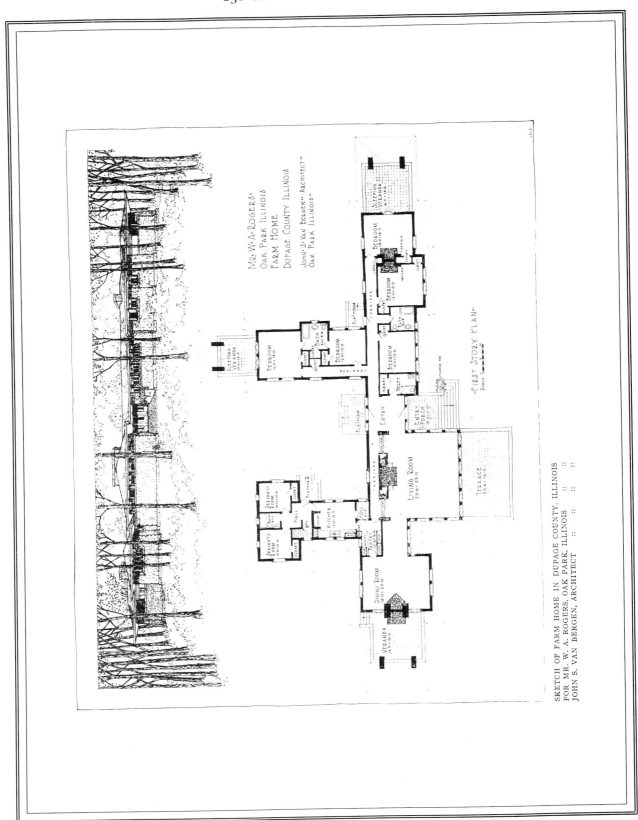

MR. W. A. ROGERS'
OAK PARK ILLINOIS
FARM HOME
DUPAGE COUNTY ILLINOIS

JOHN S. VAN BERGEN "ARCHITECT"
OAK PARK ILLINOIS"

FIRST STORY PLAN"

SKETCH OF FARM HOME IN DUPAGE COUNTY, ILLINOIS
FOR MR. W. A. ROGERS, OAK PARK, ILLINOIS :: :: ::
JOHN S. VAN BERGEN, ARCHITECT :: :: ::

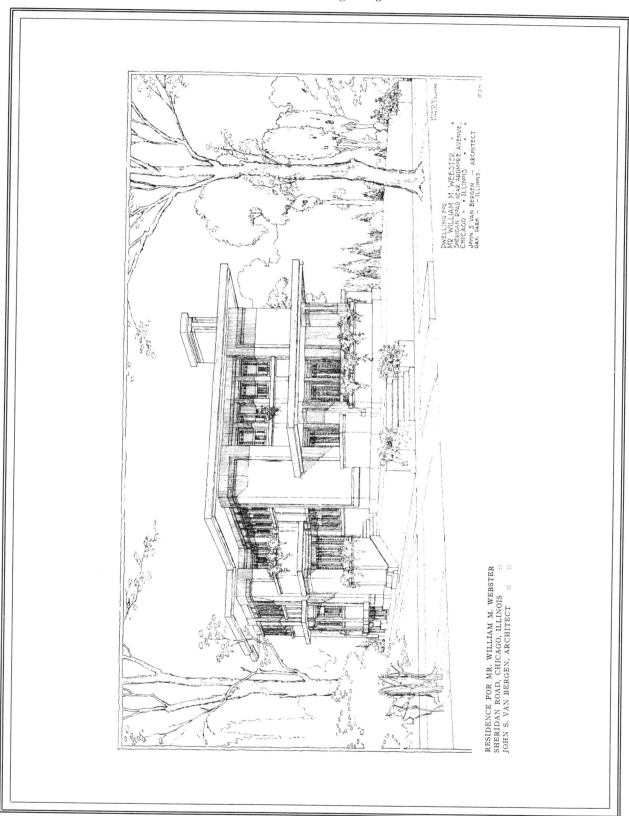

DWELLING FOR
MR WILLIAM M. WEBSTER .
SHERIDAN ROAD NEAR ARDMORE AVENUE.
CHICAGO . ILLINOIS .
JOHN S VAN BERGEN ~ ARCHITECT
OAK PARK ~ ILLINOIS.

RESIDENCE FOR MR. WILLIAM M. WEBSTER
SHERIDAN ROAD, CHICAGO, ILLINOIS :: ::
JOHN S. VAN BERGEN, ARCHITECT :: ::

ness. Thus does his work extend to regions seldom accredited to the profession.

Foremost and vitally connected with the life of the individual, though rarely realized, are our governmental groups consisting of buildings for exercising control, making of laws and judging of laws and law breakers. Here each class of work is divided into its various parts such as the post-office, fire-protection, military and hospital departments. The governmental while being the division most vital to the needs of the people, is seldom treated as though American. A visitor dropped in the midst of a group of these fine buildings would believe himself to be in a reconstructed Rome, hardly realizing a democratic twentieth century city. These buildings next to our homes should exemplify the life we live and should be an inspiration to future generations. The thought of a living architecture, an American architecture for our government's needs should be instilled into the minds of the people until nothing short of it would be accepted.

How almost impossible it is to find monuments or works of sculpture thoroughly developed from our own life. How ridiculous our great Lincoln appears in his Roman toga or Andrew Jackson, sitting on a peaceful contented horse. The entire conception representing spirit of American blood should be alive with the same heroes that prompted them.

In our religious, educational and social buildings we have made a great step forward. Here the transition from the past, with few exceptions, is so marked that our architects have exhibited themselves and their time with greater freedom. Many beautiful and inspiring churches both large and small are seen throughout our entire country. Buildings of this type have somehow wrought in the minds of architects a union of nature and materials with the highest and best in man, thus revealing what can be done. Our schools from the kindergarten to the university are improving very rapidly as new phases of their work come into demand. The proper seating, lighting, heating and ventilating of these schools has brought forth new conditions which necessarily must be disposed of in a modern way. The result has been very satisfactory in many respects and will in itself be an education to the pupils. Clubs, from the city to the country, are increasing in number very fast as our social life takes a prominent place. The automobile and electric railway coming as they have, have brought the club and especially the country club to the people as never before. Recreation features such as tennis and golf are so fast becoming popular that many are attracted to the fields and the woods, where previously very few enjoyed their benefits. Y. M. C. A.'s and secret societies are pushing outward and erecting well constructed buildings in all parts of the country. As our social habits grow our architecture is becoming more democratic and the true American spirit is fast gaining control, giving the architect in this field of work singular opportunities for design, which if he but lets his own nature speak, will produce something worthy of the art.

The recreation and amusement features of our times represent a great work in themselves growing with a rapidity unsurpassed in former years. The kindly thought given to our cities' poor by social workers has resulted in immense public and private appropriations for parks, playgrounds, field houses, concert halls and the like. As soon as our then existing parks were made "public" and in full operation, everyone recognized the importance, and their number has increased until now no city worthy of the name is without them. Even small towns and villages in urban districts are establishing their recreation centers, which are used by all classes. This one feature, the playground for children and adults is doing more to Americanize our greatly mixed population than is generally supposed. No longer do the trees, shrubs, lawns, flowers and birds exist alone for the wealthy, the whole community now shares the good. Public bathing places have been built to accommodate persons during winter and summer seasons and have in practically every case been used to their full capacity, bestowing a great amount of health and happiness. Much might be said about our theaters, large and small, scattered so thickly throughout every town and city in the country. They serve all sorts of audiences from the wealthy to the poor, who too often spend their very bread money for a little diversion at the "Movies." The large and older established playhouses have almost without an exception adhered closely to Classic, French or Italian treatments. Rarely do we find even among our later built houses a departure from the old accepted forms. Rarely is one of these buildings treated as though American. The Auditorium in Chicago, designed by the father of Americanism in Architecture, is undoubtedly a great exception to the general rule for such structures. This building to the minuteness of its decorative details is the outgrowth of a great mind rightly applied. While this work has been the inspiration of many later theatre-architects who used the central idea, namely the arched stage, the satisfying results have not been accomplished owing to the difference between the authors. Mr. Sullivan has put himself into his work and until other architects follow that requirement they will not create a living art. The field of the "Movie" has progressed far beyond that of the general theater and promises to produce interesting examples. This supplying a distinctly new type of entertainment there is a real hope for something good when the more thoughtful architects tackle the problem.

This sketch on Americanism in our architecture would not accomplish its purpose if the most complete, most satisfying building yet brought to the notice of the writer, was not here mentioned. The Midway Gardens at Chicago, a project entirely devoted to entertainment, is to our mind the most vital, living example of American architecture of this class yet produced. Frank Lloyd Wright, while devoting most of his time to the planning of homes has built a monument which will stand unparalleled for many years.

It will be a long time before another building so representative of its purpose will be conceived. The architects of the United States should regard Mr. Wright as one who has originated and builded a great work.

The business and commercial buildings of our period are offering new and ever increasing difficulties which our designers are meeting in many interesting ways. The steel sky-scraper originally merely a high building is now beginning to be clothed in a style peculiarly its own. A very wide range of materials is to be considered and while the proportionate cost is not as pressing as in the building of homes, still multitudes of problems outside of the construction and cost must be met and solved. The architects have in many cases built their individual buildings without regard to streets, other structures, or even the future of their project except as the city's code requires. Many different wants must be served in a building of this type and unless the architect will study the fundamental problems with all their diverging issues, he will not produce a work fitted to the needs of posterity. Constructed as they are, they will stand for long periods of years, and if understudied at their conception, will do much to harm our future public architecture. The sky-scraper in itself is essentially American and when embellished from unsuitable and foreign sources one is reminded of the lines from Burns.

"O wad some Power the giftie gie us
To see oursels as ithers see us!
It wad frae monie a blunder free us,
 An, foolish notion:
What airs in dress an' gait wad lea'e
 us,
 An' ev'n devotion!"

Steam and electric railway stations, wharf and dock buildings, storage and industrial plants, complete the list of buildings so called "Public." These institutions are in nearly every case typically American and should be treated to combine beauty with the great essential, usefulness. Great terminals for steam and electric railways, wharfs and docks are being constructed throughout the country with a trend for ever increasing size and expenditures. Thousands of industrial and storage plants are being built every year with the tendency toward larger projects as it has been found that to economize in manufacture all component parts must be so located as to form one unit. The result is that great institutions, almost cities in themselves, have been constructed, producing their own problems in plan and design. One usually has to go to the rears of such buildings to discover there real and best architecture. Here it is found with unsurpassed ugliness which, if treated with thought, could have been different. Average business men imagine that things beautiful are either impractical in construction or prohibitive in price, which impression has largely been put forth by a class of architects who do not care to bother. The commission for work is very precious and, while

important to all of us, should not so stand in the light that the after-life of our buildings and the growth of future generations will be hampered.

The commercial interests of this country owe more than they are giving to their employees, for how can a worker in these stations, wharfs and industrial plants

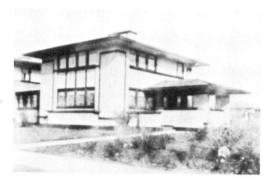

COTTAGE FOR MR. ROBERT N. ERSKINE, OAK PARK, ILLINOIS :: :: :: :: :: :: :: ::
JOHN S. VAN BERGEN, ARCHITECT :: :: :: :: ::

better himself or learn to know or want the best when most of his life is spent among such environments? Why can't something be done to make the designers of these immense institutions see the "America First" idea?

There are in our country, where thought has been expended, very conspicuous examples of what can be done toward Americanizing the entire field of our architecture, from the small country cottage of the domestic, to the steel sky-scraper and factory building of the public group. The present trend is being directed in a progressive channel and the hope of future betterment is at hand. Our resources are unlimited and when more generally, animated men are given direction, American architecture will receive an impulse hitherto unknown.

"Somebody said that it couldn't be done,
But he, with a chuckle, replied
That 'maybe it couldn't,' but he would be one
Who wouldn't say so till he tried.
So he buckled right in, with the trace of a grin
On his face. If he worried, he hid it.
He started to sing as he tackled the thing
That couldn't be done---and he did it.

"There are thousands to tell you it cannot be done
There are thousands to prophesy failure;
There are thousands to point out to you, one by one,
The dangers that wait to assail you.
Then take off your coat and go to it;
Just start in to sing as you tackle the thing,
That 'cannot be done'---and you'll do it."

 ---An American.

RESIDENCE FOR C. P. SKILLIN

In many ways a building of wood covered with cement plaster is of a very interesting type. The architect has a wider range in which to work, as the construction lends itself to greater elasticity.

This home was built for Mr. C. P. Skillin at Wilmette, Illinois, one of Chicago's most picturesque suburbs. It was planned to embody utility, comfort and restfulness. The building faces south and care was taken to make all rooms bright and cheerful, both in summer and winter. The results have proven very satisfactory as the photographs will indicate, all being taken without the use of the flash light.

The general plan is that of a cross, placing the living room in the center between library and dining room. This arrangement exposes the interior to the most possible sun-light while forming very attractive vistas. It is so arranged that the dining room gets the sunlight in the morning, the living room through the day, and the library towards the afternoon and early evening. Consequently brightness is the prevailing feature. By the arrangement of rooms it is possible to use each separately or en-suite as may be required.

The features of the living room are the fireplace toward the center of the house, the sun-veranda toward the south, and the window and French window treatments. The library, off the entry, is well lighted and provided with large book cases, which together with the living room fireplace give a welcome immediately upon entering. The sun-veranda at the south end of the living room is provided with glass and heat for winter and screens for the summer. Flower boxes fill the entire south rail, exhibiting the plants from both inside and outside. The supporting piers are at the living room side and not at the outer end, thus giving an unobstructed view in three directions.

Much study has been given to get a workable plan of room arrangement. The kitchen and service portion is in easy reach of the main entrance thus saving many steps. The maid's room and bath are placed on the first floor, removing the necessity of the double stairs and giving the help a more convenient and pleasant portion of the house. This kitchen is a source of pleasure as things were placed with care for convenience. The sinks are directly under windows, giving ample light and pleasure while working. These sinks are of special interest. There are two, each equipped with hot and cold water and a plug strainer attachment. With this strainer attachment, water can be held for washing and rinsing of dishes without the need of the usual ungainly dish pan. At one side of the kitchen is an ample pantry, where cooking supplies are kept in quantity. The main pantry is between kitchen and living room, provided with spaces for both common and better dishes, table leaves, brooms and refrigerator.

Throughout, except on the sleeping veranda, the out swinging casement window is used, adding greatly to the airiness of the rooms. The sleeping veranda windows were made to swing in, to more easily dispose of the draperies, which are a source of trouble in rooms of this character. The windows swing in pairs, thus enclosing all the draperies when all are opened. Above the casements will be seen small transoms to be used in inclement weather. It will be noticed that nearly all second-story windows open out in pairs, making the washing problem very simple. An ordinary step ladder is all that is necessary to reach the first-story sash.

The color schemes in and out were chosen with care that the light, cheerful appearance might prevail. A rich cream colored cement plastering covers the entire exterior of the building. The trim is of rough sawed cypress, stained yellow-brown with sash tinging on the bronze. The roofing is of plastic shingles covered with ground yellow red tile.

Inside, the entry, library, living and dining rooms are treated in the same colors. The walls to the height of the continuous head casing are a light buff, with cream color ceilings. Throughout these rooms a rough sand finish plaster has been used, giving a certain texture that can be obtained only in this way. All the woodwork, including the doors, is enameled ivory white treated to remove the high gloss. The window draperies and shades are of ecru color with tan over-hangings stenciled with dull pinks and greens. Large rugs of sombre browns cover the floors. The furniture is of antique oak upholstered in soft colored materials, with wicker work interwoven in panels, giving a light, pleasing effect. The fireplace, of light grey, Roman brick and white mortar, with its cement hobbs and lintel, gives a substantial contrast to the light airy appearance of the remainder of the rooms. Old gold has been used very effectually for picture frames and lamp standards, which combines very well with the ivory flower boxes and lighting fixtures.

Lighting for these three rooms has been accomplished with the indirect method. The light thrown to the ceiling in turn is reflected throughout the room, giving a soft, pleasing effect and removing the usual glare that is so tiring to the eyes. Base plug outlets have been installed for piano, table and desk lamps.

The colors employed in furnishing the sun-veranda are almost entirely of ivory. Wicker and pottery of this light color, combined with the rich greens of the plants give the desired results. The entire floor is of red quarry tile laid with black mortar joints. Rough, stained cypress, together with the rough exterior plaster are used here to preserve the out-of-door appearance.

The kitchen, pantries and maid's quarters are trimmed in white enamel, with light yellow buff walls and cream ceilings.

The entire second story trim is treated in dull white enamel. Light, simple paper is used for bedroom walls, while the walls of the bathrooms are tiled. Here again, creams and buffs are used in the decorations and furnishings accented with greys, pinks and yellows.

The combined efforts of both owner and architect have, I think, produced a building to meet every requirement and an addition to the community.

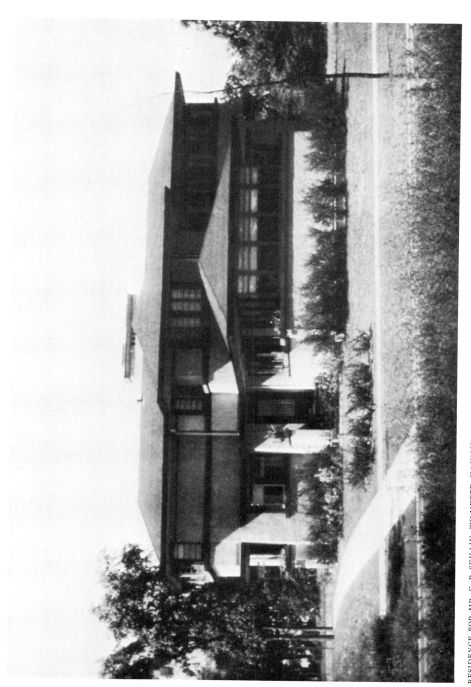

RESIDENCE FOR MR. C. P. SKILLIN, WILMETTE, ILLINOIS
JOHN S. VAN BERGEN, ARCHITECT, OAK PARK, ILLINOIS

RESIDENCE FOR MR. C. P. SKILLIN, WILMETTE, ILLINOIS
JOHN S. VAN BERGEN, ARCHITECT, OAK PARK, ILLINOIS

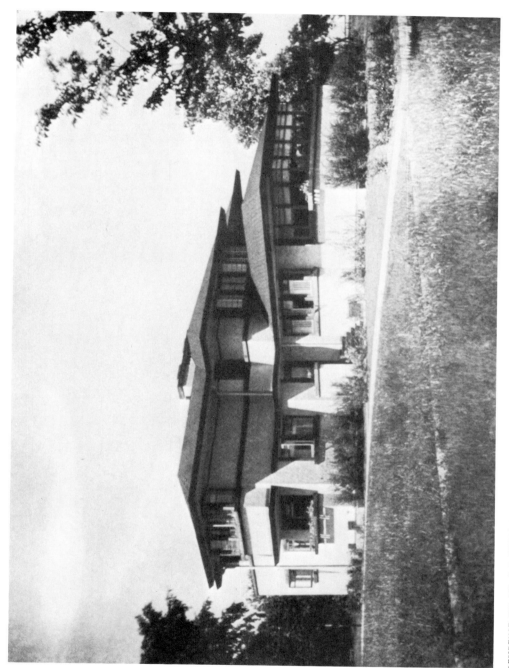

RESIDENCE FOR MR. C. P. SKILLIN, WILMETTE, ILLINOIS
JOHN S. VAN BERGEN, ARCHITECT, OAK PARK, ILLINOIS

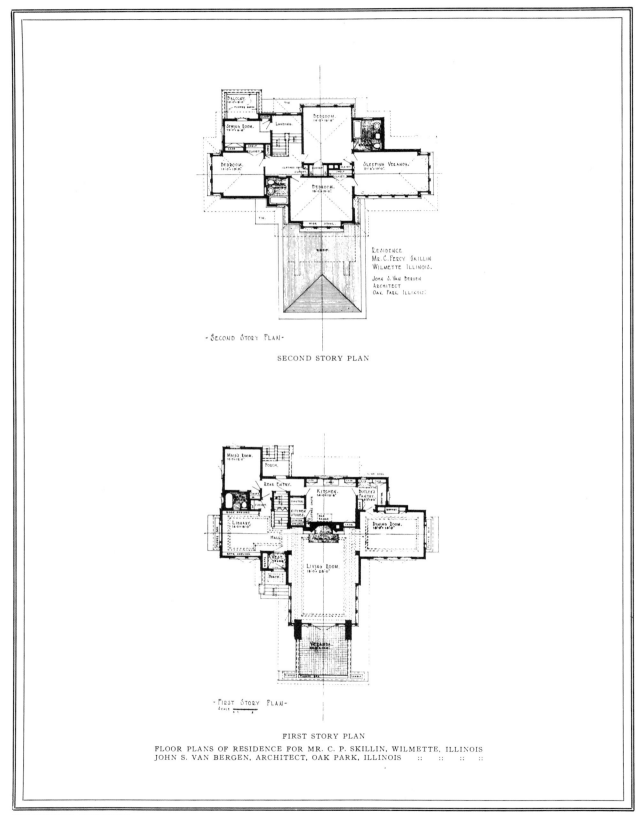

SECOND STORY PLAN

FIRST STORY PLAN

FLOOR PLANS OF RESIDENCE FOR MR. C. P. SKILLIN, WILMETTE, ILLINOIS
JOHN S. VAN BERGEN, ARCHITECT, OAK PARK, ILLINOIS :: :: :: ::

SLEEPING ROOM IN RESIDENCE OF MR. C. P. SKILLIN, WILMETTE, ILLINOIS
JOHN S. VAN BERGEN, ARCHITECT, OAK PARK, ILLINOIS :: :: :: ::

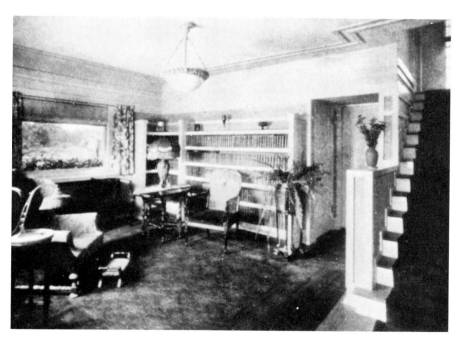

LIBRARY IN MR. C. P. SKILLIN'S RESIDENCE, WILMETTE, ILLINOIS
JOHN S. VAN BERGEN, ARCHITECT, OAK PARK, ILLINOIS :: ::

THE WESTERN ARCHITECT
APRIL :: :: 1915

SUN ROOM IN MR. C. P. SKILLIN'S RESIDENCE, WILMETTE, ILLINOIS
JOHN S. VAN BERGEN, ARCHITECT, OAK PARK, ILLINOIS :: :: ::

LIVING ROOM IN MR. C. P. SKILLIN'S RESIDENCE, WILMETTE, ILLINOIS
JOHN S. VAN BERGEN, ARCHITECT, OAK PARK, ILLINOIS :: :: ::

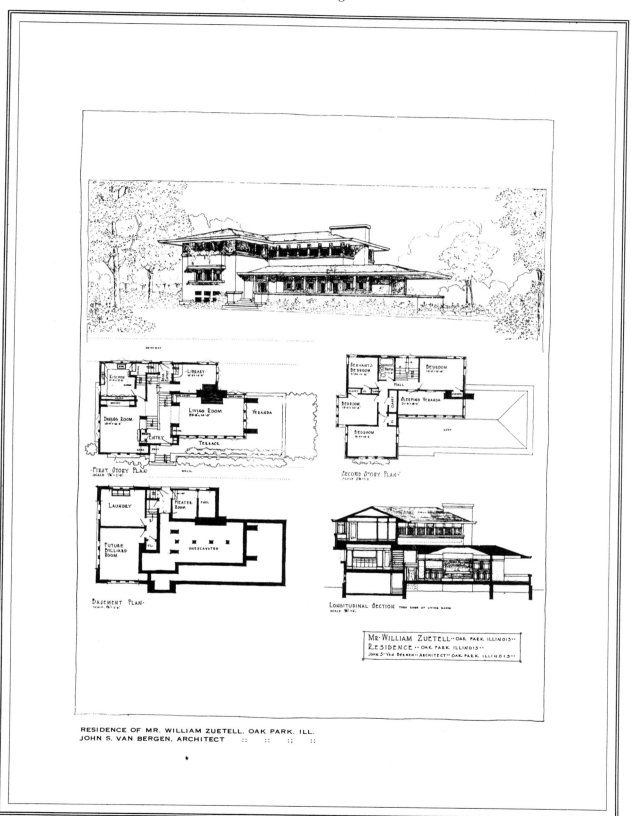

RESIDENCE OF MR. WILLIAM ZUETELL, OAK PARK, ILL.
JOHN S. VAN BERGEN, ARCHITECT :: :: :: ::

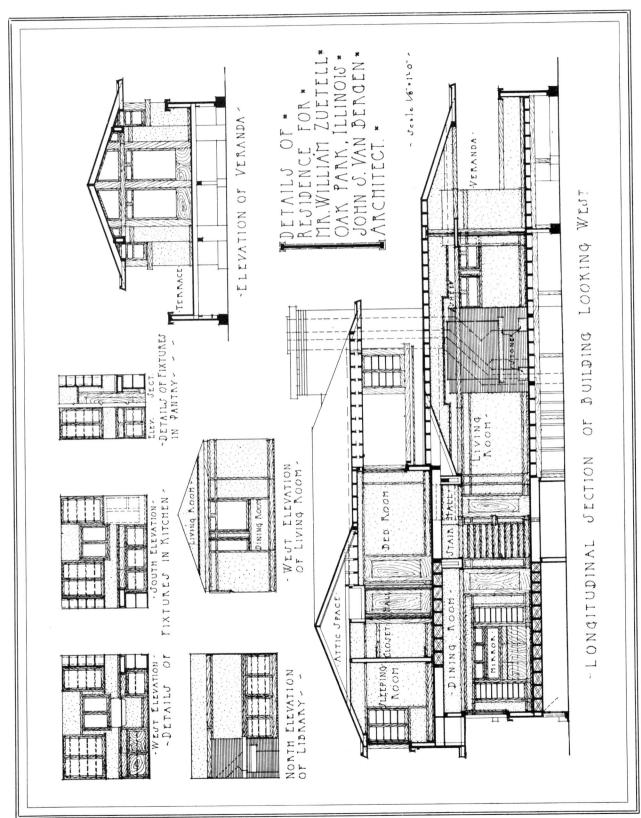

- ELEVATION OF VERANDA -

DETAILS OF
RESIDENCE FOR
MR. WILLIAM ZUETTELL
OAK PARK, ILLINOIS
JOHN S. VAN BERGEN
ARCHITECT.

- Scale 1/8" : 1'-0" -

- TERRACE -

- DETAILS OF FIXTURES
IN PANTRY -

ELEV. SECT.

- SOUTH ELEVATION -
- DETAILS OF FIXTURES IN KITCHEN -

LIVING ROOM

DINING ROOM

- WEST ELEVATION
OF LIVING ROOM -

- WEST ELEVATION -
- DETAILS OF LIBRARY -

NORTH ELEVATION
OF LIBRARY -

VERANDA -

LIVING
ROOM -

ATTIC SPACE

BED ROOM

SLEEPING
ROOM

CLOSET HALL

STAIR HALL

DINING ROOM

MIRROR

- LONGITUDINAL SECTION OF BUILDING LOOKING WEST -

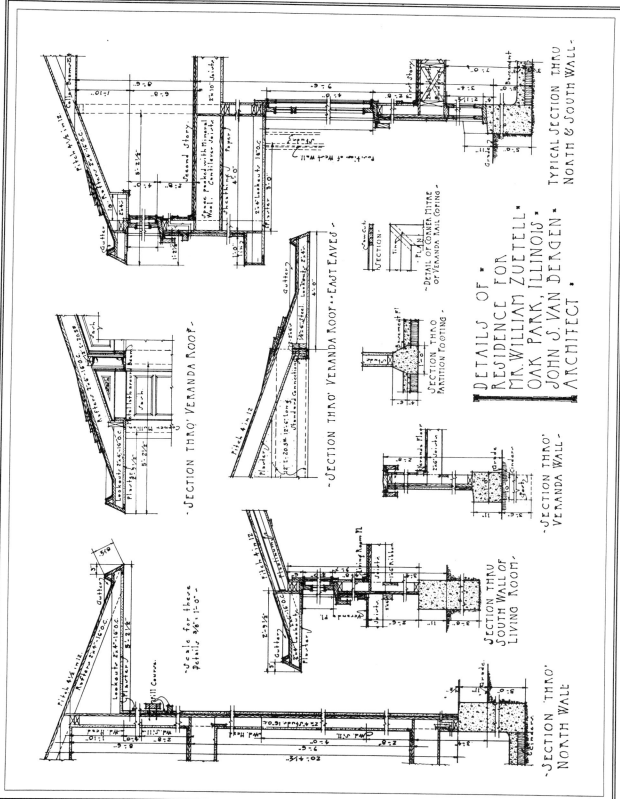

DETAILS OF
RESIDENCE FOR
MR. WILLIAM ZUETELL
OAK PARK, ILLINOIS
JOHN S. VAN BERGEN
ARCHITECT

RESIDENCE MR. ALFRED BERSBACH, WILMETTE, ILLINOIS
JOHN S. VAN BERGEN, ARCHITECT, OAK PARK, ILLINOIS

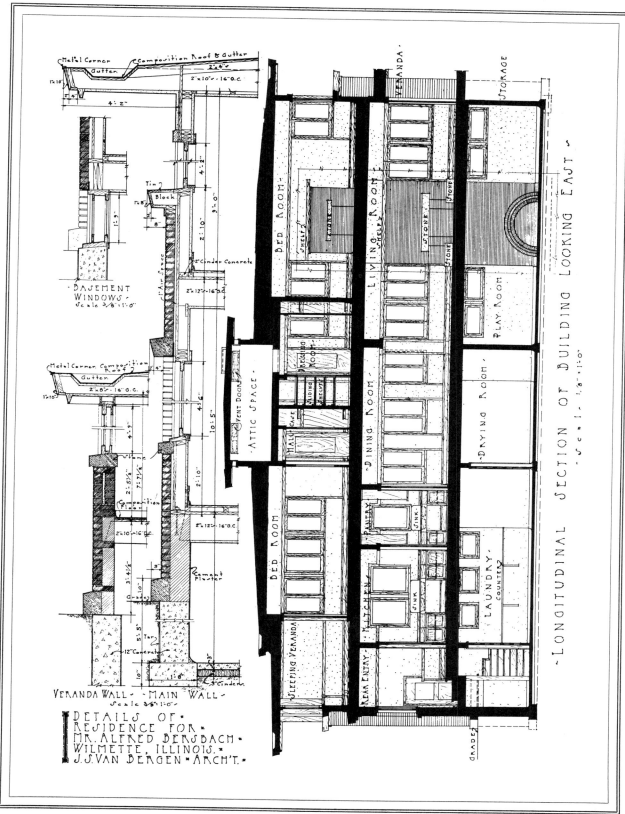

- BASEMENT WINDOWS -
Scale 3/8" = 1'-0"

VERANDA WALL - MAIN WALL -
Scale 3/8" = 1'-0"

DETAILS OF -
RESIDENCE FOR -
MR. ALFRED BERSBACH -
WILMETTE, ILLINOIS -
J. S. VAN BERGEN - ARCH'T -

- LONGITUDINAL SECTION OF BUILDING LOOKING EAST -
- Scale 1/8" = 1'-0"

THE WESTERN ARCHITECT
JUNE : : 1915

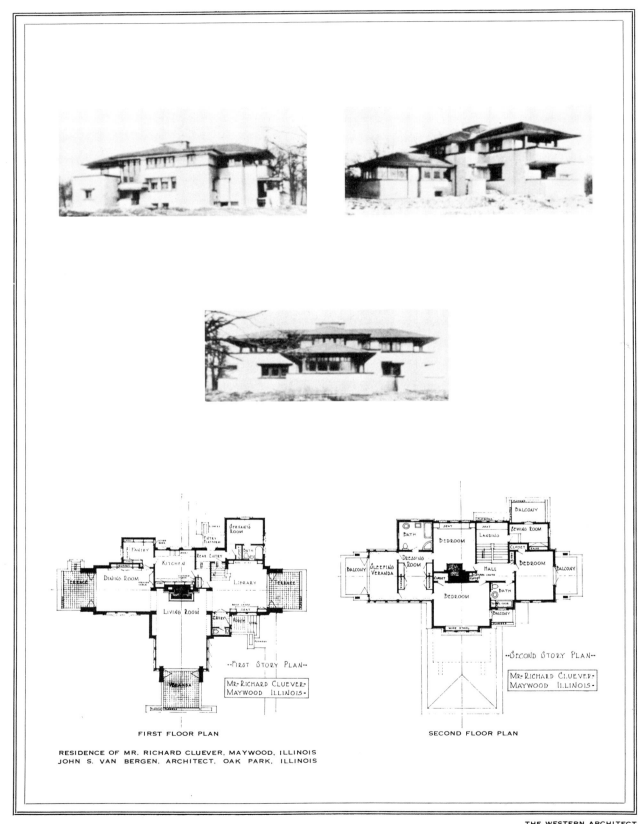

FIRST FLOOR PLAN SECOND FLOOR PLAN

RESIDENCE OF MR. RICHARD CLUEVER, MAYWOOD, ILLINOIS
JOHN S. VAN BERGEN, ARCHITECT, OAK PARK, ILLINOIS

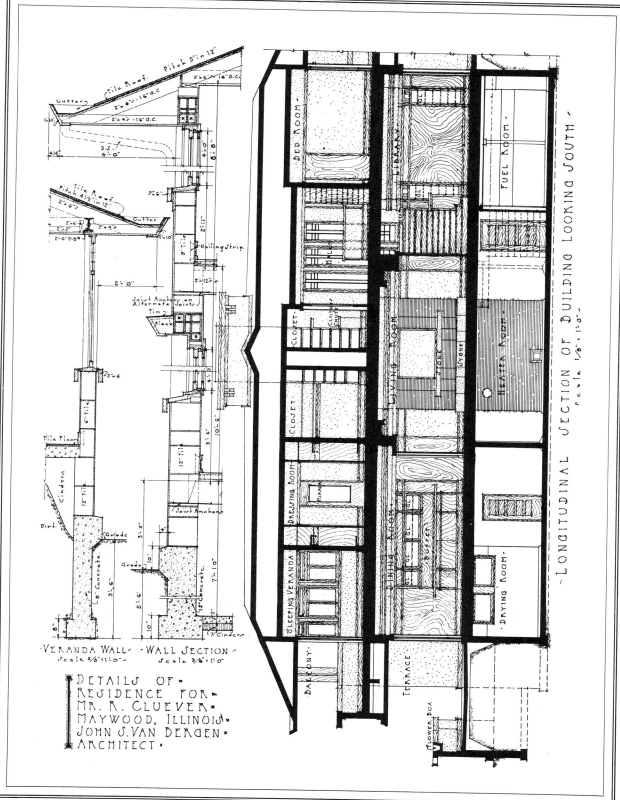

·VERANDA WALL·
·Scale 3/8"=1'-0"·

·WALL SECTION·
·Scale 3/8"=1'-0"·

DETAILS OF·
RESIDENCE FOR·
MR. R. CLUEVER·
MAYWOOD, ILLINOIS·
JOHN S. VAN BERGEN·
ARCHITECT·

·LONGITUDINAL SECTION OF BUILDING LOOKING SOUTH·
·Scale 1/8"=1'-0"·

THE WESTERN ARCHITECT
JUNE : : : 1915

THE WESTERN ARCHITECT

A NATIONAL JOURNAL OF ARCHITECTURE AND
ALLIED ARTS, PUBLISHED MONTHLY

THE WORK OF TALLMADGE & WATSON, ARCHITECTS

In endeavoring to present examples of progressive architectural work in the West which are typical of advancement rather than innovation, the works of Tallmadge and Watson of Chicago seem to meet those critical requirements.

This firm, the members of which are experts, but not specialists in the realm of domestic architecture, is manifestly interested in bringing about an evolution in architectural form and imbuing it with a real and genuine expression of our nationality. That it is not at all hide-bound in its avoidance of renaissance architecture and has no hesitancy in using historic forms, is seen in the handling of the Colonial house for Mr. Kerr, and that it finds no inconsistency in the use of the Gothic is shown in the excellently studied designs for the Methodist church at Evanston, Illinois, and the Chapin Memorial church at Niles, Michigan.

It will be noted that this feeling for the Gothic and other styles is always tempered by a due regard for local conditions and surroundings, united with accessible materials and an expressed freedom in their application.

In the photograph of the Fleming house a rather unsatisfactory viewpoint seems to have been selected, as a more direct front view showing the loggia would

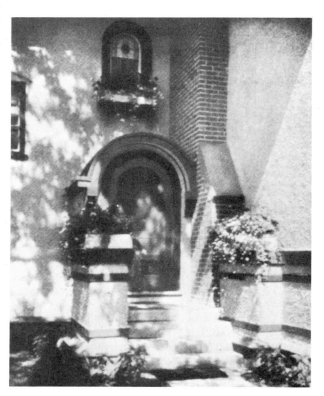

ENTRANCE DETAIL—RESIDENCE F. D. EVERETT, HIGHLAND PARK, ILL.
:: :: TALLMADGE & WATSON, ARCHITECTS, CHICAGO, ILL. :: ::

have given a much better idea of the composition.

In these and other respects the designs of Tallmadge and Watson illustrated in this issue, are typical of the better work done throughout the Middle West, particularly in the field of domestic architecture.

This is significant because if there is anything in our architecture that truly reflects a National ideal, if there is anything that we can call really ours, it is the house of our average citizen, and we in the west like to think that the houses of the average citizens in our part of the country, are just a little more American than those of our brothers on the Atlantic coast.

If we except some of the great mansions copied from English manors or French chateaux, we can be assured that our domestic architecture impresses the foreign visitor with the same sense of strangeness that we feel in wandering among the white-washed walls and tile roofs of a French village, or in gazing up at the precipitous brown facades of a Tuscan town.

It is a comforting thought in these days of aesthetic pessimism, that while the heavy hand of Europe seems in some places to stifle our monumental architecture, the small house on account of its insignificance, or perhaps its independence, has escaped a like fate.

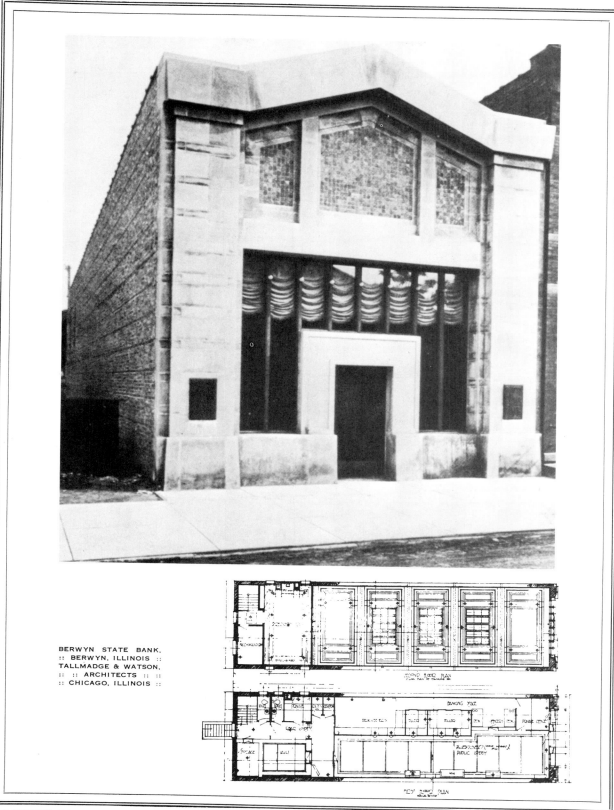

BERWYN STATE BANK.
:: BERWYN, ILLINOIS ::
TALLMADGE & WATSON,
:: :: ARCHITECTS :: ::
:: CHICAGO, ILLINOIS ::

Using inexpensive and local materials and designing with the limitations of American workmen and American pocket-books in mind, is largely responsible for the style of these homes, though equally potent is of course the conscious effort to make the buildings, beautiful and original as may be.

The members of this firm are both still in their thirties, and were both trained in the schools—Mr. Tallmadge being graduated from the Massachusetts Institute of Technology and Mr. Watson from the Armour Institute. Born in the classic tradition they were reared under the aegus of these styles. Then both serving upwards of seven years in the office of D. H. Burnham & Company. However, they, as draughtsmen, took part in the activities of the Chicago Architectural Club. In those days, the club was a hotbed of architectural unrest, and Perkins, Spencer, Dean, Birch Long, and others were sounding the slogan of "progress before precedent." On great occasions, Louis Sullivan himself either criticised the concours, or expounded from his architectural Primer.

The principles of design acquired in this influence, were very potent in vitalizing and directing the work of this firm in their years of beginning, and many other architects of the younger generation are also under the same obligation to the Chicago Architectural Club.

After Mr. Tallmadge returned from Europe in 1905, whither he had journeyed as winner of the Architectural Club Scholarship, the partnership was formed with Mr. Watson. Since then, they have had a steady and increasingly large practice of a general nature. Besides his practice, Mr. Tallmadge is interested in Architectural Education and for the last six years has lectured on Architectural History at the Art Institute and the Armour Institute. He is also a director and charter member of the Chicago Society of Etchers, and has exhibited many times, usually with plates of an architectural character.

The subjects chosen for this number, have been with few exceptions, houses chiefly of a suburban character.

Lack of space and a disinclination to interrupt the homogeneity of the exhibit, seemed to advise against illustrating any commercial work of which they have done considerable in reinforced concrete and mill construction. Several store buildings and apartments and a large hotel in Winter Park, Florida, a school in Evanston, etc., have for this reason not been included.

These houses do not differ from those of many other architects of the Middle West in their dependence on local materials, and the evidence they have shown of giving the owner a filled measure for his money. Some of the traits in common that these houses possess, are: an emphasis of the horizontal line, perhaps an evidence of the influence of Sullivan or Wright;—a strong base, generally of concrete, something of which that the houses of the nineties were entirely innocent; —a marked preference for cement, stucco, or brick to wood, or shingles for exterior walls; the bringing of the heads of all windows and doors on the exterior and interior to the same level. The use of casement windows wherever the owner will stand for them; the use of leaded glass of a straight line pattern wherever expense will allow; boldly projected eaves with strong square gutters and plastered soffits; the transference of downspouts wherever possible from the exterior to the interior of the walls. The avoidance of columns, colonnades, cornices and other carpentry

ENTRANCE—RESIDENCE H. H. ROCKWELL, OAK PARK, ILLINOIS
TALLMADGE & WATSON, ARCHITECTS, CHICAGO, ILLINOIS

work which is expensive to build and maintain; a very sparing use of ornament of any kind, which when found is usually of an abstract or geometrical nature and confined to patterns in the brick or forms pressed into cement or plaster; a marked preference for mouldings of straight and original profiles to those of classic form.

Naturally, a careful study is shown in all the plans, and where possible an axial arrangement is used resulting in vistas which enlarge and unify the house.

The ceilings are usually low—nine feet six inches a maximum for the first story, and eight feet six inches for the second.

Our Anglo-Saxon ideas of what is homelike, have been formed in the last three or four centuries by living in houses of English and colonial design—and the most serious criticism that has been advanced against the work of our extreme Western modernists is, that they have lost the home quality and that the architectural theories and the personality of the architect has been stamped, perhaps rather ruthlessly, on his client.

The houses illustrated herewith seem to have avoided this indictment, and architecture on entering the door has not chased the home quality out of the window.

:: ENTRANCE TO RESIDENCE OF C. E. MATHEWS ::
:: :: :: OAK PARK, ILLINOIS :: :: :: ::
TALLMADGE & WATSON, ARCHITECTS, CHICAGO, ILL.

DETAIL OF ENTRANCE—RES. OF W. J. FLEMING, CHICAGO, ILL.
TALLMADGE & WATSON, ARCHITECTS, CHICAGO, ILLINOIS

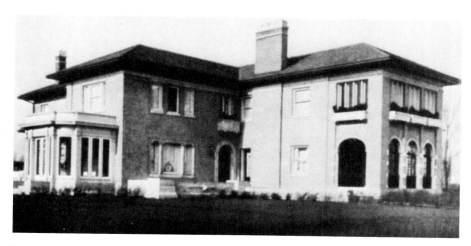

RESIDENCE OF W. J. FLEMING, CHICAGO, ILLINOIS :: ::
TALLMADGE & WATSON, ARCHITECTS, CHICAGO, ILLINOIS

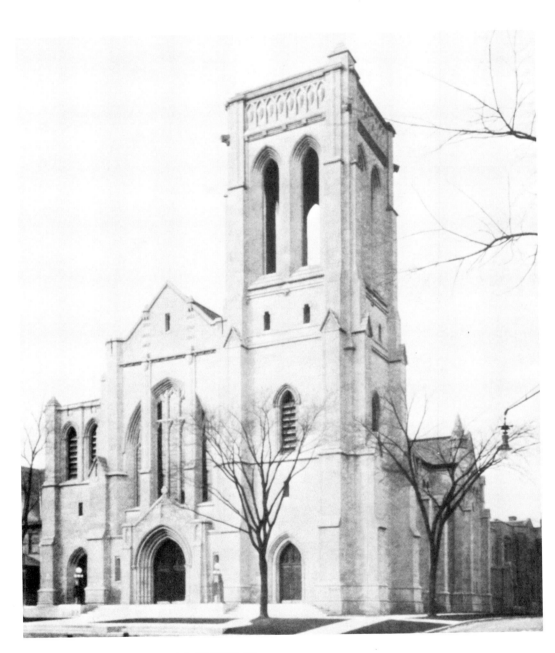

FIRST METHODIST EPISCOPAL CHURCH, EVANSTON, ILL.
TALLMADGE & WATSON, ARCHITECTS, CHICAGO, ILL.

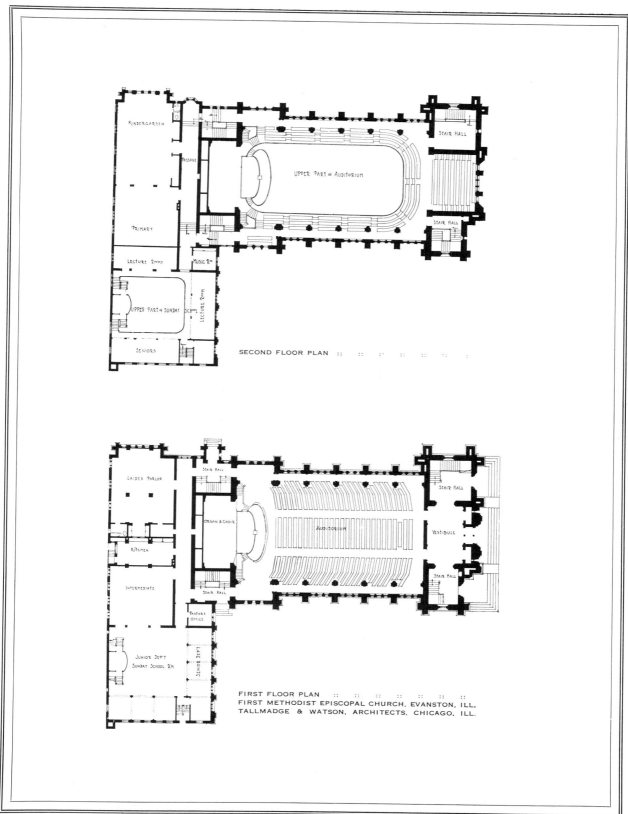

SECOND FLOOR PLAN

FIRST FLOOR PLAN
FIRST METHODIST EPISCOPAL CHURCH, EVANSTON, ILL.
TALLMADGE & WATSON, ARCHITECTS, CHICAGO, ILL.

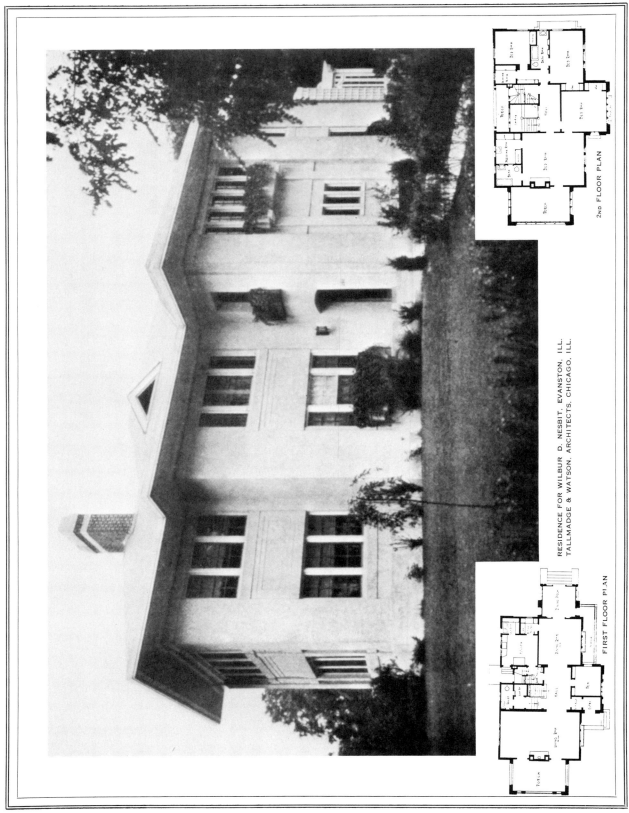

RESIDENCE FOR WILBUR D. NESBIT. EVANSTON. ILL.
TALLMADGE & WATSON. ARCHITECTS, CHICAGO. ILL.

2ND FLOOR PLAN

FIRST FLOOR PLAN

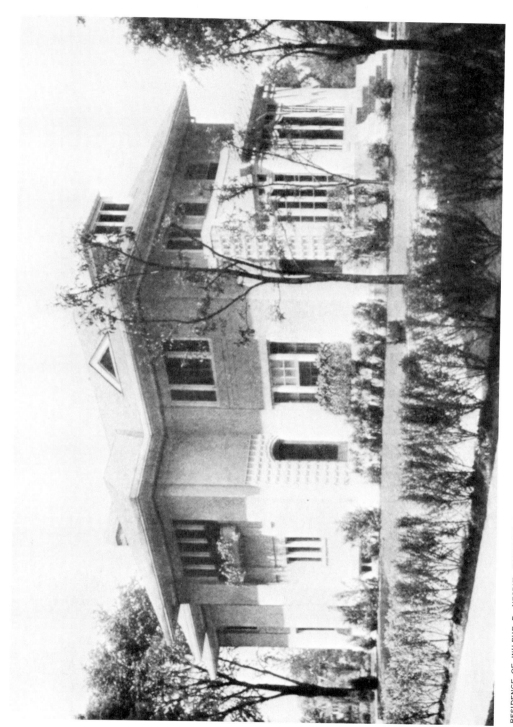

RESIDENCE OF WILBUR D. NESBIT, EVANSTON, ILL.
TALLMADGE & WATSON, ARCHITECTS, CHICAGO, ILL.

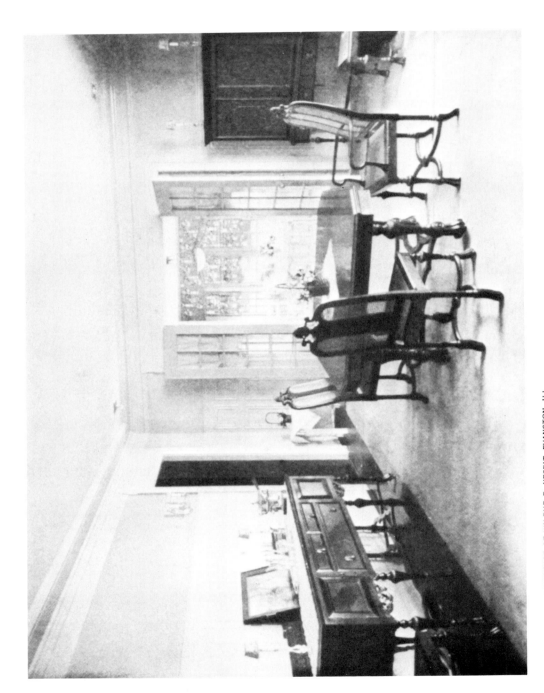

DINING ROOM IN RESIDENCE OF WILBUR D. NESBIT, EVANSTON, ILL. TALLMADGE & WATSON, ARCHITECTS, CHICAGO, ILL. :: :: :: ::

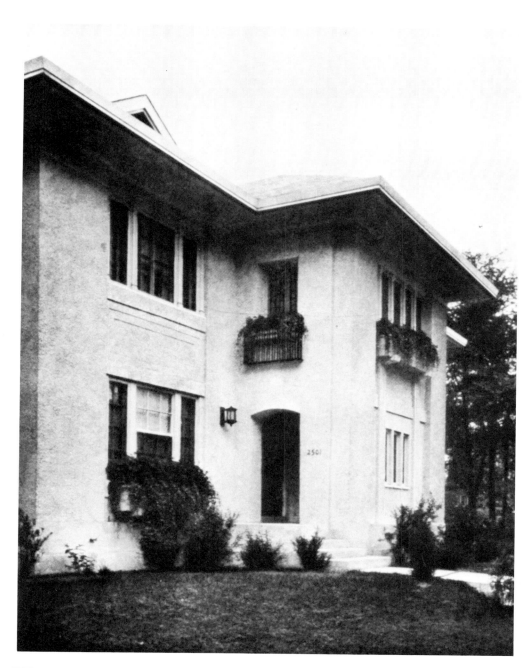

ENTRANCE TO RESIDENCE OF WILBUR D. NESBIT, EVANSTON, ILL.
TALLMADGE & WATSON, ARCHITECTS, CHICAGO, ILL. :: :: :·

RESIDENC E. H. GOLD, HOLLAND, MICHIGAN :: ::
TALLMADGE & WATSON, ARCHITECTS, CHICAGO, ILL.

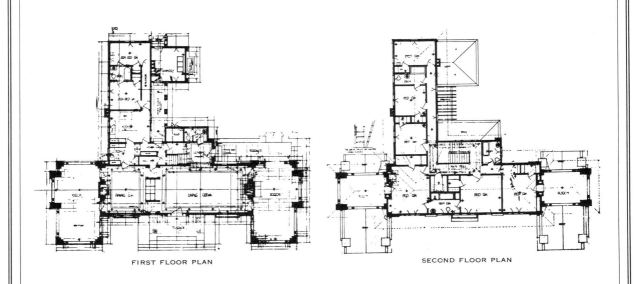

FIRST FLOOR PLAN

SECOND FLOOR PLAN

RESIDENCE OF E. H. GOLD, HOLLAND, MICHIGAN
TALLMADGE & WATSON, ARCHITECTS, CHICAGO, ILL.

RESIDENCE FOR CHAS. M. HOWE, EVANSTON, ILL.
TALLMADGE & WATSON, ARCHITECTS, CHICAGO, ILL.

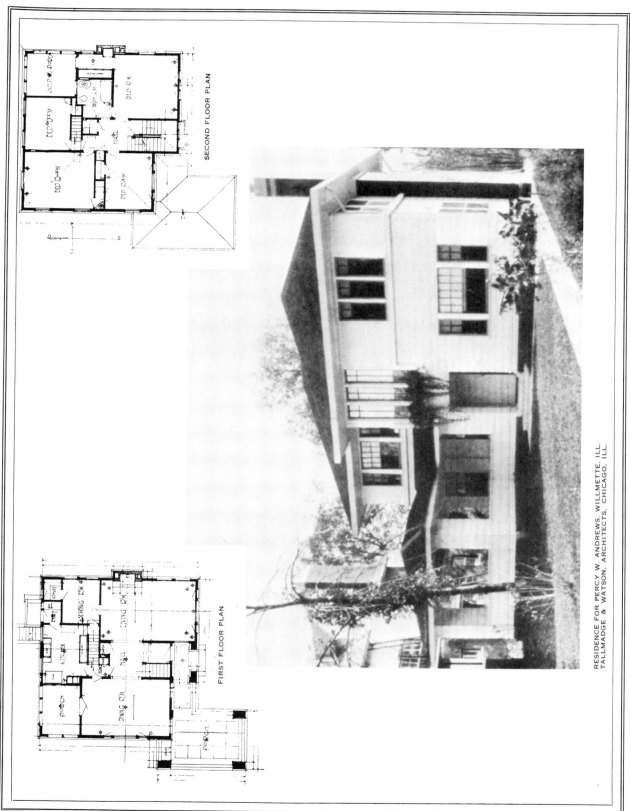

SECOND FLOOR PLAN

FIRST FLOOR PLAN

RESIDENCE FOR PERCY W. ANDREWS, WILMETTE, ILL.
TALLMADGE & WATSON, ARCHITECTS, CHICAGO, ILL.

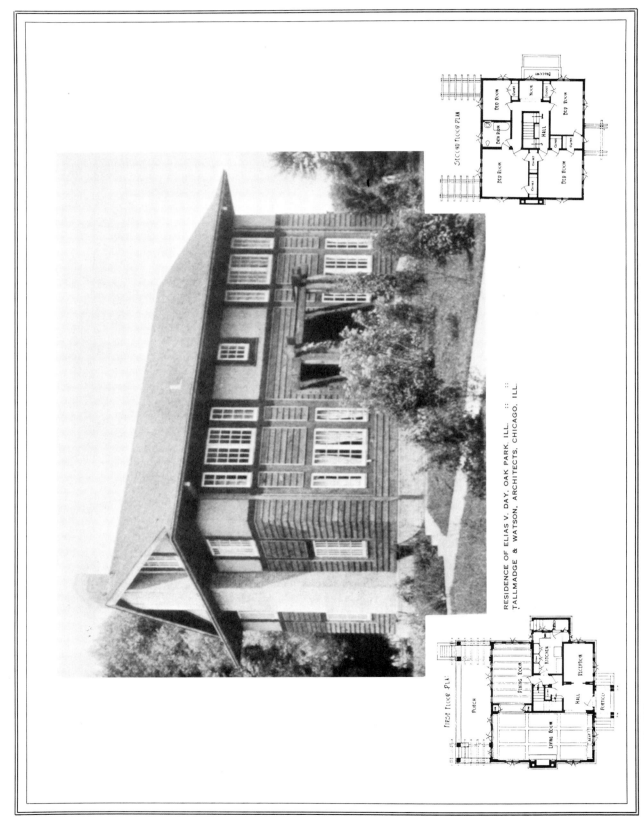

RESIDENCE OF ELIAS V. DAY, OAK PARK, ILL. :: ::
TALLMADGE & WATSON, ARCHITECTS, CHICAGO, ILL.

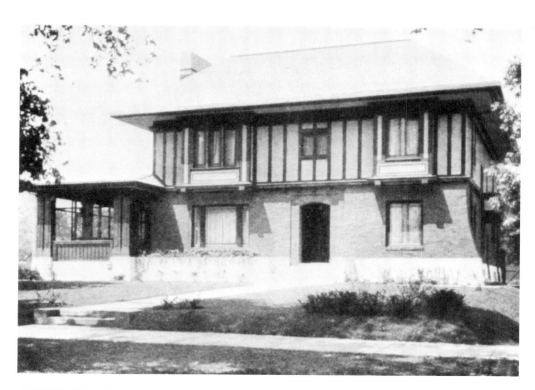

RESIDENCE FOR R. M. ROLOSON, EVANSTON, ILL. ::
TALLMADGE & WATSON, ARCHITECTS, CHICAGO, ILL.

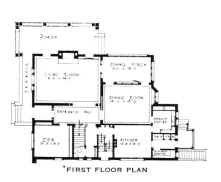

FIRST FLOOR PLAN

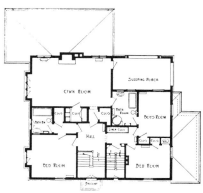

SECOND FLOOR PLAN

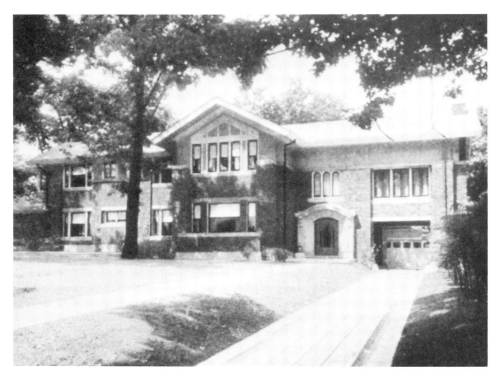

RESIDENCE OF G. BABSON, OAK PARK, ILL.　　　TALLMADGE & WATSON, ARCHITECTS, CHICAGO, ILL.

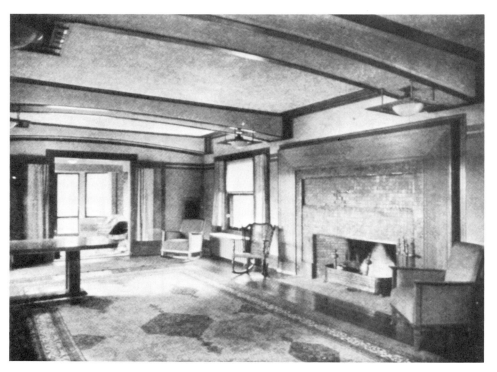

LIVING ROOM　::　::　::　::　::　::

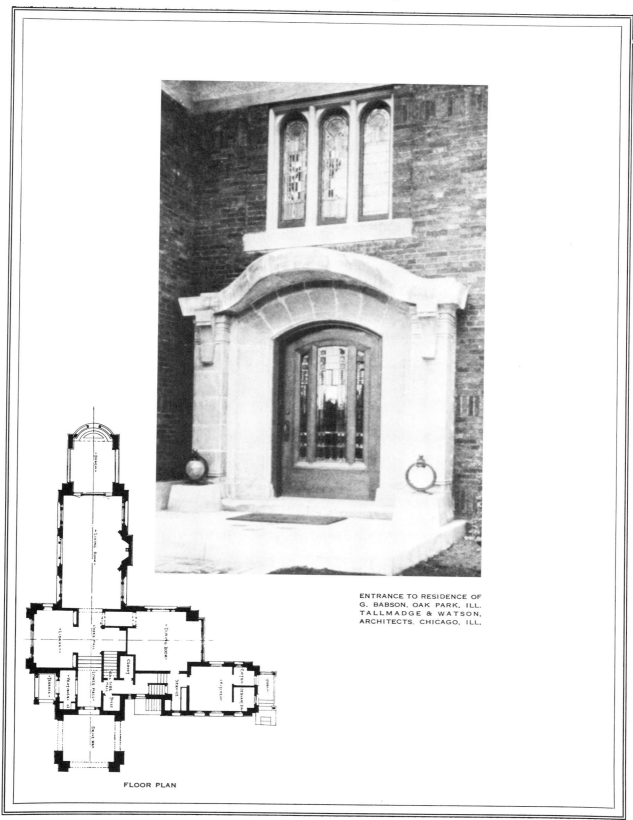

ENTRANCE TO RESIDENCE OF
G. BABSON, OAK PARK, ILL.
TALLMADGE & WATSON,
ARCHITECTS, CHICAGO, ILL.

FLOOR PLAN

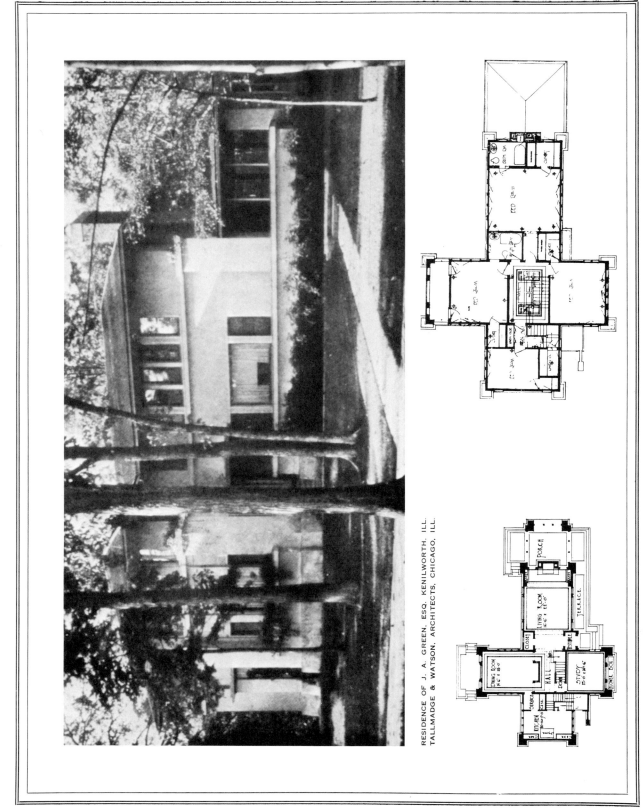

RESIDENCE OF J. A. GREEN, ESQ. KENILWORTH, ILL.
TALLMADGE & WATSON, ARCHITECTS, CHICAGO, ILL.

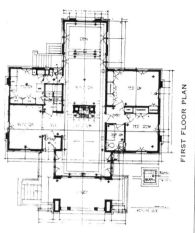

FIRST FLOOR PLAN

RESIDENCE OF T. S. EASTERBROOK, OAK PARK, ILL.
TALLMADGE & WATSON, ARCHITECTS, CHICAGO, ILL.

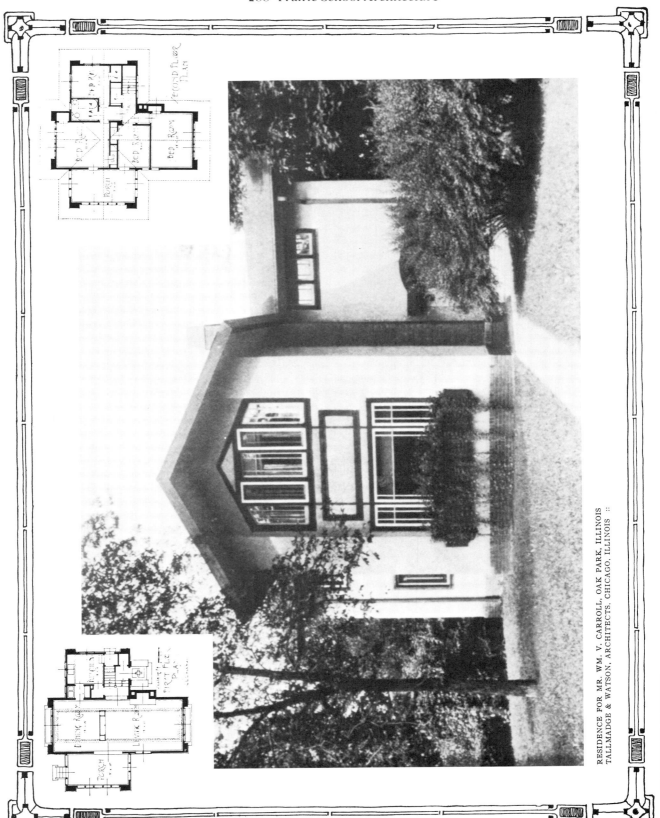

RESIDENCE FOR MR. WM. V. CARROLL, OAK PARK, ILLINOIS
TALLMADGE & WATSON, ARCHITECTS, CHICAGO, ILLINOIS ::

THE WESTERN ARCHITECT
NOVEMBER :: 1914

RESIDENCE FOR J. S. GUY, OAK PARK, ILLINOIS :: ::
TALLMADGE & WATSON, ARCHITECTS, CHICAGO, ILLINOIS

MERCHANTS NATIONAL BANK, GRINNELL, IOWA

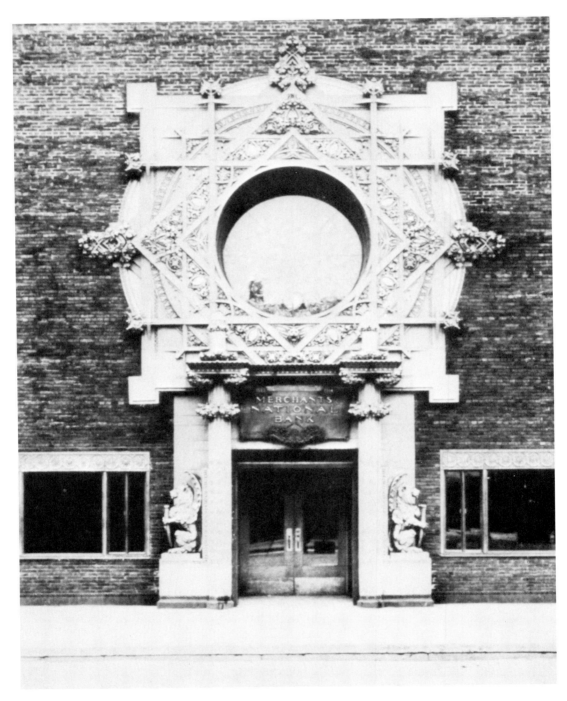

ENTRANCE DETAIL :: :: :: :: :: :: ::
MERCHANTS NATIONAL BANK, GRINNELL, IOWA ::
LOUIS H. SULLIVAN, ARCHITECT, CHICAGO, ILLINOIS

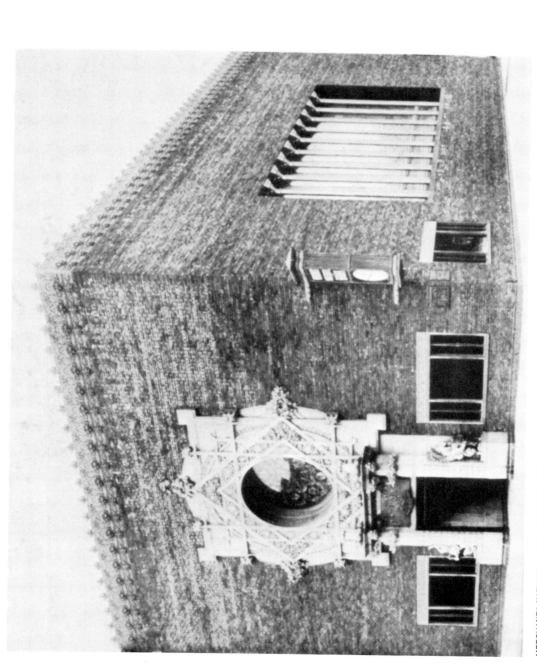

MERCHANTS NATIONAL BANK, GRINNELL, IOWA ::
LOUIS H. SULLIVAN, ARCHITECT, CHICAGO, ILLINOIS

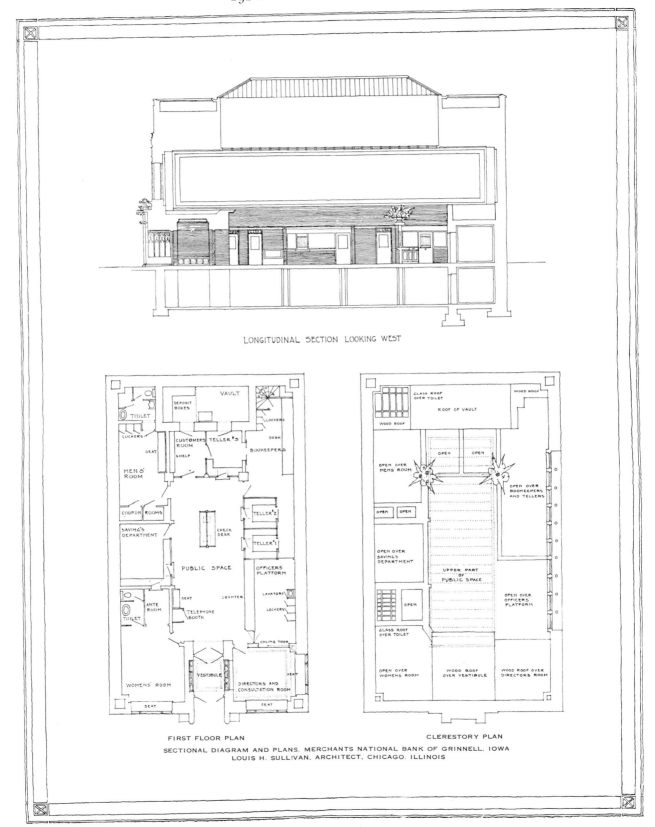

LONGITUDINAL SECTION LOOKING WEST

FIRST FLOOR PLAN

CLERESTORY PLAN

SECTIONAL DIAGRAM AND PLANS, MERCHANTS NATIONAL BANK OF GRINNELL, IOWA
LOUIS H. SULLIVAN, ARCHITECT, CHICAGO, ILLINOIS

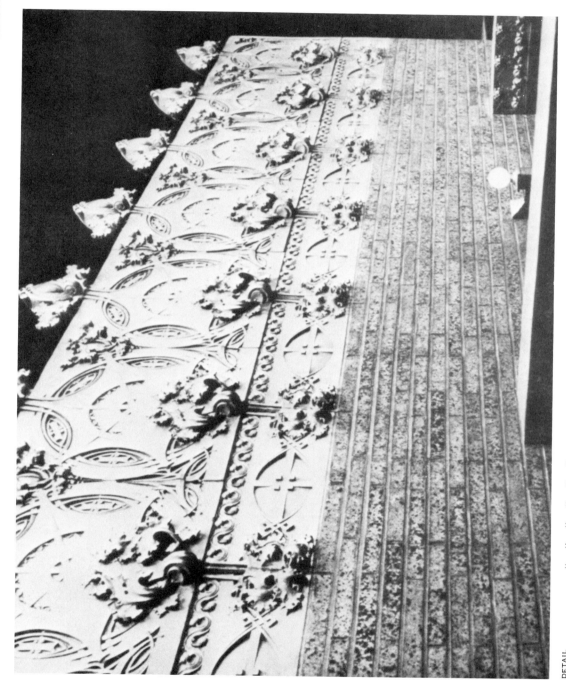

DETAIL
MERCHANTS NATIONAL BANK, GRINNELL, IOWA
LOUIS H. SULLIVAN, ARCHITECT, CHICAGO, ILLINOIS

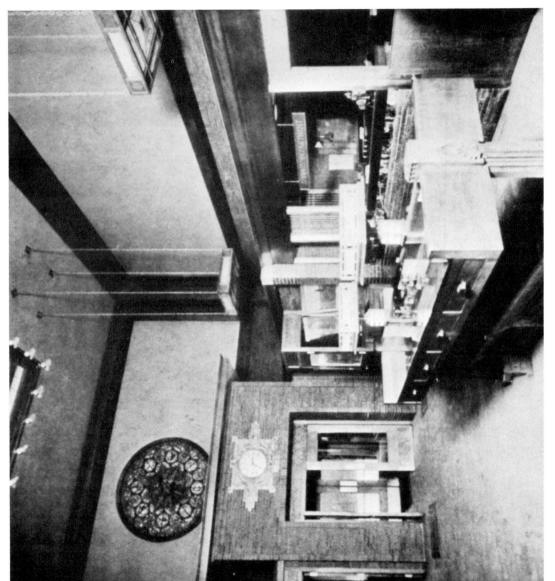

MERCHANTS NATIONAL BANK, GRINNELL, IOWA ::
LOUIS H. SULLIVAN, ARCHITECT, CHICAGO, ILLINOIS

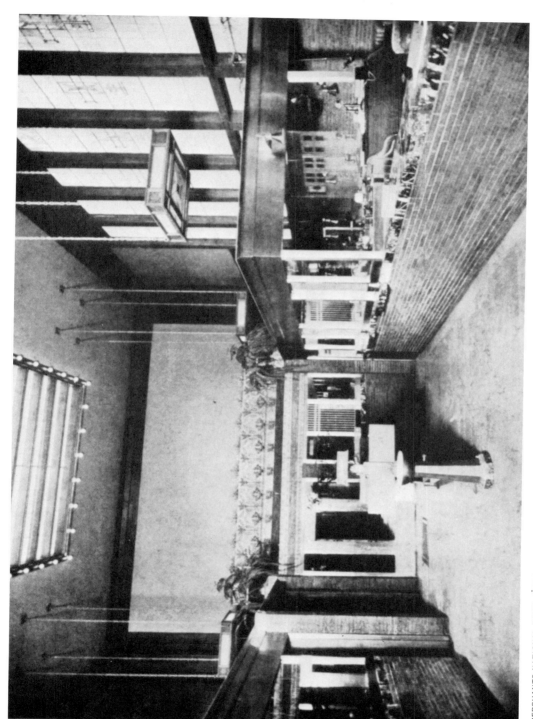

MERCHANTS NATIONAL BANK, GRINNELL, IOWA ::
LOUIS H. SULLIVAN, ARCHITECT, CHICAGO, ILLINOIS

MERCHANTS NATIONAL BANK. GRINNELL. IOWA ::
LOUIS H. SULLIVAN. ARCHITECT. CHICAGO, ILLINOIS

THE WESTERN ARCHITECT
FEBRUARY : : 1916

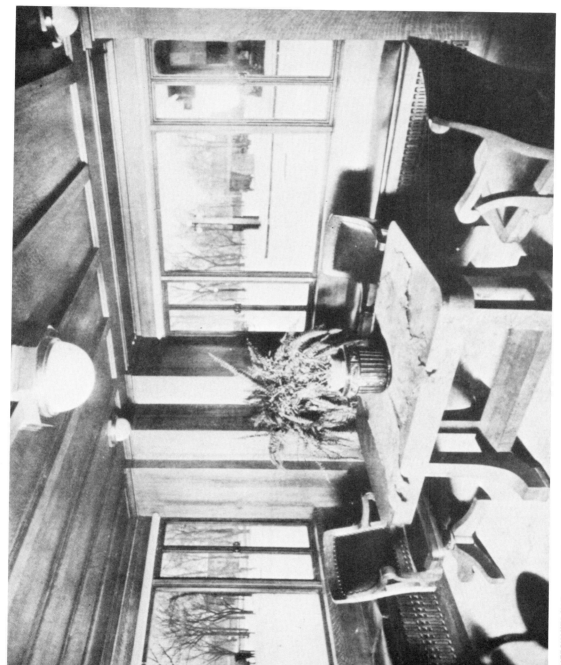

MERCHANTS NATIONAL BANK, GRINNELL, IOWA ::
LOUIS H. SULLIVAN, ARCHITECT, CHICAGO, ILLINOIS

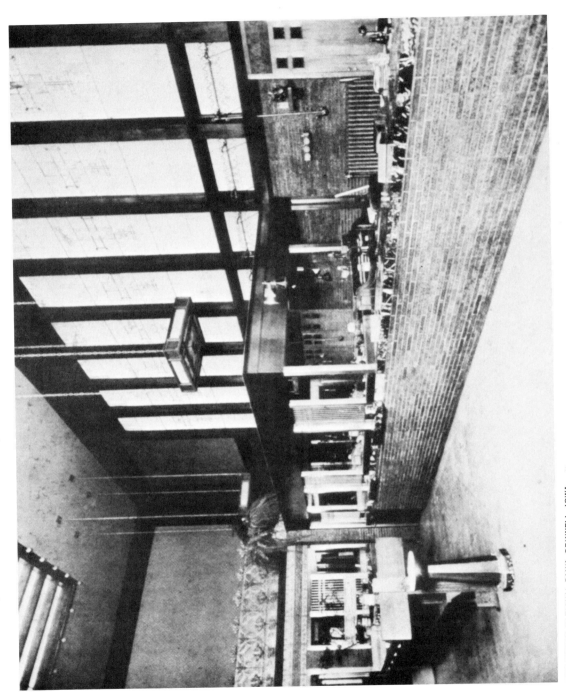

MERCHANTS NATIONAL BANK, GRINNELL, IOWA ::
LOUIS H. SULLIVAN, ARCHITECT, CHICAGO, ILLINOIS

THE WESTERN ARCHITECT
FEBRUARY : : 1916

MERCHANTS NATIONAL BANK, GRINNELL, IOWA ::
LOUIS H. SULLIVAN, ARCHITECT, CHICAGO ILLINOIS

THE WESTERN ARCHITECT
FEBRUARY : : 1916

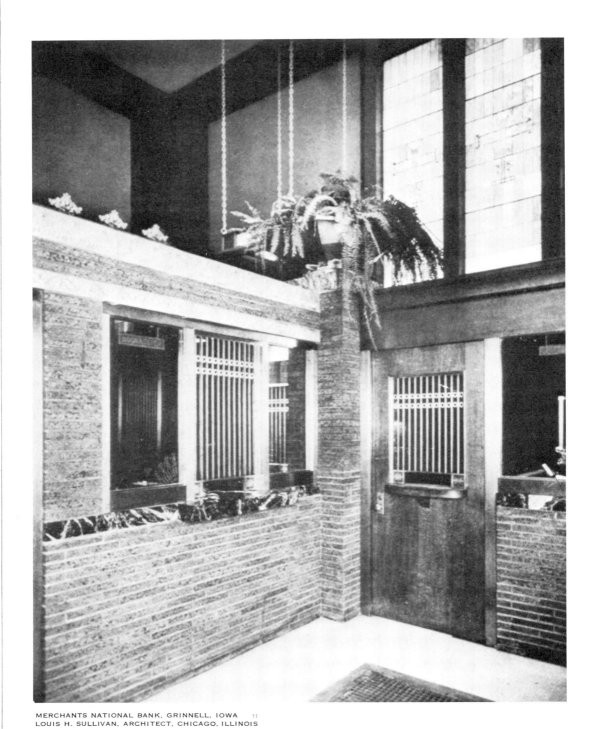

MERCHANTS NATIONAL BANK, GRINNELL, IOWA ::
LOUIS H. SULLIVAN, ARCHITECT, CHICAGO, ILLINOIS

Louis Henry Sullivan

BELOVED MASTER

BY FRANK LLOYD WRIGHT

THE beloved Master who knew how to be a great friend is dead. My young mind turned to him in hope and affection at eighteen, and now, at middle age, I am to miss him and look back upon a long and loving association to which no new days, no new experiences may be added.

He needs no eulogy from me, this man of men, this high-minded workman—who would not sell out! He would take no less than his price—and his price was too high for his time! His price for Louis Sullivan, the Architect, was as high as principle is high; for Louis Sullivan, the sentient human being, his price was not high enough. He was prodigal with his bodily heritage. Recklessly he flung it into the crucible that was his soul, or carelessly he wasted it in physical reactions to dispel loneliness, the loneliness that is the result of disillusionment—the loneliness that every great, uncompromising mind knows well and dreads and inherits, together with those who have gone the lonely road before him where only one at a time may tread. His lesser self was his, to do with as he pleased. He spent it with that extravagance that goes with the opulent nature, rich in resources, and we had him for a shorter time in consequence. The loss was ours—perhaps it was not his.

To know him well was to love him well. I never liked the name Frank until I would hear him say it, and the quiet breath he gave it made it beautiful in my ears and I would remember it was the name of freemen—meant free. The deep quiet of his temper had great charm for me. The rich humour that was lurking in the deeps within him and that sat in his eyes whatever his mouth might be saying, however earnest the moment might be, was rich and rare in human quality. He had remarkable and beautiful eyes—true windows for the soul of him. Meredith's portrait of Beethoven—"The hand of the Wind was in his hair—he seemed to hear with his eyes," is a portrait I have never forgotten. If someone could give the warmer, different line, that would give the Master's quality! I feel it and I have tried—but I cannot write it.

I left him just after the Transportation Building brought him fame—to "make my own," and did not find him again until he was in trouble—some nine years ago, and needed me. Since that time the relation between us, established so early and lasting at that early period seven years, seemed, although the interruption was seventeen years long, to be resumed with little or no lapse of time. We understood each other as we had done always.

Somehow I am in no mood to talk about his work. I know well its vital significance, its great value, the beautiful quality of its strain. I know too, now, what was the matter with it, but where it fell short, it fell short of his own ideal. He could not build so well as he knew nor so true to his thought as he could think, sometimes, but sometimes he did better than either.

Genius he had as surely as there is Genius in the great work called Man. The quality of that Genius his country needed as the parched leaf or the drying fields need dew or rain. A fine depth was in him and he was broad enough, without reducing the scale of it, or showing up the quiet strength of it. And yet his country did not know him!

He loved appreciation. He was pleased as a child is pleased with praise. No measure of it was too much for him, because he well knew that no such measure could reach his powers, much less go beyond them. And any achievement visible as praiseworthy he knew was as nothing compared to what already was achieved in the consciousness that was his.

He was a fine workman. He could draw with consummate skilfulness. He could draw as beautifully as he could think and he was one of the few architects of the age who could really think. I used to fear his graphic facility this virtuosity of his, as an enemy to him in the higher reaches of his genius. It was not so. The very extravagance of his gift was a quality of its beauty in an age when all in similar effort is niggardly or cowardly or stale.

I feel the emptiness where he was wont to work. The sterility of my time closes in upon his place. Machine-made life in a Machine-age that steadily automatizes, standardizes, amortizes the living beauty of the Life he knew and loved and served so well—seems desolation, damnation! Without him the battle seems suddenly to have gone wrong—the victory in doubt!

HERE, in our country, where individual distinction of the highest order must be distorted or swamped in the cloying surge of "good taste!"

Here where free initiative is treated as dangerous or regarded as absurd!

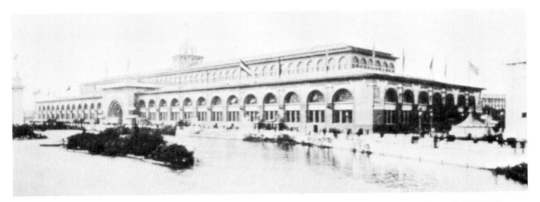

THE TRANSPORTATION BUILDING, WORLD'S COLUMBIAN EXPOSITION. ADLER AND SULLIVAN, ARCHITECTS

Here, where the Gift is suspected, feared or hated unless entertainment can be got out of it!

Here, where the plain man has, in a bogus Democracy, license to sneer at all above him or sit on all below him!

Here, where thought is ankle-deep, activity non-creative, but both, in motion and quantity, over all heads!

Here, in a country so nobly dedicated, root and branch, to Truth and Freedom as no more than Justice, yet where the government itself officially encourages the mental grip of "the middle," the sacred average that all but paralyzes head and heart and hand!

Here where a stupendous, mechanized industry is fast becoming reflected in mechanized mentality, sterilizing Life, Love, Hope—standardization, without light from within is stagnation!

Here where there are religions but no Religion!

Here where there are arts but no Art!

Here where religion and art are utterly divorced from life and automatic substitutes everywhere are in the shop windows, in the streets, in the seats of the mighty, in the retreats of the humble, in the sanctuaries of the Soul!

Here where Institutes turn out droves of illustrators and egotists—mannikins, instead of interpreters and givers!

Here where tainted minor-arts make shift in profusion and disorder upon the ruins of the great Arts!

Here, in this blind aggregation of wealth and power, a great Master was, in despair, forced to relinquish his chosen work in *Architecture*, the great Art of Civilization needed now as of time immemorial, the Art of all arts most needed by his country—and was compelled to win recognition in a medium that is the all-devouring monster of the age—the literal art that has sapped the life and strength of all the other great Arts and to no good purpose: no, to the ever-lasting harm of culture and good life, to the eventual impoverishment of the human establishment! Inasmuch as there are five senses, five avenues open to man's communion with Life—four-fifths of human sensibility is lost when one Art usurps the place of the other four. Human beings are fast becoming human documents, Humanity, a litany!

Here, in free America, this prophetic mind with trained and gifted capacity for the regeneration of this now ugly, awkward work of this world, in *living* forms of Beauty, was little used and passed by, that the process, inexorable as Fate, might not be interrupted—nor little hoards of little men be unduly squandered above the animal plane of economic satisfaction!

That a country in such need, his country,—any country—at such a time—a crisis—should have failed to use one of her great men—in many respects, her greatest man—to do the work he loved and in which he was not only competent but prophetic—is terrible proof of how much more disastrous is half-knowledge, than either Ignorance or Folly could ever be. This I call Tragedy!

* * * * * *

AND now this book, "The Autobiography of an Idea"—his book—has come to convince an unwilling world, tainted with that hatred for superiority that characterizes a false Democracy, of what it missed in leaving a man of such quality to turn from the rare work he could do, to give, in a book, proof of that quality in a medium his kindred had learned to understand—proof of his quality—too late.

It is a characteristic triumph of Genius such as his that he should lay this book upon the library table of the nation he loved, as he died! His fertility was great enough to scatter seed no matter what the disability—no matter what the obstruction. If the eye of his country was uneducated, inept, objective, illiterate or merely *literal*; if its sense of Beauty of

Page 65

Form as Idea or beauty of Idea as Form was unawakened, he took literature, the literal medium by which the literal may most easily be reached and, perhaps, literally made to understand—grasped it and made himself known—the Master still.

But he was most needed where the workmen wait for the Plan—where the directing Imagination must get the work of the world done in such masterfashion that mankind may see and forever more believe that Spirit and Matter are one—when both are real. Realize that Form and Idea are one and inseparable—as he showed them to be in that masterkey to the Skyscraper as Architecture—the Wainwright Building. To this high task he came as an anointed prophet—to turn disillusioned to the cloister as so many have turned before him and will so turn still—although his cloister was the printed page—the book, that, opened now, all may read.

<p style="text-align:center">* * * * * *</p>

ANY appreciation of the Master must be an arraignment of the time, the place, the people that needed and hungered for what he had to give, but all but wasted him when he was fit and ready to give. Yes, in the neglect of this great man's genius and his power to get many more noble buildings built for his country than he was allowed to build—we see the hideous cruelty of America's blind infatuation with the Expedient—this deadly, grinding spoliation of the Beautiful.

Louis Sullivan was a sacrifice to the God of Temporal Things by a hard working, pioneering people, too vain of the culture of lies in their heads, over empty, hungry hearts, a heedless people living a hectic life no full hands may ever make worth while —and who either could not or would not know him. The regret and shame those feel who knew his quality —who knew what his hand held ready to give to truly enrich his kind, the impotent rage that all but chokes utterance that this treasure of a greatly rich and powerful nation was neglected, was comparatively unknown—when the opportunism of the inferior, the fashionable, the imitative were in favor, is hard to bear.

What is left to us is the least of him—but it will serve.

Out of the fragments of his dreams that were his buildings— out of the sense of Architecture as entering a new phase as a *plastic* Art—great things will yet be born. Every thing he did has some fine quality, was some solution of a difficult problem— some sorely needed light on practical affairs. Practical? Truly here was a practical man in a radical sense—rooted in Principle, and as richly gifted as he was impressionable—as deep-sighted as he was farseeing.

<p style="text-align:center">* * * * * *</p>

The work the master did may die with him—no great matter. What he represented has lived in spite of all drift—all friction, all waste, all slip—since time began for man. In this sense was Louis Sullivan true to tradition—in this sense will the divine spark, given to him from the deep centre of the universe and to which he held true, be handed on the fresher, more vital, more potent, enriched a little, perhaps much, by the individuality that was his. There is no occasion for deep despair—although chagrin, frustrated hopes, broken lives and broken promises strew the way with gruesome wreckage. The light that was in him lives—and will go on—forever.

<p style="text-align:center">* * * * * *</p>

Later when I have him more in perspective I intend to write about and illustrate his work. It is too soon, now. I hope to make clear in unmistakable concrete terms, what is now necessarily abstract. A privilege I feel as mine and one I know from him that he would be pleased that I should take, as I have assured him I sometime would do.

The Evolution of a Personal Style

AS SHOWN IN THE WORK OF
BARRY BYRNE AND RYAN COMPANY

In this issue we present some examples of the work of Barry Byrne and Ryan Company, Architects, Chicago, to point out, among other things, the fresh, original and personal trend, that the recent work of the firm has taken (see Frontispiece) and the evolution (typical after all in the sense that it is the way of arrival of all original and personal expressions) through which the firm's work has passed in arriving at its present, somewhat individual, vernacular. Whether or not the reader subscribes to the types presented or considers them appropriate or beautiful, matters little. If it can be shown that the work presented, herewith, resulted from the sincere desire upon the part of the architects, to solve their problems as freely and unhampered as possible by past precedents, prejudices and forms, and at the same time to arrive at a sane, logical, economical and beautiful (as they saw it) expression, in the terms of the materials at hand, the purpose of this review shall have been accomplished.

That Mr. Francis Barry Byrne was once a pupil and follower of Mr. Frank Lloyd Wright, the reader will immediately guess when he examines the residence of Mr. J. B. Franke of Fort Wayne, Indiana, (1914) (Plates I-IV). Here he will note the same treatment of exterior walls, the same dominant horizontal lines and wide overhang of eaves, the same low, thick-set chimneys, the same use of materials that characterized the residence work of Mr. Wright.

But this was only to be expected. The regrettable thing would be that he should never have done anything else, as a thousand imitators might have done. Mr. Wright, in an utterance as long ago as 1908, when speaking of the young men in his office—Mr. Byrne among them—had this to say: "For although they will inevitably repeat, for years, the methods, forms and habits of thought, even the mannerisms of the present work, if there is virtue in the principles behind it, that virtue will stay with them through the preliminary stages of their own practice until their own individualities truly develop independently." The Franke house is unquestionably imprinted with much that Mr. Wright taught and practiced, but the personality of Mr. Byrne is as unmistakably sensed.

The Plates I to XVI, and ending with the Frontispiece, are arranged in an order to show the change that has taken place in the stylistic expression of the firm. One will note in the residence of Mr. J. F. Clarke at Fairfield, Iowa, done the next year (1915) after the Franke House, a tendency to break with the manner of the past, although even here there is still much that is reminiscent of the work of Wright. It may be that here many of the mannerisms of the former work have disappeared, although the general principles set down by Mr. Wright as applicable to "prairie architecture" are assuredly expressed. The interior here lacks that "Japanese" quality which characterizes the living-room of the Franke house, and the ceiling is lightened by the absence of the wooden treatment so frequently encountered in Mr. Wright's work.

A commission of the next year (1916) shows unmistakably the trend which Mr. Byrne's work is taking. The handling of the dark-golden brick-work of the Clarke residence anticipates, in a way, the expression that we find in the apartment for Mr. John Travis Kenna, Chicago; but in the latter structure we find a complete emancipation from the forms or manner of the teacher. Here, simple brick, with straightforward openings, are accepted facts, and the designer sets out to do the best he can with the materials at hand and in the most economical manner. It goes without saying that it is more difficult to design a simple thing than one slightly more ornate or involved, for in the utterly simple the total appeal and interest must come through perfect proportion.

It is difficult to say whether or not we can at once accept the mass that the Kenna Apartment presents in such a view as that shown on Plate XI. Our inability may be at once charged up, it seems, to our previous architectural associations. Certainly much of the structural integrity and architectural logic that Mr. Byrne's early training inculcated is expressed here. The materials are used with a naive simplicity and adorable straightforwardness, the only elements of adornment being the little chevron-decorated moulding around the windows and the two delightful panels by Mr. Alfonso Ianelli, the sculptor and decorator, who is responsible for the sculptural and color notes of the firm's work.

These panels, typical of the creative instincts of the two elements of the race, the male and female, are most appropriate to the home, and it is to be hoped that the panel depicting motherhood is here symbolical of the facts, and not so out-of-place as it would generally be upon most apartment house structures from which children, like animals, are excluded.

The dining-room of the Kenna apartment, if compared with that of the Mrs. William F. Tempel residence in Kenilworth, Illinois (1920) (Plate XVI) will show the firm's tendency regarding interior treatment. The Tempel dining-room is a very harmonious, restful and relatively simple interior, as is also the living-room (Plate XV).

The doorway detail (Frontispiece) of the Saint Francis Xavier School, Wilmette, Illinois (1923) sets forth the firm's latest stylistic development. Here the chevron motif, shown also on the Kenna apartment, which harmonizes with the pointed arch of the doorway and the ingenious, but thoroughly legitimate, manipulation of the brick-work to relieve the angles of the structure, impart a fresh and interesting

(Continued to Page 35)

THE EVOLUTION OF A PERSONAL STYLE
(Continued from Page 31)

diversion from the old and hackneyed methods of brick treatment. This doorway gives some hint of what the current work of Messrs. Byrne and Ryan Company promises. It is hoped that in the near future we may be able to present the present chapter of this interesting evolution of a personal architectural expression, an expression made living through several new Catholic churches, parochial schools and convents.

In all the work herewith presented, Mr. Byrne has had the fullest measure of understanding and cooperation from Mr. Ianelli, the sculptor and decorator, with whom he collaborates in this work. He points out also the excellent landscaped settings made for his work through the efforts of Mr. George Tirrell, in the case of the Franke house, and Mr. Arthur Seifried in the case of the Clark house.

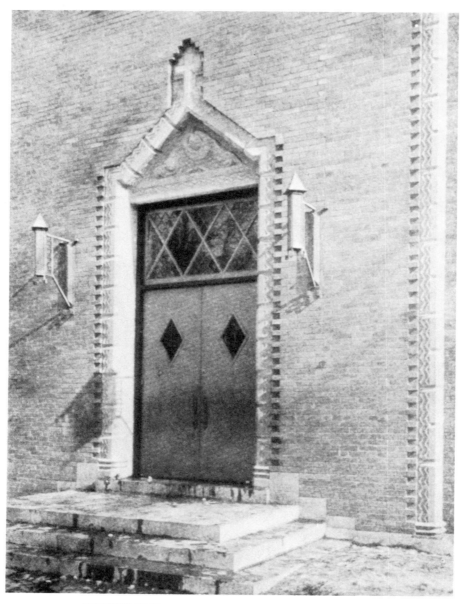

DOORWAY OF ST. FRANCIS XAVIER SCHOOL, WILMETTE, ILLINOIS
THE RIGHT REVEREND F. C. KELLEY, D. D., PASTOR
BARRY BYRNE AND RYAN COMPANY, ARCHITECTS
IN COLLABORATION WITH ALFONSO IANELLI

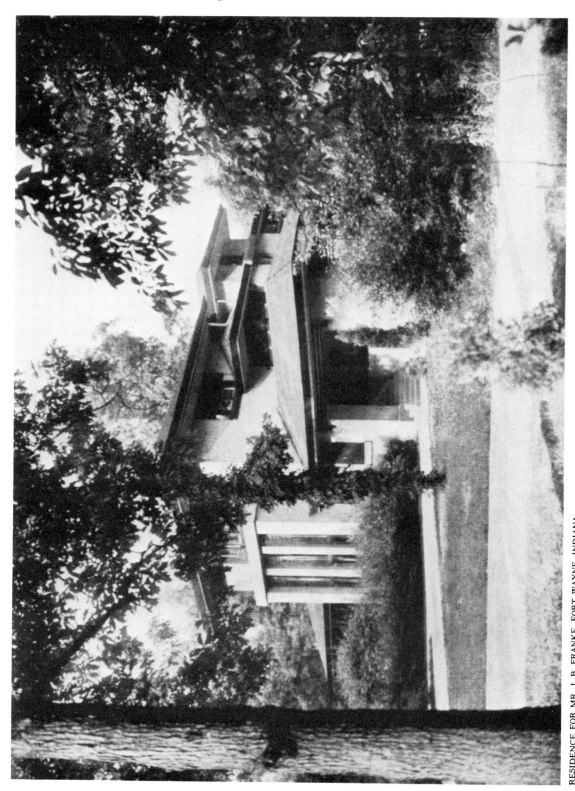

RESIDENCE FOR MR. J. B. FRANKE, FORT WAYNE, INDIANA
(ERECTED IN 1914)
BARRY BYRNE AND RYAN COMPANY, ARCHITECTS ::
PLANTING IN COLLABORATION WITH GEORGE TIRRELL

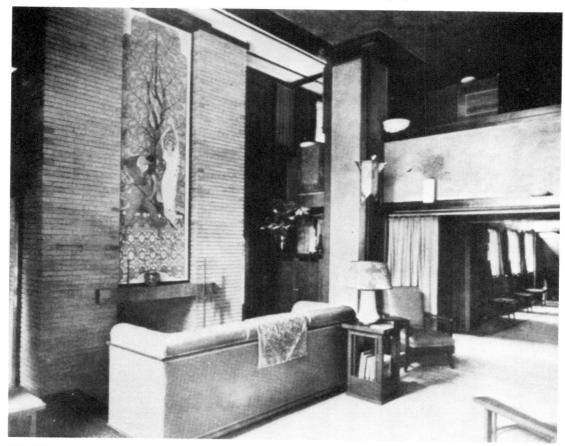

LIVING ROOM

THE WOOD BANDING IS OF NATURAL WALNUT
WITH THE ROUGH PLASTERED WALLS GILDED.
THE AREA OF GILT IS SUFFICIENT TO MAKE IT
THE CONTROLLING TONE. IN THE LOWER PART
OF THE ROOM ARE PANELS OF VERMILION, AND
IN THE CEILING BANDS OF IVORY. THE RUGS
AND HANGINGS ARE OF GREEN BLUE AND THE
UPHOLSTERING MATERIAL OF PALE GOLD. THE
MURAL DECORATION, DESIGNED AND EXECUTED
BY MR. IANELLI, WHO IS ALSO THE AUTHOR OF
THE COLOR ARRANGEMENT FOR THE INTERIOR,
IS OF ROSE RED, GOLD, GREEN, IVORY AND BLUE.

RESIDENCE FOR MR. J. B. FRANKE, FORT WAYNE, INDIANA
BARRY BYRNE AND RYAN COMPANY, ARCHITECTS :: ::
IN COLLABORATION WITH ALFONSO IANELLI :: :: :: ::

FIRST FLOOR PLAN

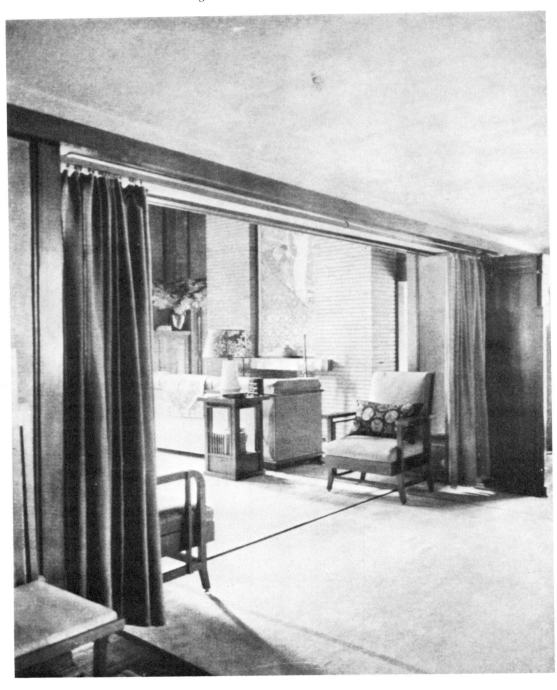

VIEW INTO LIVING ROOM
RESIDENCE FOR MR. J. B. FRANKE, FORT WAYNE, INDIANA
BARRY BYRNE AND RYAN, ARCHITECTS :: :: :: :: ::
IN COLLABORATION WITH ALFONSO IANELLI :: :: :: ::

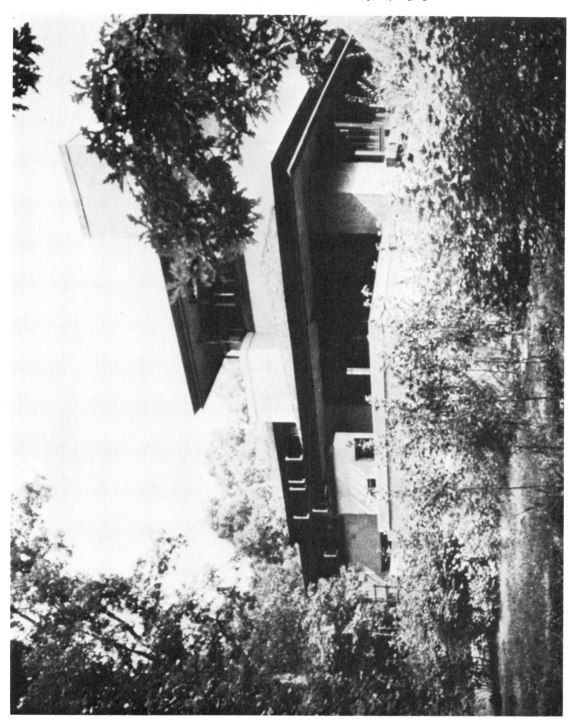

GARDEN SIDE
RESIDENCE FOR MR. J. B. FRANKE, FORT WAYNE, INDIANA
BARRY BYRNE AND RYAN COMPANY, ARCHITECTS :: ::

COLOR ARRANGEMENT BY ALFONSO IANELLI—BRICK OF DARK GOLDEN COLOR, WOODWORK BLACK WITH WHITE SASH: ROOF GREEN: DOOR AND BALCONY BLUE. ROOF PLANTING IN COLLABORATION WITH ARTHUR SEIFRIED

RESIDENCE FOR DR. J. F. CLARKE, FAIRFIELD, IOWA (ERECTED IN 1915)

BARRY BYRNE AND RYAN COMPANY, ARCHITECTS ::

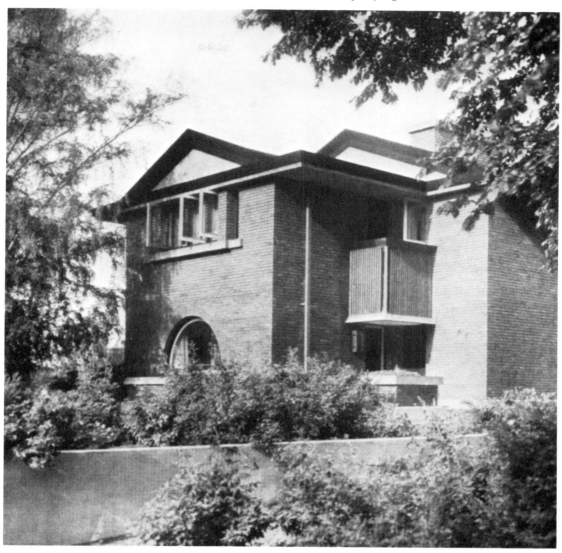

EXTERIOR DETAIL OF ENTRANCE

FIRST FLOOR PLAN

RESIDENCE FOR DR. J. F. CLARKE, FAIRFIELD, IOWA
BARRY BYRNE AND RYAN COMPANY, ARCHITECTS ::

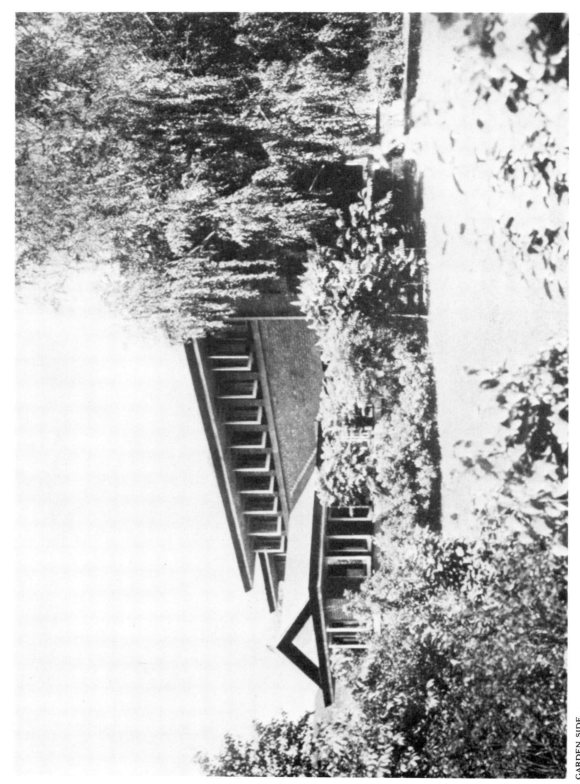

GARDEN SIDE
RESIDENCE FOR DR. J. F. CLARKE, FAIRFIELD, IOWA
BARRY BYRNE AND RYAN COMPANY, ARCHITECTS ::

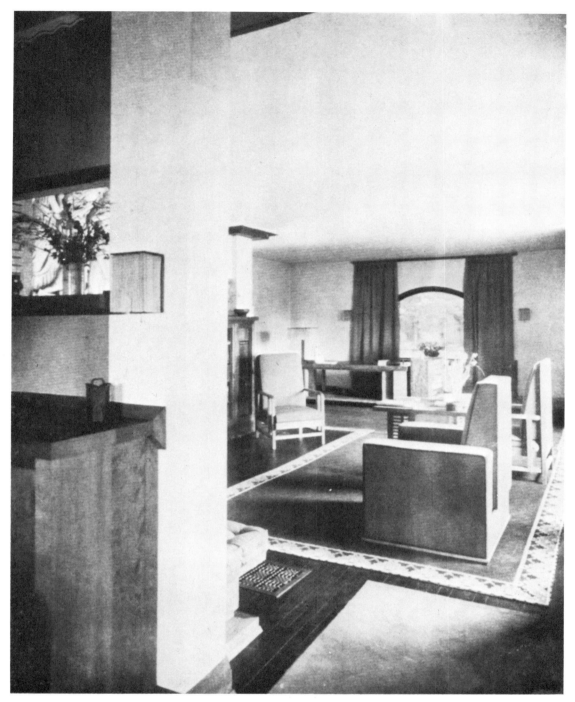

LIVING ROOM
RESIDENCE FOR DR. J. F. CLARKE, FAIRFIELD, IOWA
IN COLLABORATION WITH ALFONSO IANELLI :: ::

COLOR ARRANGEMENT: BLACK FLOOR, RED RUG WITH GOLD, WHITE AND BLUE BORDER; WHITE WALLS AND CEILING;
SILVER GREY WOODWORK AND FURNITURE; UPHOLSTERY COVERING, BLUE EDGED WITH BLACK; HANGINGS GOLD
TONED WITH BLUE STENCILS.

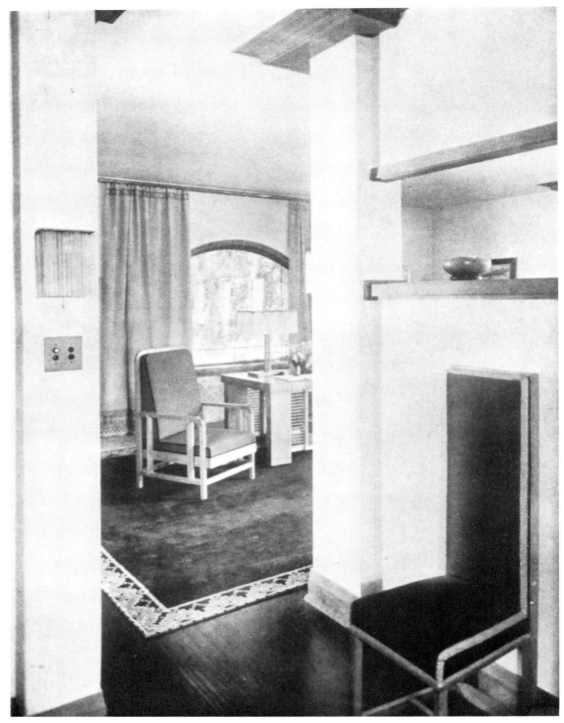

VIEW INTO LIVING ROOM
RESIDENCE FOR DR. J. F. CLARKE, FAIRFIELD, IOWA
BARRY BYRNE AND RYAN COMPANY, ARCHITECTS ::
IN COLLABORATION WITH ALFONSO IANELLI :: ::

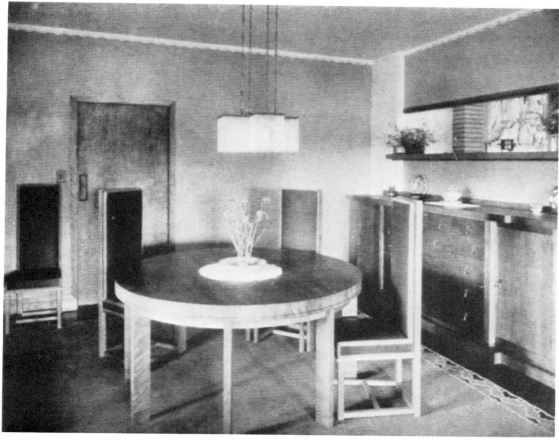

DINING ROOM

COLOR ARRANGEMENT: FLOORS BLACK, WOOD-
WORK AND FURNITURE SILVER GREY; RUG
BLUE WITH RED AND WHITE ENRICHMENT;
WALLS, PURE YELLOW, CEILING WHITE; UPHOL-
STERY MATERIAL RED WITH GOLD EDGE.

RESIDENCE FOR DR. J. F. CLARKE, FAIRFIELD, IOWA
BARRY BYRNE AND RYAN COMPANY, ARCHITECTS ::
IN COLLABORATION WITH ALFONSO IANELLI :: ::

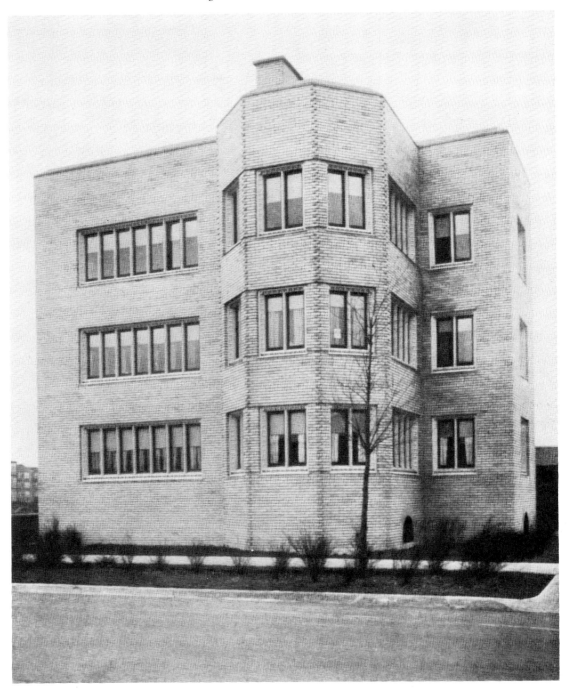

APARTMENT FOR MR. JOHN TRAVIS KENNA, CHICAGO
ERECTED IN 1916 :: :: :: :: :: :: :: :: :: ::
BARRY BYRNE AND RYAN COMPANY, ARCHITECTS ::

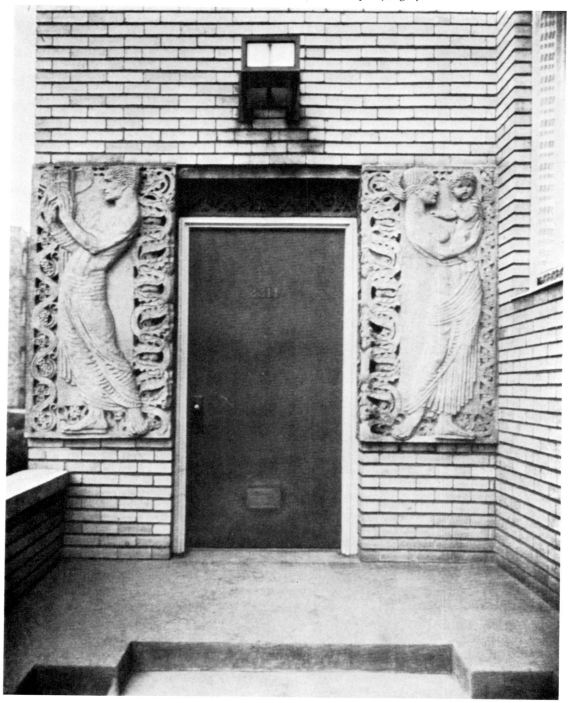

DETAIL OF ENTRANCE
APARTMENT FOR MR. JOHN TRAVIS KENNA, CHICAGO
BARRY BYRNE AND RYAN COMPANY, ARCHITECTS ::
IN COLLABORATION WITH ALFONSO IANELLI :: ::

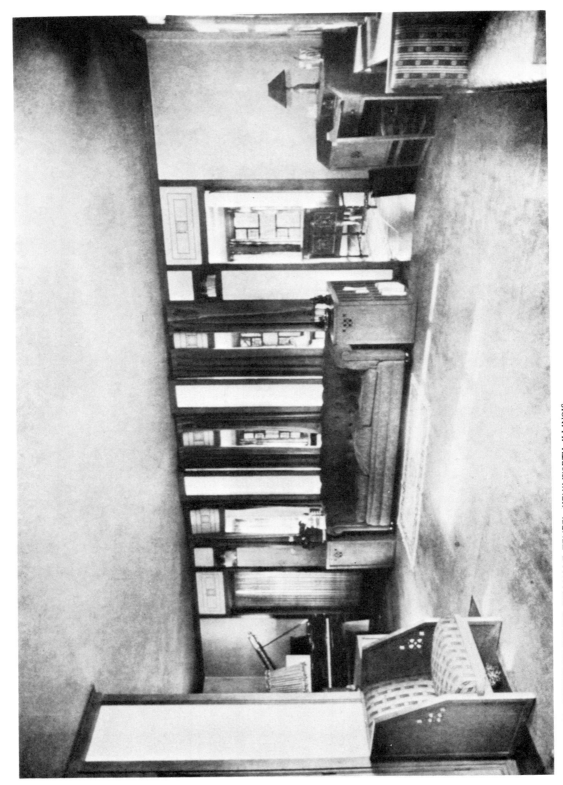

LIVING ROOM: RESIDENCE FOR MR. WILLIAM F. TEMPEL, KENILWORTH, ILLINOIS
ERECTED IN 1920 :: :: BARRY BYRNE AND RYAN COMPANY, ARCHITECTS :: :: :: :: :: ::
IN COLLABORATION WITH ALFONSO IANELLI :: :: :: :: :: :: ::

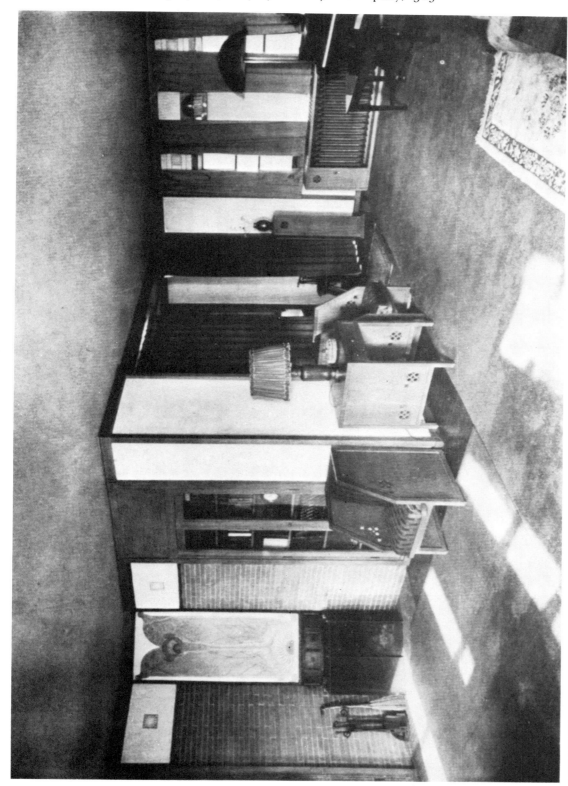

LIVING ROOM
RESIDENCE FOR MR. WILLIAM F. TEMPEL, KENILWORTH, ILLINOIS
BARRY BYRNE AND RYAN COMPANY, ARCHITECTS :: :: :: :: ::
IN COLLABORATION WITH ALFONSO IANELLI :: :: :: :: ::

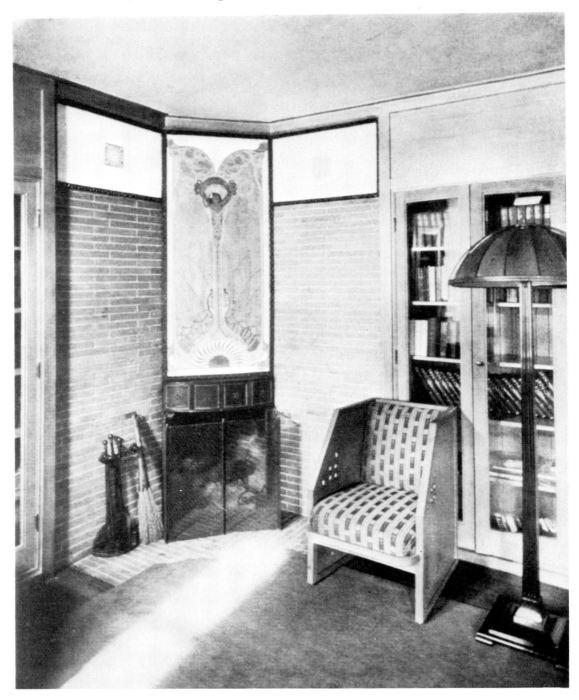

DETAIL IN LIVING ROOM

RESIDENCE FOR MR. WILLIAM F. TEMPEL, KENILWORTH, ILLINOIS
BARRY BYRNE AND RYAN COMPANY, ARCHITECTS :: :: :: ::
IN COLLABORATION WITH ALFONSO IANELLI :: :: :: :: :: ::

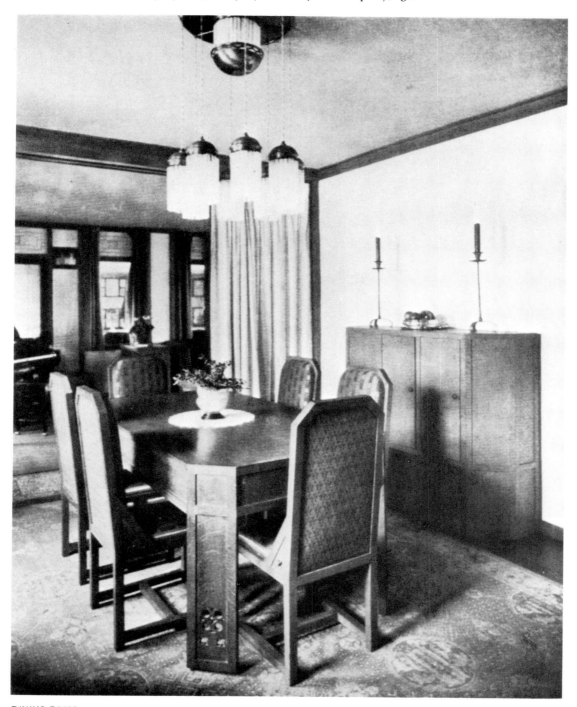

DINING ROOM
RESIDENCE FOR MR. WILLIAM F. TEMPEL, KENILWORTH, ILLINOIS
BARRY BYRNE AND RYAN COMPANY, ARCHITECTS :: :: :: ::
IN COLLABORATION WITH ALFONSO IANELLI :: :: :: :: :: ::

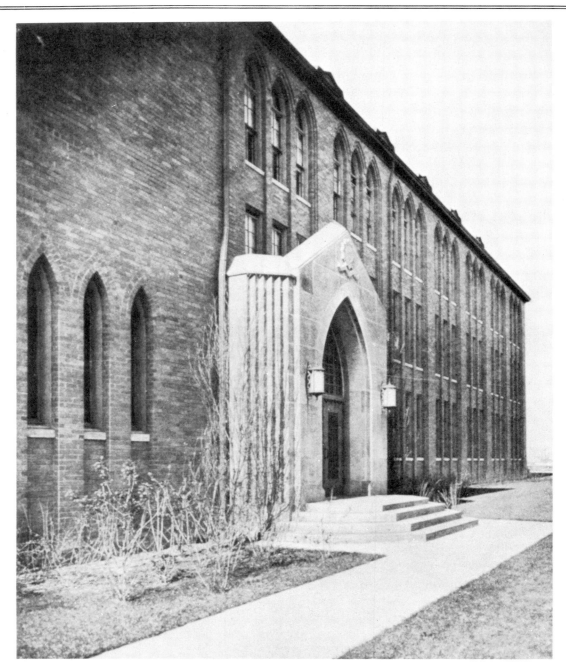

DETAIL OF EAST ELEVATION

THE IMMACULATA HIGH SCHOOL, CHICAGO
THE SISTERS OF CHARITY OF THE B. V. M.,
BARRY BYRNE AND RYAN COMPANY, ARCHITECTS

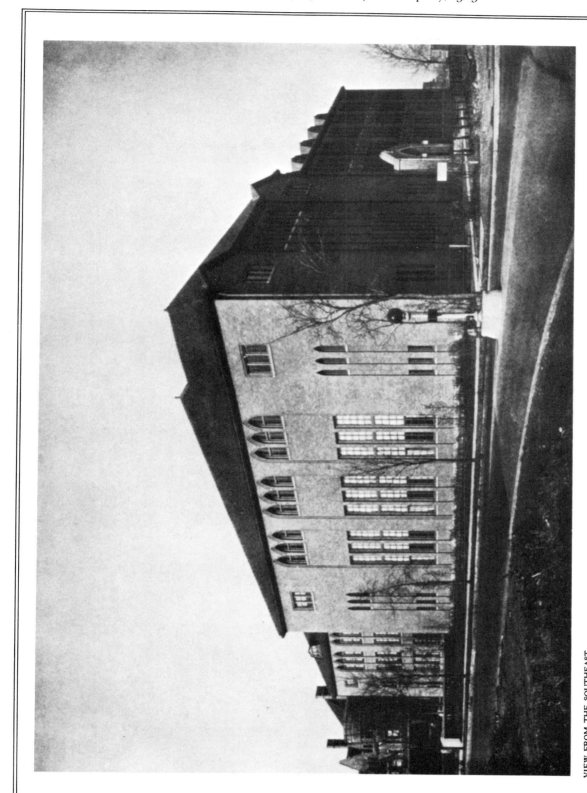

VIEW FROM THE SOUTHEAST
THE IMMACULATA HIGH SCHOOL, CHICAGO
THE SISTERS OF CHARITY OF THE B. V. M.
BARRY BYRNE AND RYAN COMPANY, ARCHITECTS

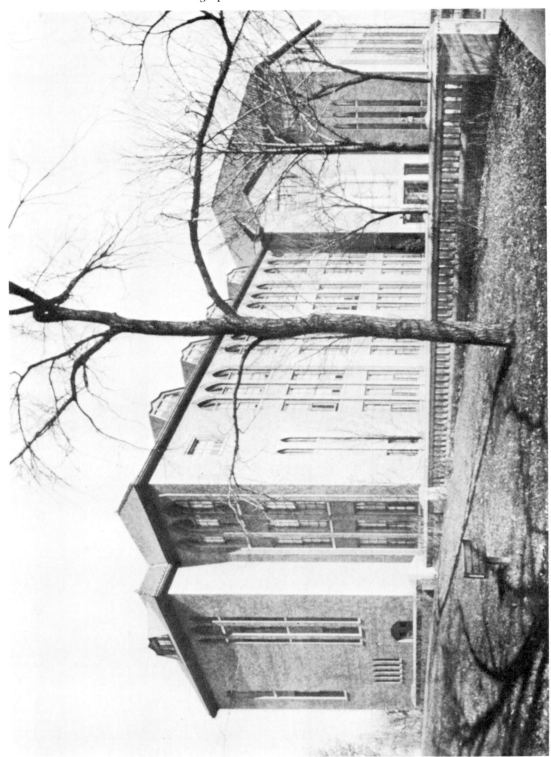

VIEW OF MAIN ENTRANCE FROM THE SOUTHWEST
THE IMMACULATA HIGH SCHOOL, CHICAGO,
THE SISTERS OF CHARITY OF THE B. V. M.,
BARRY BYRNE AND RYAN COMPANY, ARCHITECTS

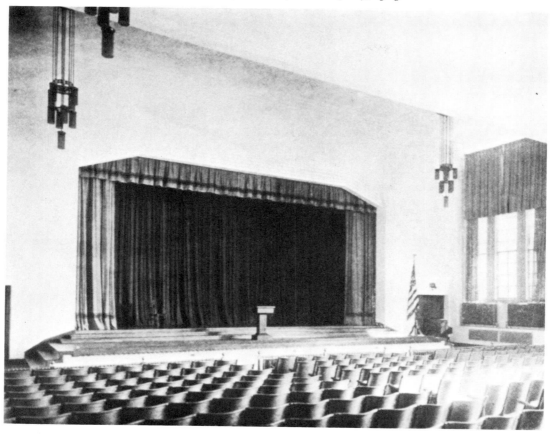

AUDITORIUM

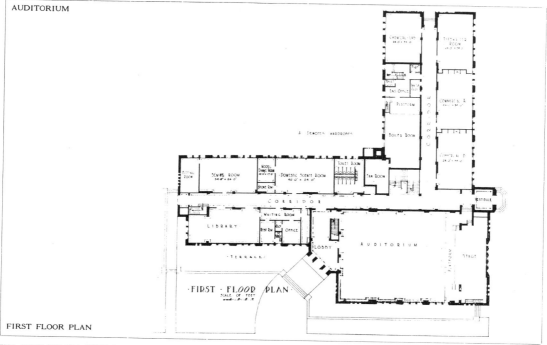

FIRST FLOOR PLAN

THE IMMACULATA HIGH SCHOOL, CHICAGO
THE SISTERS OF CHARITY OF THE B. V. M.,
BARRY BYRNE AND RYAN COMPANY, ARCHITECTS

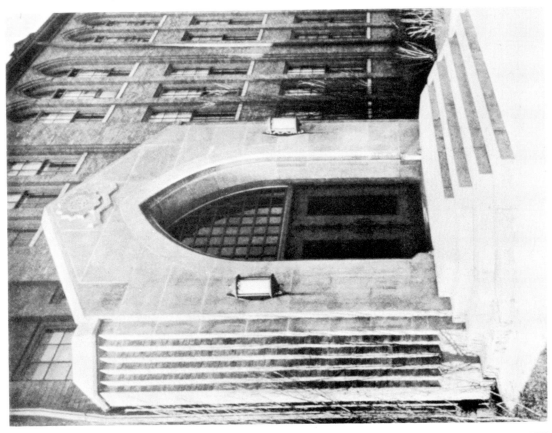

DETAIL MAIN DOORWAY

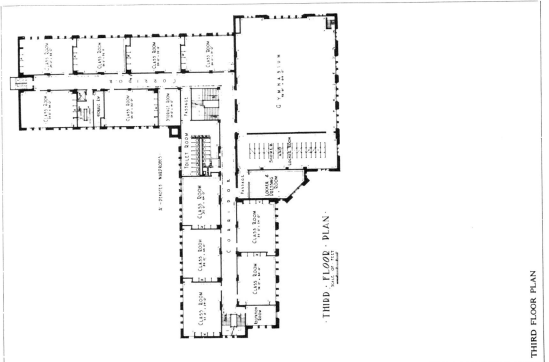

THIRD FLOOR PLAN

THE IMMACULATA HIGH SCHOOL, CHICAGO
THE SISTERS OF CHARITY OF THE B. V. M.
BARRY BYRNE AND RYAN COMPANY, ARCHITECTS
GRILLES, LIGHT FIXTURES AND ENRICHMENT BY ALFONSO IANNELLI

PLATE FIVE

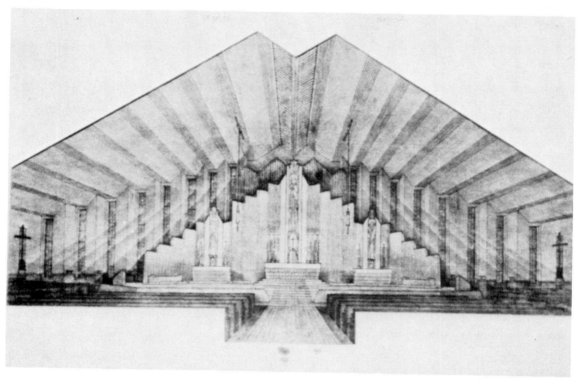

INTERIOR PLAN, CHRIST KING CHURCH, CORK, IRELAND, BARRY BYRNE, ARCHITECT

Christ King Church---Cork, Ireland

By Barry Byrne

WHEN Dr. Cohalan, the Bishop of Cork, commissioned the architect to design a church, the idea he had in mind was not that of a modern church, as the meaning of that term has come to be understood. The appeal to him of the ideas, as stated in the accompanying creed, was that they made possible a genuine Catholic Church, suitable for worship. Modernism was the result. The basis was practical functionalism, imaginatively treated.

The emphasis of the exterior design of this building is on the entrance, which leads towards the altar; on the interior the emphasis is on the altar and its great screen reredos, which dominate the entire church.

The building is of monolithic concrete as to walls. The roof is spanned by steel trusses. The exterior is white cement with a buff red, tile roof. The figure of Christ at the main entrance, is cast in concrete. The sculptor for this architectural figure is John Storrs.

All of the interior surfaces are of cement in some form. The walls and ceilings above the wainscote are white cement. The wainscote and floor are of black terrazo, to assemble the detail of the

FRONT ELEVATION

pews into one tone.
The sanctuary, altar
and reredos are of
white, pre cast terrazo,
enriched with yellow
t e r r a z o and gold
mosaic. The narrow
windows are, mainly,
deep blue in tone and
in abstract patterns.
There is a skylight the
length of the church at
the ridge of the roof.
This admits white light
through a perforated
cement grille.

Editor's Note:
Lewis Mumford visited Mr.
Byrne in Chicago and became
acquainted with his work here.
Afterwards Mr. Mumford
wrote an article describing and
stating the theory or creed in
this work. It was through
this article that Dr. Cohalan
became acquainted with Mr.
Byrne.
A brief statement of these
principles is given as follows:

FUNCTION AND BUILDING

THE b a s i s f o r
architectural design
is to be sought in the
functions of a building.
In the difference of
functions, allied to types of structure, lies the pos-
sibility for variety in expression, that is desirable in
architecture.

Function is at the beginning of design; imagina-
tion finds its place in sensing the value of these
functions for artistic disposition and effect.

The purpose for which the building is erected is
prior to the building. The progress of the design of
a building has order and rightness when the function
determines both the plan and the architectural forms
that result from the plan.

Building forms, because of themselves alone,
have no artistic validity. Their claim to be archi-
tectural forms depends on their relation to function
and structure.

This relation may be literal and the building
honest; it may be imaginative and the building
honest and architecturally great. The difference is
that between the honest craftsman and the endowed
artist. The former is the man, who, in a multitude
of many of his kind, produces a democracy of art,
in which the total is architectural greatness.

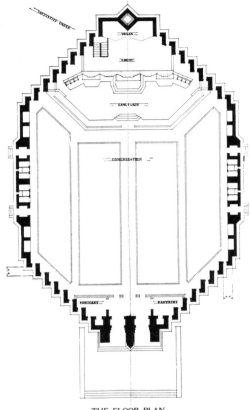

THE FLOOR PLAN

The latter, function-
ing as an architect,
producing valid archi-
tecture, is the crafts-
man plus a talent that
cannot be defined in
exact words. One is of
the soil of Art; the
other is the rare flower
of Art. The architec-
tural craftsman, in his
group, is great as an
army is great; the other,
in his solitude, as a
leader is great. Periods
of living art are made
up of both types. A
decadent period has
only the exotic flower-
ing of genius, which
seems to be independ-
ent of season and
clime.

The large body of
minor artists are then
involved in futility.
They become fashion
adepts. And yet a liv-
ing architecture is im-
possible without them,
for their total may
produce architectural
magnificence far beyond their capacity as individ-
uals. The Gothic is an illustration of this.

The way of architecture is from the ground up;
from the general to the particular.

Function is first; building, second.

In a Catholic Church, then, what are the func-
tions?

First, the altar. It is primary. The church
building exists to house it, the celebrants at it and
the people who come before it. The building struc-
ture surrounds these with walls, covers them with
the span of a roof. This is a church.

The people come to worship and to participate
in worship. The liturgy of the Mass is not for the
few, it is for all to follow, as intimately as they
can. The altar and the worshippers then must be
as one, or as much so as space and a large number
of worshippers permits.

The modern church is for the people who build
it and of the day that produces it. If it fulfills the
functions of its use and structure, it is a church in
the truest sense of that word.

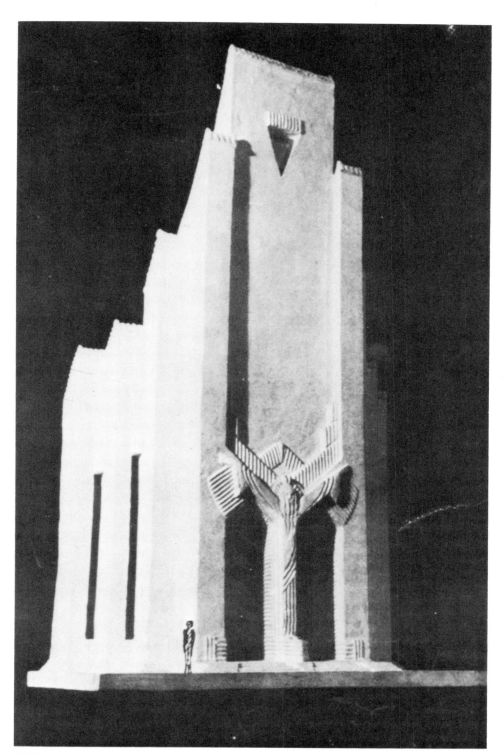

CHRIST KING CHURCH, CORK, IRELAND (MODEL)
BARRY BYRNE, ARCHITECT, CHICAGO; R. BOYD-BARRETT, SUPERVISING ARCHITECT, CORK, IRELAND

Index

Illustrations and articles are listed according to architect